ifficult and every-
he once said. "The
 do nowadays is sit
he woods and eat

'If that happens to you, you now believe in God if you didn't,' a chief says.

the city and

TYPOGRAPHY 34

HARPER
DESIGN
An Imprint of HarperCollinsPublishers

TYPOGRAPHY 34

HarperCollins books may be purchased for educational, business, or sales promotional use.
For information, please write:
Special Markets Department,
HarperCollins*Publishers*,
10 East 53rd Street, New York, NY 10022.

FIRST EDITION

First published in 2013 by:
Harper Design
An Imprint of HarperCollins*Publishers*
10 East 53rd Street
New York, NY 10022
Tel: (212) 207-7000
Fax: (212) 207-7654
HARPERDESIGN@HARPERCOLLINS.COM
HARPERCOLLINS.COM

Distributed throughout the world by:
HarperCollins*Publishers*
10 East 53rd Street
New York, NY 10022
Fax: (212) 207-7654

ISBN: 978-0-06-211281-1

Library of Congress Control Number: 2013942719

Book Design by Chip Kidd.

Carol Wahler
Executive Director
Type Directors Club
347 West 36th Street, Suite 603
New York, NY 10018
Tel: (212) 633-8943
e: director@tdc.org
w: tdc.org

Produced by Crescent Hill Books, Louisville, KY
CrescentHillBooks.com
Printed in Seoul, Korea

ACKNOWLEDGMENTS

The Type Directors Club gratefully acknowledges the following for their support and contributions to the success of TDC59 and TDC2013.

Design: Chip Kidd
Production: Adam Wahler for A to A Studio Solutions, Ltd.
Editing: Dave Baker, supercopyeditors.com

Judging Facilities: Pratt Institute, Manhattan Campus
Exhibition Facilities: The Cooper Union
Chairpersons' and Judges' Photos: Catalina Kulczar-Marin

TDC59 Competition (call for entries):
Design: Chip Kidd
Online submission application development: adcSTUDIO

The principal typeface used in the composition of TYPOGRAPHY 34 is Blender Pro. This typeface was designed by Nik Thoenen and is distributed by Gestalten Fonts (gestaltenfonts.com).

TDC59 DESIGNER'S CONCEPT COMMENTS *TEXT AND CONTEXT.* 6

TDC59 COMMUNICATION DESIGN CHAIRMAN'S STATEMENT 9

TDC59 JUDGES 13

TDC59 BEST IN SHOW AND STUDENT DESIGN AWARDS 29

TDC59 JUDGES' CHOICES 37

TDC59 WINNERS 53

TYPEFACE DESIGN 2013 255

TYPEFACE DESIGN 2013 CHAIRMAN'S STATEMENT 257

TYPEFACE DESIGN 2013 JUDGES 261

TYPEFACE DESIGN 2013 JUDGES' CHOICES 271

TYPEFACE DESIGN 2013 WINNERS 281

TDC10 AWARDS CATALOG 293

TDC OFFICERS 347

TDC MEMBERSHIP 350

TYPE INDEX 354

INDEX 356

"It all kind of happened at once. Now I have psoriasis."

'I'm supposed to
do this, and I can't
tell you why.'

most nent socialites,
House ch

They're Tan And Toned, But They're Not Very Nice

TEXT AND CONTEXT.
BY CHIP KIDD

It's on the bucket list of any serious graphic designer: art-direct and design the TDC annual. A year ago, when the phone rang with the offer to do just this, my first thought was: "What an honor to be asked!" Then, almost as immediately, reality hit me like a cold wet carp to the forehead: "Wait! What the hell am I going to do?" But it was too late. Of course I said yes. Now what?

Over the past 33 years, the list of designers and illustrators who have given the Type Directors Club annual its look reads like a Who's Who of the history of the discipline. This was going to be the graphic design equivalent of going on stage after the Beatles. To wit, the previous year's designer of the book was . . . Paula Scher.

Thanks a lot.

One bit of advice that quickly came to mind was something that Lanny Sommese, my graphic design teacher at Penn State, once told us after assigning a particularly tricky problem: "Find out what everyone else in the class is doing," he said, "then do something else." So that was my goal here, but it didn't make it any easier.

The TDC staff very kindly lent me access to all their annuals, especially from the last ten years. This was of course informative, but what I learned was what I feared the most: I was screwed. Seemingly every kind of typographic approach had been done, from formal experimentation to historical references, classicism, pop, grunge, and everything in between. What could I possibly add to this? I hadn't the slightest idea, so I did what I always did in this situation: I set it all aside and worked on something else.

And about a week later, while I was reading an article in the *New York Post* about a new scientific study that concluded that your pets actually know if you just had sex, I got it: the pull-quotes.

For about ten years now, one of my many questionably unhealthy obsessions has been to rip curious pull-quotes and headlines from the newspapers and save them. For what, I wasn't sure, but I supposed it was my version of painting on the weekends. Anyway, I read both *The New York Times* and the *New York Post* daily; the former to find out what's going on in the world, the latter to be entertained by and informed about what The Enemy is thinking. I can't remember what phrase got me started, but once I did, I couldn't stop scanning the papers to find real doozies:

DRUNKEN DRIVER ARRESTS HIMSELF

PILLOW TALK FOR THE WEARY

DENTISTS, NUNS AND ORGAN-SELLING

WILL AMERICANS FINALLY GIVE LARD ITS DUE?

Hypothetically, donating sperm so friends can have a baby is a simple decision.

Aha. Here was real typography by, for, and about real people. It wasn't pretty and didn't need to be. It just has to get your attention long enough to read the story. Also, removed from their context, the phrases take on the quality of lines from absurd, neurotic haikus. I had gathered hundreds over the years.

And now I finally had a use for them. This would be my strategy—Found Typography—which I was fairly certain had not been done for the TDC before. At least not like this. The only thing left to figure out conceptually was how to connect the quotes to the Type Directors Club in a meaningful way. The answer came quickly: I could only use only quotes or headlines that had a T, D, and C, in that order. Then I would highlight them in primary colors, revealing that the TDC (like typography itself) is everywhere, hiding in plain sight. Sort of like the obsessions of Russell Crowe's character in *A Beautiful Mind*, only in my case it's *A Mind In Distress*.

My sincere thanks to Carol Wahler and the TDC board for not showing me the door upon being presented with this admittedly unorthodox scheme. Ditto the folks at HarperCollins. And eternal gratitude to Adam Wahler for doing all the production heavy lifting.

In conclusion (and at the risk of pointing out the obvious), I should note that this approach works the way it does only because the examples are ink on paper: the saturation of the colors on the newsprint, the torn edges, the uneven printing of the type, the occasional bleed-through of whatever's on the other side. They are artifacts—keepsakes of the ongoing chronicle of the wonderful and strange human story.

And, like this book, they cannot be turned off with a switch.

—C.K., NYC, June 2013

A choreographer, working with a team of scientists, depicts a neurological illness onstage.

TDC59 COMMUNICATION DESIGN
CHAIRMAN'S STATEMENT
BY SEAN KING

Those of us who love letters discover beautiful and innovative typography in the pages of every TDC annual. Each year, designers and typographers enter their best work in the TDC competitions and cross their fingers, hoping their work is good enough to make it into this book. I have lost count of how many designers have told me the same story: the day they saw their first TDC annual, and the treasure of type and lettering between its covers. (People usually get a faraway look in their eyes and wear a wistful smile when they tell this story.)

It is a tradition that reaches back to the very beginning of the Type Directors Club. The twin traditions of the TDC have always been competition and education. Both ideals are contained in this book: We elevate the art and craft of typography by celebrating the best each year.

I discovered typography through the TDC annuals. I found a few in my high school library and realized there was a name for design with letters. I realized some other people must be as fascinated with letters as I was, because there was a whole book of it published every year. The TDC and an earlier iteration of this book helped to steer my career. You can imagine my delight when I was invited to chair TDC59. It is an honor and a privilege, and I am proud to bring you the fruit of so many people's labors in the pages of *Typography 34*.

Allow me to thank a few of the people who labored to make this happen. Chip Kidd created a unique, provocative, and very funny design style for this year's competition and book. Who knew the club's influence ran so deep? (Cue maniacal laughter.) Our jury is a varied group of women and men with expertise in branding, packaging, publishing, type design, editorial design, lettering, filmmaking, dimensional typography, and design education. As varied as their talents are, all the jurors have two things in common. They are all passionate about type, and they are not shy with their opinions. (Three things, actually: They are all a pleasure to work with. Thanks, guys!) Of course, the secret ingredient that makes the competition and annual happen every year is Carol Wahler. Her energy and organizational skills are simply amazing, and her hard work has brought this annual into existence.

The real stars of the show are the talented designers whose work was chosen to appear here. It was a wide field with tough competition this year; only the very best entries won. This book showcases incredible innovation alongside classical beauty, sumptuous print design alongside digital interaction, established professionals alongside promising students.

We are pleased to present the typographic feast you are about to devour. Enjoy.

New for this year: TDC members are identified in the credits with a ●

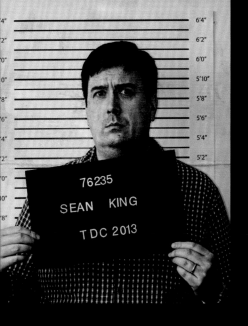
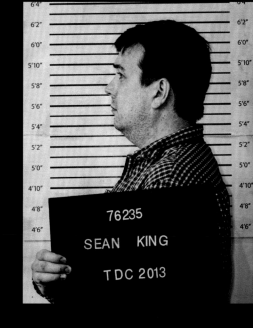

SEAN KING

seankingdesign.com
@seankingdesign

Sean King is a graphic designer, typographer, type designer, design educator, and author. He has worked in print shops, ad agencies, and branding firms. He is a graduate of the Type@Cooper condensed program. The common thread running through all his work is a love of letters, in all their varied forms. He lives and works in New York City and draws inspiration from NYC's rich cultural mix. He is writing a book on typographic best practices, to be published in fall 2014. Sean has served on the board of the TDC for the past four years.

The eloquent gumshoe

Vast orbital habitats

★MEMPHIS MEANS MUSIC★

INTERMEZZO: Vespa Sopressa

Eighteen Million and One

A jury that reached a
guilty verdict without
having all of the facts.

TDC59
COMMUNICATION
DESIGN
JUDGES

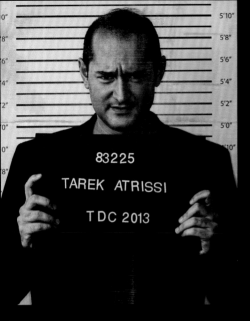

TAREK ATRISSI

atrissi.com
@atrissi

Beirut-born Tarek Atrissi is one of the most recognized designers in the Arab world. He runs the Netherlands-based multi-disciplinary design studio Tarek Atrissi Design, which specializes in Arabic typography and design (www.atrissi.com). His typographic and cross-cultural design approach produced projects that left a significant influence on the contemporary graphic design landscape in the Middle East.

Atrissi holds an MFA in design from the School of Visual Arts in New York, a master of arts degree in interactive multimedia from the Utrecht School of the Arts in Holland, and a postgraduate degree in typeface design from the Type@Cooper program of The Cooper Union, New York. His awards include the Adobe Design Achievement Awards, TDC, and the Dutch Design Award, among others.

الحروف لا تبوح بأسرارها
وبالتالي بروعة جمالها
إلا لمن يرنو إليها بعمق

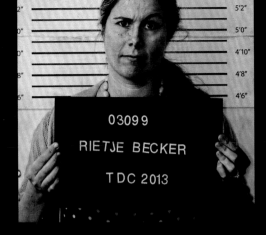

RIETJE BECKER

rietjedesign.com
@rietjedesign

Rietje Becker is a designer, design director, and type enthusiast based in New York City. She specializes in corporate identity and packaging design, and has completed successful design programs for a wide range of internationally known brands and clients, including the 9/11 Memorial, Jane Goodall, Leviton, Ernst & Young, Entenmann's, Kraft, Royal Ahold supermarkets, Johnson & Johnson, Schering-Plough, and Sharp USA. Becker has worked at several branding agencies, including Sterling Brands, Landor Associates, and Interbrand. Originally from the Netherlands, she provides a global perspective to her clients.

When not at work, Becker enjoys sharing design inspiration on her blog and is a contributor for UnderConsideration's Brand New. She is also an adjunct professor in FIT's Packaging Design department.

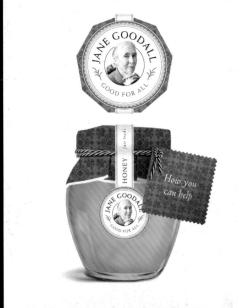

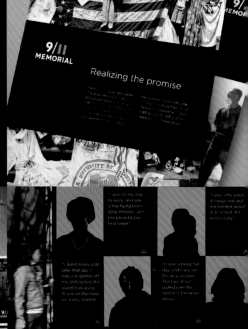

9/11 MEMORIAL

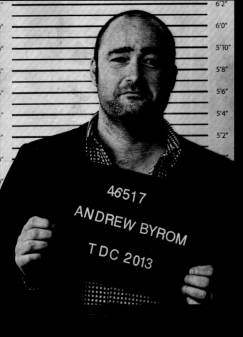

ANDREW BYROM

andrewbyrom.com

Andrew Byrom is a British-born graphic designer based in Los Angeles.

His work explores the conventions of typographic design in three dimensions, using unfamiliar applications, materials, and processes to define new forms. This development led to a natural foray into the field of environmental graphic design, where he is collaborating on projects for the built environment.

His experimental and multi-disciplinary design has been exhibited across the United States, Europe, and Asia and has been recognized with certificates of excellence from the AIGA and Type Directors Club. In 2012 he was elected as a member of The Alliance Graphique Internationale.

Byrom's clients have included the Architecture and Design Museum, *The New York Times Magazine*, Penguin Books, Sagmeister Inc., and UCLA Extension.

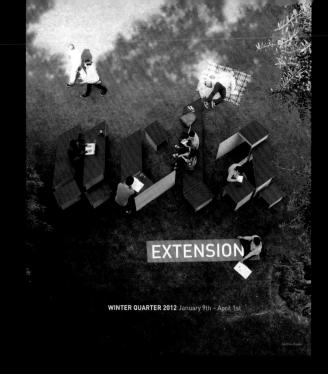

EXTENSION

WINTER QUARTER 2012 January 9th – April 1st

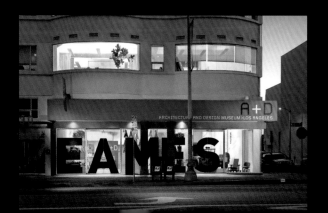

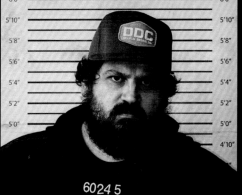

6024 5

AARON DRAPLIN

TDC 2013

AARON JAMES DRAPLIN

draplin.com
@draplin

Located in the mighty Pacific Northwest, the Draplin Design Co. proudly rolls up its sleeves on a number of projects related to the print, identity, web development, illustration, and Gocco muscle categories. We make stuff for Coal Headwear, Union Binding Co., Richmond Fontaine, Field Notes, *Esquire*, Nike, *Wired*, Timberline, Chunklet, Incase, Giro, Cobra Dogs, Burton Snowboards, Hughes Entertainment, Megafaun, Danava, Ford Motor Company, Woolrich, and even the Obama administration. We pride ourselves on a high level of craftsmanship and quality that keeps us up late into the wet Portland night.

Our proud list of services: graphic design, illustration, friendship, clipping pathery, garying, jokes/laughter, campfire strummin', Gocco dynamics, road trip navigation, trust, guitar tuning, gen'l conversation, culture critique, color correcting, existential wondering, bounty hunting, heavy lifting, advice, a warm meal, simple ideas, and occasional use of big words.

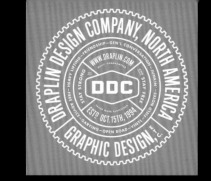

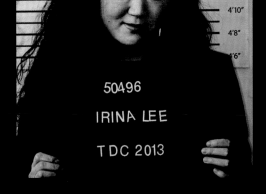

50496

IRINA LEE

TDC 2013

IRINA LEE

irinalee.com
@irinatlee

Irina Lee is a graphic designer, writer, and educator based in New York. As the founder and executive director of First Person American, a story-telling initiative that uses film and multimedia to spark social change, she has brought New York Welcoming Stories to life through filmmaking and storytelling workshops, public screenings, and large-scale events in partnership with major institutions such as the Statue of Liberty–Ellis Island Foundation, the New York Public Library, Facing History and Ourselves, Tenement Museum, and many others. She has received the Sappi Ideas that Matter and Adobe Foundation Design Ignites Change grants. She has worked as an independent designer on a variety of projects including film and video production, web, print, and everything in between for corporate and nonprofit clients. She serves as the managing editor for the New York chapter of AIGA.

The Graphic Design Reference & Specification Book: Everything Designers Need to Know Every Day, an indispensable handbook for graphic design projects (co-written with Poppy Evans and Aaris Sherin), was published by Rockport Publishing in 2013.

Lee earned a master of fine arts degree in design from the School of Visual Arts, where she now teaches typography.

The
Graphic
Design

Reference +
Specification
Book

ROCKPORT

Everything Graphic Designers Need to Know Every Day

Measurement conversion charts
Copyright and trademark standards
Proofreaders' symbols
Abbreviation guide
Image file formats
Standard camera formats and sizes
Finding the best scanning resolution
Type basics and terminology
General guide to printing processes
North American sheet sizes
International, or ISO, sheet sizes
Paper usage guide
Standard binding types
Process color finder
Proofing methods

COLOR FOR INTERIORS
VISUAL CONCEPTS
FURNITURE DESIGN
HISTORIC PRESERVATION
LANDSCAPE DESIGN
CONTRACT DESIGN
PROFESSIONAL PRACTICE
CONCEPTUAL SKETCHING
KITCHEN & BATH DESIGN
DESIGN THEORY
CODES
RETAIL DESIGN
SET DESIGN
GREEN DESIGN
RESIDENTIAL DESIGN
BASIC DRAFTING
ANTIQUE APPRAISING
HOSPITALITY DESIGN
ELEMENTS OF RENDERING
HISTORICAL STYLES
HEALTHCARE STUDIO
BUILDING SYSTEMS
MODERN ARCHITECTURE
MATERIALS OF CONSTRUCTION
SUSTAINABLE STUDIO
TEXTILES FOR INTERIORS
THE SCIENCE OF LIGHT
ENVIRONMENTAL PSYCHOLOGY
ART AND SOCIETY
HISTORY OF BUILDING TYPES
CULTURAL ANTHROPOLOGY
DESIGN & DRAWING
CONSTRUCTION DOCUMENTS
DAYLIGHTING STUDIO
DECORATIVE PAINTING
STUDY ABROAD
SURVEY OF ART
20TH-CENTURY DESIGN
HEALTHCARE FACILITIES

New York
School
of Interior
Design

View Book
2013/2014

MERRY
&
BRIGHT

first person american

WHAT'S YOUR STORY?

CRAIG WARD

wordsarepictures.com
@mrcraigward

Craig Ward is a British designer and art director based in New York.

A contributor to several industry journals, author of the best-selling book *Popular Lies About Graphic Design*, recipient of the TDC's Certificate of Typographic Excellence, former ADC Young Gun, and TEDx speaker (Philadelphia, 2012), he has been fortunate enough to work with some of the biggest clients in the advertising, music, fashion, and editorial fields.

DANGEROUS

MACY'S
FOURTH
of JULY
FIREWORKS

27945

ALYCE WAXMAN

TDC 2013

ALYCE WAXMAN

alycewaxman.com
@awyeh

Designer, illustrator, and art director Alyce Waxman works across a variety of media, from print and photography to video and environments. With a background in art history, she leverages her interest in how aesthetics can reflect and connect with culture and society to create engaging brand experiences. Recent clients include Jack Spade, Condé Nast, Henri Bendel, Sondre Lerche, and the National Academy of Art.

Waxman has held positions at prominent design institutions throughout her career, including Landor Associates, Number Seventeen, and Cooper-Hewitt National Design Museum. She holds a degree in graphic design from Parsons The New School for Design as well as a degree in art history from Carleton College. She has spoken at Western Michigan University and served as a judge for the Type Directors Club's 2012 annual awards. Her work was published in *Infiltrate: The Front Lines of the New York Design Scene* (with Paul Sahre) and shown at the Type Directors Club in New York City.

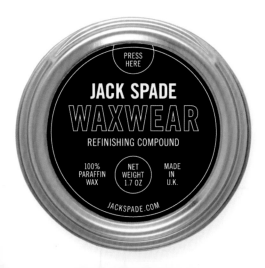

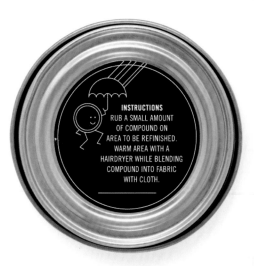

"I had no restraint. They were crawling up towards my face."

TDC59

BEST IN SHOW
AND
STUDENT DESIGN AWARDS

BEST IN SHOW

The poster for the 2012 Brand New Conference was a modest giveaway to the attendees, but really it was an excuse to showcase the ingredients of the conference's identity— which are also included in this annual, and you can read in detail about their concept and execution. The identity consists of two main layers: custom geometric letterforms that spell out the name and twelve patterns that are made up of "debris" from well-known logos.

For the poster we wanted to highlight both these layers in a subtle way, because the rest of the identity was very much in-your-face and colorful. The logo patterns are printed as tinted letterpress, meaning they only darken the color of the heavy red paper. The geometric letterforms are then applied on top through a clear foil stamp; you can still see the color and texture of the paper but with a nice gloss. If you look at the poster straight on, you almost can't see a thing—but once the light hits at an angle, it's full of highlights and shadows.

The clear foil plate on the poster was reused on the cover of the conference's program— also featured in the book—but on purple paper so that we were able to both establish some visual consistency between the materials and save some money. The poster also has some good old-fashioned typography in the bottom right corner with the basic conference information and the eight speakers in Meta Serif and Proxima Nova, both of which performed great in letterpress and the less forgiving clear foil stamp.

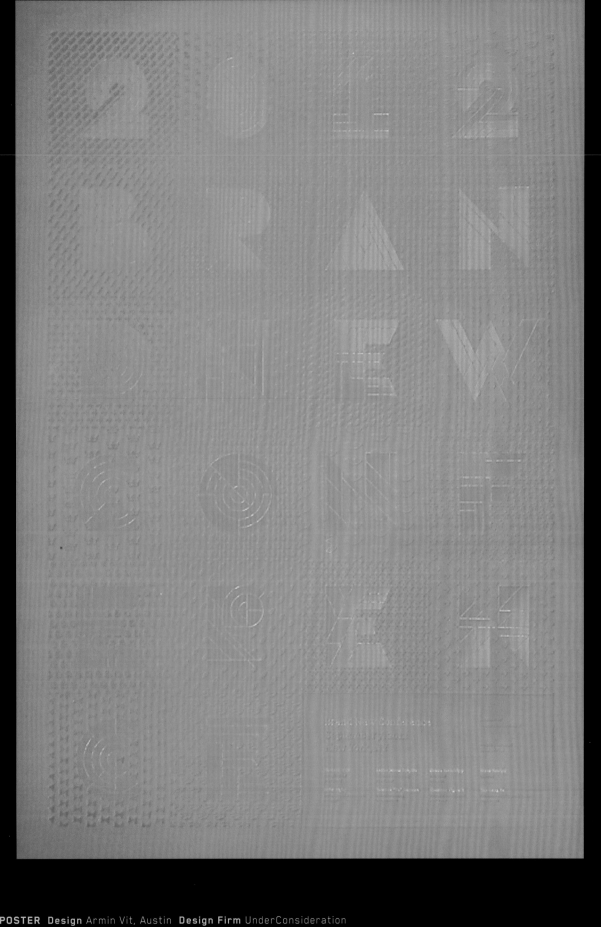

POSTER **Design** Armin Vit, Austin **Design Firm** UnderConsideration
Principal Type FF Meta Serif, Proxima Nova, and custom geometric letterforms **Dimensions** 16.5 x 24 in. (41.9 x 61 cm)
Commemorative poster for the 2012 Brand New Conference identity featuring the identity's custom geometric letterforms and heavy patterns of pieces of popular logos. Printed by Henry+Co using letterpress and clear foil stamping on Neenah's CLASSIC CREST paper in Red Pepper color.

It was hard to be counterculture and give cellulite tips.

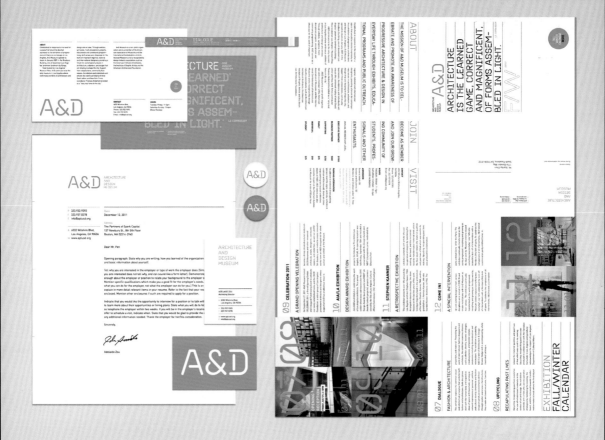

FIRST-PLACE STUDENT AWARD
STUDENT PROJECT **Design** Stanley Xing Chen, Pasadena, California **Researchers** Stanley Xing Chen and Kit Cheong
Instructor Brad Bartlett **School** Art Center College of Design **Principal Type** A&D Bespoke (custom) and FF Din
Dimensions Various
This project is a rebrand and identity system for the Architecture and Design Museum in Los Angeles, an institution
and exhibition space exclusively for showcasing innovative architecture and design. The objective is to reposition
the museum, attracting a broader audience while creating an updated, modern aesthetic that is cohesive across all
media platforms. "Ideas Flow" is the brand concept and illustrates the interaction between the heaviness of physical
architecture and lightness of the creative process. Typography and grid structure, color, and materials are used to
demonstrate how they influence and "flow" through one another.

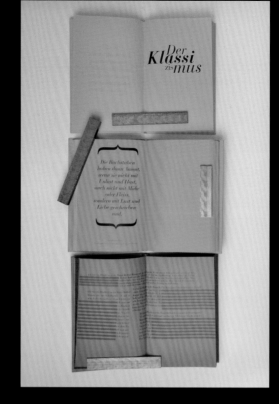

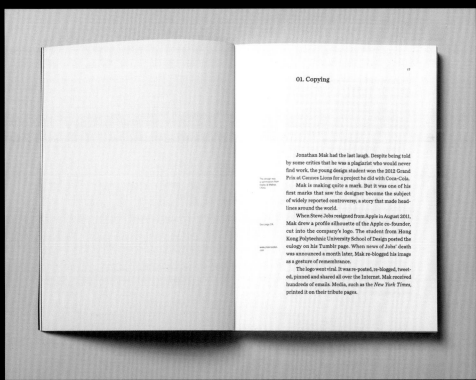

THIRD-PLACE STUDENT AWARD
STUDENT PROJECT Design Kate Cullinane, Auckland **Copywriting Professor** Jonothan Dennis
Design Professor Dean Poole **School** Auckland University of Technology
Principal Type Chronicle Text G3 Roman and Theinhardt **Dimensions** 5.9 x 7.9 in. (15 x 20 cm)

I believe copying is fundamental to the creative process. Good designers copy existing work with the intention of surpassing it; thus I believe the act of copying advances design. The book *Sample Copy* discusses copying, learning, counterfeiting, authenticity, originality, plagiarism, copyright, cyberspace, coincidence, and sharing. To uncover the true status of copying in design, I have interviewed some internationally renowned designers, namely Dana Arnett, Andrew Ashton, Andreu Balius, Marian Bantjes, Milton Glaser, Steven Heller, Jonathan Mak, Dean Poole, Stefan Sagmeister, Adrian Shaughnessy, and Massimo Vignelli.

A romantic tour offers city views and a lecture on how to sterilize sludge.

TDC59
JUDGES'
CHOICES

DESIGNER'S STATEMENT

"Touch" is a special exhibition in two parts, jointly organized by a design museum and a scientific museum. In a very interactive and tactile presentation, it explores this particular sense through scientific experiments and design objects.

Their goal was to communicate that people must touch the experiences: the opposite of the usual message.

I knew we couldn't be concrete and show any actual piece in the campaign (too restrictive). So we decided to go to the extreme: simply with the "touch" message. We put injunctions all over the design pieces, using all the verbs that imply a tactile action.

Instead of a very usual, clean typographic solution, I chose to draw words manually: It gives the feeling of tactile "handmade," and it speaks in an open way to audiences that could be frightened by scientific and artistic experiences. Metallic colors were chosen to contrast with the freehand style and to bring a scientific/technical touch. We added tactile effects in the mini-catalog with special varnishes and textures, as a mini-experience. And the "invitation" to touch the three posters is real: The center dot can be scratched, revealing three scents.

That campaign did well. The two institutions significantly increased the number of visitors and reached new audiences. Scratches on the posters confirm this.

JUDGE'S STATEMENT

What makes a specific typographic piece stand out among thousands of other entries presented at the TDC competition? It is hard to explain, but the "Touch" poster series certainly got my attention.

On one hand, the posters managed to do exactly what they intended to do: invite you to approach them and "touch" them, in an attempt to communicate the tactile aspect of the exhibition they are promoting. This was probably the result of multiple factors such as the beautiful metallic colors used and the well-thought-out composition built around a central focus point.

On the other hand, the posters relied mostly on lovely handlettering that gave them an overall playful manual feel. It is a "rough" style that contrasts with the clean design approach typically adopted by museums for exhibition graphics. And it is a style that clearly distinguishes itself from the well-known Swiss typographic design tradition— yet it retains a strong, dynamic graphic quality. This typographic visual language was successfully applied further to a wider range of printed items.

"Touch" is a purely typographic solution that combines several characteristics, making it an example of typographic excellence. It is simple, visually engaging, well crafted, and mainly composed from beautifully hand-drawn letters.

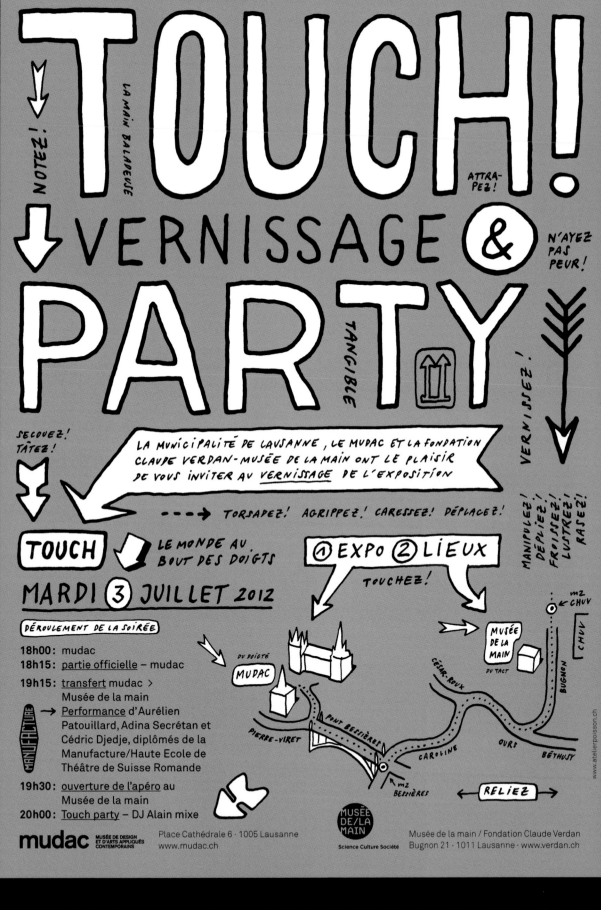

EXHIBITION **Design** Giorgio Pesce ●, Lausanne, Switzerland **Art Direction** Giorgio Pesce **Printer** Sérigraphie Uldry **Graphic Design Studio** Atelier Poisson **Client** Musée de la main and Mudac Musée de design **Principal Type** Akkurat, Pradell, and handmade **Dimensions** Posters: 35.2 x 50.4 in. (89.5 x 128 cm); Flyers: 8.3 x 5.8 in. (21 x 14.8 cm)

The original problem was to clarify the company's brand, which, until then, had had a distinct name and image for each of the organization's three specialties: F. Ménard, the founder's name, for the breeding unit, Agromex for the processing unit, and Boucherie 235 for the sales unit/site.

The brand positioning that emerged was "Innovating for Quality—A Family Tradition." It was only natural that the name F. Ménard became the official signature that covered breeding, processing, and the butcher shop. The brand platform makes use of photos dating from the '60s, red coloring to link the old and new brand images, and current photos that demonstrate in a single glance the innovation that is a key company priority and the source of its leading-edge quality.

JUDGE'S STATEMENT

This entry is a great example of a brand that solved an architectural challenge with a compelling, cohesive design solution.

The rebrand is beautiful.

This design had the benefit of coming from a great strategy, "Innovating for Quality—A Family Tradition." The positioning places importance on both the company's fifty-year history and its product innovations, a combination that is perfectly captured in the brand's new visual expression.

The crafting of the logo balances a vintage look with clean, modern typography. The system consists of three type styles: the flared serif typeface of the name, and a combination of a bold slab serif and a sans. Often, too many typefaces in one logo present a problem. In this case they go a long way toward telling the brand's story. I particularly enjoy the occasional use of the italic sans to highlight important information.

The same style is used consistently throughout the visual language. All collateral and stationery reflect the same typographic look, complemented by the bold use of red, photography, and simple infographics.

It is rare to see a system where all the brand elements are so complementary. They manage to make a meat-producing company look seductive and rich in history.

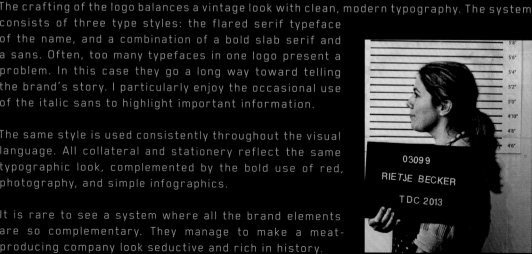

03099
RIETJE BECKER
TDC 2013

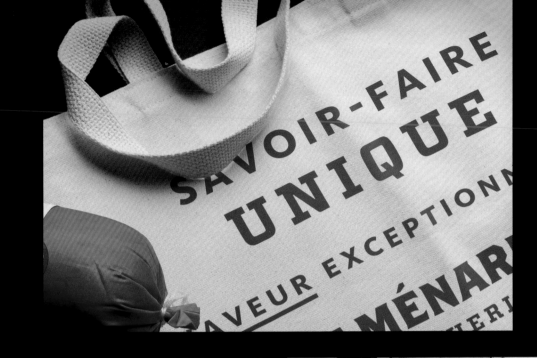

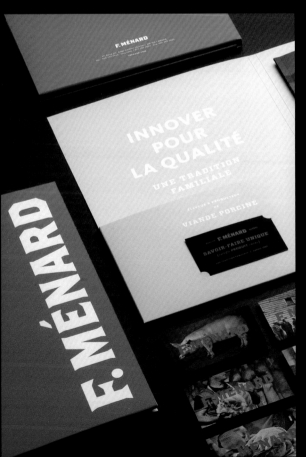

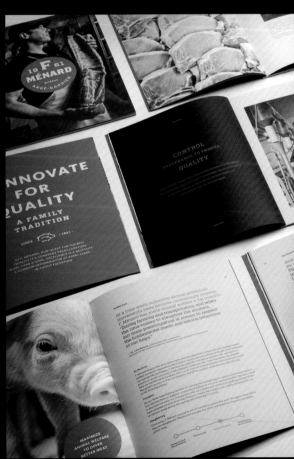

DESIGNER'S STATEMENT

This is a poster for Milk Chocolate, a product of Meiji Seika, familiar to many as Milchi since 1926. The image contains the slogan "LOVE MILCHI," coated with chocolate, in 3D typography. The floating tables, cups and saucers, chairs, etc. give the viewer a sense of stopped time, realizing a dreamy atmosphere. The exciting abstract world is a representation of the "gleeful feeling one gets from eating Milchi."

JUDGE'S STATEMENT

I think anyone who has had the honor of judging the Type Directors Club competition would agree that although stimulating, it is a strange, disorienting, and heady experience.

It's natural when viewing so many examples of graphic design to start recognizing similar approaches and stylistic trends. My reaction to this was to start (rightly or wrongly) searching for the new or different. So it was the designs that bucked some of the most obvious trends (line art flourishes, neon inks, hand-drawn lettering, etc.) that I was naturally drawn to.

This large-scale poster for Milchi chocolate—with its nod to 1940s Salvador Dalí photography and its dreamlike elements—went against the flow and gave me a jolt.

Conceptually it is pretty straightforward. Its aim—to make the viewer want to eat Milchi chocolate—is no doubt achieved. But I fell for this design not for its message but because it is unashamedly beautiful. The quality of

DESIGNER'S STATEMENT

Don't Believe in You Either—A Bigfoot-Inspired Art Show

Office created a Bigfoot art exhibition benefitting 826 Valencia (home of the Pirate Supply Store) and 826 Boston (home of the Bigfoot Research Center), two nonprofit writing centers for kids.

We searched Gold Country and Reno for amazingly awful landscape paintings and then painted Bigfoot-inspired art over them, hoping to make the pieces as covetable as in their wood-paneled family room heyday. This resulted in thirty-eight original paintings, a hundred vintage postcards, and a limited-edition poster.

We also invited several local artists to reimagine tree stumps based on their own interpretations of Bigfoot. And we worked with kids in 826 Valencia's programs to write descriptions of each piece—in their own (creative) words—and featured them in the exhibit.

Why Bigfoot? Because he eludes pretty much everyone, yet we choose to believe in him, just a little bit. We channeled the imaginations of our inner 10-year-olds, which, incidentally, is exactly what happens at 826 chapters every day.

JUDGE'S STATEMENT

First off, I believe in Bigfoot, but being the professional that I am, I compartmentalized and put any cryptozoological biases aside as I devoured this project. What had me coming back to this one was simply this: Each time you checked it out, you discovered another little something that was awesome. From the hit of gold foil, to the fun, well-crafted typography, to the savory thick lines, and those outdoor color palettes, I kept coming back for more. And it was funny.

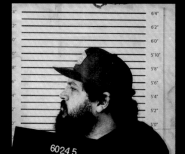

EXHIBITION **Design** Rob Alexander, Mike Andersen, Emily Brock, Ashley Ciecka, Will Ecke, Jasmine Friedl, Cecilia Hedin, Gaelyn Jenkins, Alison Kim, Chris Mann, Dominique Mao, Jenny Pan, Richard Perez, Steve Reinmuth, Jason Schulte, James Trump, Kelly Wahlstrom, and Jon Wong, San Francisco **Creative Direction** Jill Robertson and Jason Schulte **Writers** Ben Barry, Lisa Congdon, Brent Couchman, Alan Dye, Dave Eggers, Brian Flynn, Jessica Hische, Caleb Kozlowski, Erik Marinovich, Richard Perez, Christine Strohl, and Eric Strohl **Producer** Cindy Wu **Design Firm** Office: Jason Schulte Design **Client** 826 Valencia, San Francisco and 826 Boston, Boston **Principal Type** Futura and custom

we decided to carry out a performance consisting of the creation of a book—an object in several dimensions. In the format of 145 x 200 mm, it was designed from a typographic grid; every act is characterized by different paper, as if each page discovered a new world defined by linear variations of the rhythm.

It features black on black, black on white, white on white, white on black (positive and negative contrasts), and white overprinted on black (creation of the third value).

The book is reversed (turned upside down), and therefore the page numbering starts with eighty-one (of 160 pages total). The story begins on page one, from the cover placed in the center of the book.

JUDGE'S STATEMENT

I love books, and this book was a masterpiece. I was drawn to this book for its typographic excellence, flawless craftsmanship, precision, and elegant abstraction. Each spread was a playful composition of typography, shape, and texture—reminiscent of a painting, where the color palette was reduced to black and white and the paint was replaced with typography. The book stood out to me for its minimalist elegance, quiet beauty, brilliant concept, and meticulous attention to detail. This book is full of wonder and beauty. It's no surprise that three out of seven judges wanted this book as their Judge's Choice. There should be a book dedicated to this book.

6'0"
5'10"
5'8"
5'6"
5'4"
5'2"
5'0"
4'10"
4'8"
4'6"

50496

IRINA LEE

TDC 2013

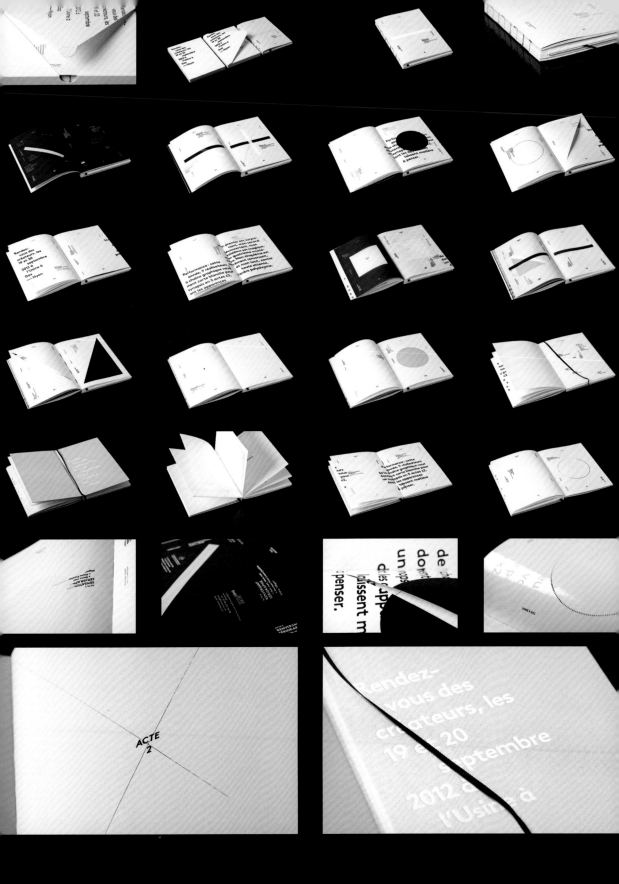

BOOK **Design** Ninon Carrier and David Zahno, Geneva **Graphic Studio** Marks **Client** Rendez-vous des créateurs

DESIGNER'S STATEMENT

This is a poster series for the third edition of the drawing festival The Big Draw Berlin 2012. The subject was "Drawing Space." Step by step, the colored pencils are making their way out of color dust into forming the three- dimensional title of the festival.

JUDGE'S STATEMENT

That I saw this series in the very first room on the first morning of judging is testament to how much I like it. We saw a great number of interesting works and poster series that weekend, several of which were simply color variations or crops of a single design, so in terms of an idea that justified an entire series, this was by far my favorite.

What Ariane has created here is a conceptually relevant execution that, while clearly having taken a very long time to create (have you ever sharpened a pencil down to nothing? how about several hundred?), doesn't ever feel labored or overworked or dull. In fact, it feels effortless, which is something you can say only of the best design: a solution to a brief that couldn't have existed any other way. It is clear, bright, simple, typographically unfussy, and—arguably most important of all—fun to look at. Conceived and well designed but then, in turn, shaped by the process of its creation.

That the posters are intended to be seen in reverse as a teaser is also a nice touch, with the second in the series possibly being my favorite—blurring the lines between abstraction, legibility, and communication. A+.

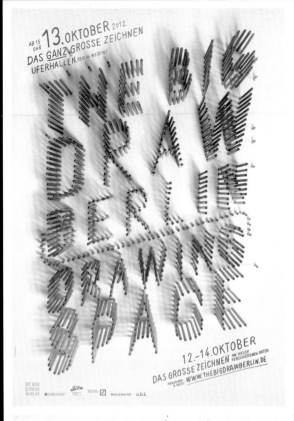

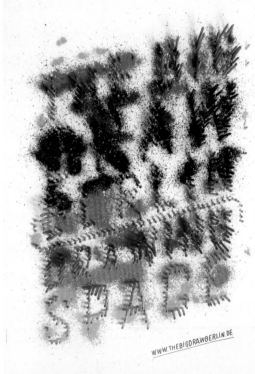

POSTERS **Design** Maria Nogueira, Berlin **Art Direction** Ariane Spanier **Design Firm** Ariane Spanier Design
Client The Big Draw Berlin / Kulturlabor e.V. **Principal Type** Custom **Dimensions** 23.4 x 33.1 in. (59.4 x 84 cm)

I don't think an assignment will ever cross my desk more exciting than creating titles for a Wes Anderson film. Wes definitely had something particular in mind for the titles and we worked together to realize his vision. The project originally called for lettering for the beginning credits and a typeface for the end credits, but we ended up creating a typeface in two optical weights, a legible script for the end credits and its display counterpart. The typeface was used extensively on posters and other marketing materials. Inspiration was drawn from various sources, including the titles from Claude Chabrol's *La femme infidèle*.

JUDGE'S STATEMENT

I love the films of Wes Anderson, from their uniquely imaginative story lines to their tightly curated art direction. After years of Anderson's dedicated use of Futura Bold, of course the next step in the evolution of his creative reach would be to commission a typeface specific to his film. Jessica Hische created a delightful script that is as playful, romantic, and timeless as *Moonrise Kingdom* itself. The idiosyncrasies and imperfections perfectly reflect the quirky tone of Anderson's work.

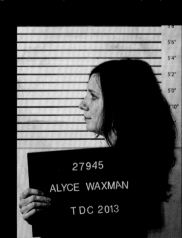

Just as Anderson's films somehow seem to tap into my childhood nostalgia, Hische's typeface is similarly reminiscent of another era. It makes sense that the pair was inspired by the titles from *La femme infidèle* as it reminds me of the titles from old films I would watch on TV as a child.

I love that Hische grew the project from lettering for the titles to an entire typeface with multiple weights. Bringing typographic excellence into the mainstream, this piece is as twee as it is refreshingly clean.

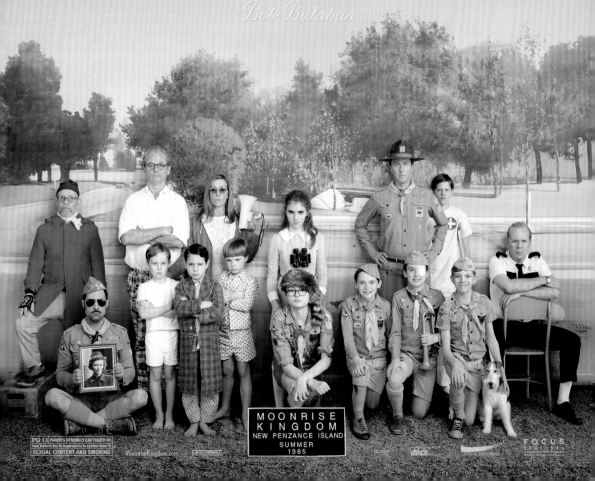

Focus Features and Indian Paintbrush Present an American Empirical Picture "Moonrise Kingdom"
Casting by Douglas Aibel Co-Producers Molly Cooper Lila Yacoub Costume Designer Kasia Walicka Maimone
Original Music by Alexandre Desplat Music Supervisor Randall Poster Editor Andrew Weisblum, A.C.E.
Production Designer Adam Stockhausen Director of Photography Robert Yeoman, A.S.C. Executive Producers Sam Hoffman
Mark Roybal Produced by Wes Anderson Scott Rudin Steven Rales Jeremy Dawson
Written by Wes Anderson & Roman Coppola Directed by Wes Anderson

Moonrise Kingdom

A Film by Wes Anderson

Bruce Willis

Edward Norton

Bill Murray

Frances McDormand

Tilda Swinton

Jason Schwartzman

Bob Balaban

MOONRISE
KINGDOM
NEW PENZANCE ISLAND
SUMMER
1965

A feat its engineer likened to cutting the legs off a table while dinner is on it.

TDC59
WINNERS

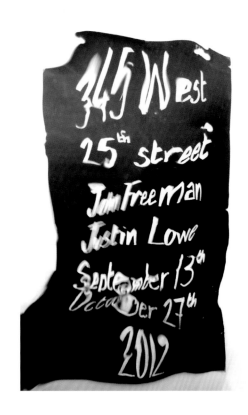

STUDENT PROJECT **Design** Myriam Amsalem, New York **Instructors** Brett Kilroe and Nic Taylor
School School of Visual Arts, New York **Principal Type** Hand-drawn **Dimensions** 29 x 42 in. (73.7 x 106.7 cm)

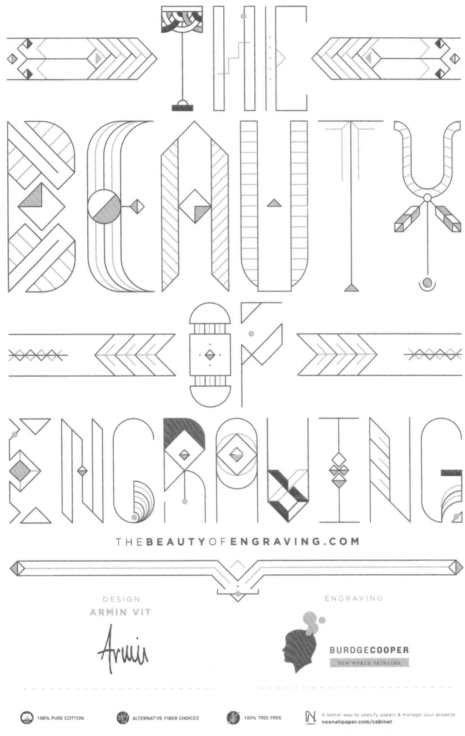

INVITATION **Design** Armin Vit, Austin **Design Firm** UnderConsideration **Client** Neenah Paper
Principal Type ZWEI (modified) **Dimensions** 5.5 x 8.5 in. (14 x 21.6 cm)

The brief was simple: Showcase the beauty of engraving (and spell it out). Because engraving holds thin lines so well, I wanted to do something that showcased that capability. I had stumbled onto Jacopo Severitano's font many months before and thought it would be perfect once I got the assignment. I did additions and modifications to some of the characters to have more or fewer lines and changed the thickness as needed so that no matter the type size, the stroke would be the same. I also broke apart some of the letters to create new borders.

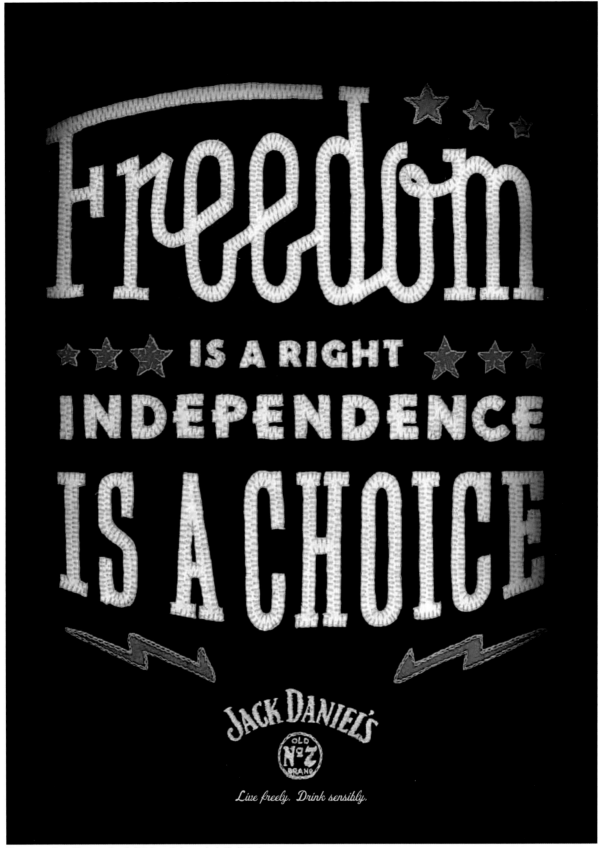

This poster was made out of American-made muslin fabric that was dyed, sewn and embroidered by hand. JACK DANIEL'S and OLD NO. 7 are registered trademarks. ©2012 Jack Daniel's Tennessee Whiskey 40% Alcohol by Volume (80 proof). Distilled and Bottled by JACK DANIEL DISTILLERY, Lynchburg, Tennessee.

POSTER Design Helms Workshop and Travis Robertson, Austin and Boston
Art Direction Helms Workshop and Travis Robertson **Group Creative Officer** Wade Dever
Chief Creative Direction Pete Favat, Boston **Agency** Arnold Worldwide **Client** Jack Daniel's
Principal Type Custom **Dimensions** Flag: 24 x 32 in. (61 x 81.3 cm); poster: 18 x 24 in. (45.7 x 61 cm)
To celebrate Independence Day in the United States, we focused on creating posters that used methods of true handcraft in their design and construction. In this instance, we designed the custom letterforms, then transferred, cut, and set each in hand-dyed muslin fabric. The custom typography uses a mix of slab and sans serif faces and even a unique slab-script (you don't see those every day). The assembled poster was then sewn and embroidered by hand.

zenibako,
otaru,
hokkaido,
japan
www.sunaie.com

POSTER **Design** Masayuki Terashima, Sapporo, Japan **Design Firm** Terashima Design Co. **Client** Sunaie
Principal Type Custom
Dimensions 28.7 x 40.6 in. (72.8 x 103 cm)

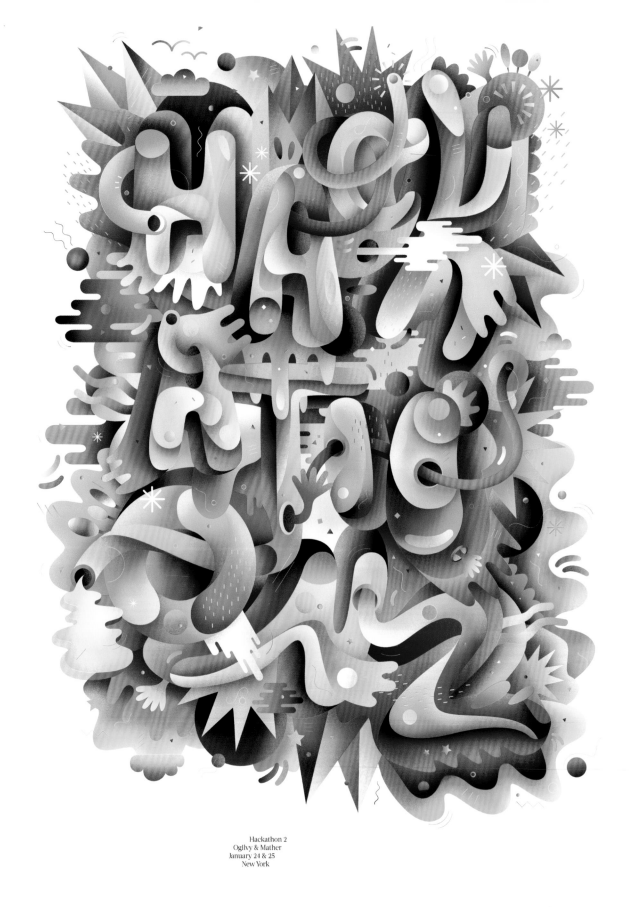

Hackathon 2
Ogilvy & Mather
January 24 & 25
New York

POSTER Design Brian Collins and Matt Luckhurst, New York **Creative Direction** Brian Collins **Design Firm** Collins:
Client Ogilvy & Mather New York **Principal Type** Acta Display Book **Dimensions** 24 x 36 in. (61 x 91.4 cm)
Designed for Ogilvy & Mather's new Hackathon event series.
The poster takes an unorthodox approach to identity design, inspired by the messy, free-form thinking that is
encouraged in these events. The typography serves as the backbone to an otherwise abstract form. This reflects an
appreciation for surprise and reinvention rather than the need for legibility and linear communication design.

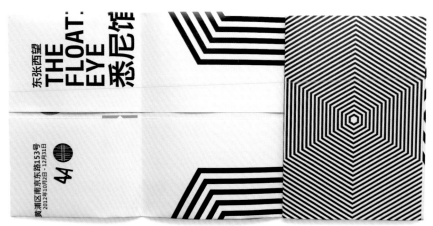

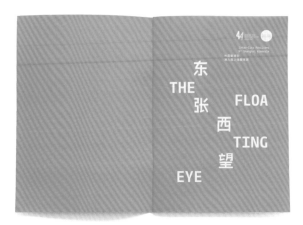

CATALOG Design Michael Boston, Erin Hoffman, Jason Little ●, and Alexis Waller, Sydney **Design Direction** Michael Boston **Senior Design** Sam Byrnes **Junior Design** Sam McGuiness **Creative Direction** Jason Little **Client** 4A Centre for Contemporary Asian Art **Principal Type** Fedra Mono Std and Hiragino Sans GB **Dimensions** 5.8 x 8.3 in. (14.8 x 21 cm)

The Floating Eye™ was the curatorial theme of the Sydney Pavilion in the Shanghai Biennale, the largest international art event in mainland China, attracting more than 8 million visitors. Sydney was part of the Inter-City Pavilions, offering observations of a city's shifting references and influences.

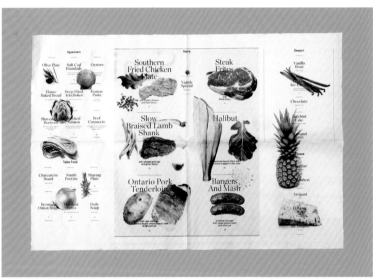

Smith. Fresh Food. Fresh Menus.

Smith Restaurant serves fresh food, locally & seasonally inspired.
The newspaper format for their menu, featuring impactful photography of the ingredients,
spoke to the freshness of the daily offerings. It was the perfect solution for a menu
that needed to change frequently.

MENU Design Chris Duchaine, Scott Leder, and Tracy Ma, Toronto **Creative Direction** Lisa Greenberg
Chief Creative Officer Judy John **Photography** David Picard **Agency** Leo Burnett, Toronto **Client** Smith Restaurant + Bar
Principal Type Chronicle Display and Hudson **Dimensions** 17 x 22.75 in. (43.3 x 57.8 cm)

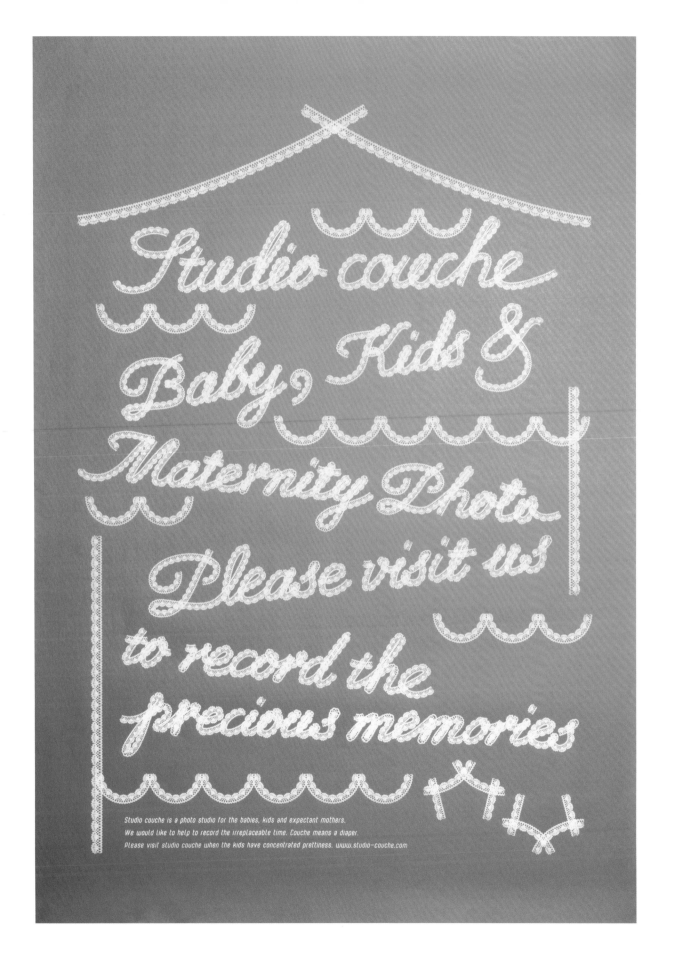

POSTER **Art Direction** Hiroko Sakai, Tokyo **Design Firm** coton design **Client** couche-studio **Principal Type** Lace Script
Dimensions 28.3 x 40.2 in. (72 x 102 cm)
Couche-studio is a photo studio for kids. The poster represents that this studio is a relaxing space, like a house.

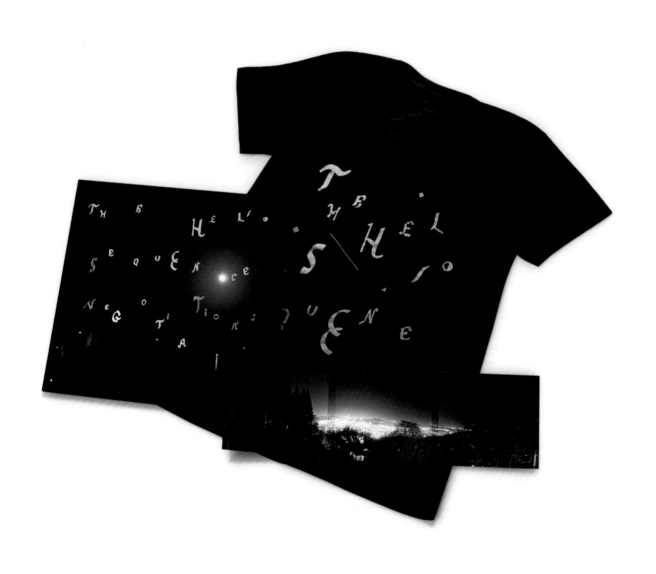

PACKAGING Design Jiri Adamik-Novak and Pavlina Summers, Stockholm and Portland, Oregon
Art Direction Jiri Adamik-Novak **Photography** Pavlina Summers **Client** SubPop Records, Seattle
Principal Type Handwritten and custom **Dimensions** CD: 5.5 x 4.9 in. (14 x 12.5 cm); LPH: 12.3 x 12.3 in. (31.3 x 31.3 cm)
The theme of "night" is central to the identity of the new Helio Sequence album, *Negotiations*. It was over countless
evenings that the songs came together and were written, recorded, and mixed. The hand-drawn typography on the
cover is meant to evoke the starlit night sky, and at the same time subtly allude to the bright lights of the concert
stage. The photographer took pictures of the band and their surroundings on the way to the studio on the final night
of the recording sessions, emphasizing the documentary feeling of the recording process and letting the viewer inside
the creative world of the band.

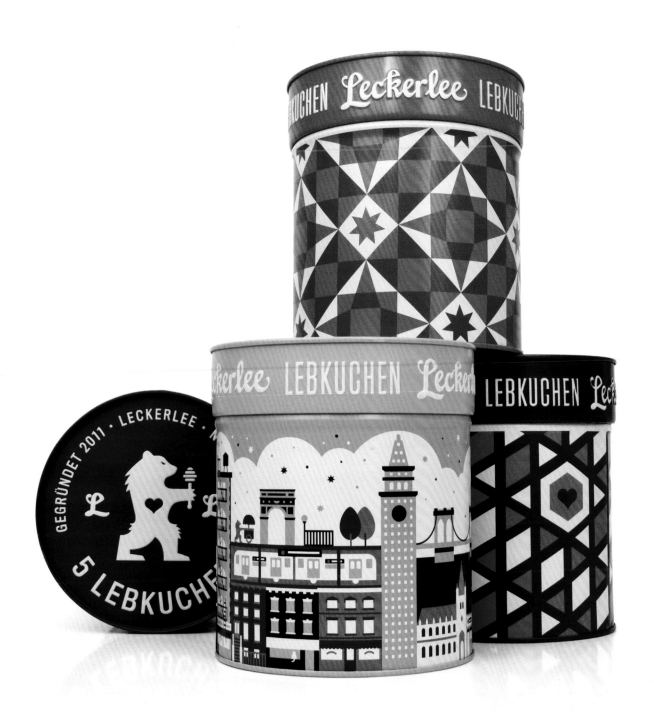

PACKAGING **Design** Christine Celic Strohl and Eric Janssen Strohl, San Francisco **Design Firm** Strohl
Client Leckerlee, New York **Principal Type** Custom **Dimensions** 4.75 x 5.25 in. (12 x 13.3 cm)
Reminiscent of gingerbread, Lebkuchen are traditional German holiday cookies that have been sold in decorative
tins for hundreds of years. We used traditional Lebkuchen tins and other antique German confection examples as
a groundwork for the logo, iconography, and patterns. A bear is a sentimental animal in German culture, creating
visions of small-town Christmas and warming foods. An upright script logo, paired with traditional grotesque
typography and holiday-motif patterns, completes this distinctly German identity.

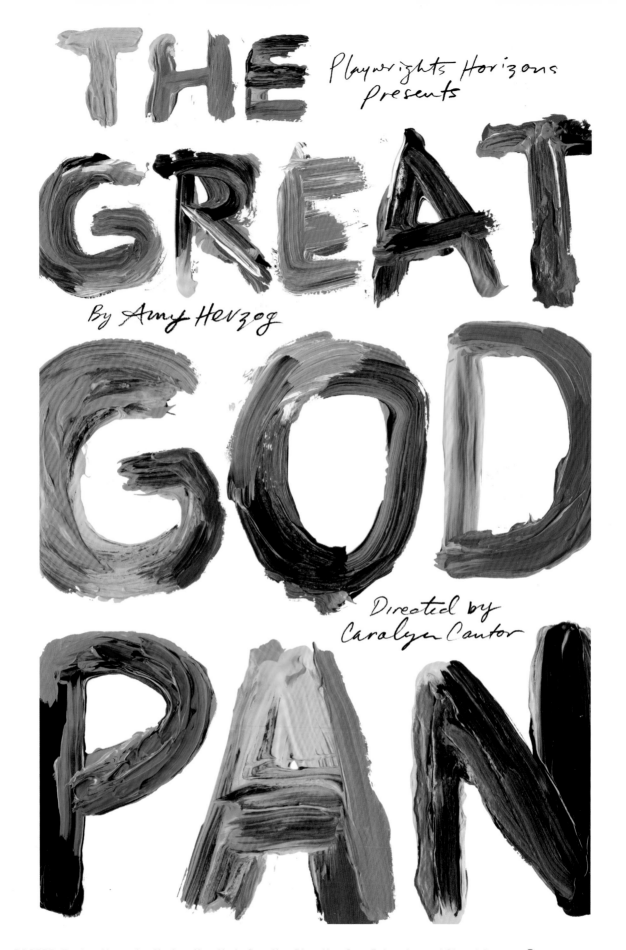

Playwrights Horizons
presents

THE GREAT GOD PAN

By Amy Herzog

Directed by
Caralyn Cantor

POSTER **Design** Alexandra Marino, New York **Creative Direction** Sam Eckersley and Stuart Rogers ●
Senior Design Jane Huschka **Design Firm** Rogers Eckersley Design **Client** Playwrights Horizon
Principal Type Handwritten and hand-painted **Dimensions** 28 x 44 in. (71.1 x 111.8 cm)
The Great God Pan tells the intimate story of a man whose buried childhood trauma is resurrected, throwing his life
into a tailspin. The manic finger paint represents his attempt to come to terms with this adolescent memory.

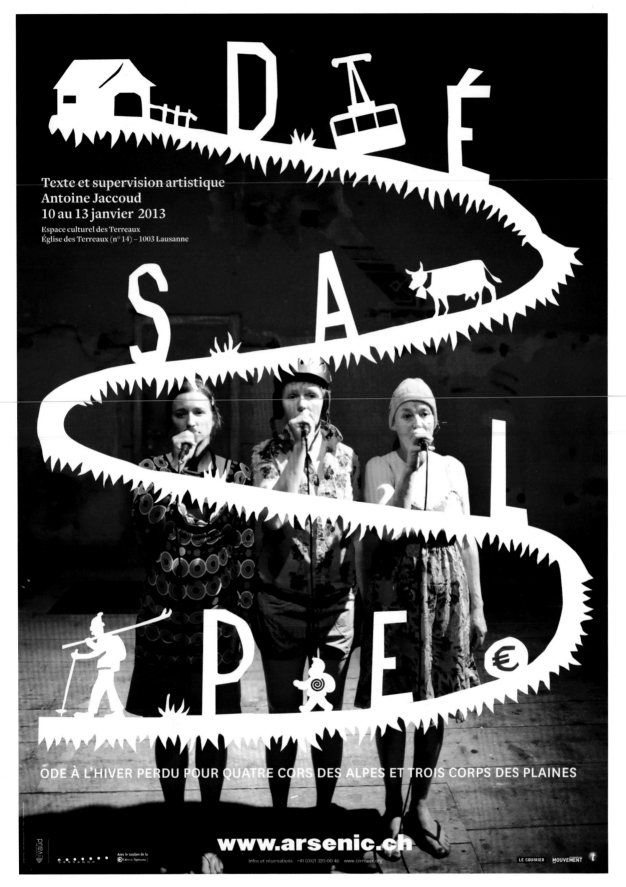

POSTER **Design** Giorgio Pesce ●, Lausanne, Switzerland **Art Direction** Giorgio Pesce **Photography** Guillaume Perret
Graphic Design Studio Atelier Poisson **Client** ARSENIC Theatre **Principal Type** Champion, Freight, and National
Dimensions 35.2 x 50.4 in. (89.5 x 128 cm)
This is a poster for a play about the end of the "white gold," the declining business of tourism and skiing in the Swiss
Alps. People have to leave the mountain and go down to the plain. The word "desalpe" is a peasant word for the sated
cows going down from the mountain, at the end of summer, and is typically illustrated by "poyas" (traditional art of
découpage). That's what I did: a poya. Among cows and peasants I added a skier, a cabin, etc. on top of one of the
photos of the play.

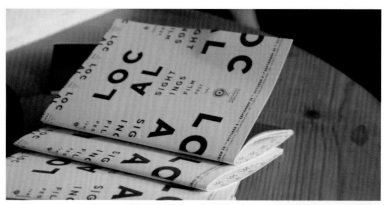

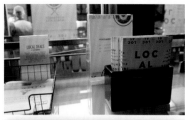

BROCHURE Design Steve Cullen and Clara Mulligan, Seattle **Art Direction** Steve Cullen and Clara Mulligan
Executive Creative Director Jim Haven **Account Manager** Kate Ratliffe **Agency** Creature **Client** Northwest Film Forum
Principal Type Gotham **Dimensions** 18 x 24 in. (45.8 x 61 cm)
The name "Local Sightings" lends itself to the idea of searching for and spotting something unexpectedly. As a fun play on that insight, we turned the festival identity into an interpretive eye chart, something to prepare people to look at film as they have never done before.

STUDENT PROJECT **Design** Minjeong Kim, Seoul **Instructor** Chris Ro **School** Kookmin University College of Design
Principal Type Custom **Dimensions** 23.4 x 33.1 in. (59.4 x 84.1 cm)
"A Marvelous Sight" is a poster of typographic experiments. This poster explores the way people view and experience
type through experiments in digitally created typography that displays a sense of craft, individuality, and wonder. The
hope was to create typography that possibly has never been seen before.

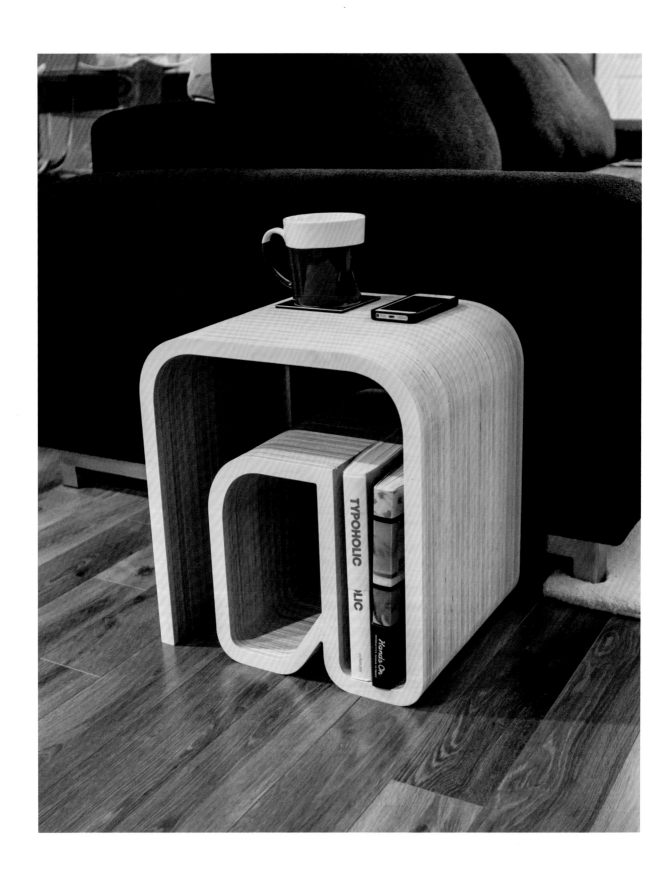

EXPERIMENTAL Typographic Design Mark Caneso, Garden Grove, California **Studio** pprwrk studio/pstype
Principal Type Custom **Dimensions** 14.5 x 15.5 x 12 in. (36.8 x 39.4 x 30.5 cm)
The custom @ symbol was designed with multiple functions in mind: side table, magazine/book holder,
and pure eye candy.

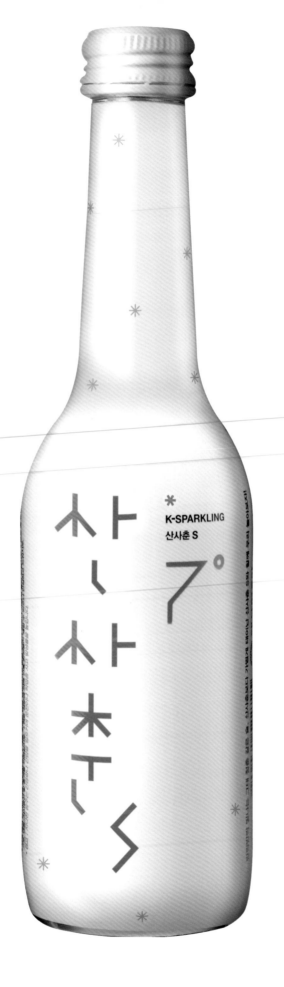

PACKAGING Senior Design Kym Ryun Soo, Seoul **Art Direction** Kim Hee Bong **Creative Direction** Cho Hyun
Studio S/O Project **Client** Baesangmyun Brewery **Principal Type** Custom **Dimensions** 8.7 x 21.7 in. (22 x 55 cm)

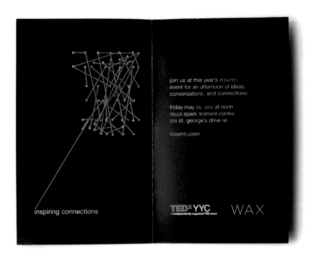

INVITATION **Design** Brad Connell, Calgary **Design Direction** Monique Gamache **Art Direction** Brad Connell
Executive Creative Direction Joe Hospodarec **Copywriter** Shannon King **Agency** WAX **Client** TEDxYYC
Principal Type Gotham Thin and Helvetica Neue 35 Thin **Dimensions** 2.5 x 7.5 in. (6.4 x 19 cm)
Beneath the theme of the "inspiring connections" advertising campaign, personalized invitations were delivered to
our clients to attend the highly popular TEDxYYC event. The type on the cover is based on Gotham Light and was hand-
stitched with a single piece of thread. When opened, it created a physical representation of a social network sprouting
from a single node that culminates in the dotting of the "i" in the tagline.

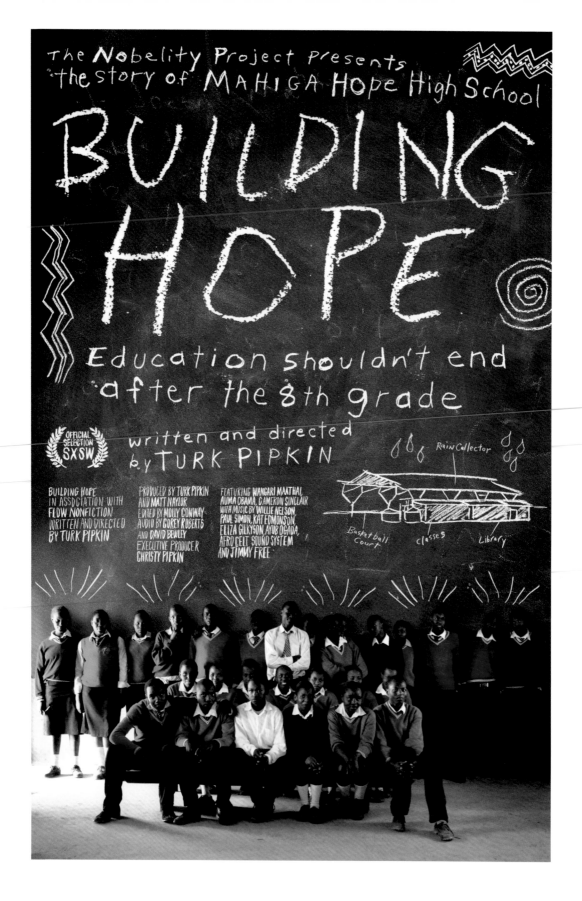

POSTER **Design** DJ Stout ● and Stu Taylor **Graphic Design** Stu Taylor **Art Direction** DJ Stout **Creative Direction** DJ Stout **Studio** Pentagram Design Austin **Client** Turk Pipkin and the Nobelity Project **Principal Type** Custom **Dimensions** 27 x 41 in. (68.6 x 104.1 cm)

Longtime friend of the studio Turk Pipkin and his foundation needed a poster for the South by Southwest debut of their feature-length documentary about Mahiga Hope High School, which they helped build in Kenya. There was an existing visual "branding" to the project that we decided to abandon from the start. The typographic look we landed on was inspired by a series of student portraits shot by Pipkin. They posed in front of a large blackboard, "the focal point of the classroom," and their names were written next to them.

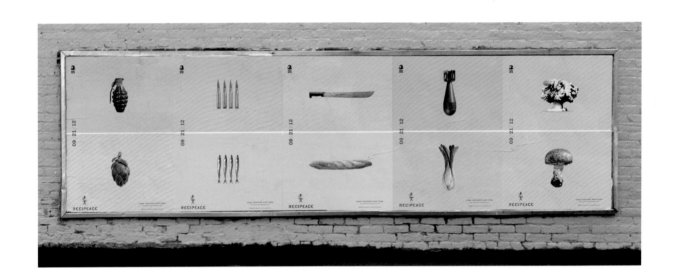

POSTERS **Design** Casey Martin, Chicago **Senior Designers** Kelly Dorsey, Kyle Poff, and Peter Ty
Art Direction Kate Harding-Jackson **Creative Direction** Phil Jungmann and Matt Miller **Chief Creative Officer** Susan Credle
Global Chief Creative Officer Mark Tutssel **Executive Creative Director**Jeanie Caggiano **Design Direction** Alisa Wolfson
Assistant Account Executive Riley Bernardin and Dane Gunderson **Account Director** Josh Raper
Executive Producers Nina Abnee and Laurie Gustafson **Copywriter** Adam Ferguson **Agency** Leo Burnett Chicago
Client Peace One Day and D&AD, United Kingdom **Principal Type** Brown and Sentinel **Dimensions** 24 x 26 in. (61 x 66 cm)

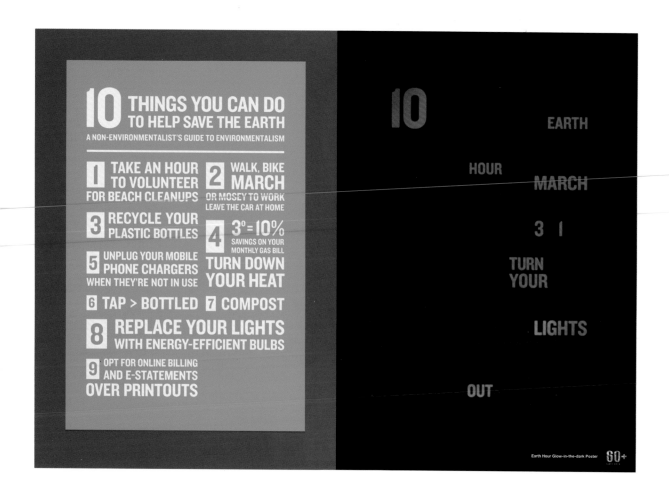

POSTERS Design Guybrush Taylor, Chicago **Creative Direction** Nuno Ferriera and Ryan Wagman
Chief Creative Officer Susan Credle **Art Creative Direction** Guybrush Taylor **Executive Producer** Rob Allen
Producers Jon Lueken and Laura Stern **Account Manager** Sarah Tynan **Agency** Leo Burnett Chicago
Client Earth Hour, Singapore **Principal Type** Knockout HTF50 Welterweight **Dimensions** 24 x 36 in. (61 x 91.4 cm)

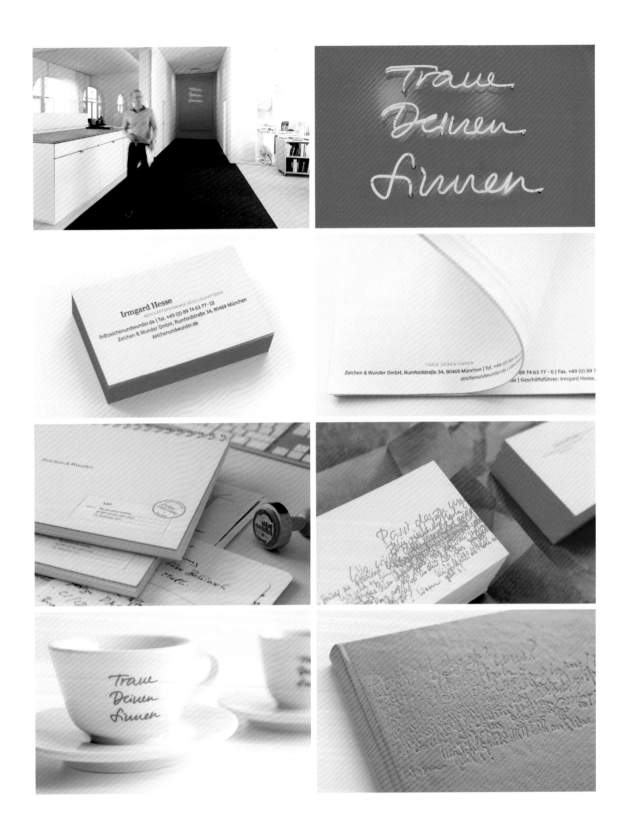

SELF PROMOTION AND CORPORATE IDENTITY **Design** Michaela Huml, Münich **Art Direction** Annika Kaltenthaler
Direction Irmgard Hesse and Marcus von Hausen **Agency** Zeichen & Wunder **Principal Type** ZWInterstate and Walbaum
Dimensions Various
Zeichen & Wunder ("Signs and Wonders") is an owner-managed design and brand agency in Münich, founded in 1995,
ranked in the top fifteen of Germany's corporate design agencies. Zeichen & Wunder's mission is to discover the
exceptional and make it tangible. The claim "Trust your senses!" is a serious challenge issued to all clients and staff
members. The new corporate design of Zeichen & Wunder embodies what the agency stands for: precision in content
and a sure instinct in design that you can see and feel.

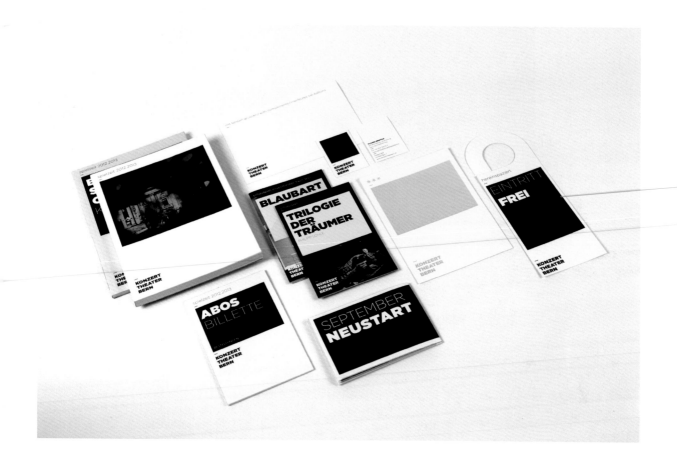

CORPORATE IDENTITY **Creative Direction** Tim Finke, Timo Hummel, Svenja von Doehlen, and Steffen Wierer, Berlin **Design Firm** formdusche **Client** Konzert Theater Bern **Principal Type** Gotham and Swift **Dimensions** Various Konzert Theater Bern is a theater with four branches: drama, opera, dance, and Bern Symphonic Orchestra. Accommodating this diversity, formdusche's central element is a black square that serves as a projection surface. Artists and audience members alike are invited to fill that black box with their individual visions. Thus, the theater's corporate identity expands interactively from the auditorium into its surroundings. The cover of this season's brochure seizes on this idea. Using heat-sensitive ink, the black box reveals an underlying image with the mere touch of a hand. The visual idea is a utopian vista of Bern, created by collages of well-known locations of the city.

BOOK **Art Direction** Chris Steurer, Wiesbaden, Germany **Agency** Fuenfwerken Design AG
Client dreizeichen Verlag and Teunen Konzepte GmbH **Principal Type** Bauer Bodoni and Typ 14
Dimensions 8.9 x 11.2 in. (22.5 x 28.5 cm)
The elaborate publication features a fine cloth binding and embossing that captivates readers with a dynamic folder system that allows them to experience each cycle individually. Here, traditional book art meets an innovative design concept with cutting-edge typography.

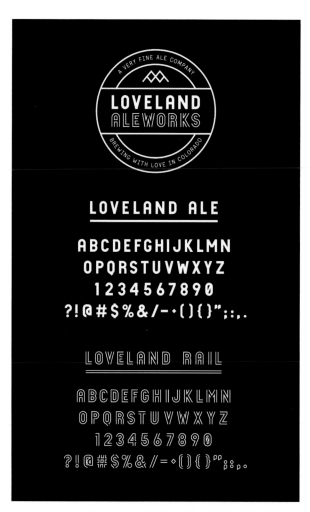

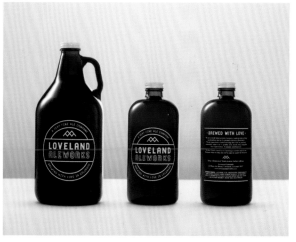

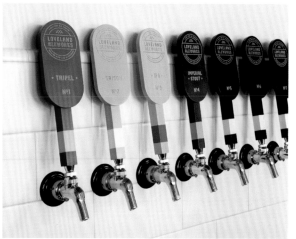

CORPORATE IDENTITY Design Dante Iniguez and Eileen Lee, San Francisco **Creative Direction** Tom Crabtree
Producer Patricia Callaway **Design Studio** Manual **Client** Loveland Aleworks **Principal Type** Loveland Ale and Loveland Rail
Dimensions Various

The Loveland Aleworks identity takes cues from Loveland's history as a railroad town—from the badge logo to beer tap
handles based on nineteenth-century railway signal levers. A central part of the identity is a custom- designed type-
face in two styles. A key focus of our design strategy was to marry the old with new and bring style into the brewery
tasting room experience. We developed the interior and exterior design exemplifying the brewery's charm. Honest
materials including plywood posters, letterpress coasters, and heavyweight forged signage give visitors an immediate
impression of Loveland Aleworks' passion for handmade craft.

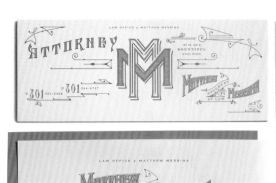
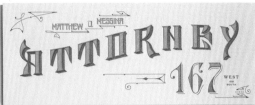

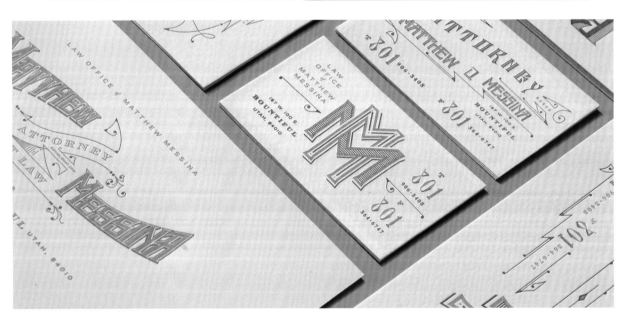

CORPORATE IDENTITY Design Kevin Cantrell, Arlo Vance, and Ben Webster, Salt Lake City **Art Direction** Kevin Cantrell
Lettering Kevin Cantrell **Printer** The Mandate Press **Client** Law Office of Matthew Messina, Bountiful, Utah
Principal Type Bauer Bodoni BT, Escorial EF, Knockout HTF, and custom **Dimensions** Various
Authentic, genuine, forthright. With a direct client-relations approach, the Law Office of Matthew Messina embodies
traditional values that provide the best legal services possible, with an emphasis on estate planning, trusts, wills,
contracts, and family law. The handlettering and letterpress printing epitomize the authentic and personalized
experience you'll receive upon choosing Matthew Messina as your attorney.

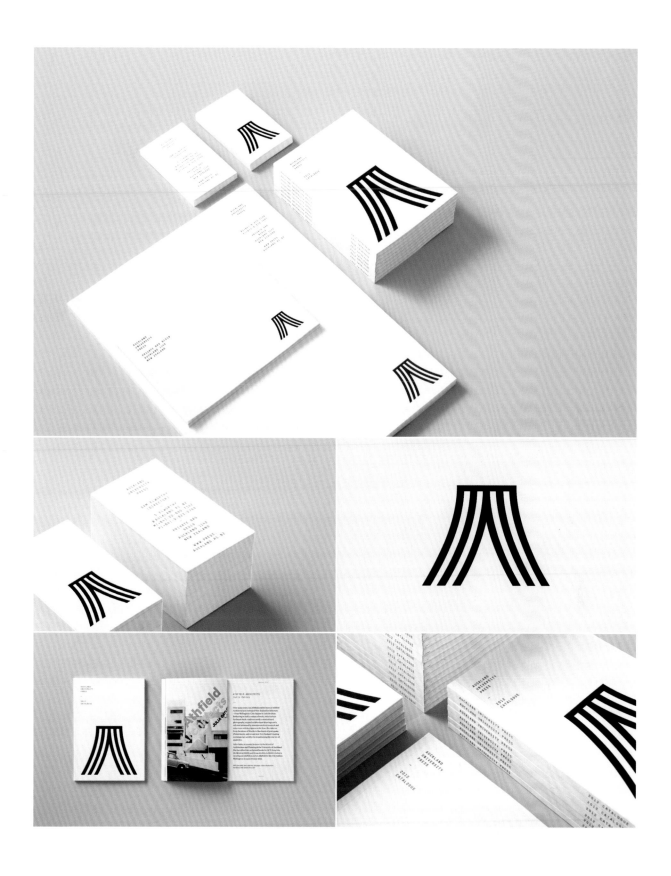

CORPORATE IDENTITY **Design** Jinki Cambronero, Katarina Mrsic, and Dean Poole, Auckland
Creative Direction Dean Poole **Agency** Alt Group **Client** Auckland University Press **Principal Type** Chronicle Text G2
and T-Star Mono Round **Dimensions** Various
Auckland University Press is New Zealand's leading scholarly publisher. The AUP identity is one of complementary
elements—a bold and distinctive logo mark with a light and unobtrusive wordmark and typography. Designed around the
idea of an open book and the form of the letter A, the logo mark references its name as well as its offering. The mark
is descriptive, pictorial, and metaphorical. It simply says a book. The identity was implemented through stationery,
signage, web elements, and an A6 catalog that is more book than directory.

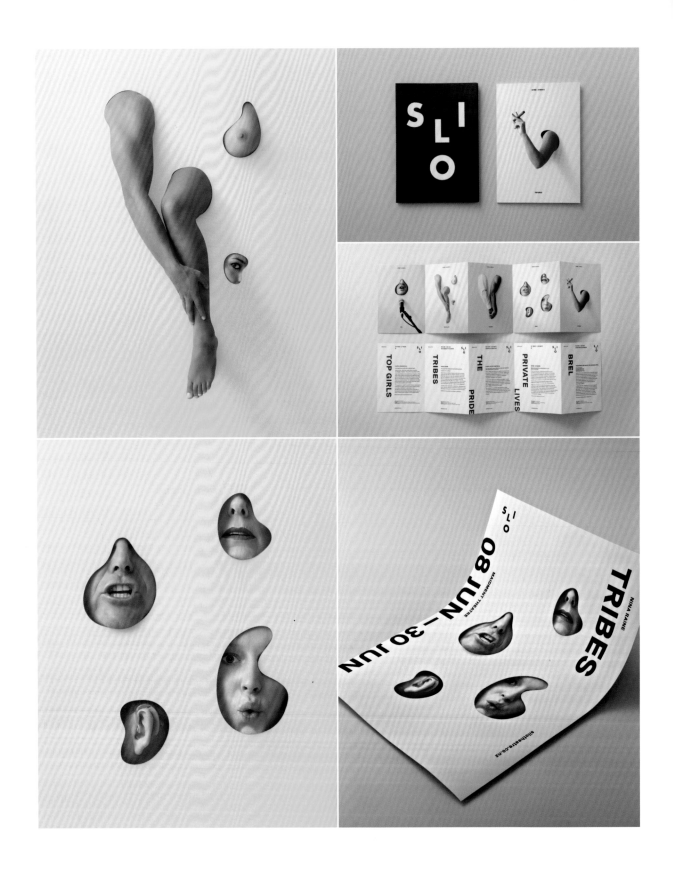

CORPORATE IDENTITY Design Dean Poole, Anna Myers, Emma Hickey, Aaron Edwards, Alan Wolfgramm, Kris Lane, Sons & Co., Auckland **Creative Direction** Dean Poole **Agency** Alt Group **Client** Silo Theatre
Principal Type Suisse **Dimensions** Various
The Silo logo mark has been made by arranging the letters of the name to depict an image of a face. As a symbol it references the Greek comedy and tragedy masks, which have become the universal signifier for theater. The Silo logo is a facial expression of surprise and shock, synonymous with the company's ambition to perform challenging contemporary theater. To launch the Silo 2012 season, a series of campaign images was created that hints at the underlying themes of each play. The art direction references the soft forms of surrealism and the preoccupation with dismembered limbs.

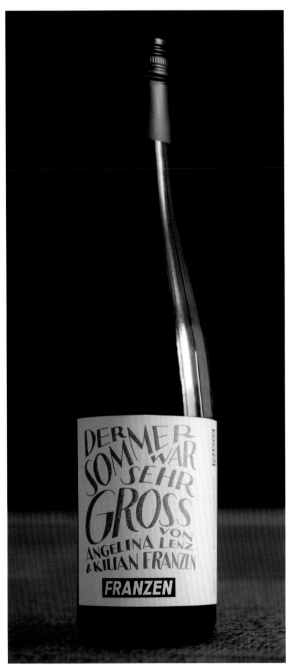

CORPORATE IDENTITY Design Fuenfwerken Design AG, Wiesbaden, Germany **Client** Weingut Reinhold Franzen
Principal Type Arno Pro **Dimensions** Various
Together with renowned wine journalists Cornelius and Fabian Lange, Fuenfwerken came up with the name, concept, wine label, and information brochure behind the successful debut of The Summer Was Great, a new Riesling from young winegrowers Kilian Franzen and Angelina Lenz. The handwritten script on the label has a gold tone that recalls the logo of the winery. The logo is also found on the back of the info brochure, which can be unfolded to create a multi-page poster covering the personal story behind Kilian and Angelina's indeed quite moving "year of wine."

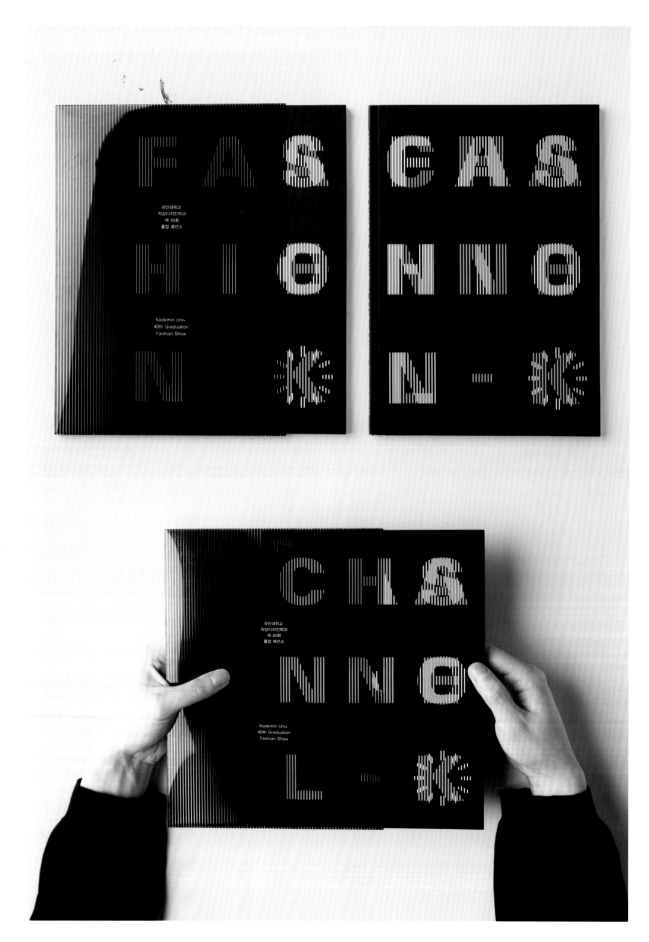

STUDENT PROJECT **Design** Wooksang Kwon, Seoul **Instructor** Jaehyouk Sung **School** Kookmin University
Principal Type Univers LT Std **Dimensions** 7.2 x 10.1 in (18.2 x 25.7 cm)
There are two sets of words on the book cover. The striped case hides one set of the words and shows the other.
Another set of the words will alternately show up when readers pull the book out of the case. I hope they enjoy this
book by experiencing its unique features.

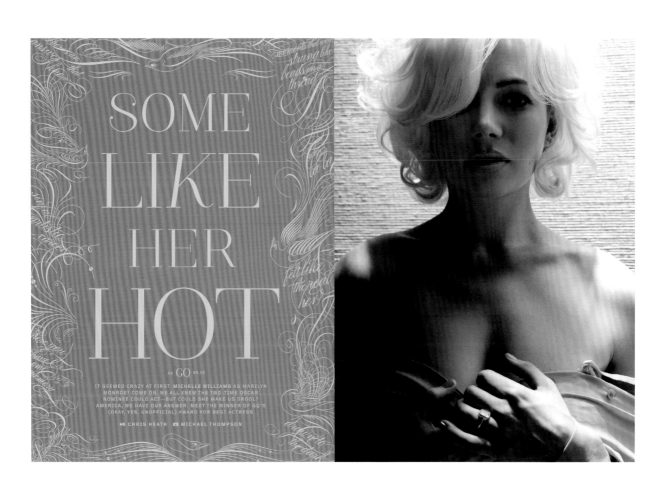

SOME
LIKE
HER
HOT

62 GQ 02.12

IT SEEMED CRAZY AT FIRST. MICHELLE WILLIAMS AS MARILYN
MONROE? COME ON. WE ALL KNEW THE TWO-TIME OSCAR
NOMINEE COULD ACT — BUT COULD SHE MAKE US DROOL?
AMERICA, WE HAVE OUR ANSWER. MEET THE WINNER OF GQ'S
(OKAY, YES, UNOFFICIAL) AWARD FOR BEST ACTRESS

➡ CHRIS HEATH 📷 MICHAEL THOMPSON

MAGAZINE SPREAD Design Chelsea Cardinal, New York **Design Direction** Fred Woodward ●
Director of Photography Dora Somosi **Photography** Michael Thompson **Publication** GQ
Principal Type Guadalupe Essential Gota and Poem Script **Dimensions** 11 x 16 in. (27.9 x 40.6 cm)

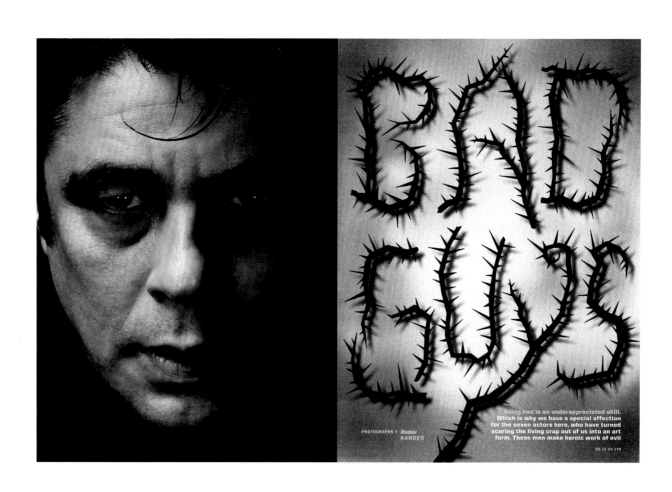

Being bad is an underappreciated skill. Which is why we have a special affection for the seven actors here, who have turned scaring the living crap out of us into an art form. These men make heroic work of evil

PHOTOGRAPHS › *Nadav* KANDER

MAGAZINE SPREAD **Design** Chelsea Cardinal, New York **Design Direction** Fred Woodward ●
Director of Photography Dora Somosi **Photography** Nadav Kander **Publication** *GQ*
Principal Type Custom **Dimensions** 11 x 16 in. (27.9 x 40.6 cm)

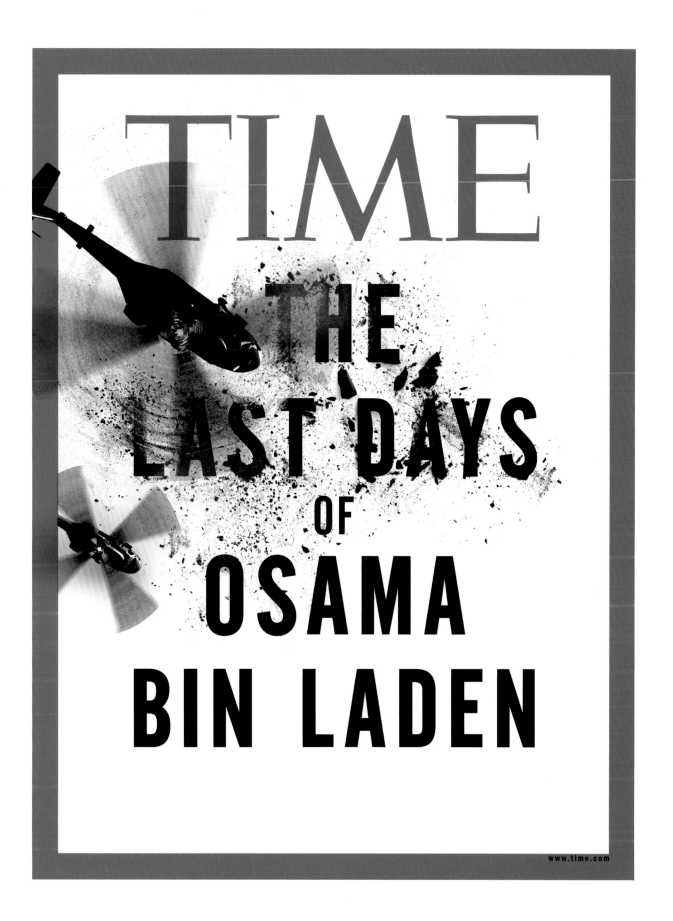

MAGAZINE COVER **Design** Sean Freeman, London **Design Direction** DW Pine, New York
Art and Photo Coordinator Skye Gurney **Studio** THERE IS Studio **Client** *TIME*
Principal Type Custom **Dimensions** 7.9 x 10.5 in. (20 x 26.7 cm)
We wanted to create a graphic way of illustrating the demise of Osama bin Laden and in this case felt the best way to achieve that would be to feature the ominous two black helicopters on their approach, destroying the type as they go.

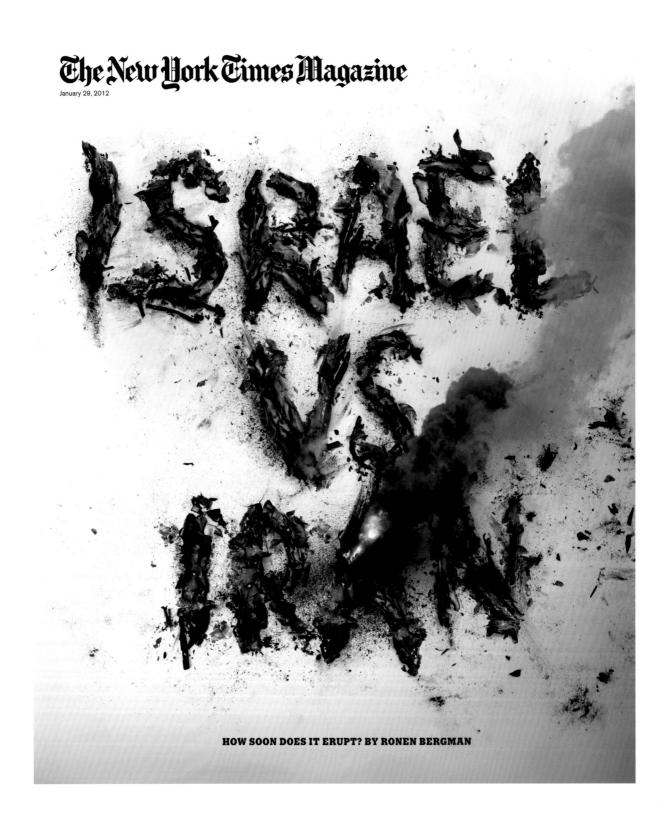

MAGAZINE COVER **Design** Arem Duplessis ● , New York **Art Direction** Gail Bichler **Illustration** Sean Freeman, London **Client** *The New York Times Magazine* **Principal Type** Custom organic type **Dimensions** 10.4 x 12.7 in. (26.4 x 32.1 cm) The intention of this piece was to create a war-torn cover to highlight the main story of the conflict between Israel and Iran. We wanted this to come across in a graphic way, but obviously without making it gory, so we stuck to war-torn destruction to make the type.

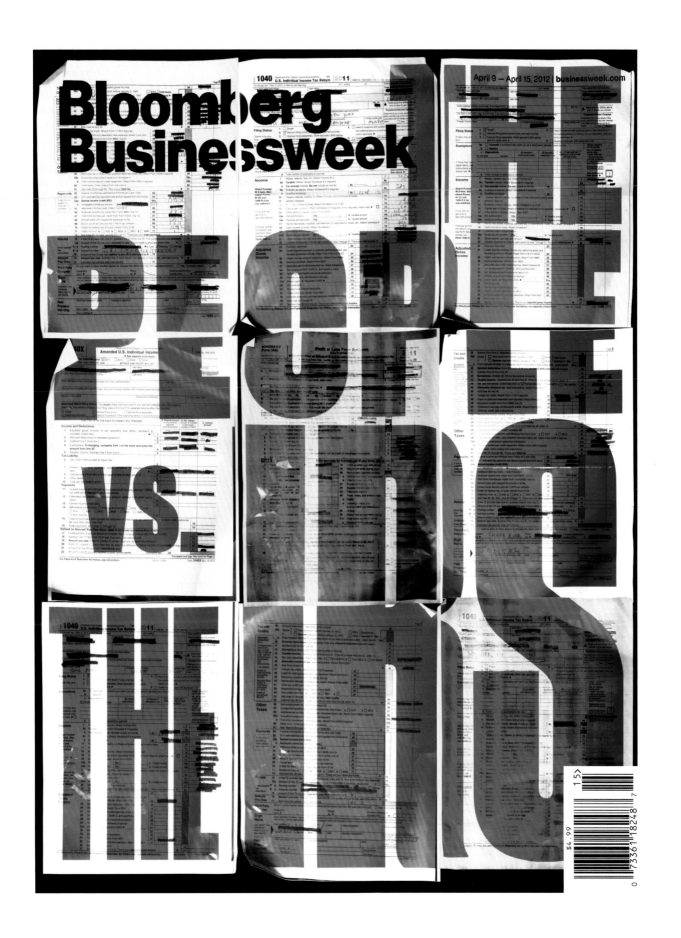

MAGAZINE COVER Assistant Creative Direction Tracy Ma, New York **Creative Direction** Richard Turley
Publication *Bloomberg Businessweek* **Principal Type** BW Druk **Dimensions** 7.9 x 10.5 in. (20.1 x 26.7 cm)

May 7 — May 13, 2012 | **businessweek.com**

Bloomberg
Businessweek

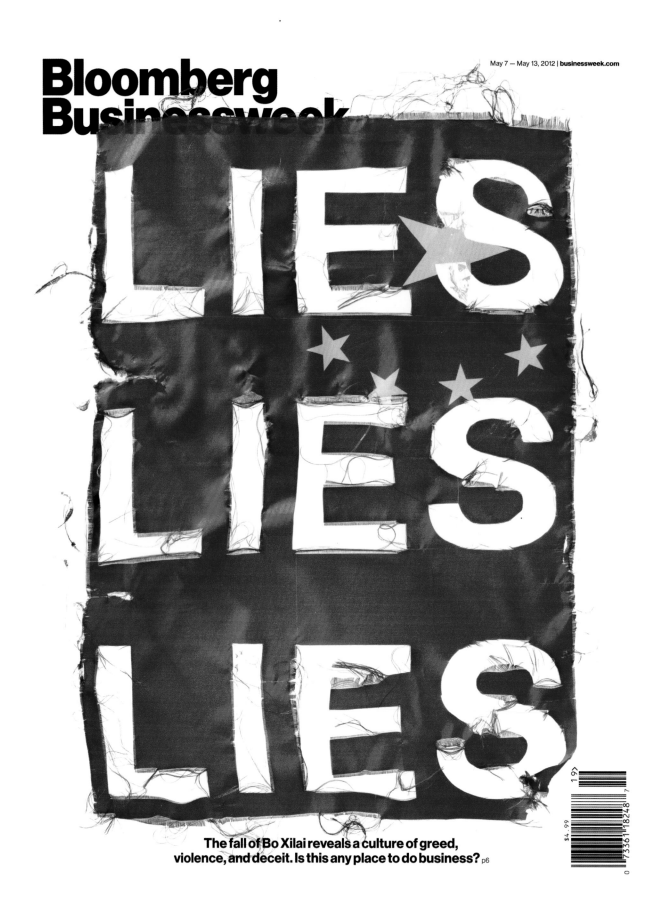

The fall of Bo Xilai reveals a culture of greed, violence, and deceit. Is this any place to do business? p6

$4.99

MAGAZINE COVER **Assistant Creative Direction** Tracy Ma, New York **Creative Direction** Richard Turley
Publication *Bloomberg Businessweek* **Principal Type** BW Haas Head **Dimensions** 7.9 x 10.5 in. (20.1 x 26.7 cm)

This Will Never Scale: A Conversation With Sam Potts – If I had to characterize the work of Sam Potts, I wouldn't – because being surprised is the whole point. But to give you an idea, he's designed satirical tax forms, storefronts for superheroes (below) and a diagram of David Foster Wallace's Infinite Jest. Outside of design, he has Twittered by mail. He has lived in China. Currently he works full-time at IDEO as a communications designer, and you might know his covers for John Hodgman's The Areas of My Expertise, More Information Than You Require, and That Is All. There's a look to his design that is totally addictive – my favorites are where he's working with an overflow of information and is just trying to corral the absurdity of it all. Inspired by his work on this year's AIGA/NY poster, I started emailing Sam with the idea that I was going to write an article about humor in graphic design. But I had so many questions about his work that it quickly turned into an interview (and I regret nothing).

What was your first design project? What I count as my first design project is a zine I did starting in college, called "...and that Fritz Lang," although at the time I did not call it design and did not even know what graphic design was. But that was a project that was very much about form and ideas and also a lot of vagueness and obscurity. My first proper graphic design project was designing "Bright College Years" by Anne Matthews at Simon & Schuster. That was the first book I ever designed. Years later, on my own, my first projects were Aix restaurant in New York and the JEHT Foundation, both of which sadly no longer exist. But two things definitely came out of my time in editorial work: an approach that's centrally typographic. Type was the first thing that I loved about graphic design. And second, editorial work is requires thinking about the structure of a thing as well as its particulars. This helps in pretty much all design work, and certainly all typographic work.

When did you start implementing humor in your own work? How has this approach changed over time? I guess for me humor is a way of escaping the repetition of design work, which can happen when you're self-employed (as I was, though no longer) and falling into habits. The way out of doing the same thing over and over is to make up jokes. It's kind of the easy way out, maybe. So then, humor started to play whatever part it played in my projects once I started to feel in control of the basic design methodology (learn-sketch-present-refine) and once I started to feel like I was getting to do the aesthetic things I wanted to do. Soon enough you do all those things that you want to do — letterpress, fancy paper, minimalist, et cetera — you've got your chops. This is when it can get repetitive as you start to lean on what works and what's familiar. Jokes were a way of feeling like I was doing my job, coming up with something new or at least entertaining.

Looking at your first book cover for John Hodgman, The Areas of My Expertise, and then later the Infinite Jest diagram there's this tone that I see evolving – it's this overflow of information, where there's so much that it just overwhelms the eye. The overflow gives the work a sense of bounce and excitement. But is that how you think of it? It's interesting that you connect these two projects in this way, around an overflow of information. It's a sharp observation. Making each of these projects were such different approaches that I think of them as very separate things. The IJ poster was a self-initiated project, first of all, and it's essentially a severe reduction of the novel (everything but names subtracted) in order to visualize connections. The Hodgman cover design — this will come as no surprise — was John's idea. As many people have noted, it's taken from the Dr. Bronner's label design, somewhere between homage and rip-off. But the concept was, the "expert" who's written this book is crazy and even maniacal, but there's a kind of insane version of the world and history created by this nut. If you read the Bronner's label, the same craziness is in there. So that was the idea. So then this would be the place to mention that humor and especially irony are really verbal things. It's hard to do that doubling of meaning by which you can share a wink and get someone's drift. It's hard to do timing in two dimensions on a poster, say, because there's no pause then punchline. Imagery sinks in in a different way, so there's nothing to get, somehow. Some book jackets can generate irony, mainly by playing the image off the title. But does it last? Visual jokes are kind of one-liners that are never as funny the next time. That bounce and excitement that you might see in the graphic is quite a different experience from laughing at something that was said in a way you didn't expect. Which is not to denigrate imagery — nothing seduces like imagery and probably visual beauty lasts a lot longer in the memory than humor. Most of the things we laugh at aren't even jokes, anyway. They're someone mishearing a question and giving the wrong answer, or the perfectly timed familiar expression inserted in an out-of-context moment, and so on. The whole "you had to be there" story that was funny when it happened, but isn't funny any more. You can't really get spontaneity with graphic design, not only because it's so planned out beforehand but once it's down on paper, it's the opposite of spontaneous.

Do you see this tone as a contrast or a compliment to your work for the Everything Will Be All Right Eventually Creative Review cover? That was about an unfunny topic — the economy (regardless of what state it's in) — that seemed to have already had its seriousness beaten to death. My original sketches for that cover were jokes: a pink slip, a graph measuring schadenfreude (playing on budgetary infographics), and someone pissing their pants. The cover we settled on was certainly dependent on cleverness but maybe not exactly humor. You get the message by turning the thing around, which the type forces you to do. Pretty sure I stole this from an old book cover that James Victore designed (and which I can't find on the web right now).

How did your experience as an Associate Editor at St. Martins Press shape your graphic design aesthetic? Ha! Good question. I was a college English textbook editor, by the way, so it's not like I was bathing in the shimmering waterfall of pop culture glamor that you think of when you think of big time New York Publishing. But two things definitely came out of my time in editorial work: an approach that's centrally typographic. Type was the first thing that I loved about graphic design. And second, editorial work it requires thinking about the structure of a thing as well as its particulars. This helps in pretty much all design work, and certainly all typographic work.

So did you study design in college and then go into publishing? No, I majored in comparative literature in college, which was more varied than an English major. Publishing was a natural (read: only) option for work after college and I just happened to end up in college textbook publishing. I was laid off after a few years and ended up working for Amy Hill at Simon & Schuster in the design department, where I learned to design book interiors. From there I went to Portfolio Center in Atlanta in 1998, which was my design schooling, properly speaking.

The Twitter on Paper project is much different from your other work because it uses hand-type and mixed media. What inspired you to write out 743 tweets? In a word: stupidity. I really thought I'd only have to do like 50 of them and then the thing would die out.

MFA DESIGN GUEST LECTURE

AN UNPLANNED ROUTE THAT INCLUDED PUBLISHING, SUPERHERO SUPPLIES, TRAVEL IN CHINA, AND NOW IDEO

SAM POTTS

| JANUARY 24 3:00PM–4:30PM | 310 EAST 22ND ST. NEW YORK | MFA DESIGN STUDIO RM 536B |

"I LOVE THAT THERE CAN BE AN ART TO NEARLY EVERYTHING. I LOVE THAT GEOMETRY IS ANCIENT. I LOVE THAT FRANK LLOYD WRIGHT WAS SHAMELESS. I LOVE THAT THE LITTLEST THINGS CAN MAKE BIGGEST DIFFERENCES, LIKE CUFFLINKS OR A PINCH OF SALT OR JUST 5 MINUTES. I LOVE THAT SOME THINGS ARE INEXPLICABLE, IN FACT MORE THINGS THAN YOU'D EXPECT. I LOVE THAT NO EXPERTISE IS NEEDED TO APPRECIATE A WELL-MADE THING. I LOVE THAT YOU CAN PRETTY MUCH ALWAYS ASSUME THERE IS A BETTER WAY. I LOVE THAT ANYTHING CAN SEEM NEW. I LOVE THAT A COMPUTER IS REFERRED TO AS A MACHINE. I LOVE THAT MUSIC DOESN'T HAVE TO MEAN ANYTHING TO BE BEAUTIFUL. I LOVE THAT THERE ARE THEORIES ABOUT HANDWRITING, THE COMPOSITION OF MATTER, AND HORSE RACING. I LOVE THE KNUCKLEBALL. I LOVE THE LIGHTBULB JOKE ABOUT HOW MANY BORING PEOPLE. I LOVE THINGS THAT GET REMEMBERED ARE USUALLY THE THINGS THAT GET REMEMBERED. I LOVE THE MOMENT AT DUSK WHEN THE F TRAIN COMES OUT OF THE TUNNEL AFTER CARROLL ST. AND FILLS WITH GOLDEN SUNSET LIGHT AND FEELS LIKE A CATHEDRAL. I LOVE THE SLOW MOTION REPLAY. I LOVE THE WAY THAT HAT LOOKS ON YOU. I LOVE THAT JAPANESE ARCHITECTS DELIBERATELY INSERTED MISTAKES INTO THEIR DESIGNS TO APPEASE THE GODS, WHO BELIEVE ONLY THEY ARE PERFECT. I LOVE THAT THE HEART IS A MUSCLE. I LOVE THE SIMPLICITY OF PUNCTUATION. I LOVE THE RADIATOR BUILDING, THE QUEENSBORO BRIDGE, AND SUMMERTIME. THAT PERFECT SWING. I LOVE THAT LINE ABOUT HOW MEMORY IS LIKE A TRAIN. I LOVE THAT ANYTHING IS INTERESTING IF YOU LOOK AT IT CLOSELY ENOUGH. I LOVE THAT EVEN A CHEAP HAMBURGER IS STILL PRETTY GOOD."

"IF WE DON'T CHANGE
OUR DIRECTION,
WE WILL SURELY END UP
WHERE WE'RE GOING."

PLEASE BE ADVISED: SAM POTTS INC. IS CLOSED FOR BUSINESS AND THEREFORE NOT HIRING DESIGNERS, INTERNS, OR CONTRACTORS. THANKS FOR YOUR INQUIRIES AND GOOD LUCK.

SIGNATURE:

+1 347.407.3320 | SAM@SAMPOTTSINC.COM

projects that require humor or were specifically funny items — my experience with that is, you get way too constricted by the client's expectations. Better to have a straightforward project, have no idea what to do, and poop out something dumb but not too dumb.
Source: *THIS WILL NEVER SCALE: A CONVERSATION WITH SAM POTTS by Evan Johnston*

Sam Potts, Brooklyn Superhero Supply Co. - Sam Potts runs a generalist graphic design practice in New York City. He designed all the branding, packaging, posters, and store materials for the Brooklyn Superhero Supply Co. as well as the publications and website for the superhero store's alter ego, 826NYC, a nonprofit writing and tutoring center in Park Slope, Brooklyn.

How did you come to do all the very cool product designs for the Brooklyn Superhero Supply Co.? The superhero store is the storefront for 826NYC, a nonprofit writing and tutoring center for students of all ages. The center is completely free, and open to all, and offers after-school tutoring, workshops on a wide variety of topics (candy, novel writing, filmmaking, maonsters and robots, cheese), school field trips in which classes write stories together, and a host of other such programs. It's also a place where young writers are published. We've published two anthologies of assorted writing, three full-fledged books, and countless booklets of work from specific workshops.

Who is the audience? Primarily superheroes and sidekicks. I would have thought that's obvious, but you'd be surprised who comes in looking for a superhero "costume." We don't sell costumes; we do sell superhero uniforms. We don't cater to villains of any

STUDENT PROJECT Design In Hee Bae, New York **Instructor** Steven Heller **School** School of Visual Arts, New York
Principal Type Adobe Caslon Pro and DIN 1451 Engschrift Std **Dimensions** 12 x 18.5 in. (30.5 x 47 cm)

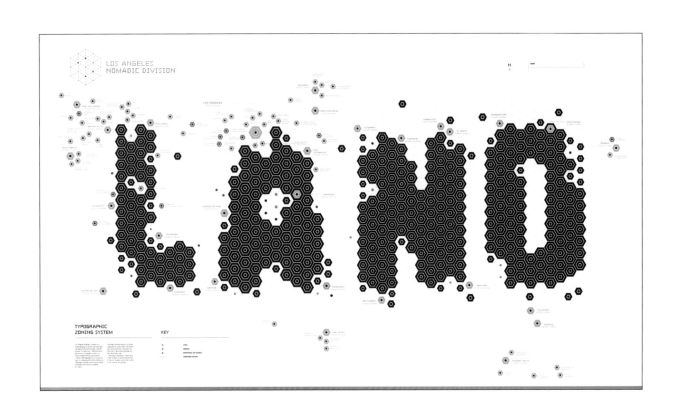

STUDENT PROJECT **Design** Jerod Rivera, Pasadena, California **Instructor** Simon Johnston
School Art Center College of Design **Principal Type** FindReplace and Klavika **Dimensions** 42 x 24 in. (106.6 x 61 cm)
This infographic is part of a fictional identity system for the contemporary art entity Los Angeles Nomadic Division (LAND).
A hexagon was used for the logo that becomes a tool to map out different cities in Los Angeles as well as locate art
museums and cultural entities. The hexagon shape also becomes a typographic tool that can help guide a reader to
imply that LAND is involved with the entire Los Angeles art and culture community.

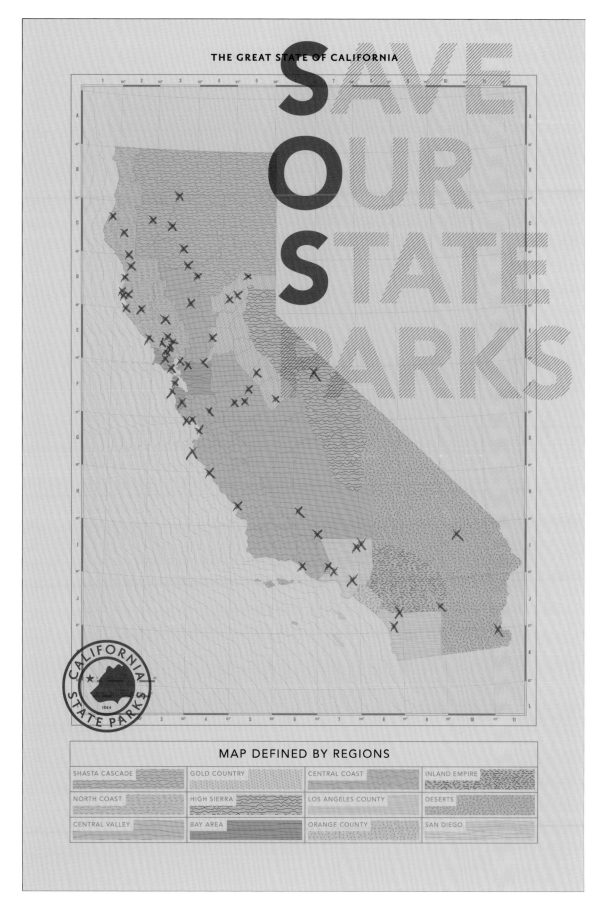

STUDENT PROJECT Design Matt Locascio, Pasadena, California **Instructor** Brad Bartlett
School Art Center College of Design **Principal Type** Priori **Dimensions** 24 x 36 in. (61 x 91.4 cm)
Founded in 1864, the California State Parks strive to preserve the state's biological diversity and protect its most valued natural and cultural resources. The rebrand of the California State Parks identity system integrates textures and patterns that reflect the diverse geographic terrains and park designations of California, and applies these to create a flexible system adaptable to each park. Inspired by the Arts and Crafts movement, the rebranded system includes a website, poster series, mobile phone application, apparel, wayfinding signage, and ID collateral.

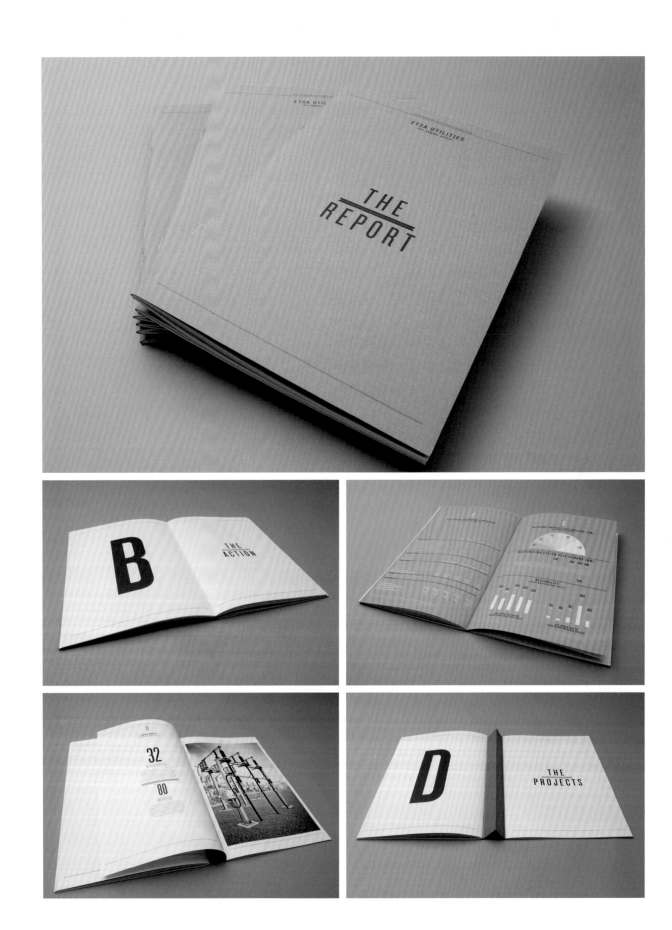

ANNUAL REPORT **Design** Tom Crosby and Anthony De Leo, Adelaide, Australia **Creative Direction** Anthony De Leo
Photography Randy Larcombe **Agency** Voice **Client** ETSA Utilities **Principal Type** Akkurat and Knockout
Dimensions 8.3 x 11.7 in. (21 x 29.7 cm)

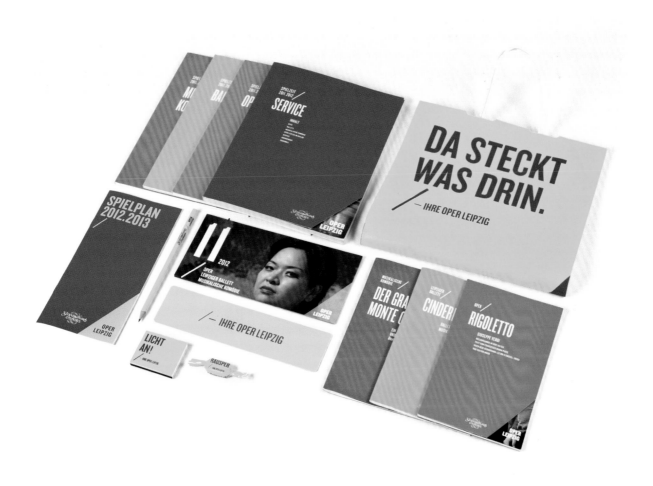

CORPORATE IDENTITY **Creative Direction** Tim Finke, Timo Hummel, Svenja von Doehlen, and Steffen Wierer, Berlin **Client** Opera Leipzig **Principal Type** Knockout and Proforma **Dimensions** Various
The fundamental issue was the reintegration of the individual (three) divisions under the umbrella brand of the Leipzig Opera and the convergence of opera to the city of Leipzig and its citizens. For the visualization of the complexity of the opera, in relation to its artistic orientations, but also as part of a cultural place in the structure of the city, we made the opera a mathematical equation, a common denominator of the city. The ensuing formal language is created by the slant of the fraction bar that divides all formats and media and thus forms a strong brand recognition.

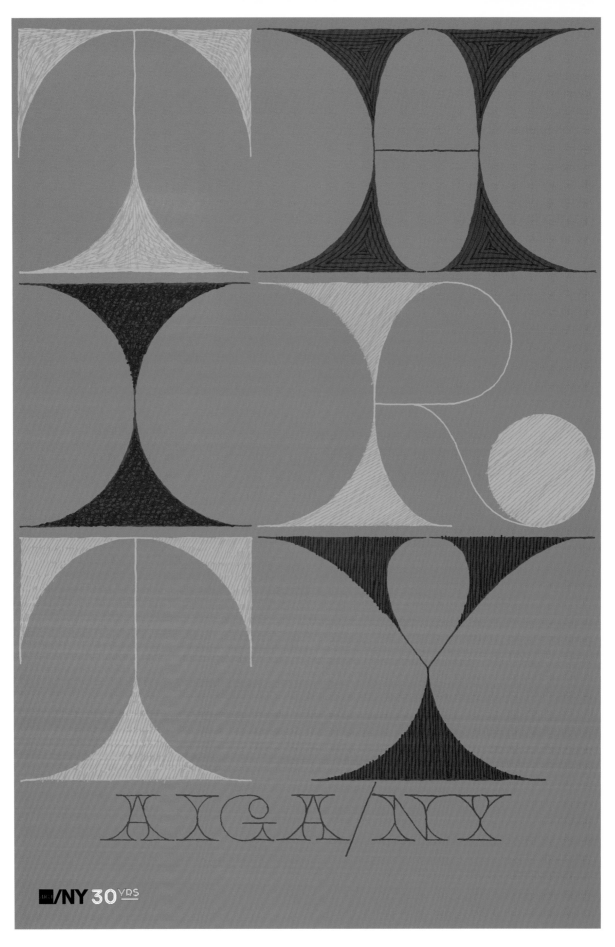

POSTER **Creative Direction** Matteo Bologna ●, New York **Design Firm** Mucca Design
Client American Institute of Graphic Arts, New York (AIGA/NY) **Principal Type** Custom **Dimensions** 24 x 36 in. (61 x 91.4 cm)
The year 2012 marked the thirtieth anniversary of the New York chapter of the American Institute of Graphic Arts.
To commemorate the occasion, the institute asked us to design a limited-edition poster.

BOOK JACKET **Design** Charlotte Strick ●, New York **Publisher** Farrar, Straus and Giroux
Principal Type Sculpted wet paper **Dimensions** 5.5 x 7 in. (14 x 17.8 cm)

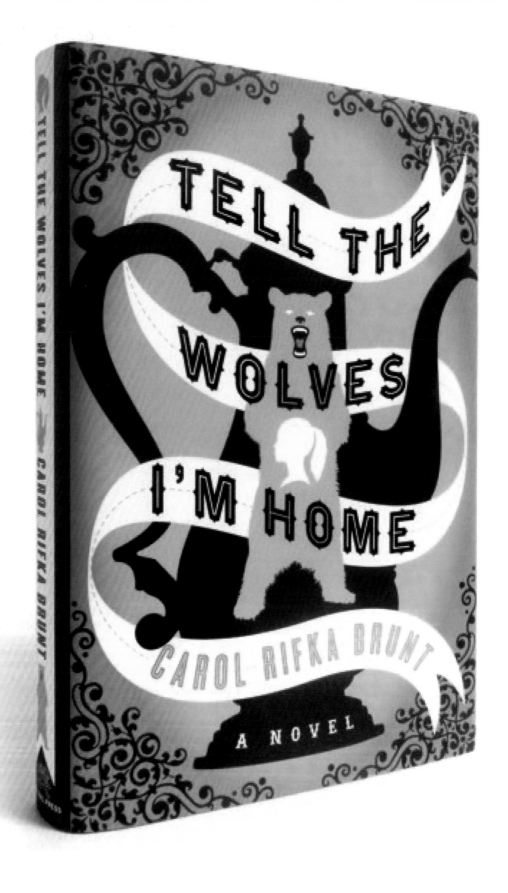

BOOK JACKET **Design** Roberto de Vicq de Cumptich ●, New York **Art Direction** Tom Stvan
Publisher Random House Publishing Group **Principal Type** Cyclone, Falfurrias, and Hessian
Dimensions 6.25 x 9.5 in. (15.9 x 23.8 cm)

Marooned in the suburbs outside New York City in the '80s, an adolescent girl feels bewildered and distant from her immediate family. The suburb's lack of personality and the loss of her gay uncle to AIDS propel the narrative. In his will, the uncle leaves her a teapot with a dancing bear on it. The design borrows from fairy tales, emphasizing the solitude and vulnerability of our heroine. The teapot becomes an urn, and the dancing bear howls like a wolf. The cover was very successful, appearing in 2012's best covers list by several blogs and design associations.

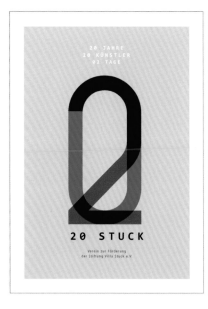
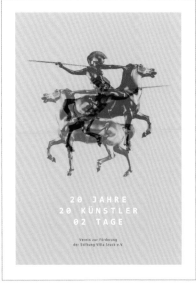
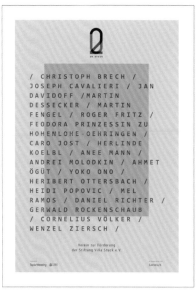

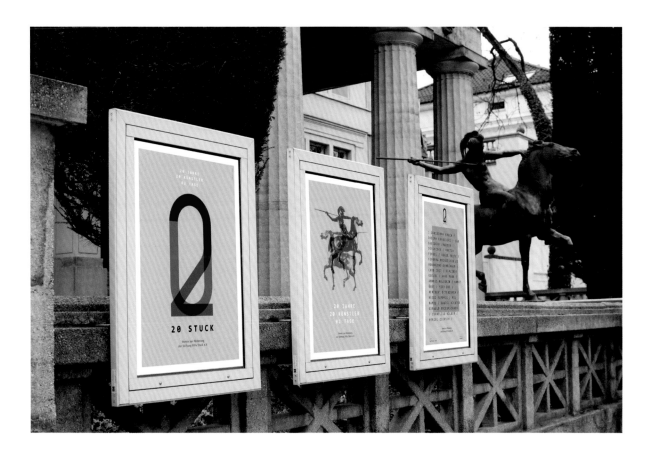

POSTERS Design Marc Heckner, Münich **Art Direction** Annika Kaltenthaler **Direction** Irmgard Hesse and Marcus von Hausen
Agency Zeichen & Wunder **Client** Support association Villa Stuck e.V.
Principal Type Consolas Bold and Frutiger 57 Condensed **Dimensions** 33.1 x 46.5 in. (84.1 x 118.9 cm)
In 2012, Münich's Villa Stuck celebrated its twentieth anniversary as a municipal museum and foundation. To mark this
occasion, the Friends' Association hosted a charity exhibition. The motto of the two-day event was "20Stuck" (which
can be read as "20pieces" in English) as the exhibition displayed twenty works of twenty different artists, such as
Mel Ramos and Yoko Ono. Zeichen & Wunder was commissioned to design all marketing material for the anniversary
event: invitation package, brochure, and website. The central means of communication was a three-part poster series.

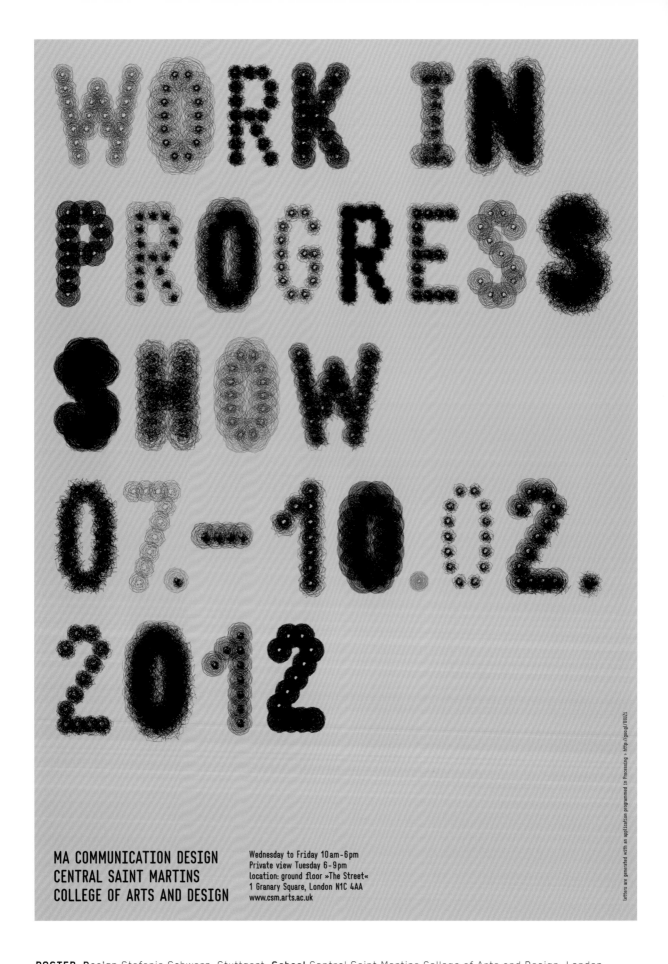

POSTER **Design** Stefanie Schwarz, Stuttgart **School** Central Saint Martins College of Arts and Design, London
Client Patrick Roberts **Principal Type** AF Module **Dimensions** 23 x 33 in. (59 x 84 cm)
In order to get a huge variety of progressing letter shapes, a customized application was programmed using the open-source software Processing.

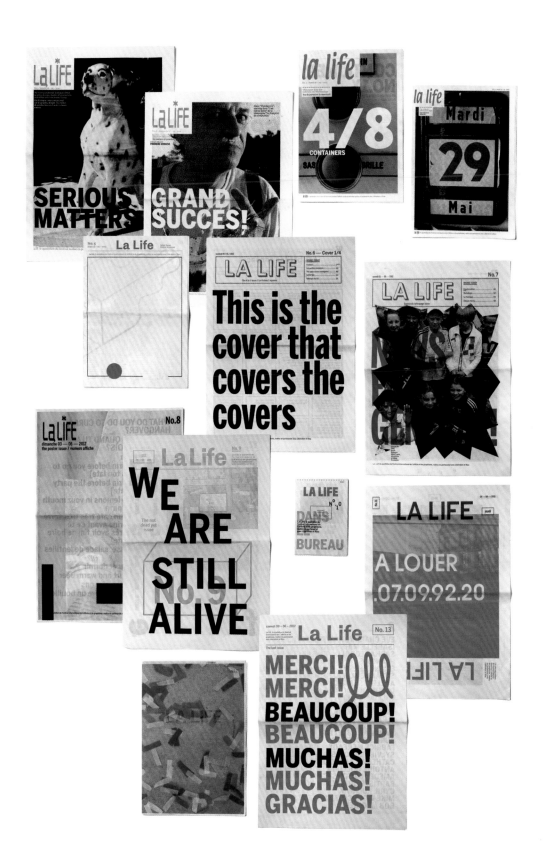

NEWSPAPER **Design** Stefano Giustiniani, Santa Carita, California **Art Direction** Susanna Shannon, Marseille, France **Editor** Maria Giustiniani **Editor-in-Chief** Susanna Shannon **Curator** Etienne Hervy **Design Firm** designdept **Client** Festival International du Graphisme de Chaumont **Principal Type** Various **Dimensions** Various

My dream was to produce a daily newspaper that everybody would be dying to read every day because its content would be somehow exactly like our lives. So we published thirteen issues of the paper as an experiment in a small town in France called Chaumont during the Festival International du Graphisme, a graphic design conference that takes place every year in May. The paper covered all sorts of topics ranging from graphic design to catch-matches to daily life in the town. The run was 300 copies daily, and we sold out every day.

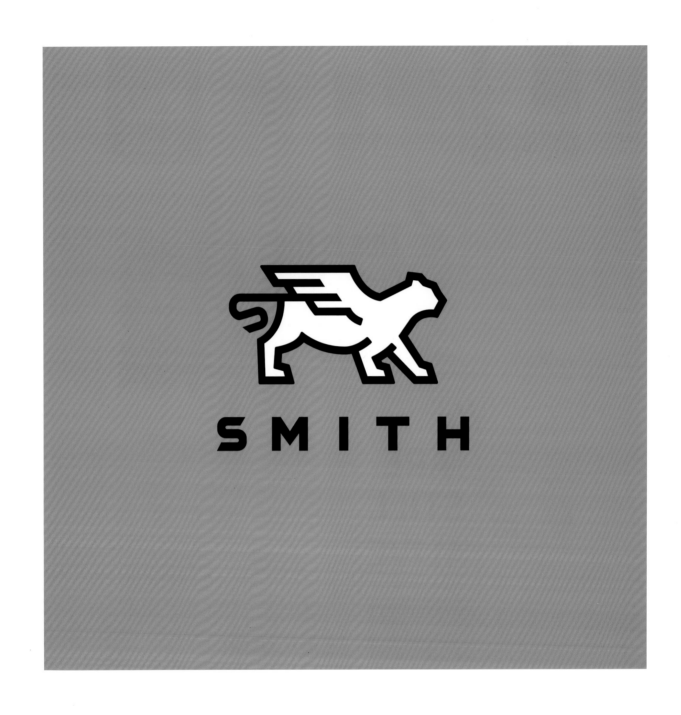

LOGOTYPE Design Christine Celic Strohl and Eric Janssen Strohl, San Francisco **Design Firm** STROHL
Client Smith Electric Vehicles, Kansas City, Missouri
Smith is the world's leading producer of zero-emissions and zero-noise commercial vehicles. Our redesign, a winged tiger, communicates the core values of the company—innovation, impact, and unity—and reflects the company's eighty-year heritage and passion of its employees. Tigers have long been a symbol of power and energy, an attribute that is at the core of Smith's business. The orange color was carried over from the previous brand—maintaining continuity and differentiation for Smith among the "green-washed" world of sustainable branding.

MAGAZINES Design Catrin Sonnabend, Frankfurt **Art Direction** Kai Bergmann **Studio** Bergmann Studios
Client Green Youth Hesse (GJH), Germany **Principal Type** Gill Sans **Dimensions** 8.3 x 5.9 in. (21 x 15 cm)
It should not look like it is from a political party but rather appeal to teenagers and young adults who are
interested in politics.

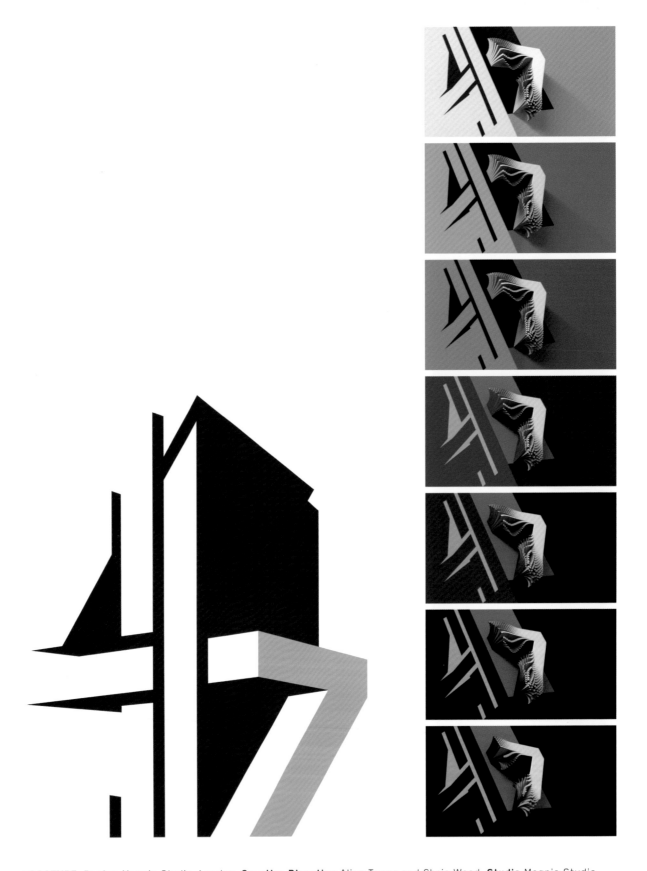

LOGOTYPE **Design** Magpie Studio, London **Creative Direction** Alice Tonge and Chris Wood **Studio** Magpie Studio
Client 4Creative **Principal Type** 4Seven

4Seven is a new channel from Channel 4. The channel features the best programming from the past seven days and integrates social media. The brief was to create a cohesive on-and-off-air package that would sit comfortably as part of the Channel 4 family. Solution: The marque features a hidden "7" within the existing Channel 4 logo revealed as you pan around a corner. This corner approach creates a visual signature for the channel's on-screen graphics. This is further showcased in a set of idents that result in a logic-defying scene, reminiscent of M.C. Escher. These idents feature ordinary environments wrapped around a corner with the logo at the heart of each scene. The on-screen graphics take the brand into three dimensions with a reactive "7," which reflects the amount of buzz around programming during the day.

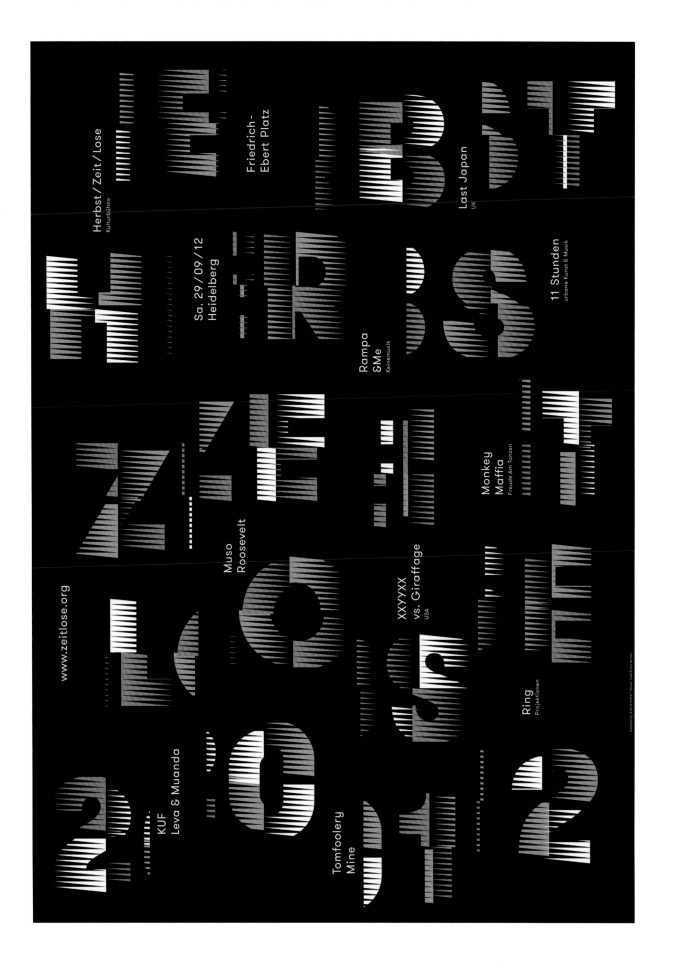

POSTER **Design** Götz Gramlich, Heidelberg, Germany **Agency** gggrafik **Client** Patrick Forgacs
Principal Type GT Walsheim (modified) **Dimensions** 23.4 x 33.1 in. (59.4 x 84 cm)
Pattern-filled parts of type form new letters, symbolizing the fusion of the multi-art festival Herbstzeitlose.

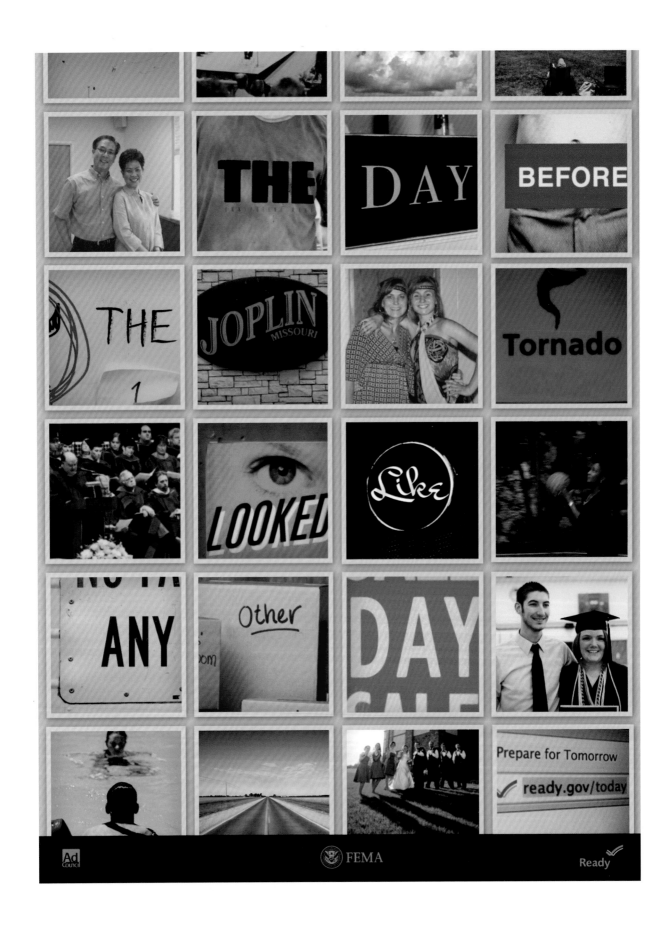

POSTER **Design** Nuno Ferreira, Chicago **Art Creative Direction** Guybrush Taylor **Creative Direction** Nuno Ferriera and Ryan Wagman **Executive Producer** Rob Allen **Chief Creative Officer** Susan Credle **Account Director** Rich Pieczynski and Rob Raidt **Senior Account Executive** Danielle Wilburn **Account Executive** Christine Zinker
Agency Leo Burnett, Chicago **Client** Earth Hour, Singapore **Principal Type** Various and handlettering
Dimensions 24 x 36 in. (61 x 91.4 cm)

STUDENT PROJECT Design Virgilio Tzaj, New York **Instructor** Ori Kleiner **School** School of Visual Arts, New York
Principal Type Agency, Cubano, and Verlag **Dimensions** 24 x 36 in. (61 x 91.4 cm)
Poster design for the Motion Graphics Department held at the Art Directors Club. I wanted to find a way to move the
viewer's eye around the poster while at the same time fitting the numerous names and information into the design.
Using a limited color palette and a geometric format allowed me to play with the type and make a cohesive and clean piece.

CHIMERA
by Britta Hope

STUDENT PROJECT **Design** Britta Carlson, New York **Instructor** Yego Moravia St. Victor
School School of Visual Arts, New York **Principal Type** Hand-drawn

STUDENT PROJECT **Design** Seth Mach, Savannah **Instructor** Bob Newman **School** Savannah College of Art and Design **Principal Type** Various **Dimensions** 21 x 31 in. (53 x 79 cm)

In 1929, America experienced perhaps the worst economic collapse in its short history. The decade that followed contained suffering and turmoil in job markets and culture. Yet the 1930s produced some of the lasting design standards still used in constructing consumer products, architecture, advertising, and communication design as a whole. In response to such societal stress, America was given the opportunity to reinvent itself into whatever was needed. This poster is the celebration of the good that came from the decade when everything seemed to fall apart.

STUDENT PROJECT **Design** Pedro Messias, New York **Instructor** Carin Goldberg **School** School of Visual Arts, New York
Principal Type FF Din and custom **Dimensions** Various

SELF-PROMOTION **Design** Brent Couchman, San Francisco **Client** Friends of Type **Principal Type** Custom
Dimensions 16 x 20 in. (40.6 x 50.8 cm)
This is something of a personal motto turned into a print for Friends of Type, inspired by Rolly Crump's Tower of the
Four Winds and Eames' "Do Nothing Machine."

LOGOTYPE Design Adrien Moreillon, Lausanne, Switzerland **Art Direction** Adrien Moreillon
Creative Direction Nadja Imhof **URL** www.a--m.ch **Studio** Adrien Moreillon and transistor.ch **Client** Les Toises
Principal Type Custom
Les Toises is a new psychotherapy center in Lausanne, Switzerland. For their corporate identity, we created a mono-
gram using the letter "T" (for Toises) and the Greek letter "Ψ" (for Psychotherapy). The monogram was designed on
the basis of a labyrinth, a graphic metaphor of the process experienced in psychotherapy (self-seeking, accompani-
ment, individual solution).

LOGOTYPE **Design** Jinki Cambronero, Katarina Mrsic, and Dean Poole, Auckland **Creative Direction** Dean Poole
Agency Alt Group **Client** Auckland University Press
Designed around the idea of an open book and the form of the letter "A," the logo mark references its name as well as
its offering. The logo mark has a sense of weight through the use of simple bold black lines and references the graphic
nature of antipodean arts, crafts, and architecture. The mark is descriptive, pictorial, and metaphorical. It simply says,
a book.

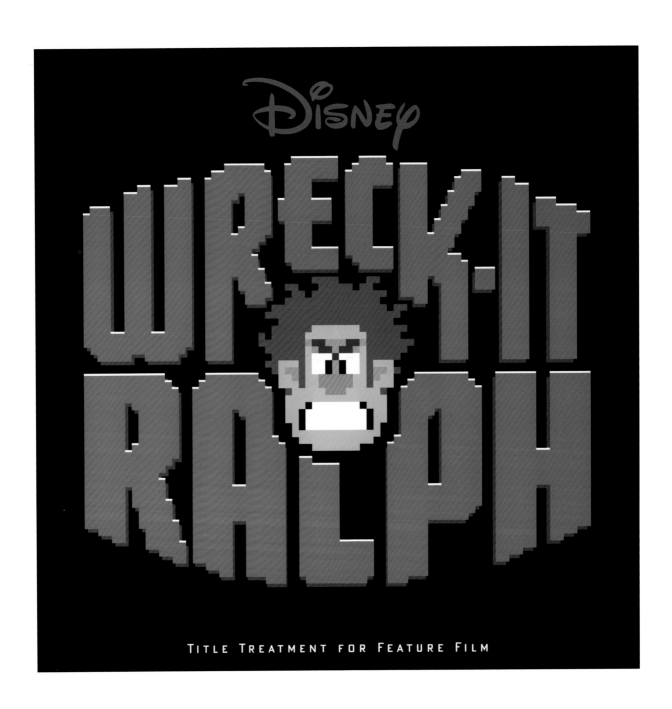

TITLE TREATMENT FOR FEATURE FILM

LOGOTYPE **Design** Michael Doret, Hollywood **Creative Direction** Disney Animation, Burbank, California
Lettering Michael Doret **Client** Walt Disney Studios Motion Pictures **Principal Type** Handlettering
This is a title treatment for a feature animated film about a 1970s arcade game character.

LOC
AL
SIGHT
INGS
FILM
FEST
IVAL

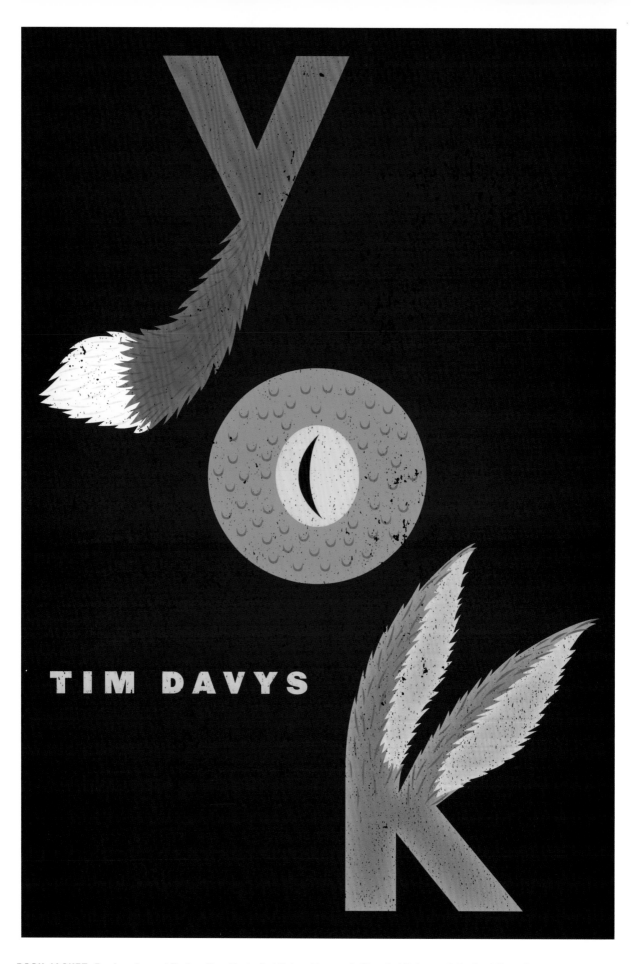

BOOK JACKET **Design** Jarrod Taylor, New York **Publisher** HarperCollins Publishers **Principal Type** Champion **Dimensions** 5.3 x 8.25 in. (13.5 x 21 cm)
This is the last in a series of four books about an alternate world populated by stuffed animals. The stories in Yok center around a fox, a gecko, and a rabbit. So why not make the type look like stuffed animals?

SOPHOCLES

A New Translation by
Robert Bagg *Elektra*

SOPHOCLS

A New Translation by
Robert Bagg *Oedipus the King*

SOPHOCLES

A New Translation by
James Scully *Philoktetes*

SOPHOCLES

A New Translation by
James Scully *Aias*

SOPHOCLES

A New Translation by
Robert Bagg *Oedipus at Kolonos*

SOPHOCLES

A New Translation by
Robert Bagg *Antigone*

SOPHOCLES

A New Translation by
Robert Bagg *Women of Trakhis*

SOPHOCLES	Elektra	Translated by Robert Bagg	HARPER PERENNIAL
SOPHOCLES	Aias	Translated by James Scully	HARPER PERENNIAL
SOPHOCLES	Antigone	Translated by Robert Bagg	HARPER PERENNIAL
SOPHOCLES	Oedipus at Kolonos	Translated by Robert Bagg	HARPER PERENNIAL
SOPHOCLES	Philoktetes	Translated by James Scully	HARPER PERENNIAL
SOPHOCLES	Oedipus the King	Translated by Robert Bagg	HARPER PERENNIAL
SOPHOCLES	Women of Trakhis	Translated by Robert Bagg	HARPER PERENNIAL

BOOK JACKET Design Oliver Munday, New York **Studio** OMG **Client** HarperCollins Publishers **Principal Type** Baskerville
Dimensions 5.3 x 8 in. (13.5 x 20.3 cm)

STUDENT PROJECT **Design** Seth Mach, Savannah **Instructor** Bob Newman **School** Savannah College of Art and Design
Principal Type Custom **Dimensions** 19 x 34 in. (48 x 86 cm)
The design of this alphabet attempts to convey a modern form of illumination in tribute to the Carolingian manuscripts such as the *Book of Kells*, the *Book of Durrow*, and the *Lindisfarne Gospels*. Just as these books highlighted the importance of a message and communication through embellishment, the botanical letters endeavor to depict complexity and beauty in diverse natural forms.

THINGS WRITTEN IN BLOOD: LIFE DEATH PEACE WAR HAPPINESS SADNESS GOD MISERY JOY LEGACY ACTION COURAGE POWER HEALTH FLY POSSIBILITY LAUGHTER CREATIVITY LOVE HATE COMMUNITY FAMILY SCHOOL FRIENDS FAITH WORK BOYFRIENDS MONEY BILLS KISS SEX HURT TEARS ANGER FORGIVENESS STRONG BEGINNING JOURNEY DIRECT PARTY EASY UNCONDITIONAL BRILLIANT INCOMPLETE BE HIDDEN FOCUS DESTINY CHALLENGE JEALOUS VALUEABLE FOOD DRINKS POPULAR OUTSTANDING BETTER OBSESSION RARE LIFTING LONGING MAGIC WANTED CANDY GOOD RISE FUN ACHIEVEMENT BEGGING DEED HOPE PAST QUESTIONS SUPPORT PRESENT REGRET GO QUIT MISUNDERSTOOD FEARS COMPANY CATS DOGS EVERYTHING SPEED REVENGE LAZY RESPONSIBILITY MONSTER PROMISE TAKE MUSIC DRUGS GREEDY HELP MERCY NOTHING FOOLED MISSING START STOP FAIL CHANGE ALONE PRETTY SIN WRONG TRY FUTURE TRICKY CLOSE BREATHE TAME SWEET FULL COME GIVE SMILE PRICE MATTER UGLY DEVIL REVIEW CRY FAR WISH YES NO MAYBE YOU ME WE FREE

STUDENT PROJECT **Design** Maria Sofie Rose, Oslo **Instructor** Charles Nix ● **School** Parsons The New School for Design
Principal Type Handlettering **Dimensions** 24.5 x 34.5 in. (62.2 x 87.6 cm)
This poster is an exploration of the conversation between writing and form. The act of writing in blood inevitably led to the darker corners of my mind and memories.

MAGAZINE SPREAD **Associate Art Direction** Doug Wheeler, Wilton, Connecticut **Creative Direction** Ken DeLago ●
Illustration Dan Saelinger **Publication** *Golf Digest* **Principal Type** Hand-drawn **Dimensions** 9.5 x 10.7 in. (24.1 x 27.2 cm)
This spread is about lowering your scores in golf and turning your sixes into fours.

The New York Times Magazine

August 19, 2012

OBA MA VS POV ERTY

Twenty-five years ago, a young community organizer in a Chicago neighborhood called Roseland decided that what the poor needed most was an advocate with real power.

He became the most powerful person on the planet.

What happened to Roseland?

By Paul Tough

MAGAZINE COVER **Design Direction** Arem Duplessis ●, New York **Publication** *The New York Times Magazine* **Principal Type** Monrod **Dimensions** 10.4 x 12.7 in. (26.4 x 32.1 cm)

TYPEFACE ✕ IN MOTION

by Minji Hong

STUDENT PROJECT Design Minji Aye Hong **Music** Dream Machine Lullaby by I Am Robot and Proud
Instructor Lara McCormick **School** School of Visual Arts, New York **Principal Type** Bodoni
Cross Over is an animated typeface. It has two layers in the same shape but different colors.
Each of them rotates in the opposite angle from 0-45 degrees to form the "X."

STUDENT PROJECT **Design** Minji Aye Hong **Instructor** Gerald Mark Soto **School** School of Visual Arts, New York
Principal Type Various

My name "Aye" does not have any specific meaning. I just like it because it is very easy to pronounce in any language and sounds very familiar. "Aye" may sound very differently depending on the emotion and the situations. All typefaces are modified to fit the sounds.

STUDENT PROJECT Design Minji Aye Hong **Music** Ku-Chi-Ta-chi by House Rulez, Aimar Molero **Instructor** Ori Kleiner
School School of Visual Arts, New York **Principal Type** Clavier and Square Slab Serif
The animals of the Eastern Zodiac (a.k.a. Chinese Zodiac) is a short and funny animation that introduces the
characteristics of each animal.

A **BRIEF HISTORY** OF THE

THE **MOUNTAIN BICYCLE** 1970

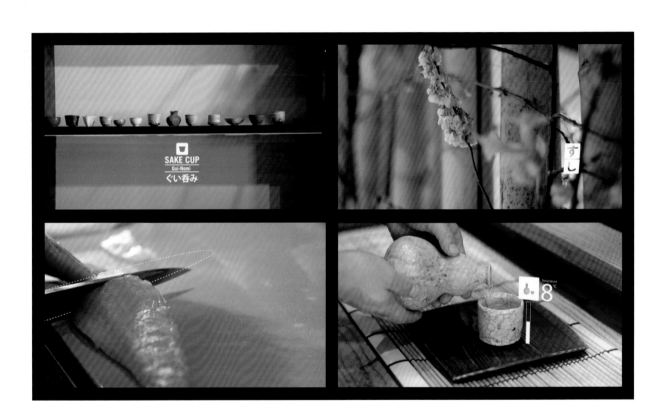

STUDENT PROJECT **Design** Seonghye Kim **Instructor** Ryan Moore **School** School of Visual Arts, New York

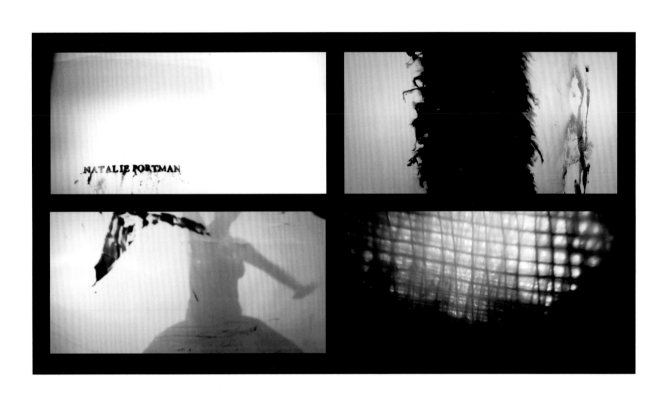

STUDENT PROJECT Design You Jin Kim **Instructor** Gerald Mark Soto **School** School of Visual Arts, New York

SIGNAGE Design Sam Sherman, New York **Art Direction** Sam Sherman **Creative Direction** Julia Hoffmann
Museum The Museum of Modern Art (MoMA), Department of Advertising and Graphic Design
Production Manager Claire Corey **Principal Type** MoMA Gothic **Dimensions** 24 x 198 in. (61 x 50.3 cm)

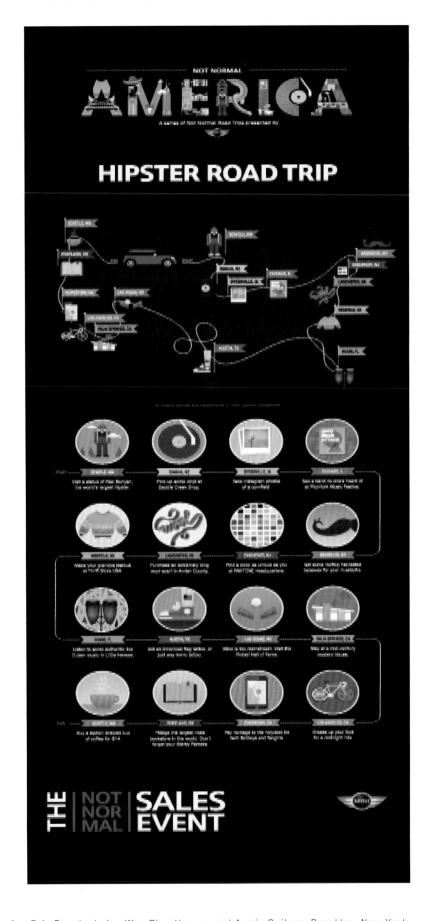

INFOGRAPHIC **Design** Eric Fensterheim, Wen Ping Huang, and Aymie Spitzer, Brooklyn, New York
Creative Direction Deroy Peraza **Illustration** Eric Fensterheim, Wen Ping Huang, and Aymie Spitzer
Copywriter Eric Fensterheim and Aymie Spitzer **Design Firm** Hyperakt **Client** MINI USA
Principal Type Helvetica Neue LT Std, Korolev Condensed, MINIType v2 Bold, and custom
We couldn't resist this one. We admit it. We love MINI. Most normal car brands don't have much personality, but MINI is not normal. It's feisty, it's fun, it's joyful, and it's not afraid to be different. To celebrate this "not normalness," we came up with a series of road trips illustrating that the America we live in can also sometimes be not normal.

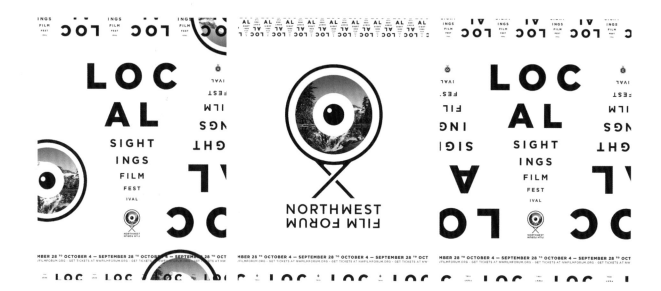

POSTERS Design Steve Cullen and Clara Mulligan, Seattle **Agency** Creature **Client** Northwest Film Forum
Principal Type Gotham **Dimensions** 18 x 24 in. (45.7 x 61 cm)

BOOK JACKET Design Ena Cardenal de la Nuez, Madrid **Publisher** Turner Publishers **Principal Type** Futura Bold (modified)
Dimensions 6 x 9.4 in. (15.3 x 24 cm)

The History of Jazz by client Ted Gioia is a bestseller from Turner Publishers. This is the hardcover version, conceived as a gift book. The client requested that the cover be lively and dynamic, with rhythm and movement. We chose a typographical design in which the word "Jazz" is the protagonist: The letters in vibrant colors move in one direction on the cover and in the opposite direction on the back cover and the spine. The title is written in Futura Bold within the letter "J" on the front and back cover; the rest of the typography is invented.

STUDENT PROJECT **Design** Abdul Rahman Askour, Chris Bouillon, Ka Li Chen, Sven Fuchs, Alexandra Goweiler, Katharina Haller, Myriam Hector, Ricarda Herguijuela, Alexander Hoffmann, Maria Horn, Martin Kalle, Esther NG, Corinna Schneider, Isabel Schwarz, Sebastian Schweig, Muriel Serf, Annabelle Wagner, Manuel Wesely, and Tin Yuet Saarbrücken, Germany **Professors** Patrick Bittner and Indra Kupferschmid **School** Hochschule der Bildenden Künste Saarbrücken **Principal Type** Akzidenz-Grotesk and various **Dimensions** 8.3 x 11.7 in. (21 x 29.7 cm) During a temporary project at the Academy of Fine Arts, Saarbrücken, under the direction of Patrick Bittner and Indra Kupferschmid, eighteen students created a fanzine about things beloved or hated, the small odds and ends. This includes, among others, awe-inspiring indoor plants, worshipped spectacle-wearers, obnoxious mugs, or the ambivalent love between Merguez and Akzidenz-Grotesk.

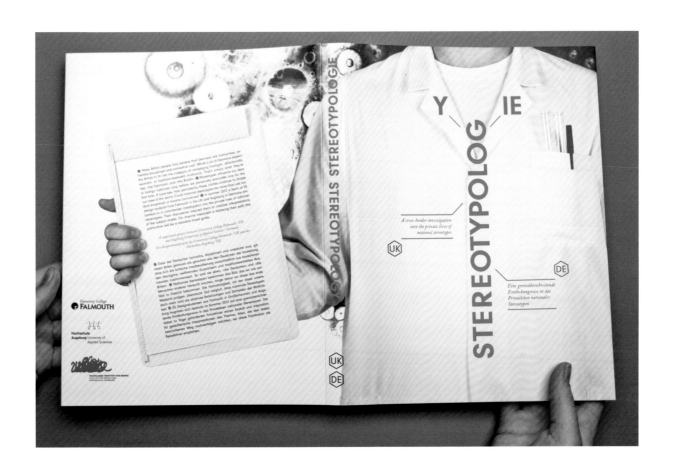

STUDENT PROJECT Design Nadine Baur, Blandine Beer, Christina Beresik, Vivian Breithardt, Henry Brown, Bianca Bunsas, James Burbidge, Hannah Cottrell, Jed Dean, Josie Evans, Jessica Fink, Bradley Fletcher, Benedikt Frommer, Andrew Gabb, Henrike Großer, Owen Harvey, Ashley Kinnard, Alexander Kohler, Saul Logan, Michael Lieu, Michael Peacock, Michael Phillips, Rose Priddy, Yvonne Sauter, Helene Schönfeld, Frauke Schwenk, Daniela Stölzle, James Sutton, Kirsty Tavendale, Sara Thurner, Annkatrin Vierrether, Jessica Webb, Stefani Wiatowski, Nicole Wiedemann, and Magdalena Winkler, Augsburg, Germany, and Falmouth, England **Senior Lecturer** Ashley Rudolph, Falmouth, England **Professor** Stefan Bufler **Schools** Hochschule Augsburg and Falmouth University **Principal Type** Adobe Caslon and Neuzeit Grotesk T **Dimensions** 8.3 x 10.9 in. (21 x 27.7 cm)

National stereotypes persistently shape our view of the world. Are they more than just bizarre caricatures? To shed some light on this subject, a team of thirty-five German and UK design students embarked on a cross-border investigation into the "private lives of national stereotypes." Contrary to what might be expected, the students looked for evidence of German stereotypes in England and English stereotypes in Germany, thus subverting the stereotype's function as an instrument of definition and demarcation. They then responded to their findings with a range of design pieces and documented the project in a 256-page "lab report."

BOOK JACKETS **Design** Geray Gencer, Istanbul **Client** Egmont Publishing—Istanbul **Principal Type** Custom
Dimensions 5.3 x 7.6 in. (13.5 x 19.5 cm)
These covers are designed for literary products of distinguished writers from different countries.

INVITATION **Design** Goretti Kao and André Mora, Seattle **Principal Type** Harriet and Pitch
Dimensions 11.4 x 15 in. (28.9 x 38 cm)

As full-time print designers making magazines and books, we wanted our wedding invitation to be undeniably paper and to have an editorial feel. Once we chose the format, we let the typography drive the design. It was a deliberate decision to use typefaces released in 2012, and the Harriet series perfectly balanced the classic and modern aspects of our wedding. Newsprint was a way for us to show our appreciation for utility and avoid preciousness. The sixteen large pages gave us ample room to invite guests to different events, share our history, and provide travel information, like a map.

TELEVISION TITLE SEQUENCE **Design Direction** Andrew Popplestone, London **Creative Direction** Nic Benns
2D Animation Alisdair Willson **Studio** MOMOCO **Client** BBC, London **Principal Type** ITC Futura
The ambition was to create a title sequence that sets the stage and period. It's inspired by the motion of a Zoetrope,
and the strobic nature is explored to create transitions. The missing letters make up the word "lady." We follow a train
that's almost abstracted, making out its form only from the geometry of windows and moonlit contours.

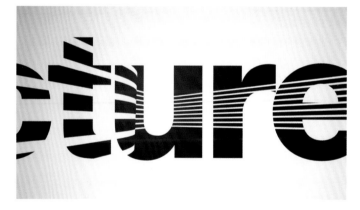

TELEVISION SHOW **Design** Ryan Moore and Dylan Mulvaney, New York **Creative Direction** Ryan Moore **Executive Creative Direction** Greg Hahn **Animation** Carl Burton, Bryan Cobonpue, Wes Ebelhar, Daniel Garcia, Jack Myers, Irene Park, and Gary Tam **Producer** Angela Foster **Music and Composing** Echolab, Dublin **Sound Design** Echolab **Production Company** Gretel **Client** VH1 **Principal Type** Helvetica Neue LT Pro and Trade Gothic Bold Condensed 20

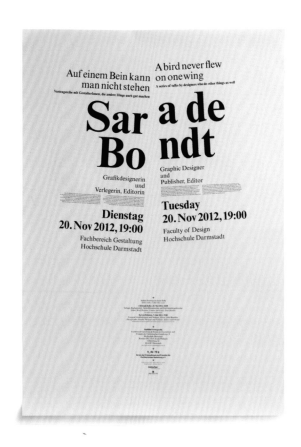

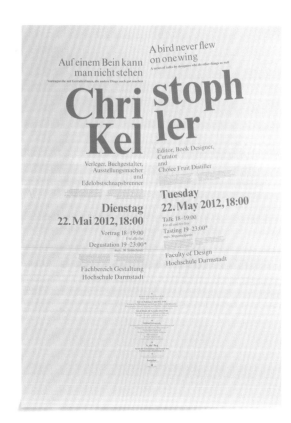

POSTERS Design Billy Kiosoglou and Frank Philippin, London and Darmstadt, Germany **Design Firm** Brighten the Corners **Client** Hochschule Darmstadt, Faculty of Design **Principal Type** Times New Roman (Regular, Regular Italic and Bold) **Dimensions** 23.4 x 33.1 in. (59.4 x 84.1 cm)

This is a poster for a series of talks at Hochschule Darmstadt, Faculty of Design, by graphic designers who also have a second practice. The poster plays with the English saying "A bird never flew on one wing" and its German equivalent, "One cannot stand on one foot."

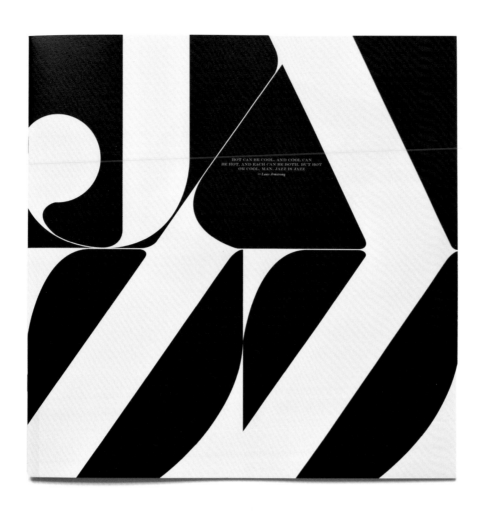

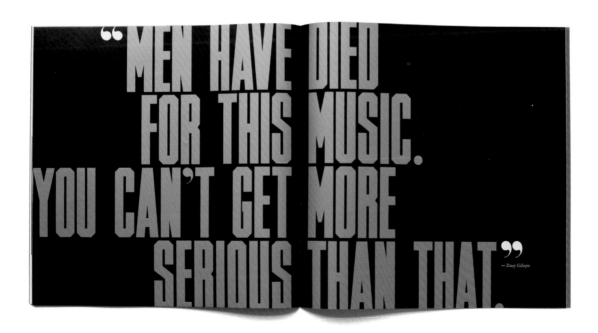

BROCHURE **Design** Matt Willey, London **Photography** William Ellis and Bob Willoughby **Client** Jazz FM
Principal Type Engravers MT, Garamond Premier Pro, and Timmons **Dimensions** 12.4 x 12.4 in. (31.5 x 31.5 cm)

CATALOG Design Joseph Johnson, Melbourne **Client** Centre for Contemporary Photography
Principal Type Plantin Std and custom **Dimensions** 10.2 x 14.2 in. (26 x 36 cm)
Newsprint catalog for the *CCP Declares: On the Nature of Things* exhibition, held concurrently across two venues. The design featured two covers, one devoted to the Centre for Contemporary Photography and the other to the Melbourne Art Fair. This approach allowed each location to have its own cover for display and section for content while remaining bound in one publication.

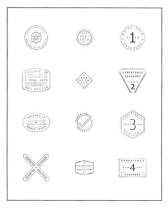

BOOKS **Design** Alex Egner, Denton, Texas **Studio** eggnerd **Client** University of North Texas–Denton
Principal Type Consolas, Courier, Georgia, and Tahoma **Dimensions** 4.5 x 7 in. (11.4 x 17.8 cm)
The UNT Communication Design program generated a list of life experiences that students should have in addition to normal-in-class studies. I formatted this list into a series of four passport books, one for each year of the degree program. Students can work through the list—visiting museums, viewing films, listening to the news, etc. and collect a series of twelve passport stamps along the way. The experience passports were distributed to students simply as black-and-white, print-ready PDFs. Students could then select a paper stock of their choice and customize the printing and binding.

BOOK Design Zofia Oslislo, Katowice, Poland **Curator** Ewa Satalecka **Client** Academy of Fine Arts, Katowice, Poland
Principal Type Scala Fraktur Medium and Scala Sans Pro **Dimensions** 5.9 x 8.7 in. (15 x 22 cm)
This publication serves to document the "Ala has a pen" workshop on calligraphy-based typeface design. It contains the
workshop teachers' essays, twenty typefaces designed by the participants, and some examples of their calligraphy.
Designed as a small booklet printed in two colors (which, combined, create a third color), the idea was both very
economical and added a certain flavor to the design. The grid that provides a structure for the layout is inspired by
the specific environment in which a typeface designer works (on paper or screen).

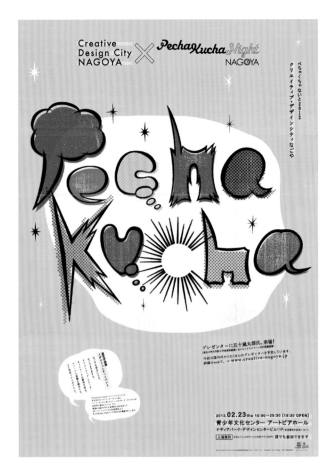

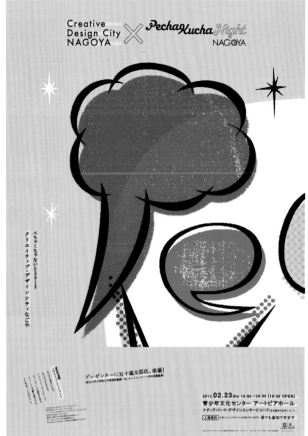

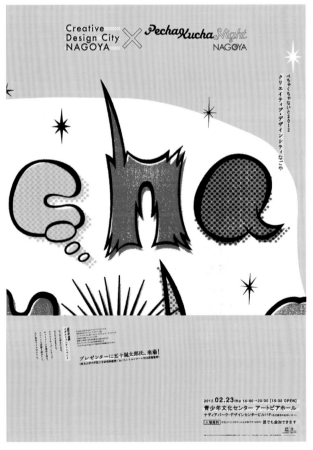

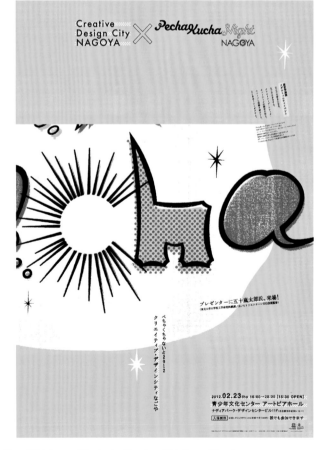

POSTERS Design Hidekazu Hirai, Nagoya, Japan **Art Direction** Hidekazu Hirai, **Lettering** Hidekazu Hirai
Design Firm Peace Graphics **Client** Creative Design City **Principal Type** Handlettering
Dimensions 28.7 x 40.6 in. (72.8 x 103 cm)
The first PechaKucha Night was held in Tokyo in February 2003 as an event for young designers to meet, network, and
show their work in public. This poster announces PechaKucha Night in Nagoya City. PechaKucha is Japanese and means
"a chat." I created the alphabet in a comic-book style.

▲ Typography, main structure ▲ Debris collected from popular logos to create patterns

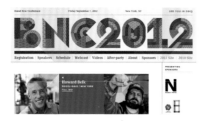

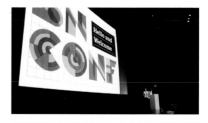

▲ Typography, with patterns ▲ Details

▲ Website ▲ Marquee ▲ Stage graphics

▲ Details

CORPORATE IDENTITY **Design** Armin Vit, Austin **Design Firm** UnderConsideration
Principal Type FF Meta Serif and custom geometric letterforms **Dimensions** Various
There were three design trends I wanted to explore (and explode): geometric letterforms, heavy patterning, and color overlays. The exploration somehow also had to be relevant to the topic of identity and branding. The letterforms were pure fun (and hell) to create as they had a very strict internal grid that allowed for many patterns within it. As if that wasn't enough, I put patterns of pieces of popular logos within the pieces of the letterforms, creating a quilt-like effect. Between the letterforms and the logo "debris" patterns, we had a lot of visual elements to play with for the identity.

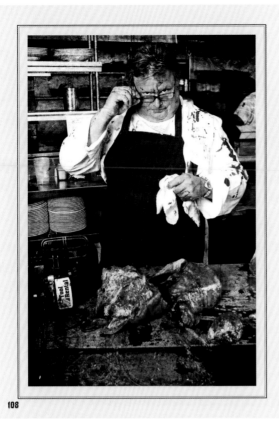
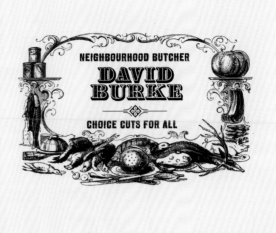

David Burke loves meat. Most chefs with steakhouses can say the same. What distinguishes Chef Burke from the herd of carnivorous creators is how MUCH he loves meat. Most chefs are smug in having bought the best Black Angus cuts with the perfect marbling at the market to serve to their patrons. Not Chef Burke. He staked out the best farm for the best cattle responsible for those perfect steaks.

"The animals were treated humanely. The bulls weren't sitting around in the hot sun all day. They were being hosed to cool off. They were listening to music. 'Stairway to Heaven,'" Chef Burke chuckles in his broad New Jersey accent. We are sitting at a gleaming wood table in the subterranean David Burke Kitchen in The James Hotel, his newest restaurant in Soho, New York. A gleaming gold duck press and mysterious glass globes containing giant shrimp

heads floating in tomato/ vegetable juice make for an atmosphere that is equal parts Willy Wonka's Chocolate Factory and New York's barn dance. Burke is enthusiastically telling us about his passion for ensuring that the ingredients used in his kitchen meet his

rigorous standards.

Creekstone Farms in Campbellsburg, Kentucky, prided itself on raising cattle naturally without the use of antibiotics or growth hormones in their purely vegetarian feed. They were the first to build a mad cow testing lab in an American slaughterhouse and actually took the US Department of Agriculture to court over the USDA's refusal to allow every animal to be individually tested. Their processing plant was designed by none other than Temple Grandin, winner of the "Proggy" award, given in 2004 by PETA to the best visionary. Her designs are based on the premise that the environment should cause the least amount of stress for the animals. Alarmed animals will release stress hormones and fluctuations in lactic acid and glycogen in muscles that can greatly reduce the quality of the meat, so great care is taken at

every stage of every animal's life to ensure a healthy and happy life. For a chef who sets an unprecedentedly high bar for himself, the search for perfection begins at the source: Burke is the first American chef to own his own bull. Prime 207L, eponymous to Burke's steakhouses in Connecticut and Chicago, is a 1500 pound hunk of beefy perfection that has sired all the animals behind the chef's succulent offerings. The meat is dry-aged onsite in a facility with walls tiled with Himalayan salt to add a subtle depth and texture to the finished cuts. He is a good-natured stickler for not taking shortcuts.

"I've always been a good butcher. It's a lost art. We cut all of our own stuff. We buy the whole animal, the whole fish and cut it ourselves. We use everything; the whole thing. We make blood sausage, our own bacon."

The farm-to-table approach is a passion for Burke who meticulously sources all his ingredients. Fishtail, his New York sustainable seafood restaurant, promises catches that are ethically raised. His company even owns its own fishing boat. The vegetables and fruits he uses are organic and

pesticide free. He has decorated his New York restaurant Kitchen with giant posters featuring the farmers he buys from proudly displaying their harvests.

His philosophy of developing a strong base from which to build extends from his own personal journey. He started as a teenage dishwasher and worked his way up. He cut his chops at the Culinary Institute of America, and then traveled to France where he trained with notable chefs such as Pierre Troisgros, Georges Blanc

and Gaston Lenôtre. By age 26 he became the first to win France's Meilleurs Ouvriers de France Diplome d'Honneur for unparalleled skill and creativity in American cuisine. Then he won Japan's Nippon Award of Excellence, another honour rarely given to young American chefs. A plethora of awards followed, stepping stones on Burke's rise to excellence. In

May 2009, Burke was inducted into the "Who's Who of Food & Beverage in America" by the James Beard Foundation. In the same month, he also won the distinctive Menu Masters award from Nation's Restaurant News as one of the nation's most celebrated innovators. He appeared twice as a Food Network's Iron Chef Challenger.

Gaining titular prestige for the nuts and bolts of technique and classical mastery is the springboard from which the wildly creative chef really soars. The words whimsical and playful frequently pepper reviews of Burke's style, referring varyingly to platings, menus, personality and decor. Those words are both accurate and deceptive. They don't reveal the dense structure of meat and bone that supports the whimsical flourishes. Rabbits and Mother Goose eggs cavort through his landscapes, but the whole is more Ray Bradbury than it is Alice in Wonderland; a joyful odyssey through quaint Americana that, when plated side by side with luscious foreign fare, is exalted to prove to the diner how astounding, how magical home is.

David Burke is a staunch advocate for local bounty in each and every detail on his premises. All of his restaurants are tastefully appointed with clean design lines to prominently feature work by local artists that range from glass sculptures by David

with whimsy and playfulness. The affable mastermind has a staff roster of over five hundred that bring the fare from convivial kitchen to salivating table. Burke himself is often found personally

Chihuly to fish art by J. Vincent Scarpace to quirky Jack-in-the-Boxes that must have been amassed from multiple visits to the master handcrafters' website Etsy. Folk art shares space with a Warhol piece from Burke's personal collection with nary a hint of pretentious kitschiness. Burke's avuncular magnanimity invites you to celebrate it all.

The celebration reaches its zenith in the presentation of the food. It is served in jam jars (chicken liver pâté with dates and pistachios with thin toasted crostini); on Ferris Wheel-like contraptions (Drunken Doughnuts that come with three mini squeeze bottles containing liqueurs); on slabs of Himalayan salt to impart subtle flavor, in tins (Monkey Bread baked and served in a tin with

a pail of frosting on the side, complete with beaters to lick – when you are done nibbling, close tin and take home to savor later) or on beds of cinnamon sticks, with many, many variations in between. Patrons come back again and again for his Pretzel-crusted Crab Cakes, Tuna Tartare and Cheesecake Lollipop Trees. Angry Lobster looks like a crustacean ode to Edward Scissorhand's bladed digits. His Salmon Pastrami was such a groundbreaker that there is officially a trademark sign beside it. It is easy to see why David Burke is synonymous

checking on diners, suggesting selections and carrying on lively conversations with selected guests at his large harvest chef's table. He is a welcoming host and takes great care to extend his warmth to all who cross his path. The consummate gracious host, he takes pride in immaculately ensuring customer

comfort: In the cold winters there is a limo parked outside featuring a bartender and a fully stocked bar, it is there solely for the comfort of those stepping out for a quick cigarette between courses.

The restaurant world changes direction rapidly and frequently, as the consumer public is constantly seeking the new flavor of the week. In order to stay viable, restaurants have to stay constantly innovative. It is quite the juggling act to keep seven of them as fresh and current as Burke has. Keeping his fingers in many pies ensures that the David Burke brand never grows stale. Books? He wrote two of them. Auxiliary product lines? He has several. His David Burke Gourmet Pops make it possible for everyone to have his delicious cheesecake or salmon cream cheese lollipops in their home freezers. His line of David Burke Flavour Sprays made it possible to spritz foods with taste explosions both sweet and savory without having to count calories or grams. He developed Flavor-Transfer Spice Sheets so that you can wrap the meat of your choice in one and transfer his spice blends into it. It does the work, home chef gets the credit. In conjunction with Samuel Adams Brewing, he released a Beef Heart-infused Beer and a BBQ Peach beer for summer enjoyment.

Unlike other chefs who grip their secret recipes close to their chests, David Burke seems almost eager to share his expertise. He regularly posts recipes to his restaurant best-sellers so people can make them at home. He can afford

to. The food is good but the experience is what keeps people coming back. He maintains an online presence by regularly posting on his website and on his facebook page. He recently shared a healthier version of his famous crab cakes with his legion of admirers. He is constantly engaged with the community at large. Saladworks gave $5,000 to a charity of Burke's choice in exchange for his developing a salad for them. He created the Asparagusto salad for them and donated the money to Table to Table, a community-based program that collects prepared and perishable food that would otherwise be wasted and delivers it free of charge to homeless shelters, drug-rehab centers and other places in need in New Jersey. He

His font of creative explosions seems to be bottomless. When he ponders the question of what is next for David Burke, he goes off into an unexpected channel: "I would like to get into the hotel business. Maybe five years from now, I'll open a little boutique hotel and see how that goes."

For now he is content to focus

paired up with Smartbox to give Children's Aid Society families a table for two dining experience at Fishtail on Mother's Day. Each mother and child duo was presented with a Smartcard. They enjoyed an appetizer, a gourmet entree and a dessert, and simply presented the card to the server at the end of their meal. Clearly the Chef With a Heart is astute and has great business acumen behind his very real generosity.

on perfecting his restaurateur skills. He is happy designing new ways to present exciting food menus that showcase Chef David Burke doing what Chef Burke does best. When asked what his personal favorite cuisine is, it comes as no surprise that his response is immediately "Chinese!" There is a slight hesitation followed by a soft "Peking Chinese." Peking cuisine gained prominence more than 5,000 years ago when chefs from every corner would compete for the emperor's favor by bringing to his court their finest culinary creations. Only the best of the

best would be allowed to stay to set up kitchens in the city now called Beijing. Burke's own lobster dumplings pay gracious homage to this legacy.

In parting, Burke is presented with the AS IF question: What would be his perfect meal for his perfect guests, given no limits or constraints? "I would like to serve my grandparents, whom I never met. It would be a ten-course meal; one for each of the decades they would have lived if they were still alive. Country style homemade bread and some hearty soups. Then I would give them something from other parts of the world (they were from Ireland). I would gear it up and polish it up, show of a little with some sea urchin caviar. I would carve something family style at the table. I would have something fun and interactive. Cheesecake to top it all off. And I would pair it off with beer, because I imagine they were beer drinkers, whiskey and wine."

His grandparents would surely have been as pleased as a long-gone Chinese emperor.

MAGAZINE SPREAD **Design** Hisa Ide and Toshiaki Ide, New York **Design Direction** Hisa Ide **Art Direction** Kumiko Ide **Creative Direction** Toshiaki Ide **Studio** IF Studio **Client** AS IF Magazine **Principal Type** Archive Garfield, Archive Gothic Ornate, and Hoefler Text **Dimensions** 23.5 x 16.5 in. (60 x 41.8 cm)
Intended to reflect the meticulous care that David Burke takes to cut each slab of meat, the design speaks of an "old-school butcher" with hand-selected classic type and etchings. The sketches themselves invoke nostalgia and sentimental yearning. The design is intended to suggest the timeless simplicity of the days when meats were hand-cut by the butcher you trusted.

The Hackers of Damascus

The Internet was a powerful weapon for the rebels fighting to topple Bashar al-Assad—until their enemies turned it against them

By Stephan Faris
Photo illustrations by Joe Magee

Taymour Karim didn't crack under interrogation. His Syrian captors beat him with their fists, with their boots, with sticks, with chains, with the butts of their Kalashnikovs. They hit him so hard they broke two of his teeth and three of his ribs. They threatened to keep torturing him until he died. "I believed I would never see the sun again," he recalls. But Karim, a 31-year-old doctor who had spent the previous months protesting against the government in Damascus, refused to give up the names of his friends.

It didn't matter. His computer had already told all. "They knew everything about me," he says. "The people I talked to, the plans, the dates, the stories of other people, every movement, every word I said through Skype. They even knew the password of my Skype account." At one point during the interrogation, Karim was presented with a stack of more than 1,000 pages of printouts, data from his Skype chats and files his torturers had downloaded remotely using a malicious computer program to penetrate his hard drive. "My computer was arrested before me," he says.

Much has been written about the rebellion in Syria: the protests, the massacres, the car bombs, the house-to-house fighting. Tens of thousands have been killed since the war began in early 2011. But the struggle for the future of the country has also unfolded in another arena—on a battleground of Facebook pages and YouTube accounts, of hacks and counterhacks. Just as rival armies vie for air superiority, the two sides in the Syrian civil war have spent much of the last year and a half locked in a struggle to dominate the Internet. Pro-government hackers have penetrated opposition websites and broken into the computers of Reuters and Al Jazeera to spread disinformation. On the other side, the hacktivist group Anonymous has infiltrated at least 12 Syrian government websites, including that of the Ministry of Defense, and released millions of stolen e-mails.

The Syrian conflict illustrates the extent to which the very tools that rebels in the Middle East have employed to organize and sustain their movements are now being used against them. It provides a glimpse of the future of warfare, in which computer viruses and hacking techniques can be as critical to weakening the enemy as bombs and bullets. Over the past three months, I made contact with and interviewed by phone and e-mail participants on both sides of the Syrian cyberwar. Their stories shed light on a largely hidden aspect of a conflict with no end in sight—and show how the Internet has become a weapon of war.

The cyberwar in Syria began with a feint. On Feb. 8, 2011, just as the Arab Spring was reaching a crescendo, the government in Damascus suddenly reversed a long-standing ban on websites such as Facebook, Twitter, YouTube, and the Arabic version of Wikipedia. It was an odd move for a regime known

for heavy-handed censorship; before the uprising, police regularly arrested bloggers and raided Internet cafes. And it came at an odd time. Less than a month earlier demonstrators in Tunisia, organizing themselves using social networking services, forced their president to flee the country after 23 years in office. Protesters in Egypt used the same tools to stage protests that ultimately led to the end of Hosni Mubarak's 30-year rule. The outgoing regimes in both countries deployed riot police and thugs and tried desperately to block the websites and accounts affiliated with the revolutionaries. For a time, Egypt turned off the Internet altogether.

Syria, however, seemed to be taking the opposite tack. Just as protesters were casting about for the means with which to organize and broadcast their messages, the government appeared to be handing them the keys.

Dlshad Othman, a 25-year-old computer technician in Damascus, immediately grew suspicious of the regime's motives. Young, Kurdish, and recently finished with his mandatory military service, Othman opposed President Bashar al-Assad. Working for an Internet service provider, he knew that Syria—like many other countries, including China, Iran, Saudi Arabia, and Bahrain—controlled its citizens' access to the Web. The same technology the government used to censor websites allowed it to monitor Internet traffic and intercept communications. Popular services such as Facebook, Skype, Google Maps, and YouTube gave Syria's revolutionaries capabilities that until a couple of decades ago would have been available only to the world's most sophisticated militaries.

But as long as Damascus controlled the Internet, they'd be using these tools under the eye of the government.

Shortly after the Syrian revolution began in March 2011, Othman's political views cost him his job. He decided to dedicate himself full time to the opposition, joining the Syrian Center for Media and Freedom of Expression in Damascus to document violence against journalists in the country. He also began teaching his fellow activists ways to stay safe online. Othman instructed

> ### "They knew everything about me.... The plans, the dates... every movement. My computer was arrested before me"

them how to encrypt e-mails and encouraged them to use tools like Tor software, which enables anonymous Web browsing by rerouting traffic through a series of distant servers. When Tor turned out to be too slow to live-stream protests or scenes of government attacks against civilians, Othman began purchasing accounts on virtual private networks (VPNs) and sharing them with his friends and contacts. A VPN is basically a tunnel inside the public Internet that allows users to communicate in a secure fashion. For a monthly fee, you can buy access to servers that create encrypted paths between computers; the VPN also disguises the identities and locations of your machine and others on the network. Spies can't read e-mails sent via VPN, and they have a hard time figuring out where they came from.

Othman's efforts worked at first, but very

quickly Damascus blocked off-the-shelf VPNs and upgraded its Internet filters in ways that made the VPNs inoperative. By the summer of 2011, Othman had become frustrated with the Western VPN providers, which he felt were too slow to adapt to the government's crackdowns. He bought space on outside servers, set up VPNs of his own, and began actively managing them to make sure safe connections remained available.

Othman was still training and equipping activists in October 2011 when he made a nearly fatal mistake. He gave an on-camera interview to a British journalist who was later arrested with the footage on his laptop. Warned by a friend through a Facebook message, Othman turned off his phone, removed its SIM card—a precaution to avoid being tracked—and hid in a friend's Damascus apartment.

In Syria, Scott-Railton recognized that the task would be different. Once Assad's government lifted restrictions on the Internet, activists were having little trouble getting their voices heard; graphic videos alleging government atrocities were lighting up Facebook and YouTube. The challenge would be keeping them safe. "If we're going to talk about how important the Internet has been in the Arab Spring, we need to think about how it also brings a whole new set of vulnerabilities," says Scott-Railton. "Otherwise, we're going to be much too optimistic about what can be done."

The first documented attack in the Syrian cyberwar took place in early May 2011, some two months after the start of the uprising. It was a clumsy one. Users who tried to access Facebook in Syria were presented with a fake security certificate that triggered a warning on most browsers. People who ignored it and logged in would be giving up their user name and password, and with them, their private messages and contacts.

In response, Scott-Railton began nurturing contacts in the Syrian opposition, people like Othman with wide networks of their own. "It wasn't that different from the strategy I had worked out in Libya: Figure out who was trustworthy and then slowly build up," he

poor communities in Senegal were adapting to climate change, had spent time in Egypt and had close friends there. When revolutionaries in Cairo occupied Tahrir Square, he set his studies aside. Working through his contacts in the country, he helped Egyptians evade Internet censors and get their message out to the world by calling protesters on the phone, interviewing them, and publishing their views on Twitter. Later, when the Arab Spring spread to Libya, he did the same, this time working with Libyans in the diaspora to broaden his reach.

and configure browsers to flag suspect sites as potential threats.

For Syrians, the system provided a quick, sure way to limit damage as attempts to break into accounts affiliated with the opposition became more sophisticated. For tech companies, it was an opportunity to address violations as they happened—though those violations have also exposed the vulnerabilities of some of the world's most popular social networking services.

Facebook, which in 2011 responded to hacking attempts in Tunisia by routing communications through an encrypted server and asking users to identify friends when anything, the company is doing in Syria. Contacted by *Bloomberg Businessweek*, a spokesperson provided a statement saying: "Security is a top priority for Facebook and we devote significant resources to helping people protect their accounts and information, wherever they live and whatever the circumstances. ... We will respond quickly to reports–whether from formal or informal channels–about worrying and problematic security threats from groups, organizations and, on occasion, from governments."

As the war intensified, the cyberattacks waged by progovernment Syrian hackers became more ambitious. In the weeks before his arrest in December 2011, Karim, the young doctor, had begun to suspect his hard drive had been compromised. His Internet bill–which in Syria varies according to the traffic being used–had more than quadrupled, though he still isn't sure exactly how his computer was infected. He suspects the malware may have been transmitted by a woman using the name Abeer who contacted him on Skype last autumn and sent him photos of herself. Another possibility is a man who sent Karim an Excel spreadsheet and said he could provide monetary support for the revolution.

In prison, Karim's captors mentioned both people. His interrogators knew about his high Internet bills as well: "The policeman told me, 'Do you remember when you were talking to your friend and you told him you had something wrong and paid a lot of money? At that time we were taking information from your laptop.'"

Before the Syrian revolution, Karim had never participated in politics. "I would just go to work and then go home," he says. But the Arab Spring awakened something inside him, and when demonstrators gathered for a second week of major demonstrations, Karim joined them. The first protest he attended was also the first in which the regime deployed the army to crush dissent, killing dozens of demonstrators across the country. Shortly afterward, Karim signed up to a man field hospitals, caring for wounded ➡

> ### Pro-regime hackers hid malware in a fake plan to help fighters in Aleppo and in Web pages claiming to show Syrian soldiers raping women

He never went home. A month and a half later, at the urging of activists who worried his arrest would compromise their entire network, he escaped across the border to Lebanon. "I had been a source of safety for my friends," he says. "I didn't want to become a source of danger."

The struggle for Syria has transcended borders. In early 2011, from his office at the University of California at Los Angeles, John Scott-Railton, a 29-year-old graduate student in Urban Planning, joined the revolutions in North Africa and the Middle East. Scott-Railton, working on a dissertation on how

says. In the meantime, he contacted security teams at major American technology companies whom he could alert when an attack was detected. Scott-Railton declined to name specific companies but confirmed he was in touch with security experts at some of the biggest brand names. In the past year and a half, progovernment hackers have successfully targeted Facebook pages, YouTube accounts, and logins on Hotmail, Yahoo!, Gmail, and Skype.

Scott-Railton's involvement in the Syrian cyberwar wasn't high-tech. Over several months, he set himself up as a bridge between two worlds, passing reports of hacking on to various companies who could investigate attacks on their users, take down bogus websites,

MAGAZINE SPREAD Assistant Creative Direction Tracy Ma, New York **Creative Direction** Richard Turley
Publication *Bloomberg Businessweek* **Principal Type** BW Haas Head **Dimensions** 15.75 x 10.5 in. (40 x 26.7 cm)

STUDENT PROJECT **Design** Katerina Trakakis and Svenja Wittmann, Bielefeld, Germany **Professor** Dirk Fütterer ●
School University of Applied Sciences, Bielefeld **Principal Type** Sabon Next LT **Dimensions** 28.7 x 38.4 in. (73 x 97.5 cm)
The poster series was designed for the 2012 Erstwerk book design award of the Institute for Book Design, which is
part of the University of Applied Sciences Bielefeld. For the promotion of the book design award, three iconic posters
were created to represent each category of the competition.

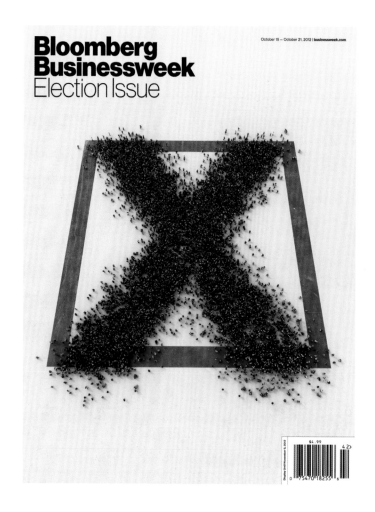

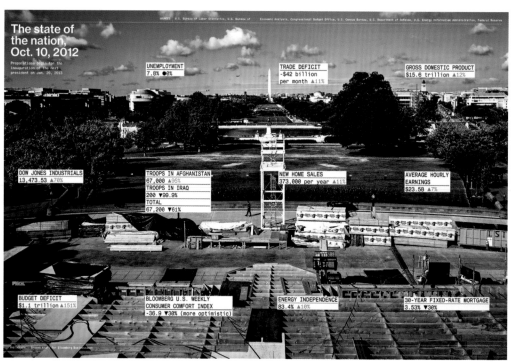

MAGAZINE Design Shawn Hasto, Chandra Illick, Maayan Pearl, and Lee Wilson, New York **Design Direction** Cynthia Hoffman
Art Direction Robert Vargas **Creative Direction** Richard Turley **Assistant Creative Direction** Tracy Ma
Graphics Evan Applegate and Christopher Nosenzo **Graphics Direction** Jennifer Daniel **Deputy Photo Editor** Emily Keegin
Director of Photography David Carthas **Photo Editors** Alis Atwel, Donna Cohen, Jamie Goldenberg, Diana Suryakusuma,
Jane Yeomans, and Meagan Ziegler-Haynes **Art Manager** Emily Anton **Publisher** *Bloomberg Businessweek*
Principal Type BW Haas Head, BW Haas Text, and BW Haas Mono **Dimensions** 10.5 x 7.9 in. (26.7 x 20.1 cm)

CATALOG **Design** Kristina Spoljar and Nedjeljko Spoljar, Zagreb, Croatia **Art Direction** Nedjeljko Spoljar
Creative Direction Nedjeljko Spoljar **Design Firm** Sensus Design Factory **Client** Kabinet grafike KG HAZU
Principal Type Akkurat, Adobe Minion Pro, and handlettering **Dimensions** 8.3 x 11.7 in. (21 x 29.7 cm)

CALENDAR **Design** Tobias Becker, Mannheim, Germany **Studio** Studio Tobias Becker **Client** Druckerei Schwoerer
Principal Type Various **Dimensions** 18.9 x 26.7 in. (48 x 68 cm)
This typographical calendar for 2013 offers one page per month and is based on the playful use of the graphic means of typography, color, and simple graphic elements. A new typeface was selected for every month of the year. Colors and combinations were chosen to match the respective season. This calendar was inspired by the work of Magma Brand Design.

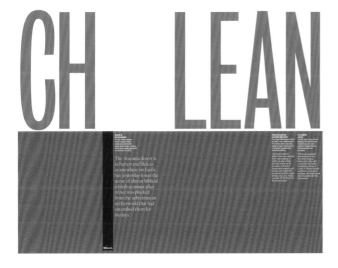

NEWSPAPER Art Direction Matt Curtis, London **Publication** *The Times* **Principal Type** Various
Dimensions 13.9 x 21.7 in. (35.4 x 55 cm)

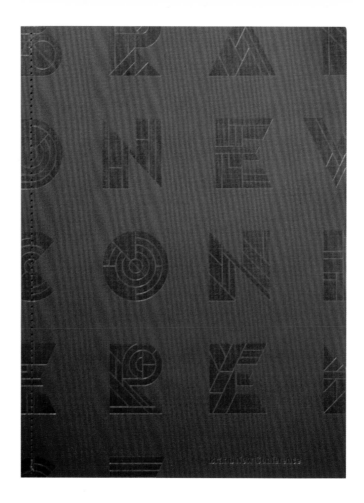

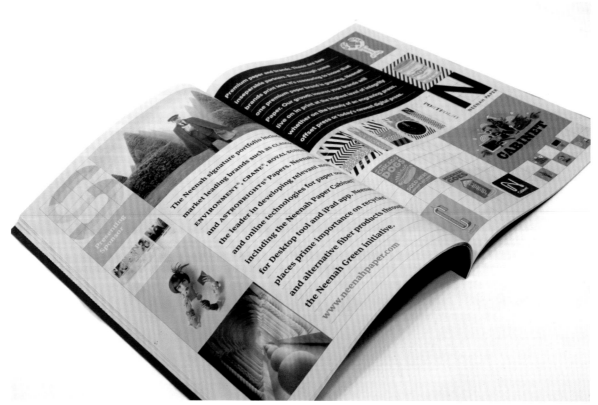

PROGRAM **Design** Armin Vit, Austin **Design Firm** UnderConsideration
Principal Type FF Meta Serif, Proxima Nova, and custom geometric letterforms **Dimensions** 11.4 x 15 in. (28.9 x 38.1 cm)
Instead of doing a typical conference program with speaker bios and their head shots and sponsor ads, we decided
to do an oversized publication that would showcase our speakers' work with heavily packed spreads, and even our
sponsors had to provide brand assets instead of ads. The program has a visible square grid on which everything falls
and aligns edge to edge.

CALENDAR **Design** Takahiro Sugawara, Tokyo **Art Direction** Katsumi Tamura **Agency** good morning inc.
Principal Type Town Original Font **Dimensions** 11.7 x 8.3 in. (29.7 x 21 cm)
Life with Design Quality designs have the power to modify space and transform the minds of its users. They offer
comfort of seeing, holding, and using. They are imbued with lightness and an element of surprise, enriching space. Our
original products are designed using the concept of "Life with Design." Town is a paper craft kit with parts that can be
freely assembled into a calendar. Put together buildings in different forms and enjoy creating your very own little town.

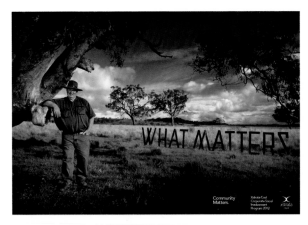

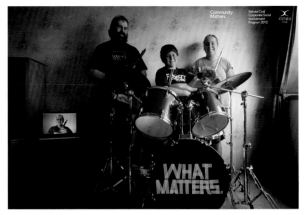

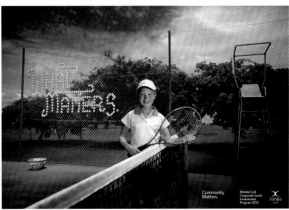

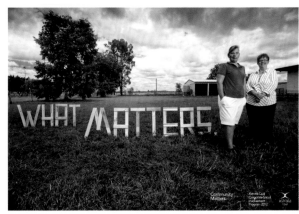

ADVERTISEMENT **Design** End of Work, Sydney **Client** Xstrata Coal Australia **Principal Type** Handlettering
Dimensions Various
The coal produced by Xstrata is used for generating electricity, industrial applications, and steel—and ultimately helps sustain or improve people's standard of living. This contribution matters deeply to Xstrata. End of Work's "What Matters" campaign communicated the impact of Xstrata's Corporate Social Involvement program by focusing on the individuals directly affected by it. Each person was photographed in context, alongside handmade typography created from relevant materials—from the fence palings of a farmer to the sporting equipment of an athlete.

CALENDAR Graphic Design Gloria Heik, San Francisco **Art Direction** Kit Hinrichs ● **Studio** Studio Hinrichs
Principal Type Various **Dimensions** 23 x 33 in. (58.4 x 83.8 cm)
Now in its twelfth year, the 2013 edition of the 365 Typography Calendar features twelve favorite typefaces chosen by several American members of Alliance Graphique Internationale: Ivan Chermayeff, Bart Crosby, Louise Fili, Tom Geismar, Carin Goldberg, Jennifer Morla, Eddie Opara, Stefan Sagmeister, Rick Valicenti, Michael Vanderbyl, Massimo Vignelli, and Kit Hinrichs. The calendar includes descriptions of the type and a biography of each AGI designer. All major holidays are noted on the calendar, along with the birthdays of the featured designers.

CALENDAR Design Kum-jun Park, Seoul **Art Direction** Kum-jun Park **Creative Direction** Kum-jun Park
Coordination Jin-young Hwang, Su-jin Jung, and So-hee Song **Illustration** Kum-jun Park **Production Manager** Jong-in Jung
Agency 601bisang **Principal Type** Univers LT **Dimensions** 17.7 x 26.4 in. (45 x 67 cm)
The concept of "Every path resembles the shape of our lives" captures the creative spirit of the 601bisang. Hangeul "□"
and the English phrase "A path is a way of life" are connected together and move along with Hangeul "□," expressing
a variety of human shapes that may be sometimes upside down or sideways.

STUDENT PROJECT **Design** Bryan Ku, Los Angeles **Instructor** Andrew Bryom
School California State University, Long Beach **Principal Type** Gill Sans Regular
This is an infographic documenting the final game of the 122nd Edition of the Wimbledon Championships
between tennis giants Rafael Nadal and Roger Federer.

STUDENT PROJECT Design Brian Biles, Laguna Beach, California **Instructor** Trudy Abadie-Mendia
School Savannah College of Art and Design, Savannah **Principal Type** Akkurat Mono Regular, Akkurat Pro Bold, and custom
Dimensions 24 in x 63 in. (61 x 160 cm)
"Signified Syntactics" explores the concept of experimentation within the typographic narrative. Using the Sol LeWitt quote, "You shouldn't be a prisoner of your own ideas," each letterform is reconstructed in an experimental way and seeks to challenge the audience's own ideas and preconceived notions about how typographic forms should look and operate. Version 2.0 additionally challenges the way that traditional meaning is constructed as the syntax of the words is scrambled and the quote must be deciphered manually. The process of creating the design was also an attempt to explore my own limits and self-imposed restrictions as a designer. The subordinate typographic information contained on each panel allows the viewer to chart the exact position of the letterform.

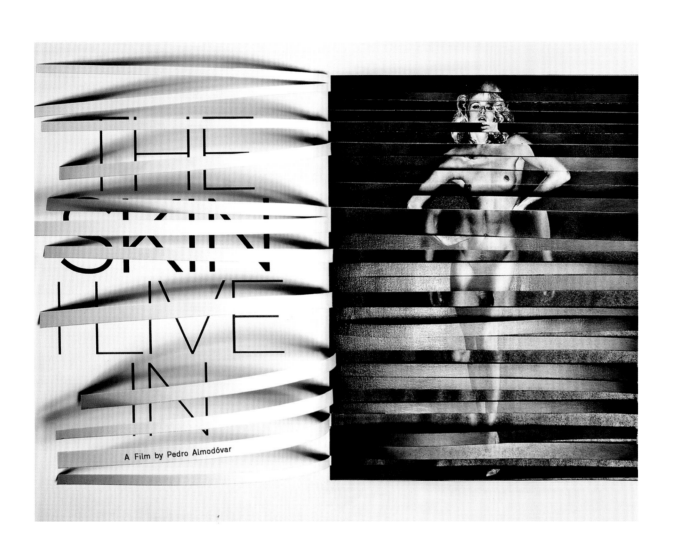

A Film by Pedro Almodóvar

STUDENT PROJECT **Design** Yue Chen ●, Brooklyn, New York **Instructor** Scott Menchin **School** Pratt Institute
Principal Type Gotham **Dimensions** 16 x 11 in. (40.6 x 27.9 cm)

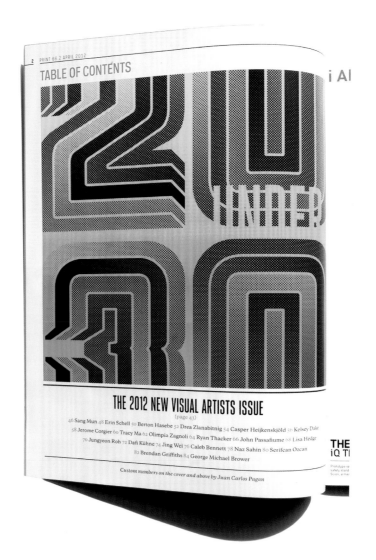

MAGAZINE Design Juan Carlos Pagan, New York **Art Direction** Ben King **Design Firm** Pagan and Sharp
Client *Print* **Principal Type** Custom **Dimensions** 9 x 11 in. (22.9 x 27.9 cm)
These custom numbers were designed for *Print's* 2012 New Visual Artist "20 Under 30" issue. Each number was designed out of five individual pieces, which act as windows. This allowed *Print* to showcase the work of all twenty winners on the cover. The numbers were also used throughout the magazine's interior.

STUDENT PROJECT **Design** Jamie Kim, La Jolla, California **Instructor** Stefan Sagmeister
School School of Visual Arts, New York **Principal Type** Custom

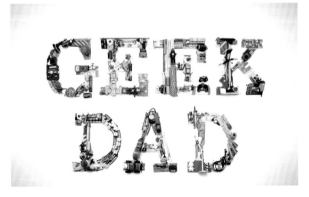

VIDEO OPENER **Design Direction** Leo Jung ●, San Francisco **Creative Direction** Brandon Kavulla
Photography Dan Forbes **Animation** Dan Forbes **Publication** *Wired* **Principal Type** Pitch Regular
We create the headline "Geek Dad" out of items mentioned in the *Wired* feature package. The items consist of experiments, projects, and games you can create at home with your children. For the tablet edition of the issue, we animated the headline by having all the items enter the frame and form the headline in a creative way.

MOTION—BUMPERS Design Patrick Leiber and Ramon Escola, Ulm, Germany, and Barcelona
Art Direction Ramon Escola **Actor** Patrick Leiber **3D and Animation** Roy Gerritsen and David Zaagsma, Amsterdam
Audio Design Sander Haakman **Video** Ramon Escola **Agency** Stupidshit **Client** OFFF Festival, Barcelona
Principal Type Various

MOVIE TITLES—END CREDITS **Design** Henry Hobson ●, Los Angeles **Creative Direction** Henry Hobson
Director Henry Hobson **Co-Director** Andrew Proctor **Producer** Lee Buckley
3D Modeling and Dynamics Carsten Becker and Stuart Robertson **3D** Eugene Guaran **3D Particles** Yorie Kumalasari
Additional Comp Ed Laag **Colorist** Greg Reese **Color Producer** LaRue Anderson **Typographic Animator** Justin Sucara
LA Executive Producer Stephen Venning **Studio** The Mill **Client** Universal Studios **Principal Type** Ravenna
To echo the character of Snow White, a feminine typeface with a hard edge and sharp lines juxtaposed with the
delicate curves. It was named Ravenna after one of the leading characters in the film.

WEBSITE **Design** Armin Vit, Austin **Design Firm** UnderConsideration **Principal Type** Avenir Next and Siseriff
To break away from the typical blog mold, we decided to take on a modern modular approach that would highlight each
of the projects we show on FPO. Because we focus on print projects, we wanted the grid to be very evident and strong
as well as have a sophisticated and detailed approach to the typography, just as one would in an annual report. The
condensed and thick serifs of Siseriff were a great foundation for the type to be readable and allow us to pack a lot
of information.

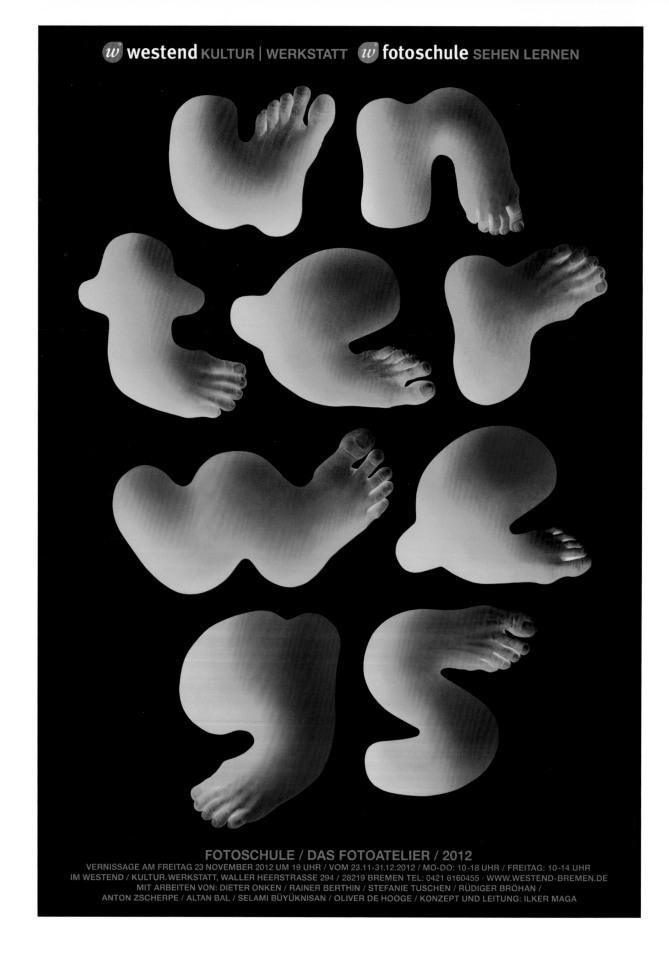

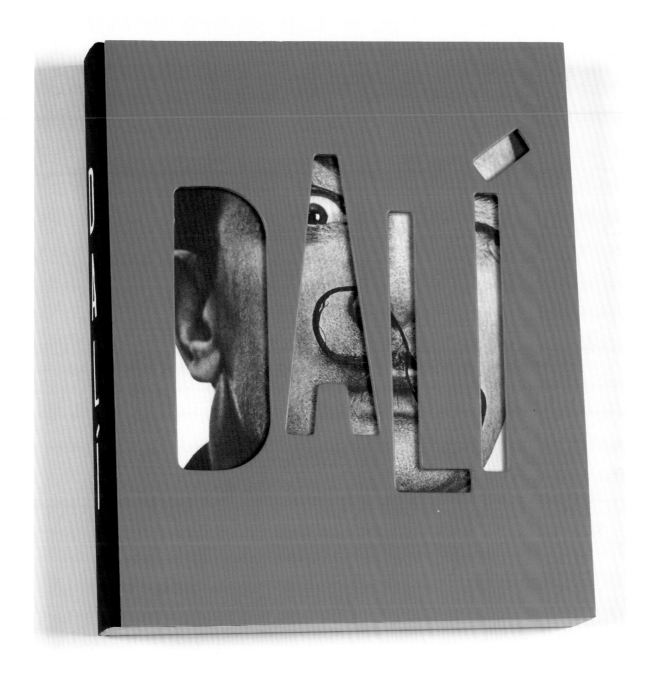

CATALOG COVER **Art Direction** Romain Hisquin, Paris **Photography** Philippe Halsman
Client Centre Pompidou, musée national d'art moderne **Principal Type** Garage Gothic
Dimensions 9.25 x 11 in. (23.5 x 28 cm)
The purpose of the Salvador Dalí exhibit at the Pompidou Center was to retrace the sixty years of this fabulous modern art creator's career. As an extravagant and controversial artist, Dalí has not only marked his time through his paintings and drawings and his input in the Surrealist movement, but also through his numerous performances. To make this catalog special, it was crucial for the cover to evoke the man's impertinence as well as the multi-disciplinarity of the artist. I chose this photography taken by Philippe Halsman for his book *Dalí's Mustache*, published in 1954.

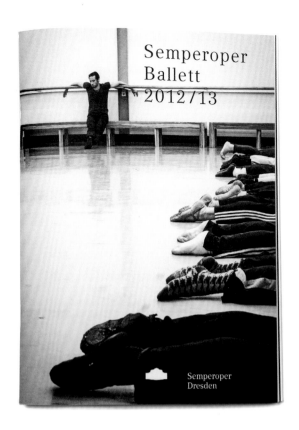

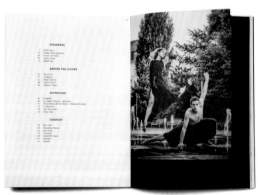

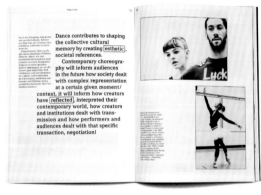

MAGAZINE **Design** Fons Hickmann ●, Susann Stefanizen, and Björn Wolf, Berlin **Studio** Fons Hickmann m23
Client Semperoper Opera Ballett **Principal Type** Compatil **Dimensions** 7.1 x 9.8 in. (18 x 25 cm)
The Semperoper Ballett under the direction of Aaron Watkins is internationally one of the most innovative. "You are your own border. Rise up and step over." is one of their mottos. For this season as well as the next, we are lucky enough to be able to work with the young photographer and dancer Ian Whalen. Together with him we have produced an exciting photo project that shows the dancers of the ballet in the urban scenery of Dresden. The large image brochures exist in parallel.

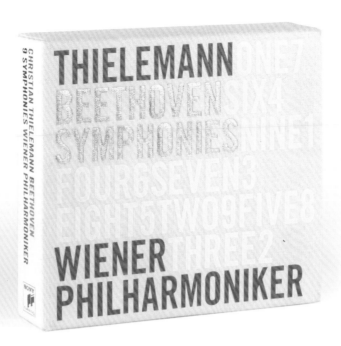

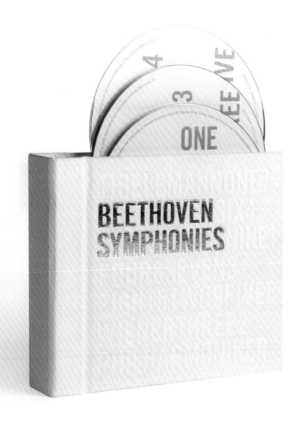

PACKAGING **Design** Fons Hickmann ● and Raul Kokott, Berlin **Studio** Fons Hickmann m23
Client Sony Classical International, Berlin **Principal Type** Trade Gothic **Dimensions** 6.1 x 5.2 in. (15.5 x 13.3 cm)

HEIMATKUNDE
Eine kosmopolitische Inventur
16.09.2011 – 29.01.2012
Jüdisches Museum Berlin
www.jmberlin.de/heimatkunde

POSTER **Design** Thomas Kronbichler, Berlin **Art Direction** Fons Hickmann ● and Björn Wolf **Studio** Fons Hickmann m23
Client Jewish Museum Berlin **Principal Type** Amerigo **Dimensions** 33.1 x 47.2 in. (84 x 120 cm)
Home is not where you live but where you are understood. Christian Morgenstern Hybrid intensities are created
through the fusion of seemingly contradictory objects. Through superficial dialectic, this provokes a confrontation
with stereotypes and aesthetics of today's cultures. The cultural background of the beholder plays an essential role
in decoding and evaluating what is seen. The poster series is an ironic play on the perceptions and expressions of the
definition of home. The typographical level merges with the visual and creates new meanings.

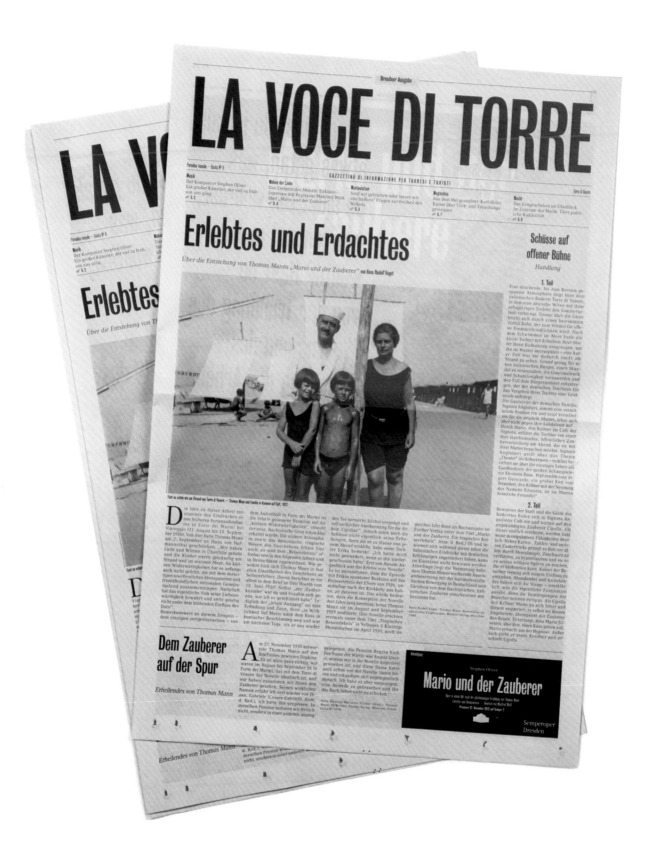

MAGAZINE **Design** Fons Hickmann ●, Susann Stefanizen, and Björn Wolf, Berlin **Studio** Fons Hickmann m23
Client Semper Opera Dresden **Principal Type** Bureau Grotesque **Dimensions** 7.1 x 9.8 in. (18 x 25 cm)

POSTERS **Design** Anne-Marie Clermont, Montréal **Creative Direction** Claude Auchu **Photography** Simon Duhamal **Strategic Planner** Sabrina Côté **Copywriter** Jean-François Perreault **Account Services** Julie Dubé, Ingrid Roussel, and Frédérique Perron-Thomas **Print Production** lg2fabrique **Agency** lg2boutique **Client** Théâtre du Quat'sous **Principal Type** Akkurat Mono and Archive **Dimensions** 48 x 72 in. (121.9 x 182.9 cm)

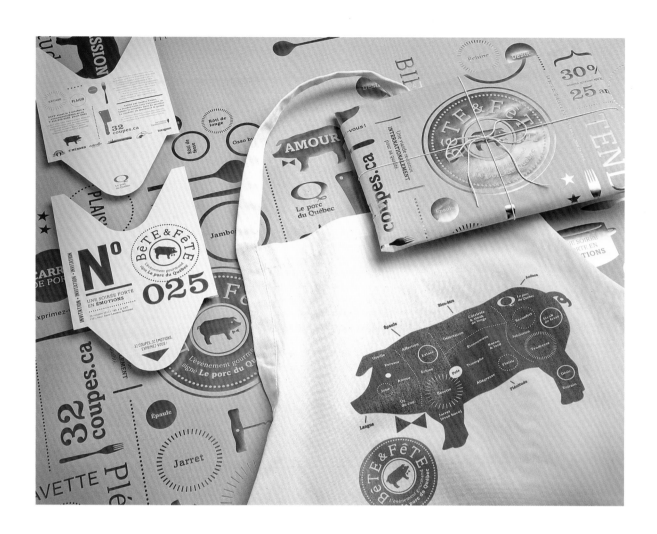

INVITATION Design Serge Côté and Sophie Valentine, Montréal **Creative Direction** Serge Côté **Print Production** Ig-2fabrique **Copywriter** François Sauvé **Account Services** Audrey Lefebvre **Agency** Ig2boutique
Client Julie Gélinas (Férédation des producteurs de porcs du Québec) **Principal Type** Amasis MT, Clarendon, and Flama **Dimensions** Various

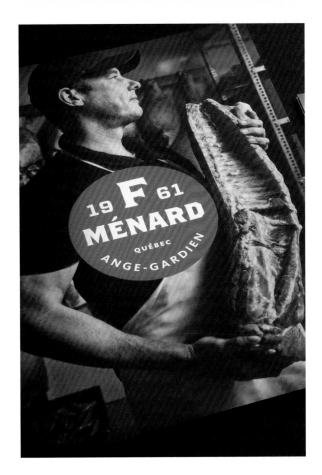

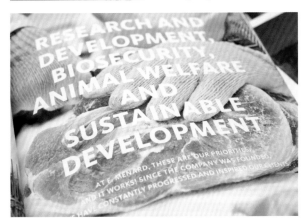

BROCHURE **Design** Serge Côté, and Andrée Rouette, Montréal **Creative Direction** Claude Auchu
Strategic Planner Pénélope Fournier **Photography** Martin Girard **Print Production** lg2fabrique
Copywriter Sophie Bordes **Account Services** Catherine Lanctot and Florence Morin-Laurin **Agency** lg2boutique
Client Luc Ménard **Principal Type** Brothers (modified), FF Kievit, and Vitesse **Dimensions** 8.25 x 11 in. (21 x 28 cm)

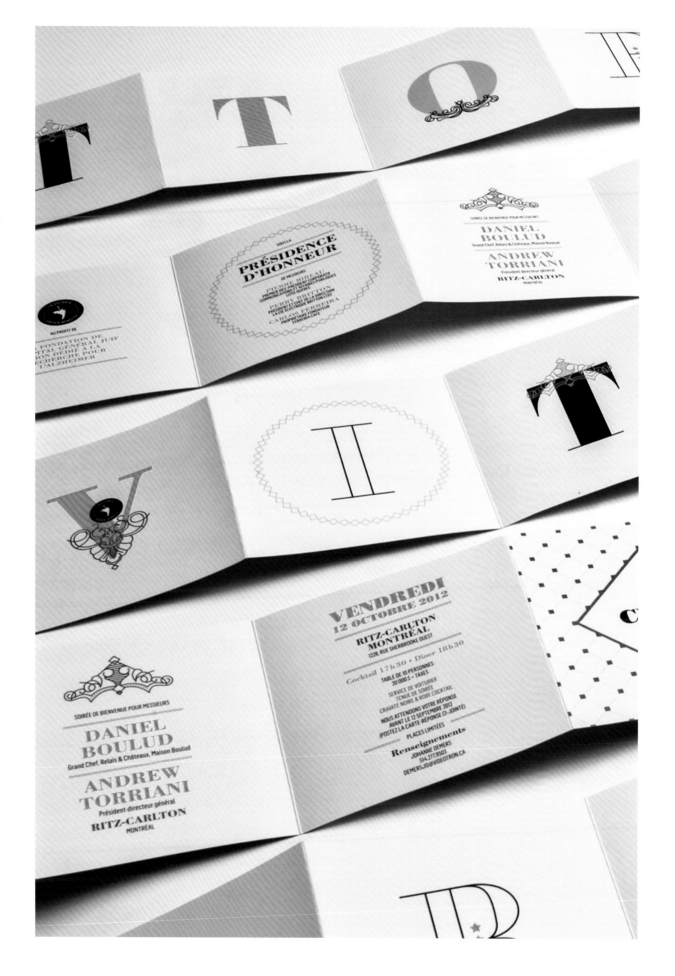

INVITATION **Design** Marie-Pier Gilbert, Cindy Goulet, and Maryse Verreault, Montréal **Creative Direction** Serge Côté
Photography Luc Robitaille **Account Services** Florence Morin-Laurin **Agency** lg2boutique **Client** Johanne Demers
Principal Type Bodoni, Firenze, Flama, and Perla **Dimensions** 4.7 x 4.7 in. (12 x 12 cm)

STUDENT PROJECT **Design** Pablo Delcán, New York **Instructors** Claudia de Almeida and Carin Goldberg
School School of Visual Arts New York **Principal Type** Handmade **Dimensions** 8.5 x 11 in. (21.6 x 27.9 cm)
My rediscovery of the original story of The *Three Little Pigs* surprised me in its carnivorous nature: Wolf eats
two pigs, third pig eats wolf. It seemed to me it would be interesting to tell the story of the brotherhood of these
pigs through the medium of their own meat. And along came this fifty-page book where the whole story is set in
vtedious, greasy, smelly, and hamish bacon.

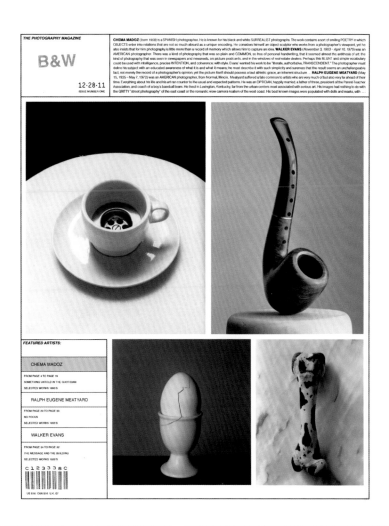

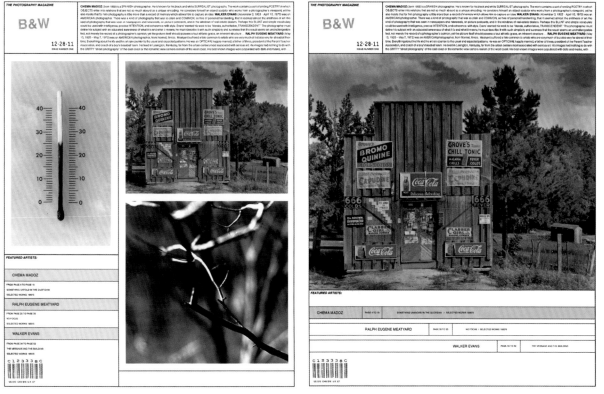

STUDENT PROJECT **Design** Pablo Delcán, New York **Instructors** Claudia de Almeida and Carin Goldberg
School School of Visual Arts, New York **Principal Type** Caslon and Helvetica **Dimensions** 10.5 x 13.3 in. (26.7 x 33.8 cm)
This spread belongs to the introduction of one of the photographers of the black-and-white magazine we designed. It
is high-contrast, vibrant, hard-to-read all-caps text highlighted with white horizontal bars. A response to the pages
followed with large, blurry photographs of the series "No-focus" by Ralph Eugene Meatyard.

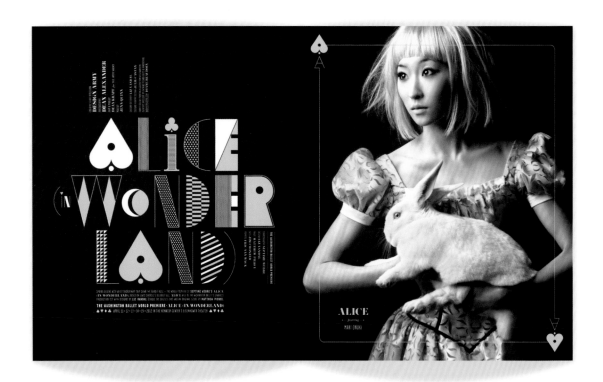

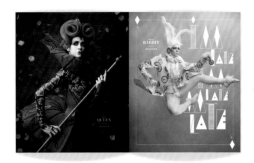

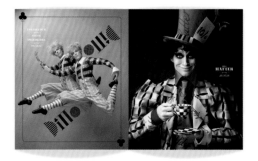

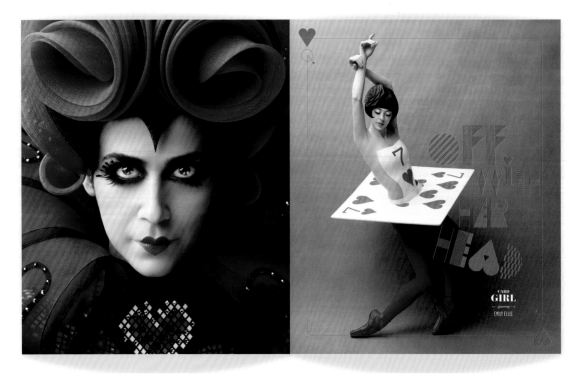

MAGAZINE SPREAD Design Mariela Hsu, Washington, DC **Art Direction** Pum Lefebure ● **Creative Direction** Jake Lefebure and Pum Lefebure **Photography** Dean Alexander **Design Firm** Design Army **Client** The Washington Ballet **Principal Type** Eloquent, Garage Gothic, Hoefler Text, and custom **Dimensions** 9 x 12 in. (22.9 x 30.5 cm)

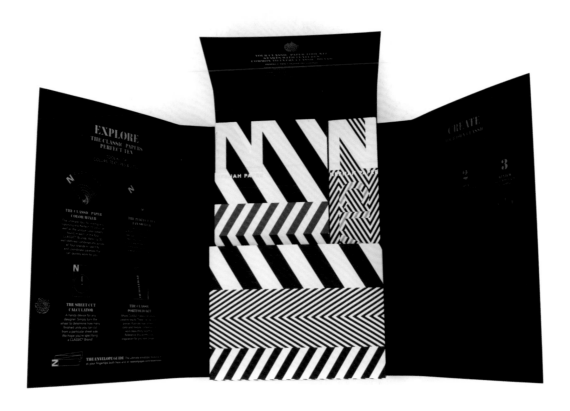

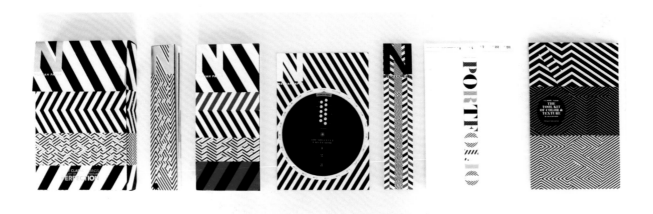

KIT Senior Art Direction Tom Wright, Alpharetta, Georgia **Senior Design** Sucha Becky and Mariela Hsu
Creative Direction Matt Chase, Jackie Lay, and Pum Lefebure ● **Writer** S.W. Smith **Design Firm** Design Army
Client Neenah Paper **Principal Type** Avenir, Eloquent, Magnola, and various custom **Dimensions** 6 x 9 in. (15 x 23 cm)

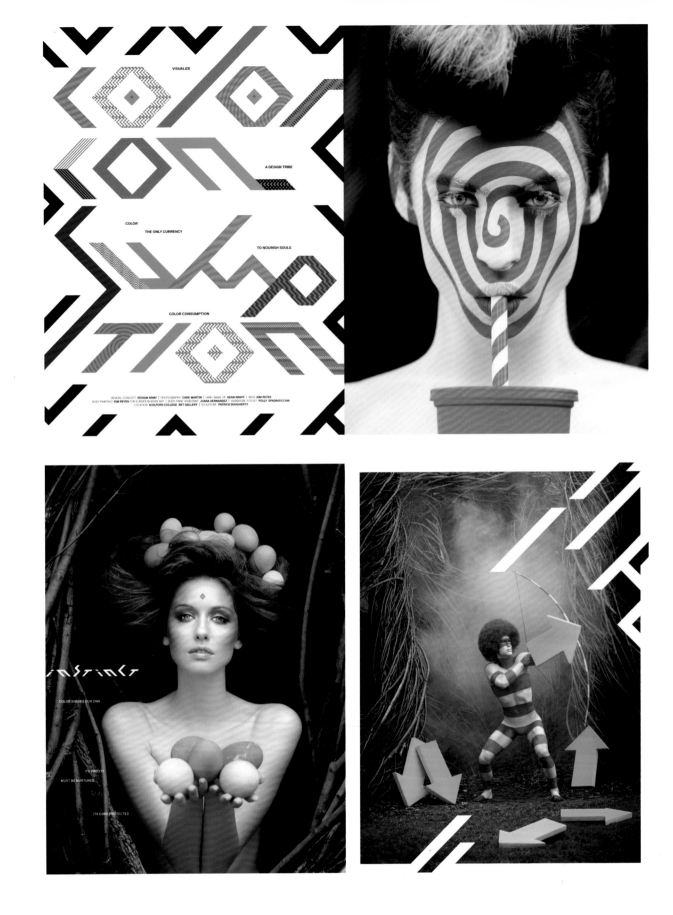

MAGAZINE SPREAD **Senior Design** Sucha Becky, Washington, DC **Art Direction** Pum Lefebure ●
Creative Direction Jake Lefebure and Pum Lefebure **Photography** Cade Martin **Design Firm** Design Army
Client Design Bureau **Principal Type** Custom **Dimensions** 9 x 12 in. (22.9 x 30.5 cm)

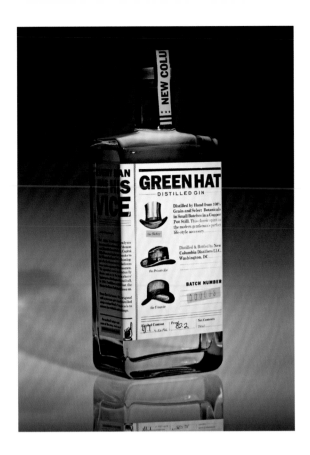

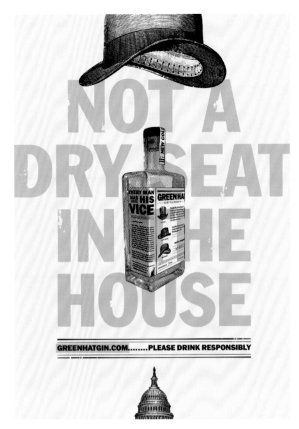

BRAND IDENTITY **Senior Design** Charles Calixto, Washington, DC **Art Direction** Pum Lefebure ●
Creative Direction Jake Lefebure and Pum Lefebure **Writer** S.W. Smith **Design Firm** Design Army
Client New Columbia Distillers **Principal Type** Century Schoolbook, ITC Franklin Gothic (various), and Web Fonts.com
Dimensions Label: 7 x 5.5 in. (17.8 x 14 cm); poster: 14 x 20 in. (35.6 x 50.8 cm)

EXPERIMENTAL **Design** Jason Mannix, Lindsay Mannix, and Gavin Wade, Washington, DC **Design Firm** Polygraph **Client** Athenaeum **Principal Type** Custom **Dimensions** 20 x 20 in. (5.8 x 50.8 cm)

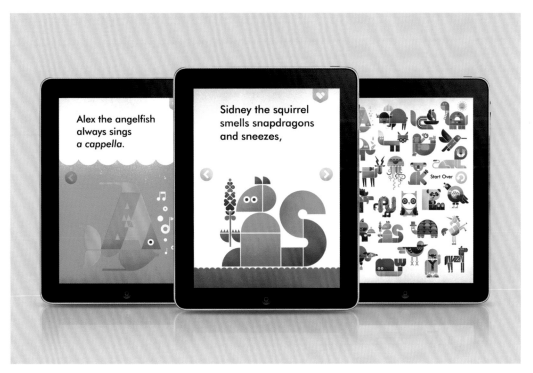

APPS **Design** Rob Alexander and Jason Schulte, San Francisco **Creative Direction** Rob Alexander, Jill Robertson, and Jason Schulte **Writer** Jill Robertson **Producer** Emily Bolls **Developer** William Lindmeier
Music and Sound Design Rabbit! **Design Firm** Office: Jason Schulte Design **Client** Wee Society, San Francisco
Principal Type Futura and custom

Office developed Wee Society's first iPad learning app for preschoolers. This included creating the Wee Alphas—a quirky crew of twenty-six characters with a letter of the alphabet hidden in each one. Silly rhymes and surprising animations entertain kids and their parents as they find the hidden ABCs and practice drawing their own "special letter" on a sketch pad.

BRAND IDENTITY **Design** Rob Alexander and Chris Mann, San Francisco **Creative Direction** Rob Alexander, Jill Robertson, and Jason Schulte **Producer** Emily Bolls **Writers** Lisa Pemrick and Jill Robertson **Photography** Rob Alexander and Jason Schulte **Design Firm** Office: Jason Schulte Design **Client** Wee Society, San Francisco
Principal Type Various **Dimensions** Various
Wee Society creates happy, colorful learning experiences to bring parents and their kids closer together. Office developed the brand name, brand strategy, visual identity, website, voice, and products. The overall identity and website were designed to reflect the brand's playful spirit. The first products include an iPad learning app for preschoolers featuring the Wee Alphas—a quirky crew of twenty-six characters with a letter of the alphabet hidden in each one. The Wee Alphas also appear in a series of art prints that Office designed, including a limited-edition thirteen-color screen print and a personalized print that is customized with your child's name along with a silly (or somewhat more serious) statement.

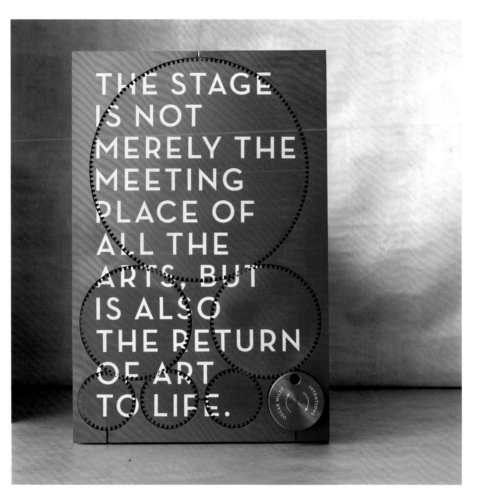

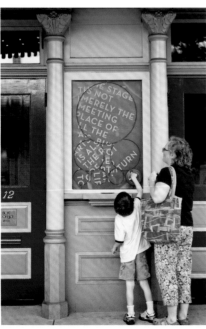

SIGNAGE Design Scott Marz, Lancaster, Pennsylvania **Creative Direction** Craig Welsh ● **Design Firm** Go Welsh
Client Poetry Paths **Principal Type** Neutra **Dimensions** 26 x 40 in. (66 x 101.6 cm)
This interactive public art for the citywide Poetry Paths project is recessed in the façade of Fulton Theatre,
a National Historic Landmark. Passersby move gears via a crank handle.

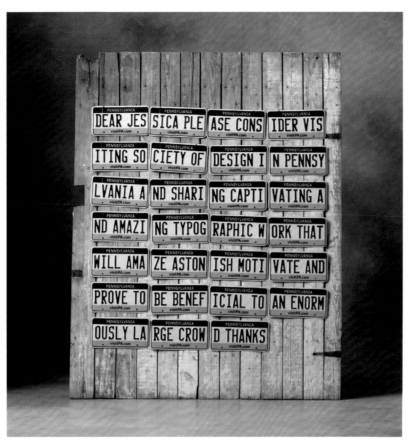

INVITATION **Design** Scott Marz, Lancaster, Pennsylvania **Creative Direction** Craig Welsh ●
Programmer Eric Salczynski **Photography** Bill Simone **Design Firm** Go Welsh **Client** Society of Design
Principal Type Standard Pennsylvania license plate font

This is an invitation to letterer, designer, and Pennsylvania native Jessica Hische, a self-described "type nerd," to present her work at a Society of Design event in her home state. Dozens of people changed their Pennsylvania Department of Transportation vehicle registrations and composed an invitation to Jessica across a series of twenty-seven custom Pennsylvania license plates. Once the plates arrived, we captured images of the participants and their new plates for a website-based invitation to Jessica: invitinghische.com.

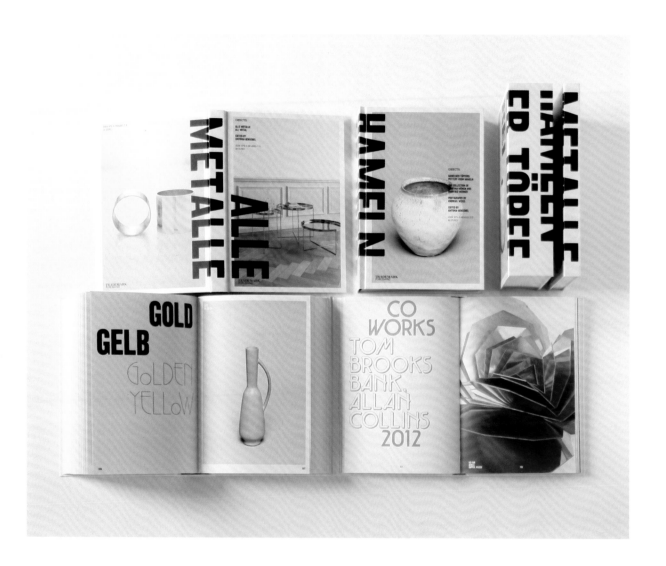

BOOK **Design** Antonia Henschel, Frankfurt am Main, Germany **Art Direction** Antonia Henschel **Editor** Antonia Henschel
Client Trademark Publishing **Principal Type** Various **Dimensions** 6.7 x 9.4 in. (17 x 24 cm)
Alle Metalle/All Metals is the second installment of the book series *t* by Trademark Publishing. It was published in 2012
as a follow-up to *Hamelner Töpferei/Pottery from Hameln*. The book series was conceived as a celebration of products
that go beyond mere compendiums. The typography is used boldly to emphasize the visuals.

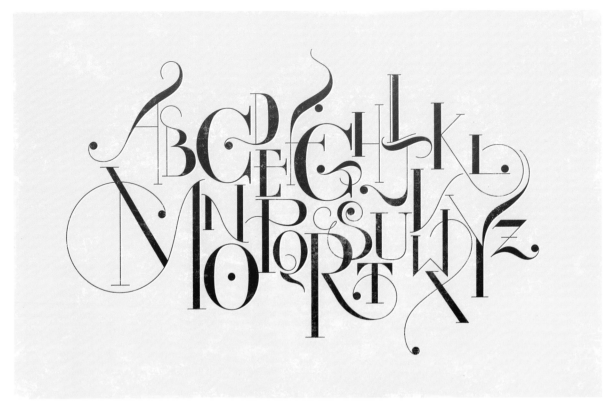

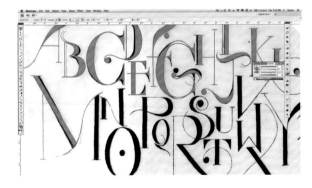

EXPERIMENTAL **Design** Harun Zankel, Brooklyn, New York **Art Direction** Harun Zankel
Principal Type Bauer Bodoni Bold and Bauer Bodoni Bold Italic **Dimensions** 24 x 16 in. (61 x 40.6 cm)
When my daughter Maya was born, I wanted to give her a gift that was both unique to her and that she could grow with and learn from. I experimented with the letter M but decided that creating a whole alphabet was better suited as an educational tool that she could explore. I chose Bauer Bodoni as the base typeface for most of the characters because of the beautiful line variation and its editorial style that is a New York signature, where Maya was born. I documented the whole process from initial sketches to final hanging print, which can be seen here: vimeo.com/hzankel/mayasa.

Philbrook Museum of Art

CORPORATE IDENTITY Design Michael Bierut ●, Deva Pardue, and Hamish Smyth, New York **Art Direction** Michael Bierut **Studio** Pentagram Design New York **Client** Philbrook Museum of Art **Principal Type** Benton Sans Condensed and Miller **Dimensions** Various

We worked with the Philbrook Museum of Art in Tulsa, Oklahoma, to create a new identity timed to an expansion of the museum downtown. While doing research for the logo, we happened to divide the city into a grid and discovered that isolating the areas of the museum's two locations formed the shape of a letter "P." The letter also resembles a human face, a subject of artists throughout history. The mark can be used as a solid form or reversed out to showcase images and can be expanded into a full alphabet.

CORPORATE IDENTITY **Design** Katie Barcelona, Michael Bierut ●, Aron Fay, and Joe Marianek, New York
Art Direction Michael Bierut **Studio** Pentagram Design New York **Client** Mohawk Paper Company
Principal Type Chalet and Sentinel **Dimensions** Various

Mohawk's new identity system is designed to help reinvent the paper company for the digital world. The M mark serves as a monogram for the name Mohawk but is also inspired by the papermaking process and the printmaking process, both of which involve paper moving around cylinders. The forms of the logo suggest paper rolls, printing presses, and circuit boards, as well as the idea of connection and communication, the core functions of paper. The M appears in different colors and configurations that can be extended in countless ways depending on the application and intended audience.

EXHIBITION **Design** Michael Bierut ● and Hamish Smyth, New York **Art Direction** Michael Bierut
Studio Pentagram Design New York **Client** New York City Department of Transportation
Principal Type Helvetica and custom
We worked with the New York City Department of Transportation to design a new symbol and campaign that reminds
pedestrians and drivers to look before entering crosswalks and intersections. Inspired by the "look right, look left"
signage on the streets of London and other cities, the symbol consists of a single, simple word: "LOOK!" The graphic
turns the O's into a pair of eyes, with the pupils positioned to the left or right to let pedestrians know exactly which
way to look. "LOOK!" was introduced with a marketing campaign that paired the mark with the eyes of New Yorkers.

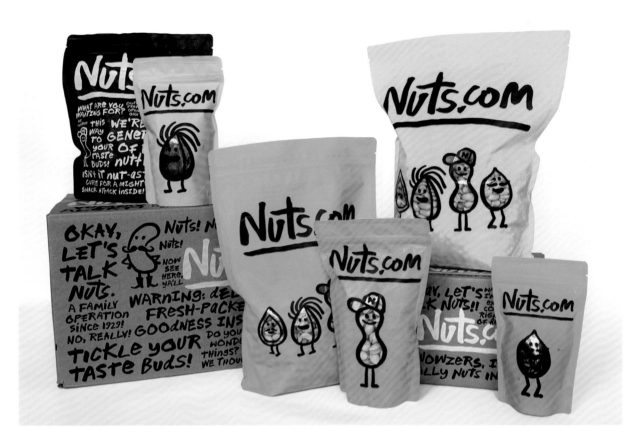

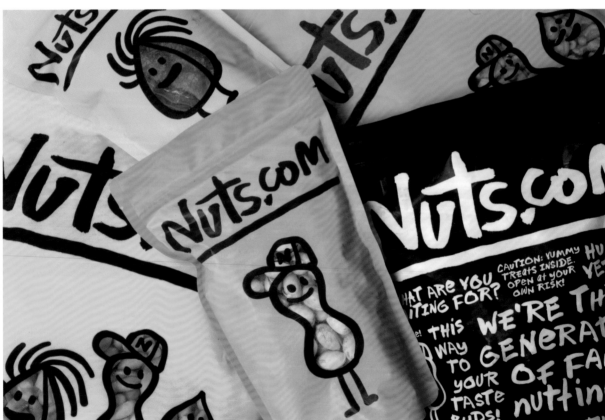

PACKAGING **Design** Katie Barcelona, Michael Bierut ●, and Aron Fay, New York **Art Direction** Michael Bierut
Illustration Christoph Niemann **Studio** Pentagram Design New York **Client** Nuts.com **Principal Type** Nutcase
Dimensions Various

Our identity and packaging for Nuts.com are designed to help establish the online retailer as a distinctive brand. A family-run business, Nuts.com prides itself on a personal approach and has always used a friendly, outgoing, and slightly zany tone of voice in its marketing, which represents the family members as cartoon nuts. Our redesign incorporates this sensibility into packaging with hand-drawn typography by Jeremy Mickel and illustrations by Christoph Niemann. A bright, appealing color palette completes the cheerful look.

PACKAGING **Design** Matthew Terdich, Chicago **Design Firm** Studio/lab **Client** University of Illinois at Chicago
Principal Type Helvetica Neue LT Std 45 Light and custom **Dimensions** 3.5 x 4 in. (8.9 x 10.2 cm)
Signature Vin is a project in which wine labels are custom-designed for the annual celebratory event welcoming
new students to the University of Illinois at Chicago (UIC) Master of Design programs. The 2012 label designs are
typographic expressions of the distinctive taste profiles and physical characteristics of Pinot Noir and Sauvignon
Blanc. The bold geometry and intentional gestalt of the typographic forms created for the Pinot Noir reflect its
characteristic depth and the susceptibility of its grape. By contrast, the nervy, vibrant quality of the Sauvignon Blanc
is represented by dualistic letterforms: compressed and open, elongated and round.

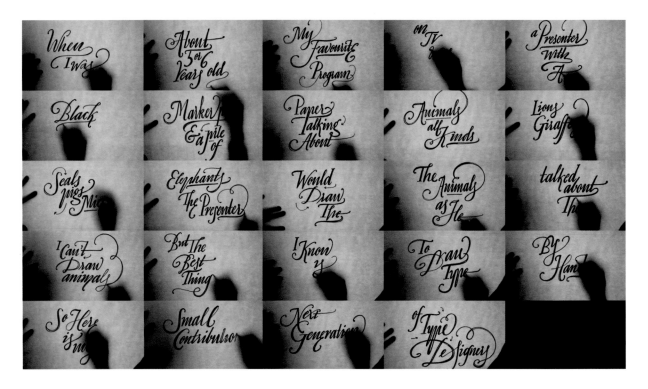

FILM **Design** Henrik Kubel ●, London **Scripting** Henrik Kubel **Voice-ove**r Henrik Kubel **Production** Animade
Design Firm A2/SW/HK **Client** A2-TYPE **Principal Type** Handlettering

SIGNAGE Design Ryan Feerer, Jeff Rogers ●, and Dana Tanamachi, Abilene, Texas, and New York
Creative Direction Ryan Feerer **Photography** Wade Griffith, Dallas **Client** Abi-Haus **Principal Type** Custom
In early 2012, designer/illustrator/educator Ryan Feerer added restaurateur to his résumé. After several years of
living and working in New York City, the native Texan returned home to the small town of Abilene and realized he missed
the dining experience he had in New York. Feerer wanted his fellow Abilenians to enjoy not just great food but also a
unique and beautiful atmosphere. Once a space was acquired, Feerer called on his friends (and fellow Texans) in New York,
Jeff Rogers and Dana Tanamachi, to fly down and collaborate on creating beautiful typographic murals that lined the
interior of the restaurant.

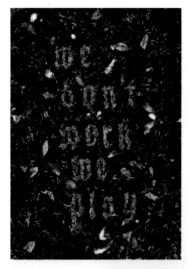

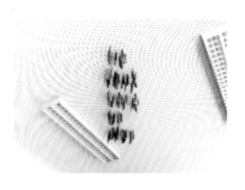

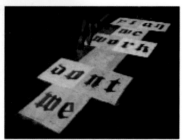

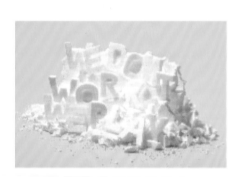

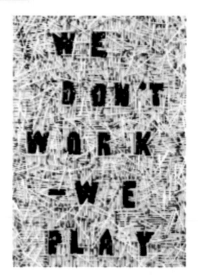

STUDENT PROJECT **Design** Yanik Balzer and Max Kuwertz, Frankfurt, Germany, and Düsseldorf, Germany
Professor Michael Gais **School** Köln International School of Design **Principal Type** Experimental
Dimensions 13 x 19 in. (33 x 48.3 cm)
The series was created for the exhibition We Don't Work–We Play, trying to show variations of the title through experimental typography and with different materials (more than a hundred variations of the same sentence have been exhibited).

BOOK JACKETS **Design** Tom Ising, Münich **Photography** Martin Fenge **Design Firm** Herburg Weiland
Client Tropen Verlag, Stuttgart **Principal Type** Various **Dimensions** 5.7 x 8.5 in. (14.4 x 21.5 cm)
This is the book jacket design for the Tropen book series.

STUDENT PROJECT **Design** Margaux Le Pierrès, New York **Instructor** Vincenzo Vella
School Fashion Institute of Technology **Principal Type** Century Gothic
Boingy is an animated typeface based on Century Gothic. This animation explores the future of typeface design within
a digital world, questioning our attention spans and thus the concept of time. Furthermore, this piece explores the
basic or, rather, intrinsic motions built into this geometric typeface.

PACKAGING **Design** Dana Deininger, Napa, California **Creative Direction** David Schuemann
Design Direction Kevin Reeves **Illustration** Dana Deininger **Design Firm** CF Napa Brand Design **Client** Hahn Family Wine
Principal Type Eloquent and Knockout **Dimensions** 4 x 5 in. (10.2 x 12.7 cm)
For riders during the Golden Age of Cycling (1860–1905), the machine of choice was the Velocipede. These early
bicycles were made entirely of wood and rattled their riders so much they came to be known as Boneshakers. Playing
off the bone theme, our design creates a skull using elaborate filigree composed of chains, gears, vines, and a
Velocipede as the eyes. The label was embossed and printed with glow-in-the-dark ink.

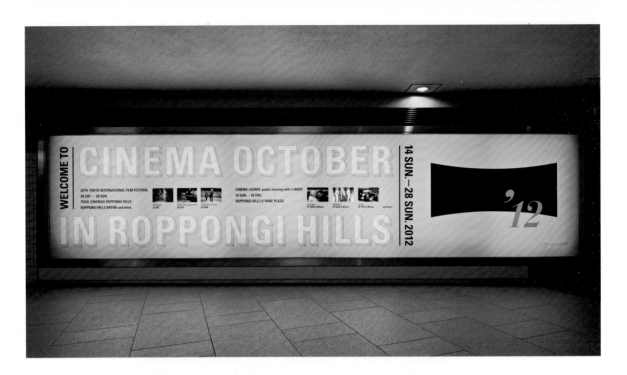

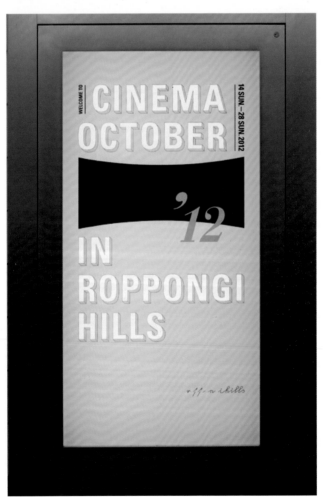

POSTERS Design Ren Takaya, Tokyo **Art Direction** Ren Takaya **Director** Maiko Toda **Producer** Maki Sato
Design Firm AD&D **Client** Mori Building Co., Ltd. **Principal Type** Univers 67 Bold Condensed
Dimensions 28.7 x 40.6 in. (72.8 x 103 cm)

This is an ad campaign for a film festival hosted annually in a complex facility. We used pop typography for the campaign title and yellow as the main color. According to color psychology, yellow is the color of communication and invokes joy to the human mind. It leaves the audience with a sense of affinity as well as excitement, allowing the ad visual to be unforgettable. Also, by iconifying the movie screen on a mirror sheet or by hot stamping, the audience can visualize themselves as the lead actor of the film. We succeeded in lengthening the audience's time spent at the site.

ADVERTISEMENT Art Direction Hugo Gallardo, Francesco Guerrera, and Francesco Pedrazzini, Milan
Creative Direction Hugo Gallardo Executive Creative Direction Francesco Guerrera and Nicola Lampugnani
Copywriters Valentina Barone and Nicola Lampugnani Agency TBWA\Italia spa Client GRUPPO FERRETTI
Photographer LSD Photo Producer Federico Fornasari Principal Type Pershing 82'
Dimensions 70.9 x 39.4 in. (180 x 100 cm)

WEBSITE Creative Direction Chris Fahey, Ralph Lucci, and Jeff Piazza, New York **Senior Designer** Alison Zack
Design Firm Behavior Design **Client** The Cooper Union **Principal Type** Gridnik
Behavior designed and built a new website for The Cooper Union for the Advancement of Science and Art, vastly improving its ability to showcase the school's remarkable students and faculty, their works and projects, and diverse events and exhibitions. Our challenge was to help the venerable institution clarify the purpose of the website, help create a more unified presence for the school's different faculties and majors, and help it devise a new content and editorial strategy to meet those goals.

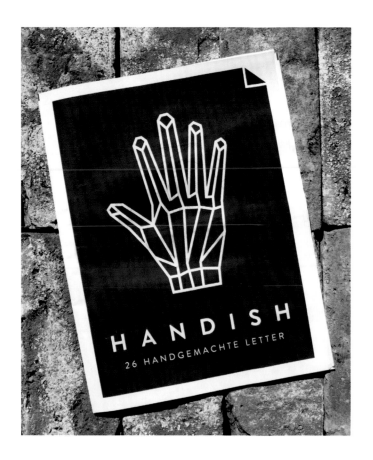

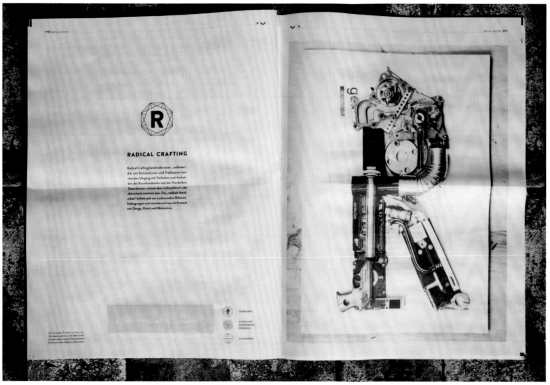

NEWSPAPER **Design** Tanja Angebrandt, Würzburg, Germany **School** University of Applied Sciences–Faculty of Design **Principal Type** Brandon Grotesque family **Dimensions** 11.4 x 15 in. (28.9 x 38 cm)

"Handish–26 Handmade Letters" portrays the do-it-yourself movement of today. Every handmade letter from A to Z describes and illustrates one term out of the DIY pool and informs the beholder about the current situation or upcoming trends in a nice and uncomplicated way. The predominant communication medium is the poster, which provides a lot of creative space to work with. Furthermore, there are a few three-dimensional objects included in this work. The posters and (3D) objects form the visual part of "Handish" and interact with the texts by interpreting and illustrating them. The materials used for each letter were supposed to vary and match its respective content. The newspaper combines text and images and displays all the letters in an attractive way.

NOMADIC APPAREL

LOGOTYPE **Design** Donovan Brien, Brooklyn, New York **Art Direction** Donovan Brien **Client** Nomadic Apparel, Boston
Principal Type Futura Std Bold

Nomadic is a start-up that is, essentially, a mobile clothing company. The company needed a logo that would be iconic, recognizable, and bold in dense visual spaces such as city streets. Another challenge was to suggest not only the movement of the truck but also the multiple destinations and directions in which the truck would be going. The solution articulates this idea of movement in multiple directions, while simultaneously forming an "N" with the negative space. The colors enable the logo to be visible from a distance, while the form is straightforward yet unique.

CATALOG **Design** Dominik Hafen, Bernhard Senn, and Roland Stieger ●, St. Gallen, Switzerland
Design Firm TGG Hafen Senn Stieger **Client** Konzert und Theater St. Gallen **Principal Type** Larish Neue
Dimensions 7.1 x 10.6 in. (18 x 27 cm)

BOOK JACKETS **Design** Emily Mahon, New York **Illustration** Mari Katogi, Chris Lyons, and Grady McFerrin, Tokyo, New York, and Brooklyn, New York **Publisher** Random House Publishing Group **Principal Type** Copperplate Gothic, Adobe Jenson, and Knockout **Dimensions** 5.2 x 8 in. (13.2 x 20.3 cm)

This is a repackaging of the Modern Library Classics series. The idea behind this series design has been to find existing contemporary art pieces, or to commission an illustrator to create something fresh for each of these books, as they come up for reprinting. Once in a while, a piece of classic art has been used but cropped in such a way to keep with the modern feel. The budget is always the same. A new silhouette encompasses the type on each cover. And a new pantone is chosen for the spine and back cover of each book.

STUDENT PROJECT **Design** Sebastian Ibler and Marcel Menke, Münich **School** Mediadesign Hochschule München **Professor** Sybille Schmitz **Principal Type** Stempel Schneidler LT and Zentenar Fraktur Mager **Dimensions** 6.3 x 9.5 in. (160 x 240 cm)

After researching Professor Schneidler and the Stempel Schneidler, we realized that a person will understand the beauty of the font only if he attends in an intensive way to it. This insight shapes the design of the book. The book is divided into two categories that are distinguished on one hand through its design and on the other hand through the use of two kinds of paper. In a nod to the character of Professor Schneidler, the binding is designed in a reticent way. The bxanderole around the book symbolizes the reticence of Professor Schneidler. We want to thank Mr. Carle for his interview of his college days with Professor Schneidler.

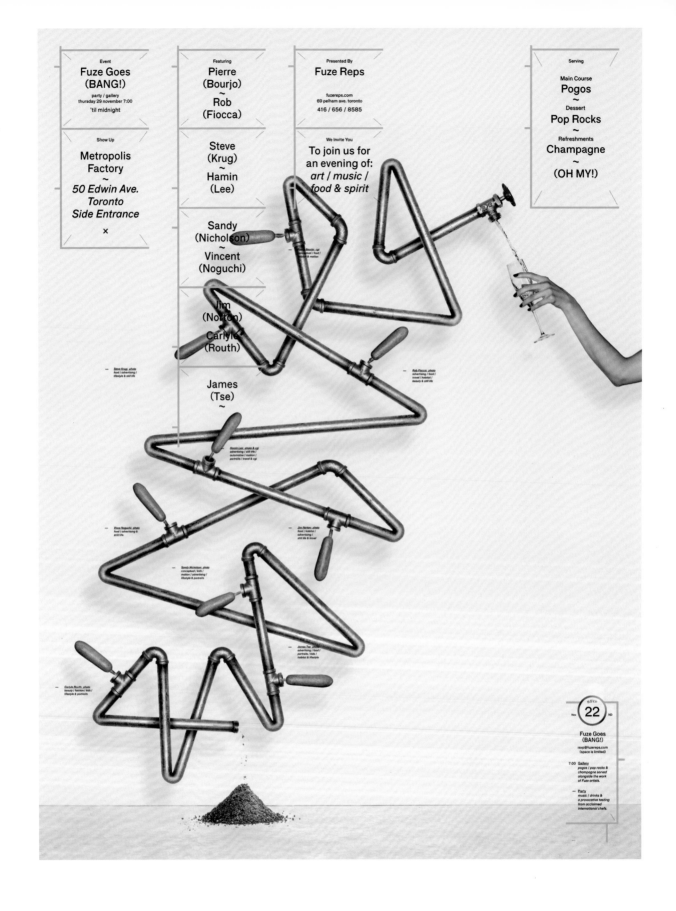

POSTERS **Design** Chris Duchaine and Scott Leder, Toronto **Creative Direction** Lisa Greenberg **Photography** Fuze Reps
Illustration Pierre Bourjo, Chris Duchaine, and Scott Leder **Agency** Leo Burnett, Toronto **Client** Fuze Reps
Principal Type F Grotesk Book **Dimensions** 24.25 x 40 in. (61.8 x 101.8 cm)

CORPORATE IDENTITY **Design** Daniel Matthews and Brittany Collard, Auckland **Creative Direction** Gideon Keith **Agency** Strategy Design and Advertising **Client** The Great Catering Co. **Principal Type** Fairplex Wide and Verlag **Dimensions** Various

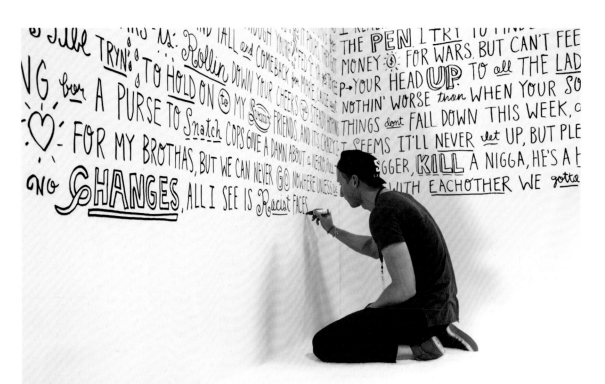

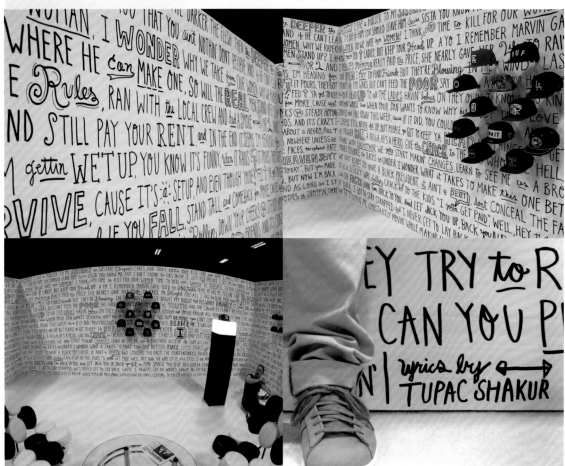

ENVIRONMENTAL GRAPHICS **Creative Direction** Timothy Goodman, New York **Producer** Andy Song, Los Angeles
Photography Daniel Rhie **Illustration** Timothy Goodman **Client** FlexFit Headwear **Principal Type** Sharpie paint
markers **Dimensions** 500 square feet of wall space (46.5 square meters)
FlexFit headwear challenged me to come up with an idea for a mural that I'd draw at their booth, real-time, during
the first day of the MAGIC trade show in Las Vegas. The show appeals to the urban/streetwear fashion community. I
handlettered Tupac Shakur lyrics on 500 square feet of wall space in nine hours. While it was important that the mural
be relative to the culture of both FlexFit and MAGIC, I also wanted to create an experience for the passersby that
wasn't too literal to the brand.

BRANDING **Design** Ged Palmer, Bristol, England **Lettering** Ged Palmer **Sign Painters** James Cooper and Ged Palmer
Client The Gallimaufry **Principal Type** Handlettering **Dimensions** 39 x 577 in. (99.1 x 1,465.6 cm)

This is branding for a restaurant and music venue. The name Gallimaufry comes from the French meaning "a mix or medley" and speaks of ethos: "to make the best of what's at hand." Given that the Gallimaufry has home-cooked food, reclaimed furniture, and a bar full of curios, the identity was composed of various letterforms crafted in a traditional style. The exterior sign was hand-painted with the help of local sign man James Cooper.

POSTERS Design Koji Matsumoto, Matsuyama City, Japan **Art Direction** Koji Matsumoto **Design Firm** Grand Deluxe Inc.
Client HORI Architect & Structure **Principal Type** Helvetica Neue 65 Medium **Dimensions** 28.7 x 40.6 in. (72.8 x 103 cm)
This poster of the architectural design office features the office name designed with wood.

huck

The *On the Road* Issue : Beat Debate
Band of Horses - Eric Koston - Ben Gibbard
Underground Vegas - Freight Hopping

9 771751 272039 35

£4.25 | ISSUE 35 | Oct/Nov 2012

MAGAZINE COVER **Creative Direction** Rob Longworth, London **Agency** The Church of London
Principal Type Bespoke and Blender Pro **Dimensions** 8.3 x 10.8 in. (21 x 27.5 cm)
To celebrate the release of *On the Road*—the film adaptation of Jack Kerouac's novel—we wanted to create a
magazine cover that looked for notions within Kerouac's work, using these as a key for the creative. We took inspiration
from the book being written on a single scroll of paper and looked at influences from the Beat generation and the ideas
of travel, exploration, and freedom. All these fed into the typography on the cover, which is constructed of one single
line that spills out of the typewriter, weaving its way across the page, forming the characters as it goes.

BOOK JACKET **Design** Eric White, New York **Art Direction** Greg Mollica **Publisher** Random House Publishing Group
Principal Type Bodoni (modified) **Dimensions** 5.5 x 8.25 in. (14 x 21 cm)

Moormann macht Sitz / *Moormann takes the chair*

1. Irgendwas ist immer / *Always something going on*
2. Ist ganz leicht ... / *It's easy really ...*
3. Die tun nix / *They simply do nothing*

März: Erste Pressversuche in der Fläche mit selbst-
gebautem Presswerkzeug aus Multiplexplatten und um-
gebogener Metallstange - Sickentiefe 10 mm.
Erste Probebleche mit Sickenverlauf der Füße können
hergestellt werden. Nach wenigen Versuchen geht
das Werkzeug kaputt, weil es dem Pressdruck nicht
stand hält.

*March: first attempts to produce beads in the sur-
face with a homemade pressing tool made from multi-
plex panels and a bent metal bar - bead depth 10mm.
The first sample sheets with beads for the feet
can be made. After a few attempts the tool breaks,
because it could not bear the beading pressure.*

eigentlich müssten wir JETZT auf die Messe ...

Actually we should set out for the trade fair right now ...

66

67

BROCHURE **Design** Olaf Jaeger and Regina Jaeger, Üeberlingen, Germany
Creative Direction Olaf Jaeger and Regina Jaeger **Client** Nils Holger Moormann GmbH
Principal Type ITC Franklin Gothic Std and Letter Gothic Std **Dimensions** 4.1 x 5.8 (10.5 x 14.8 cm)

SIGNAGE Design Ingrid Chou and Tony Lee, New York Art Direction Ingrid Chou Creative Direction Julia Hoffmann
Production Artist Paulette Giguere Animation Tony Lee Museum The Museum of Modern Art (MoMA), Department of
Advertising and Graphic Design Principal Type MoMA Gothic, Trade Gothic Light, and Trade Gothic Condensed Twenty
Dimensions Various

MAGAZINE Design Angus MacPherson, London **Design Assistant** Eve Lloyd Knight **Creative Direction** Paul Willoughby
Agency The Church of London **Client** *Little White Lies* **Principal Type** Various **Dimensions** 7.9 x 9.6 in (20 x 24.5 cm)
The issue was conceived as a response to core themes of Paul Thomas Anderson's *The Master*. The uniform schizophrenic
red and blue color scheme accentuates multidimensionality and links to themes of cult, kinship, and duality in the story.
Using the supplied spectral comb filters (3D glasses) while looking at the cover, the viewer can see Joaquin Phoenix's
character with the red filter, Philip Seymour Hoffman through the blue, then to the naked eye a combined reality based
on both portraits interacting. Inside the magazine, illustrators and copywriters were asked to respond to their briefs
in a multidimensional way.

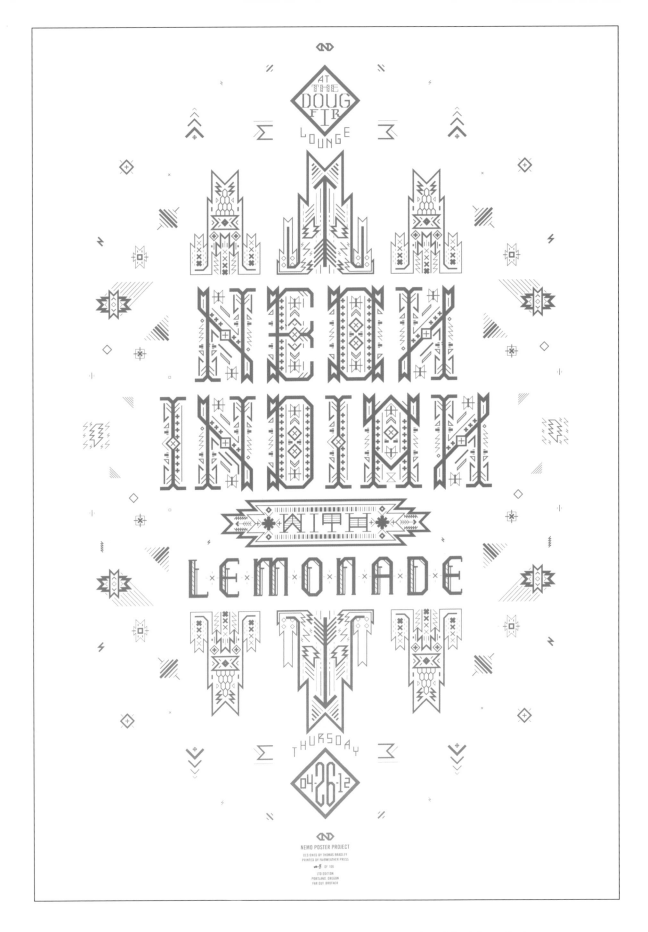

POSTER **Design** Thomas C. Bradley, Portland, Oregon **Design Firm** Nemo Design **Client** Doug Fir Lounge
Principal Type Trade Gothic **Dimensions** 19 x 25 in. (48. x 63.5 cm)
Since 2007, Nemo Design has designed and printed show posters for one of the premier music venues in Portland,
Oregon—the Doug Fir Lounge. Each print is numbered and pulled by hand, of limited quantity, and guaranteed to look rad
on a wall. This print for Neon Indian is no different. Thomas Bradley created the custom-type, two-color, split fountain
pull to be screen-printed on 19 x 25-in. archival paper. Thanks also to Justin Dickau at Fairweather Press.

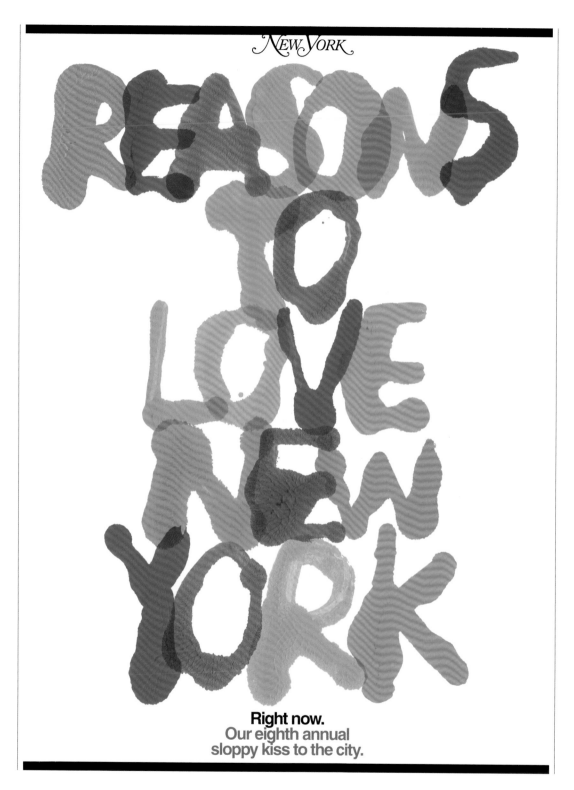

Right now.
Our eighth annual
sloppy kiss to the city.

Lettering by Mike Perry

MAGAZINE OPENER **Design Direction** Thomas Alberty, New York **Illustration** Mike Perry **Publication** *New York Magazine*
Principal Type Painted lettering **Dimensions** 7.75 x 10.5 in. (19.7 x 26.7 cm)

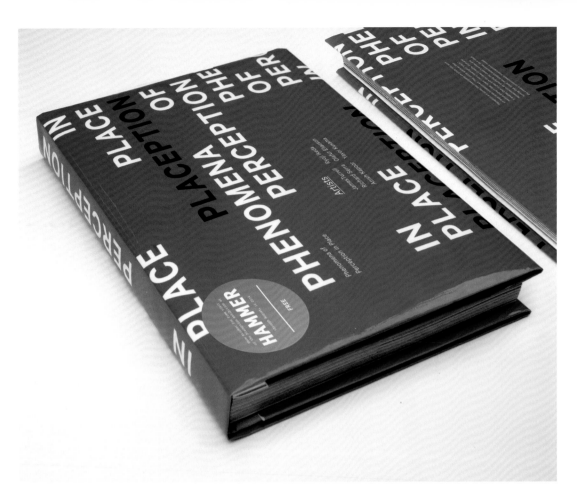

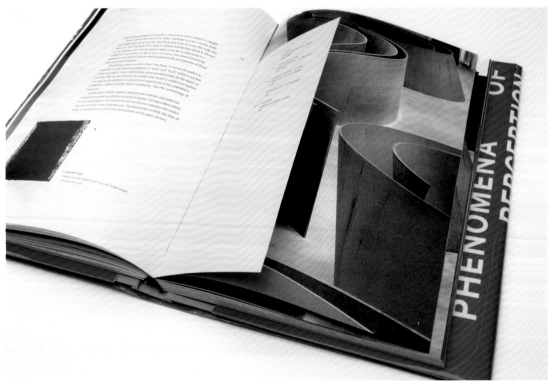

STUDENT PROJECT Design Stanley Xing Chen, Pasadena, California **Instructor** Brad Bartlett
School Art Center College of Design **Principal Type** Calibre **Dimensions** 8 x 11.5 in. (21.6 x 27.9 cm)
"Plaception" is a catalog presenting six installation artists: James Turrell, Richard Serra, Anish Kapoor, Ryoji Ikeda,
Olafur Eliasson, and Yayoi Kusama. These artists use "space" as their medium and turn it into meaningful "place." They seek
to amplify the viewer's senses through tangible experiences that play with the ideas of reality, truth, and representation.
As a result, the viewer's conscious perception of things that he or she used to take for granted is changed. Not only do
the artists communicate through emotional and sensorial touchpoints; they also create experiences that leave viewers
with wonders.

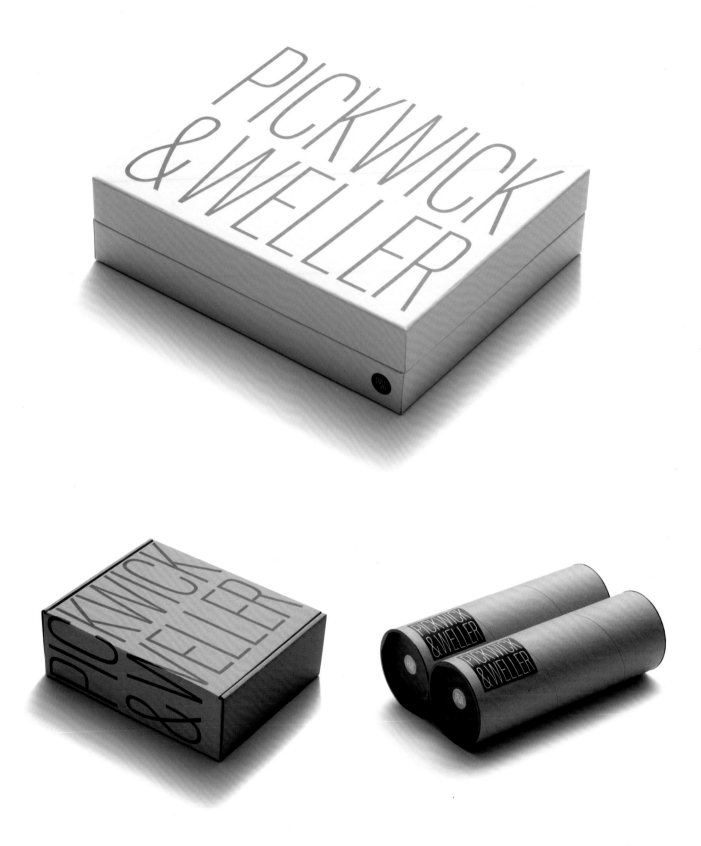

PACKAGING Design Ryan Crouchman, Toronto **Creative Direction** Diti Katona ● and John Pylypczak
Design Firm Concrete Design Communications **Client** Pickwick & Weller, Culver City, California
Principal Type FB Titling Gothic **Dimensions** Various

Pickwick & Weller is the brainchild of early PayPal contributor Ryan Donahue and actor Ashton Kutcher. The concept for the T-shirt line was inspired by Silicon Valley–based Donahue's friends and colleagues—a class of creative-knowledge workers whose wardrobes have shifted toward a more casual yet refined taste. Donahue tasked Concrete with creating tthe brand's identity. The clothing line consists of well-made, "designer-quality" T-shirts–luxury wardrobe basics–available only online. It was critical that the two principal customer touchpoints–the company's website and the "unboxing experience"– fully communicate the quality and value of the product.

EXHIBITION Design Ingrid Chou and Tony Lee, New York **Art Direction** Ingrid Chou **Creative Direction** Julia Hoffmann
Typography Tony Lee **Production Manager** Claire Corey **Museum** The Museum of Modern Art (MoMA), Department of
Advertising and Graphic Design **Principal Type** Pennsylvania and Quay **Dimensions** Various

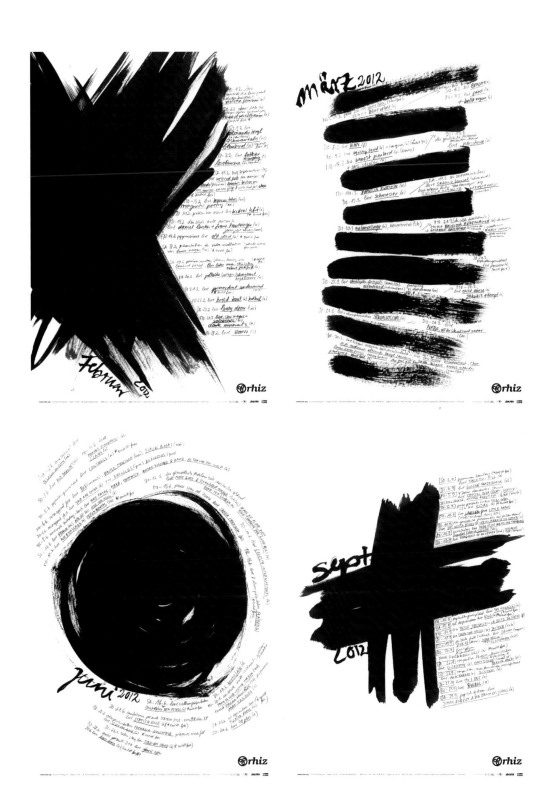

POSTERS **Design** Eva Dranaz, Vienna **Art Direction** Eva Dranaz **Creative Direction** Eva Dranaz
Image Editor Jochen Fill **Agency** 3007 **Client** rhiz/bar modern **Principal Type** Handlettering
Dimensions 23.4 x 33.1 in. (59.4 x 84.1 cm)
The poster series "unmixed" for the Viennese music club rhiz was published monthly during 2012. "Unmixed" stands
for reduced color, raw sketches, analog transmission, abstraction, creative spirit, and musical expressiveness.
The black-and-white handwritten and painted pictures play on form and area and should be read as musical scores.

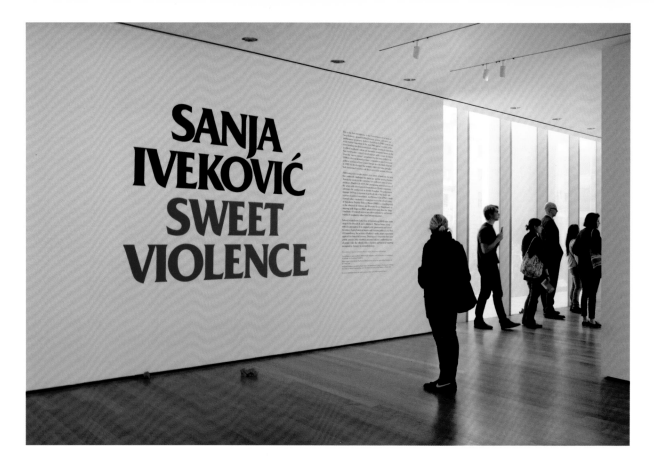

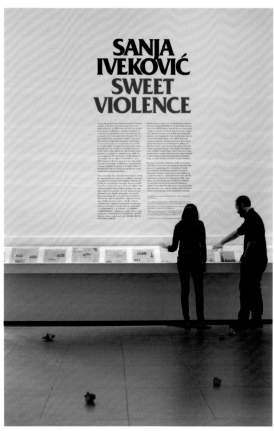

EXHIBITION **Design** Brigitta Bungard, New York **Art Direction** Brigitta Bungard **Creative Direction** Julia Hoffmann **Production Manager** Claire Corey **Museum** The Museum of Modern Art (MoMA), Department of Advertising and Graphic Design **Principal Type** Friz Quadrata **Dimensions** 66.6 x 89.1 in. (169.2 x 226.4 cm)

SEPT. 18–29
Make Combat Paper
COMBAT PAPER PROJECT

SEPT. 19
Alternative Exposure
GRANT PROGRAM DEADLINE

SEPT. 21–22
Paper/Cups
OPENING WEEKEND RECEPTION FOR MAKE COMBAT
PAPER WITH DREW CAMERON AND EHREN TOOL

OCT. 5–27
Making a Scene
TORREYA CUMMINGS, BESSMA KHALAF, AND
THE CENTER FOR TACTICAL MAGIC

OCT. 28 & NOV. 4
**Get it Done! Make Your Portfolio Website
in Two Weeks**
OLIVER WISE AND ELEANOR HANSON WISE,
CO-DIRECTORS OF THE PRESENT GROUP

NOV. 2
Actual Reality
LUCKY DRAGONS

NOV. 6
Smoke Signals
DAN ALLENDE AND IAN COX

NOV. 9–10
Animal: Collaborative Combative Drawing
MELISSA WYMAN

NOV. 30 – DEC. 1
Juried Exhibition Drop-Off Dates

DEC. 7–21
**Point of No Return, Southern Exposure's
Annual Entry-Fee-Free Juried Exhibition**

DEC. 7–21
**Southern Exposure's Youth Advisory Board
Final Project**

SEPTEMBER

OCTOBER

NOVEMBER

DECEMBER

SUPPORT SOEX AND SUPPORT ARTISTS. BECOME A MEMBER. WE NEED YOU! JOIN ONLINE AT WWW.SOEX.ORG/JOIN.HTML

BROCHURE **Design** Tim Belonax, San Francisco **Client** Southern Exposure
Principal Type Manu Sans, Proforma, and custom stencil
Dimensions Flat: 11 x 17 in. (27.9 x 43.2 cm); folded: 5.5 x 8.5 in. (14 x 21.6 cm)
Southern Exposure needed to announce its fall programs via an economical mailer. This two-color brochure/poster
was designed with contrasting typography, academic and free-form. The display typography was created with
"A Machine for Typographic Generation," a project funded through an arts grant from Southern Exposure and published
by *THE THING Quarterly*.

The calendar that follows the sun.

The Solstice Calendar. In addition to the date, it gives people a way to stay connected to the sun's yearly journey. Displaying the hours of day vs. night, the pages grow lighter as the days grow longer. And since 2012 was a leap year, it even includes a bonus day.

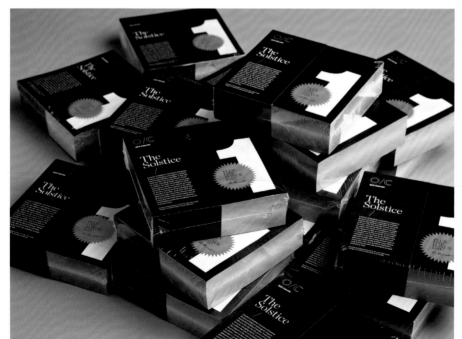

CALENDAR Design Chris Duchaine, Scott Leder, and Trong Nguyen, Toronto
Creative Direction Lisa Greenberg and Judy John **Producer** Kim Burchiel **Copywriter** Morgan Kurchak
Agency Leo Burnett, Toronto **Principal Type** Chronicle Text, Chronicle Display, and Helvetica Neue LT Pro
Dimensions 6 x 6 x 1.6 in. (15.2 x 15.2 x 4.1 cm)

UNPUBLISHED **Design** Michael Geedrick, Brisbane, Australia **Principal Type** Custom
Dimensions 33.1 x 23.4 in. (84.1 x 59.4 cm)
This experimental poster is a typographical exploration of being "caught up" in a web of passion or perhaps blinded by love. The type itself is constructed with more than 4,000 lines intertwined to allude to the individual letterforms. These lines help portray the web-like aspect of the piece.

ch3 with
white flag and
the strike

wednesday
june 15 1983
no age limit

at the troubador
9081 santa monica boulevard
west hollywood, ca

sunday
november 28 1982
a mass production

at marble bar
306 w. franklin street
baltimore, md

haus

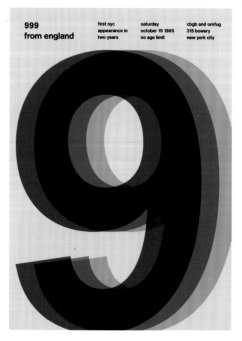

999
from england

first nyc
appearance in
two years

saturday
october 19 1985
no age limit

cbgb and omfug
315 bowery
new york city

9

POSTERS Design Mike Joyce, New York **Studio** Stereotype **Principal Type** Berthold Akzidenz-Grotesk Medium
Dimensions 24 x 33.5 in. (61 x 85.1 cm)
Swissted is a personal design project born out of my love of punk rock and Swiss modernism. I have redesigned vintage
punk, hard-core, new wave, and indie rock show flyers into hundreds of International Typographic Style posters. Each
poster is set in Berthold Akzidenz-Grotesk Medium, and every show actually happened.

SIGNAGE **Art Direction** Frank Geiger and Oliver Wörle, Stuttgart **Creative Direction** Sascha Lobe ●
Design Firm L2M3 Kommunikationsdesign GmbH **Client** Berufschulzentrum Stuttgart Nord **Principal Type** Gotham Rounded
A complex '70s architecture in which no two stories are alike includes long corridors adjoined by classrooms and two different schools as occupants. The two staircases are the only constant. We see these staircases as "epicenters" from which movement emanates and to which it returns. The story identifiers are big and easy to read; the farther you are from these points, the more the typography disintegrates. In the corridors in between, the graphic structure becomes the enlivening element, transcending the purely denotative function.

EXHIBITION **Design** Giorgio Pesce ●, Lausanne, Switzerland **Art Direction** Giorgio Pesce **Web Developer** Léonard Maret **Graphic Design** Terry Fernandez **Graphic Design Studio** Atelier Poisson **Client** Alimentarium, Food Museum **Principal Type** Neutraface and Sentinel **Dimensions** Various
This exhibition is about collecting; it shows collections of common objects related to food (cream pots, sugar bags, energy drinks, etc.). Instead of showing actual pieces that have no real value taken alone, we tried to find a way to illustrate the fact of collecting. Aligned butterflies immediately symbolizes that, so we created a collection of "food butterflies," with a little spoon (the museum's logo) as the body. For the website and catalog, we decided to show the quantity and repetition of the objects.

CATALOG **Design** Daniel Santos, Coimbra, Portugal **Art Direction** João Bicker **Project Manager** Alexandre Matos
Design Assistant Hugo Pinheiro **Design Firm** FBA **Client** Casa da Arquitectura
Principal Type Távora Display and Utopia Std **Dimensions** 8.27 x 10.6 in (21 x 27 cm)
This is the exhibition catalog for *Fernando Távora, Permanent Modernity*, one of the closing events of Guimarães 2012–
European Capital of Culture, honoring Fernando Távora, pioneer of modernist architecture in Portugal. The Távora
Display typeface was designed based on a grid and drafts of a handful of letters left by the architect. The book is
organized into two parts, signaled by the use of two types of paper. The first part reveals essays by different authors
on Távora's work, while the second part reveals images, texts, photos, and travel notes by Távora.

POSTER **Design** Stefan Guzy, Berlin **Studio** Zwoelf **Client** Deutsche Film und Fernsehakademie Berlin
Principal Type Nonpareille, Stuart Pro, and handwriting **Dimensions** 46.9 x 33.1 in. (119 x 84 cm)
The mix of a single simple shape, and huge type slashed across it, shouldn't be such a showstopper, but in the hands of designer Stefan Guzy, it is all that he needs. Guzy designed the poster to promote an art-house film that was gaining recognition and being screened at festivals. A heavy, contemplative drama, where the main character only reveals his face for a brief moment, and there is no dialogue, Guzy set about focused on a typographical solution to carry the visuals. "I hand-rendered some antique, styled horror film lettering," he says, adding a hallucinogenic quality. Having it hover over, and break the border established by the frame, only adds to the effect. The real capper is in his final decision, one in which the poster takes on another life, had the choices differed. "I was drawn to using these weird contemporary colors," he admits, "bringing the poster into another plane of existence, much like the sublime work of the studio itself."

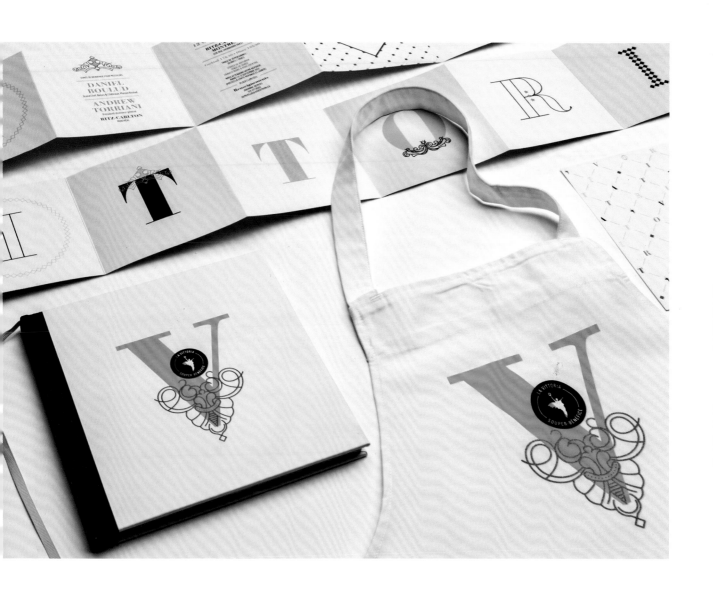

CORPORATE IDENTITY **Design** Marie-Pier Gilbert and Cindy Goulet, Montréal **Creative Direction** Serge Côté
Account Services Catherine Lanctôt and Florence Morin-Laurin **Photography** Luc Robitaille **Print Production** lg2fabrique
Copywriter Pierre Lussier **Agency** lg2boutique **Client** Johanne Demers (founder of La Vittoria)
Principal Type Bodoni, Firenze, Flama, and Perla **Dimensions** Various

CORPORATE IDENTITY **Design** David Nguyen, Montréal **Art Direction** René Clément
Project Manager Marie-Hélène Rodriguez **Account Director** Joanne Lefebvre **Client** Rochefort Costumes
Design Firm Paprika **Principal Type** Optimo and Theinhardt **Dimensions** Various
Rochefort is a company that specializes in costumes, shoes, and scene accessories. To show its wide range of services
and its craftsmen's savoir faire, we created a monogram from the tools used by those costumers, shoemakers, and
accessory makers. Six variations appear on the stationery.

POSTER **Design** Rob Alexander, San Francisco **Creative Direction** Rob Alexander, Jill Robertson, and Jason Schulte
Design Firm Office: Jason Schulte Design **Client** Wee Society, San Francisco
Principal Type Custom letterforms integrated into animals **Dimensions** 24 x 36 in. (61 x 91.4 cm)
We illustrated and designed a limited-edition, thirteen-color screen print featuring the Wee Alphas—a quirky crew of
twenty-six characters with a letter of the alphabet hidden in each one. The print is sold exclusively at weesociety.com.

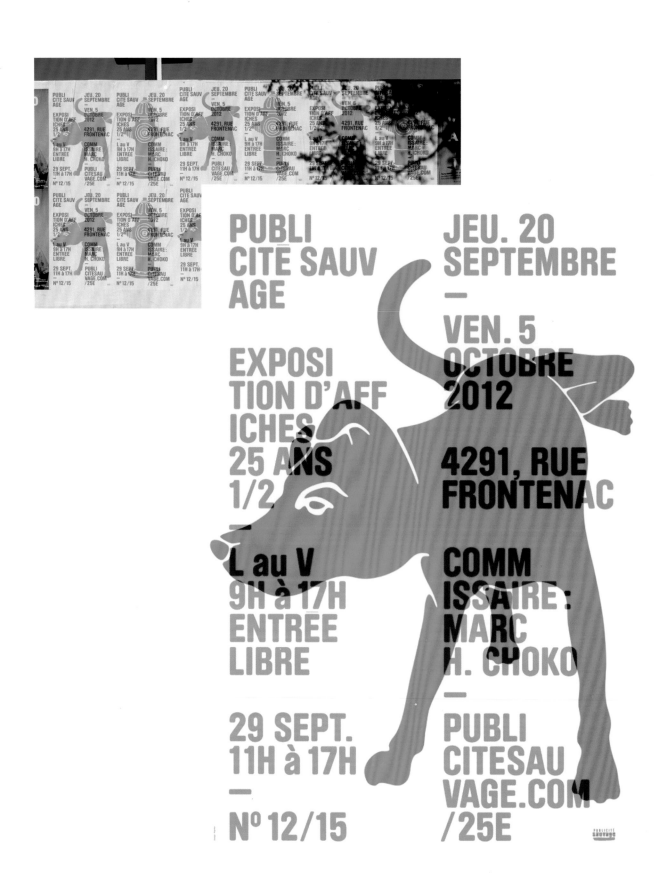

POSTERS **Design** Emanuel Cohen, Montréal **Creative Direction** Louis Gagnon ● **Design Firm** Paprika
Client Publicité Sauvage **Principal Type** Brauer Neue **Dimensions** 24 x 36 in (61 x 91.4 cm)
This poster was created for the twenty-fifth anniversary of Publicité Sauvage, a Montréal-based bill-posting company.
Fifteen poster exhibitions were put together throughout the city for the event, and Paprika was approached to design
the advertising poster for the twelfth exhibition. Fundamentally, bill posting is the "war" of marking your territory
before someone else covers you up—justifying the parallel of the urinating dog making his mark on a wall. Additionally,
the dog symbol relates to the company name, which uses the term "sauvage," French for wild.

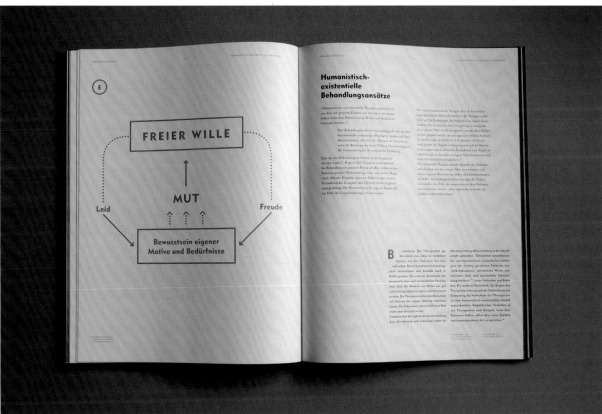

STUDENT PROJECT **Design** Florentine Heimbuche, Münich **Professors** Kai Bergmann and Günter Woyte
School Hochschule Augsburg **Principal Type** Adobe Caslon Pro and Metroblack TM **Dimensions** 10.2 x 13.4 in. (26 x 34 cm)
Everybody knows fear. Fear begins slowly and settles in the body, an emotion of unrest. The condition becomes more
intense–the feeling is no longer within reach. Often the cause is unknown, and only the inner, grueling restlessness
is noticeable. What causes anxiety and anxiety disorders? Several models attempt to give an explanation. What is the
fear of the individual? What shapes and colors are associated with fear? Starting from the theoretical discussion on
the topic and a survey, this book developed to give explanations and to show the incomprehensibility, individuality, and
intensity of this toxic emotion.

ANNUAL REPORT **Art Direction** J. Kenneth Rothermich, New York **Creative Direction** Richard Colbourne
Client Service Director Renée Marmer **Senior Design Direction** Rick Slusher **Agency** Addison **Client** Wills Eye
Institute, Philadelphia **Principal Type** Brioni and Helvetica Inserat **Dimensions** 10 x 12 in. (25.4 x 30.5 cm)
Wills Eye Institute is one of the world's premier eye-care facilities, treating more than 250,000 patients annually. We
were engaged to revitalize Wills' brand positioning and launch it with the institute's first marketing publication in
almost a decade, serving as the foundation for a broader marketing program. Wills needed a rallying cry to express
its people's collective sense of purpose. We developed the theme "Never" to convey Wills' unwillingness to give up in
its pursuit of improving sight. The look and feel of the piece reflects the theme's boldness with arresting color, image,
typography, and unconventional printing techniques.

STUDENT PROJECT Design Bennett Williams, New York Instructors Claudia De Almeida and Carin Goldberg
School School of Visual Arts, New York Principal Type Gotham Black Dimensions 6 x 9 in. (15.2 x 22.9 cm)
These are book jacket designs for three volumes of a Euripides series.

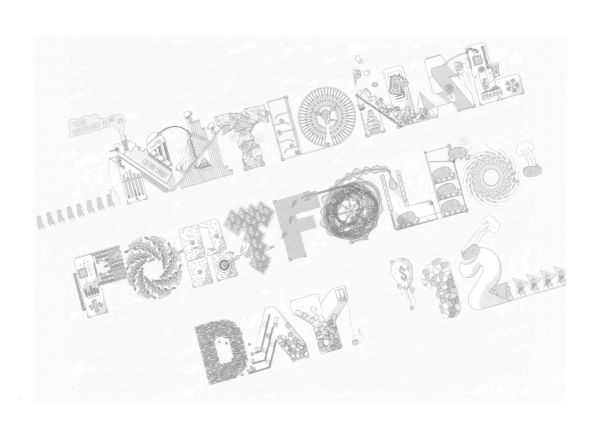

STUDENT PROJECT **Design** Quinn Keaveney ●, Chicago **Instructor** Mark Stammers
School School of Art Institute of Chicago **Principal Type** Blanch and Mrs. Strange **Dimensions** 35 x 24 in. (88.9 x 61 cm)
When I decided to come to art school, I made a conscious decision to do what I enjoy for a living. Not because it was easy, not for the money, but because it was time-consuming and exactly how I wanted to be spending my time. I came to art school to draw, and since then I have stopped drawing. That's why I wanted this piece to be so heavily illustrative. I wanted to express the reason I first came to portfolio day, in hopes of making a connection with a student who might feel the same way.

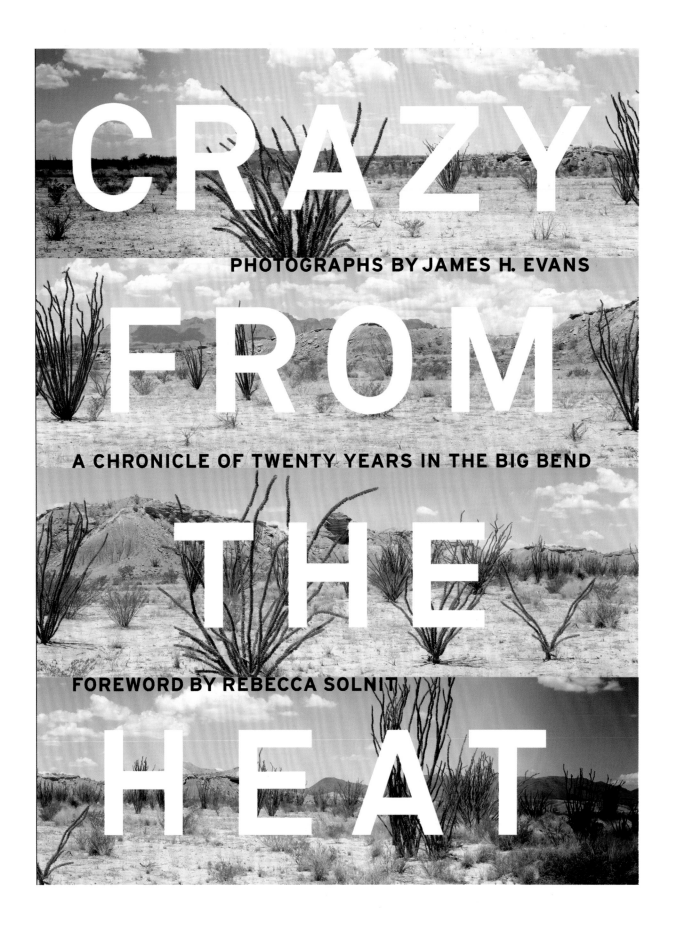

CRAZY
FROM
THE
HEAT

PHOTOGRAPHS BY JAMES H. EVANS

A CHRONICLE OF TWENTY YEARS IN THE BIG BEND

FOREWORD BY REBECCA SOLNIT

BOOK JACKET Design Julie Savasky and DJ Stout ●, Austin **Creative Direction** DJ Stout **Graphic Design** Julie Savasky
Studio Pentagram Design Austin **Client** James H. Evans **Principal Type** Akkurat **Dimensions** 10 x 14 in. (25.4 x 35.6 cm)
This book is the second monograph we designed for eccentric photographer James Evans, who lives in a desolate high
desert region of far West Texas. The interplay of the typography on the front and back covers helps to communicate
the title we penned for the book, *Crazy From the Heat*.

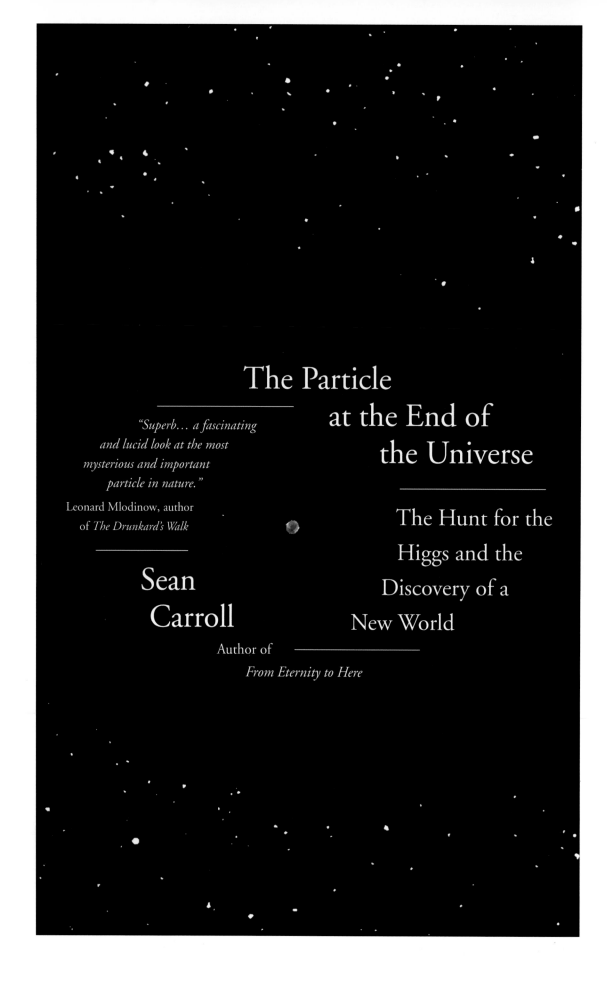

The Particle
at the End of
the Universe

———————

The Hunt for the
Higgs and the
Discovery of a
New World

———————

"Superb... a fascinating
and lucid look at the most
mysterious and important
particle in nature."
Leonard Mlodinow, author
of The Drunkard's Walk

———————

Sean
Carroll
Author of ———————
From Eternity to Here

BOOK JACKET **Design** Oliver Munday, New York **Studio** OMG **Client** One World Publications
Principal Type Adobe Garamond **Dimensions** 5.3 x 8.5 in. (13.5 x 21.5 cm)

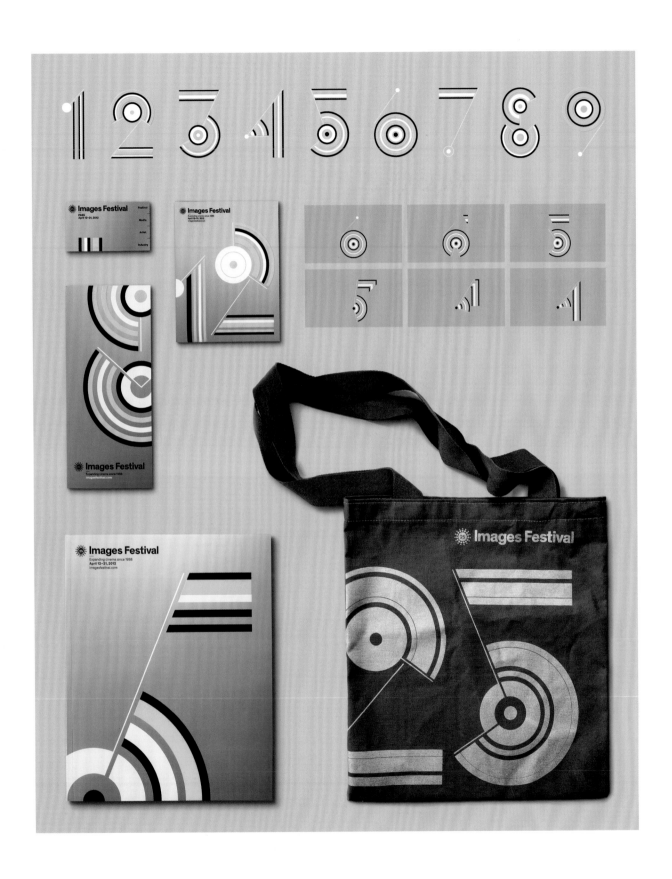

FESTIVAL BRANDING **Design** Brian Banton, Toronto **Art Direction** Gilbert Li **Design Office** The Office of Gilbert Li
Client Image Festival, Toronto **Principal Type** Theinhardt family and custom numerals **Dimensions** Various
The year 2012 marked the twenty-fifth anniversary of the Images Festival, an annual showcase of experimental film,
video, and motion art. The main visual motif of the identity is a custom set of numerals inspired by the familiar film reel
countdown. The numerals in kinetic form were featured in the festival's trailer.

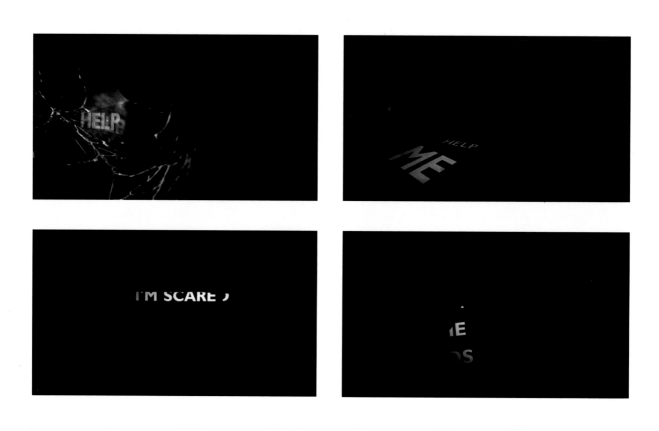

MOTION—ADVERTISEMENT Director Jonny Kofoed, Auckland **Animation** Jonny Kofoed
Executive Creative Direction Antonio Navas **Agency Art Director** Mike Davison **Agency Writer** Anne Boothroyd
Agency Assembly **Client** Women's Refuge New Zealand **Principal Type** Gill Sans MT
Traditionally PSA advertising uses live performance to get emotion across, but we decided to use nothing but simple typography. This way there isn't a certain demographic or type of person getting overrepresented. The communication is more open-ended and inclusive of all cultures and personalities. The viewers see their own stories and their loved ones in the animation. The beauty of type and animation is that they distill the horror of this violence to its simplest forms—movement and sound.

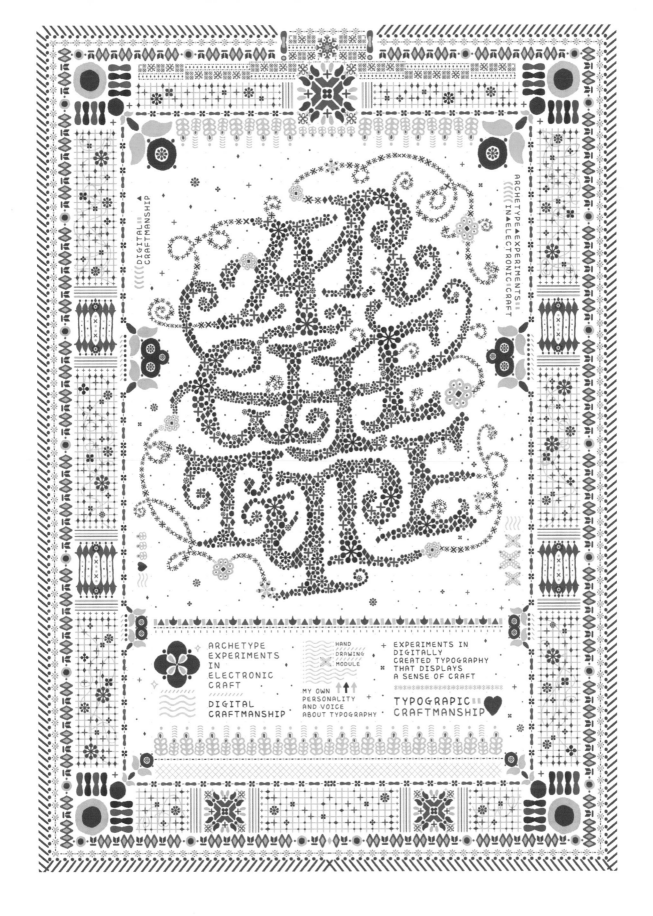

STUDENT PROJECT **Design** Song-Yi Han, Seoul **Instructor** Chris Ro **School** Kookmin University
Principal Type Handwritten **Dimensions** 23.4 x 33.1 in. (59.4 x 84.1 cm)

Archetype project is an experimental typography work, and the goal of this project is to study personal ways to express typography. My goal was to reflect handcraft style in a lively way on digital print. I wanted to combine the impression of handcraft and the advantages of digital technology. I outlined the basic module using a pen, scanned it in high definition, revised, and put in the handcraft vectors to finish. I created the simple figures and organized them variously using a computer. If you look closely at the final outputs, they appear handcrafted indeed.

orchestre symphonique genevois

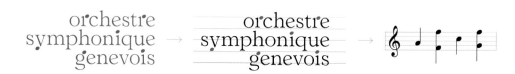

CORPORATE IDENTITY **Art Direction** Sabine Schoenhaar, Düsseldorf **Senior Art Direction** Marcus Dorau and Astrid Schroeder **Creative Direction** Juergen Adolph and Christian Voettiner **Managing Director Creation** Ruediger Goetz **Copywriter** Max Messinger **Management Superviso**r Alexandra Sobota **Digital Artist/Motion Graphics** Kevin Schiffer **Editor/Cutter** Pascal Bussmann **Junior Account Executive** Sarah Bellut **Account Executive** Julia Heckmann **GREY Creative Supervisor** Mark Hendy **GREY Creative Direction** Annette Pfeffer **Music/Sound Consultant** Ric Scheuss **Music Producer** Markus Steffen **Managing Partner/Producer** Michael Brink **Partner/Creative Direction** Rolf Muetze **Design Firms** KW43 BRANDDESIGN and GREY **Client** Orchestre Symphonique Genevois **Principal Type** Horley Old Style MT Std and modified Horley Old Style MT Std Typeface with notes **Dimensions** Various

The new brand identity of the Orchestre Symphonique Genevois combines the elegance of classical music with modern means of communication. It breaks usual boundaries by including acoustic dimensions along with visual aspects. This idea originated in the belief that an orchestra deserves a brand appearance that literally creates music. Consequently notation, the universal alphabet of music, is combined with the Latin alphabet to create a multi-sensual logotype. The "melody" thus created becomes the orchestra's "sound logo." Using the word mark as a starting point, a font was created that converts text into music, and this brand identity is consistently transmitted into every communication medium.

BOOK JACKET **Design** Lynn Buckley, Brooklyn, New York **Creative Direction** Paolo Pepe **Lettering** Lynn Buckley
Publisher Random House Publishing Group **Principal Type** Handlettering **Dimensions** 6.25 x 9.25 in. (15.9 x 23.5 cm)
The title type on this book cover is composed of several small punched holes revealing a printed book casing underneath.

TYPEFACE Design Jihye Yang, Seoul **Principal Type** CUBI

Letters that we often use are nothing more than a plane as seen from the front. What would the shape look like if we see the characters from a three-dimensional perspective? This project was motivated by this question and produced the total three-dimensional typeface rather than the typically made modern one. In this 3D typeface, geometric properties of each object were expressed creatively within the grid and formed to have various viewpoints instead of static 3D objects. The resulting product can be directly experienced through the tablet app.

POSTERS **Design** Yoshiki Uchida, Tokyo **Art Direction** Yoshiki Uchida **Principal Type** Custom
Dimensions 29 x 41 in. (73 x 103 cm)
This project expressed depression and humanity by using the Japanese letter "Kanji."

WEBSITE **Design** Giorgio Pesce ●, Lausanne, Switzerland **Art Direction** Giorgio Pesce **Graphic Design** Terry Fernandez **Web Developer** Clement Lador **Illustration** Giorgio Pesce **Graphic Design Studio** Atelier Poisson **Client** Swiss Institute of Bioinformatics (SIB) **Principal Type** Chromosome, Hermes, and Hermes Sans
This project started in 2009 as a big open-air exhibition: The SIB wanted to explain to a large audience what chromosomes are, how bioinformatic research is dealing with them, and maybe attract the interest of some young people. So for each of the twenty-two chromosomes, we illustrated and simplified specific problems and situations, examples, and quizzes for kids in a very simple style. In 2012, they asked us to come up with an interactive and responsive platform, using the existing material plus new content, that would be fun and easy to use as a tool for teachers but also for professionals. We used a simple language, with a base of two colors (mainly red and black) and simple illustrations.

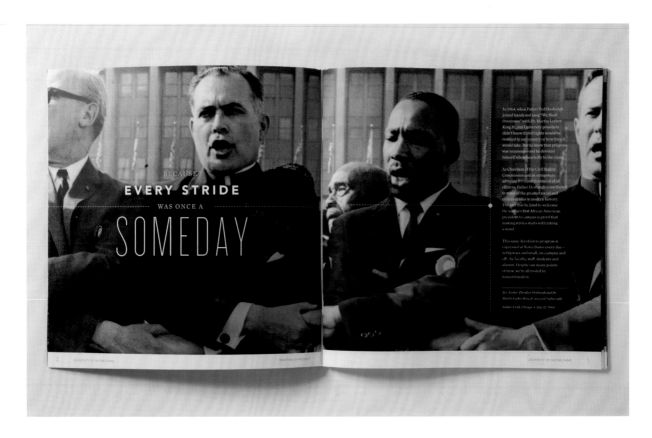

BROCHURE Design Justin LaFontaine, Philadelphia **Creative Direction** Tammo Walter
Executive Creative Director Jim Walls **Chief Creative Officer** Darryl Cilli **Writers** Anna Hartley and James Yuh
Design Firm 160over90 **Client** University of Notre Dame **Principal Type** Avenir, Chronicle G1, Cyclone Inline, and
Futura Script Regular OT **Dimensions** 9 x 9 in. (22.9 x 22.9 cm)
The University of Notre Dame's viewbook focuses on the school's unique balance of elite academics and a distinctive
Catholic experience. For the piece, we created a concept based on Notre Dame's Tradition of Progress—a culture of
innovation and creativity that forces students to understand their wider roles in the world, allowing them to make
critical, well-informed decisions. With a tone that is welcoming and challenging, confident and conscientious, this piece
engages students who value individuality while still considering their impact on the greater good.

POSTERS Design Giorgio Pesce ●, Lausanne, Switzerland **Art Direction** Giorgio Pesce **Photography** Matthieu Gafsou **Scenography and Furniture** Youri Kravtchenko **Curator** Cyril Veillon **Graphic Design Studio** Atelier Poisson **Client** Archizoom/Architecture exhibition space **Principal Type** Archizoom and EstaPro
Dimensions 35.2 x 50.4 in. (89.5 x 128 cm)
Pièces à conviction (pieces of evidence) is an exhibition about urban periphery and how to deal with it. It shows the concrete example of a periphery of Lausanne, which has succeeded in changing radically in all aspects. The pieces of evidence showing this change are physical pieces, examples taken from that area. We asked the photographer to take pictures of three very emblematic industrial buildings, and we "covered" them with black, as if they were missing. The entire exhibition was black and dark, with special black furniture designed in a simple industrial way, to stress that "crime investigation" atmosphere. Instead of a catalogue, an envelope was given at the entrance, and at each object visitors could collect the referring information they wanted to have.

BOOK **Design** Ben Barry and Tim Belonax, San Francisco **Writer** J. Smith **Agency** Facebook, Facebook Communication Design **Principal Type** Berthold Akzidenz Grotesk and Tungsten **Dimensions** 4.2 x 7 in. (10.7 x 17.8 cm)
The Book of HACK was published on the occasion of 1 billion people using Facebook. The publication is a reminder of the values and mission that led to this milestone, as well as a provocation to keep pursuing our goals.

STUDENT PROJECT **Design** Sang Wook Kim **Instructor** Gerald Mark Soto **School** School of Visual Arts, New York
Principal Type FF Din

STUDENT PROJECT Design Aran Yeo **School** School of Visual Arts, New York **Principal Type** Helvetica

Fatter Than Expected
And Kind of Lumpy

2013
TYPEFACE DESIGN

The Naked Man Doesn't Dance

TYPEFACE DESIGN 2013
CHAIRMAN'S STATEMENT
BY GRAHAM CLIFFORD

The chair and jury of the typeface design competition are a fortunate bunch. The company is good—David Berlow, Stephen Coles, Abbott Miller, and James Montalbano are each a walking tome of knowledge when it comes to the area of type design. Each judge brought with him a differing point of view on what makes a typeface great. We were sequestered in a room and battled through 197 entries from thirty-three countries. At the end, there were only fourteen typefaces left standing.

The designs were laid out in categories, and the jury went quietly through in successive waves. Any identifying marks of the designer were hidden. Surprisingly, the first cut was fairly swift; but as the day progressed, the mood became more serious. Careful analysis in some cases included comparison of entries. What ultimately shone through was the quality of the entries. The judges exhibited great knowledge, passion, and intense critical analysis and observation.

We ended up with the following winners that constitute the best typeface designs of 2012. We congratulate the winners and hope the following pages inspire current and future type designers.

I would like to point out that without an extraordinary group of individuals, this competition cannot take place. I would like to recognize and thank a great group of people who brought us the competition this year. Thank you to Carol Wahler for all her hard work behind the scenes. Thank you to Maxim Zhukov for all his hard work in coordinating the non-Latin board. Thank you to James Montalbano, who stepped in at the last minute when Margaret Calvert became snowed in at London Heathrow Airport. Thank you to the non-Latin advisory board: Huda Smitshuijzen AbiFarès, Misha Beletsky, John Hudson, Jana Igunma, Dmitriy Kirsanov, Gerry Leonidas, Ken Lunde, Fiona Ross, and John Okell. Thank you to Chris Andreola and Gary Munch for assisting on the day of judging. Finally, I want to thank everyone who entered the competition—without your talent and entries, it would have been just another chilly January Saturday in New York City.

20242

GRAHAM CLIFFORD

TDC 2013

GRAHAM CLIFFORD

grahamclifforddesign.com
@grahamclifford

Graham Clifford is a second-generation graphic designer and type director. He was trained by his father before working for some of London's best advertising agencies, including CDP and GGT. He moved to New York in the early '90s and plied his craft at Chiat/Day and Ogilvy.

Five years later, the germ of independence took root, and he opened his own design consultancy, collaborating with agencies on global brands and directly with smaller clients on projects including advertising, logo design, and brand identity.

Clients over the years have included Dell, Ford, Microsoft, American Express, AIG, Citibank, Rolex, Glenlivet, *The New York Times*, *The Los Angeles Times*, Virgin Atlantic, Molson, Teany, Orbitz, Reebok, ESPN, Absolut, HP, Kmart, and the Scottish government.

Awards have included One Show pencils, Communication Arts, Type Directors Club, and Art Directors Club appearances as well as a silver at Britain's D&AD.

Since 2006 he has served on the board of the Type Directors Club; in 2012 he was honored to become president.

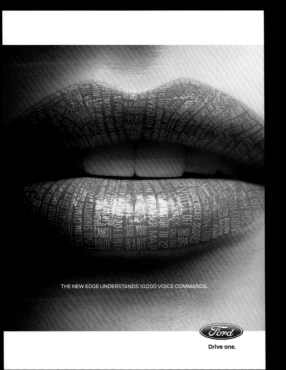
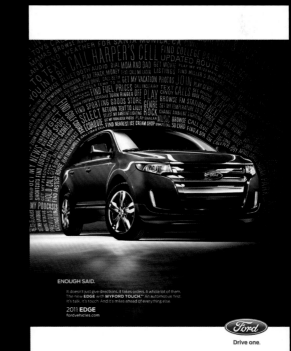

The vast majority falls into three categories: Wimps, Destroyers or Crazies.

TYPEFACE DESIGN
2013
JUDGES

94759

DAVID BERLOW

TDC 2013

DAVID BERLOW

fontbureau.com
webtype.com

David Berlow entered the type industry in 1978 as a letter designer for the respected Mergenthaler, Linotype, Stempel, and Haas type foundries. He joined the newly formed digital type supplier Bitstream, Inc. in 1982. After Berlow left Bitstream in 1989, he founded The Font Bureau, Inc. with Roger Black. Font Bureau has developed more than 300 new and revised type designs for *The Chicago Tribune*, *The Wall Street Journal*, *Entertainment Weekly*, *Newsweek*, *Esquire*, *Rolling Stone*, Hewlett-Packard, and others, with OEM work for Apple, Inc. and Microsoft Corporation. The Font Bureau Retail Library consists mostly of original designs and now includes more than 500 typefaces. In 2010 he founded WebType with several others and now works extensively for both companies. Berlow is a member of the Type Directors Club and the Association Typographique International, and remains active in typeface design.

FB KIS

Violist

Geschiedenis

FBKisDisplay Regular

FBKisDeck Regular

MODERNO FB

LADY

Moederdag

ModernoFB Light

ModernoFB SemiboldItalic

VONNES

Moerdijk

Autokeuring

Vonnes Medium

Vonnes Light Extended

EMPIRE

KRACHT

Sportschool

Empire Bold SmallCaps

Empire Regular

JULIANA

Victoria

BOEKOMSLAGEN

Juliana Text

Juliana Text Italic SmallCaps

AGENCY FB

VERKOOP

STAKINGEN

uliana Text

Juliana Text Italic SmallCaps

BUREAU GROT

Caïro

Jeruzalem

Bureau Grot Black

Bureau Grot Black

ELDORADO

KASSA

Bijeenkomsten

EldoradoDisplay Roman

EldoradoText Bold

CALIFORNIAN

Johanna

Stadstheater

Californian Bold

Californian Regular

BUREAU ROMAN

ZWEDEN

Natuurgeweld

BureauRomanZero Italic SC

BureauRomanFour Italic

GIZA

Arnhem

Willemstad

Giza 75

Giza 33

TITLING GOTHIC

HAARLEM

BOKSWEDSTRIJD

TitlingGothicFB Comp Light

TitlingGothicFB Skyline Thin

OLD MODERN

Worst

Festivalboot

OldModernCond Semi Bold

OldModern Roman

BELIZIO

Milaan

Walnootschaal

Belizio Black

Belizio Regular Italic

STEPHEN COLES

stephencoles.org
@typographic

Stephen Coles is a writer and typographer living in Oakland and Berlin. After six
FontShop as a creative director, he now publishes Fonts In Use, Typographica.
The Mid-Century Modernist, and consults with various organizations on typeface s
Coles is author of *The Anatomy of Type* and a regular contributor to *Print*.

WPA GOTHIC

A TRIBUTE TO THE POSTER ARTISTS OF THE 1930s & 1940s

READ THE BOOKS YOU'VE ALWAYS MEANT TO READ

SUPPORT OUR TROOPS
Play more tennis!

It's a fact: tennis boosts morale. When we're happy, our boys abroad are happy. So volley up!

A NAZI FEARS NOTHING MORE THEN A GAY YANK!

AABCCDEEFGGGGHIJJKHKLMN
OPQQÌRRSSSSSTUUUUWHHXYÜZ
$122334456677899{[(#&?!)]}
aaobccdefghiÁÀÅÄÉmnopq
rrsstttuuuuwwxhxyzz

A NEW TYPOMETRY
JORGE DE BUEN
INTERROBANG
UNEXPOSED {
ZARA EVENS
MAGNUS GAARDE
KARSTEN LÜCKE
LAURA MESEGUER
}
SLOW TYPOGRAPHY
JAN CONRADI

3

INTERROBANG 3

Vol. 3 No. 1 Summer 2005
A publication of The Society of Typographic Aficionados
Edited by Stephen Coles and Tamye Riggs (with help from Matthew Coles and Jon Coltz)
Designed by Stephen Coles
Printed by Moench Printing, Salt Lake City, Utah

This issue's typefaces: For *Interrobang 3*, we employ two new families, a serif and sans that are heavily influenced by the past, yet convey the very contemporary flair of their respective designers.

Eaton – designed by Randy Jones between 2003 and 2005. The text family consists of regular, italic, smallcaps, and bold. Also included are inline titling, solid titling, and ornaments for display work. Available through Fountain. [www.fountain.nu]

Maple – designed by Eric Olson between 2002 and 2005. Maple is a flamboyant family of types inspired by the irregular grotesques of the 19th and early 20th centuries. [www.processtypefoundry.com]

SOTA welcomes your submissions!
Please email article proposals, member news items, and new typeface designs for Unexposed to: interrobang@typesociety.org

Director's Office:
SOTA
attn: Tamye Riggs
3152 Fir Avenue
Alameda, CA 94502
USA

TEL 510-748-0784 FAX 510-748-6095
www.typesociety.org info@typesociety.org

Copyright ©2005 The Society of Typographic Aficionados. All Rights Reserved. All trademarks named herein are the property of their respective owners. The views expressed herein are solely the opinions of their respective contributors, and do not necessarily represent the viewpoint of SOTA. The contents of this publication may not be repurposed or duplicated without express prior written permission.

Typographica.
TYPE REVIEWS, BOOKS, COMMENTARY.

TYPE REVIEWS	▶ FEATURE	▶ DESIGNER	▶ FOUNDRY	▶ CLASSIFICATION

type of 2012

Our Favorite Typefaces of 2012

Jean Gabriel Bery
PARIS
Pont Notre-Dame
Bastille
THE 18TH CENTURY
Bery Roman, Script, and Tuscan
Fred Smeijers

BALKAN
BALKAN
Balkan Sans
Marija Juza, Nikola Djurek

SIX-CYLINDER NASCAR
3,600 RPM
HORSEPOWER WAR
$3,780
THE MACHINE
Idlewild
H&FJ

El Lissitzky
Wassily Kandinsky
Avant-garde
Culture industries
Papier Côlle
Fenland
Jeremy Tankard

GINORMOUS
INCREDIBLE
ENERGETIC
SMASHING
DYNAMITE
Timonium
Tal Leming

Fragile
übermenschen
SQUIRM
(n'est-ce pas?)
Sodachrome
Dan Rhatigan, Ian Moore

Sir & Madam
QUALM
Diplomatically
SEMIPRO
Harriet Series
Jackson Cavanaugh

neomodern
urbanism #3
fiberglass insulation
Axia
Sibylle Hagmann

BOOK REVIEWS

COMMENTARY

Dec 19, 2012 **"The Manual of Linotype Typography" is Now Online** Stephen Coles

Nov 18, 2012 **Typography and Type Design 101: Reading Lists** Stephen Coles

Sep 4, 2012 **Roof Kerning in Amsterdam** Piet Schreuders

Aug 17, 2012 **A Fruitful Discomfort: The Face of the 2012 Olympics** Hrant Papazian

Apr 6, 2012 **Robothon 2012, RoboHint, and the Gerrit Noordzij Prize** Dan Reynolds

Dec 30, 2011 **My Favorite Font Sources: A Shortlist of Trusted Foundries and Retailers** Stephen Coles

Oct 19, 2011 **Roboto is a Four-headed Frankenfont** Stephen Coles

Sep 29, 2011 **The Average Font** Stephen Coles

Apr 26, 2011 **The State of Webfont Quality from a Type Designer's View** Ross Mills

COLOPHON

Typographica is a review of typefaces and type books, with occasional commentary on fonts and typographic design. Edited by Stephen Coles, also of Fonts In Use and The Mid-Century Modernist.

Founded in 2002 by Joshua Lurie-Terrell. Relaunched in 2009 by Coles and Chris Hamamoto.

Set in Adelle Sans by Typetogether; Turnip by David Jonathan Ross, and JAF Bernini Sans by Tim Ahrens.

Brought to you by this month's nameplate sponsor, FontShop, MyFonts, FontFont, Wordpress, and the letter B. Read our editorial policy.

FEATURES
Typefaces of 2012
Typefaces of 2011
Typefaces of 2010
Typefaces of 2009
Typefaces of 2008
Typefaces of 2007
Typefaces of 2006

SECTIONS
Books
Commentary
Type Reviews

FEEDS
Reviews & Commentary RSS
Reader Comments RSS

CONTACT US
Via Email
Typographica on Twitter

SPONSOR
sticker mule
Sticker Mule is the easiest way to buy custom stickers.
Ads Powered by Fusion

OTHER SPONSORS
DHgate.com is The World's Leading B2B Online Trading Marketplace for China
Wholesale Products
Wisenuwerkes Alltag
Wix.com - Free Websites
Essay Camp - writing company helping students worldwide.
Mycustomessay.com - leading custom essay writing service.

ELSEWHERE
Fonts In Use
Type at work in the real world.
The Anatomy of Type
A book about the finer details of typefaces.

A NEW TYPOMETRY
JORGE DE BUEN

BEYOND POINT SIZE

※ CONTENTS ※
A NEW TYPOMETRY
JORGE DE BUEN
4
UNEXPOSED
NEW TYPEFACES
16
SLOW TYPOGRAPHY
JAN CONRADI
26

From the Director's Chair

It's hard to believe that it's been a year since our last issue of Interrobang. Although it is our goal to publish twice a year, the time goes so quickly when other priorities loom.

One such priority is our annual conference, TypeCon. This year, we've had the pleasure of working with two of the most respected organizations in New York City: the Type Directors Club (TDC) and Parsons School of Design.

Although we've partnered with schools in the past for workshops and special events, we've never held the main program inside their hallowed halls. TypeCon attendees are accustomed to rolling out of bed to grab coffee and a muffin and slip into the first session of the day in a ballroom at the conference hotel. This year, we'll take the train or cab it, or even walk the 30-odd blocks to Parsons each day from our sleeping quarters at the Roosevelt or wherever we may be.

I was initially a bit concerned about how attendees would feel about commuting more than an elevator ride to the conference venue. True, dammit Carol Wahler, a native New Yorker, assured me that this would be part of the New York experience. I took her word for it.

At TypeCon, we embrace the city we're in each year, making it as much a part of the event as possible. Tell us about your New York typographic experience during Type Week and TypeCONspire. Email us text and pictures, and we'll broadcast them to the world on TypeCon TV.

Tamye Riggs
Executive Director, SOTA/TypeCon

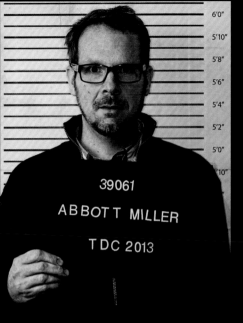

ABBOTT MILLER

pentagram.com
@abbottmiller

Abbott Miller's work as a designer encompasses identity, branding, exhibitions, signage, publication design, and web design. He and his team have evolved a uniquely hybrid design practice that crosses from page to screen to interior environments and objects. He has also embraced the role of editor, writer, and curator in many of his exhibition and publication projects, working on projects that fuse his interests in the history and theory of art, architecture, performance, fashion, and design.

Miller's environmental projects include exhibitions and major wayfinding projects, including the signage for new Barnes Foundation building in Philadelphia. Over the course of his career, Miller has collaborated with a number of artists to create distinctive books, including Nam June Paik, Hans Haacke, Matthew Barney, Yoko Ono, Diller Scofidio and William Kentridge. He has also written extensively about design: his books include *Design Writing Research*, *The Bathroom, the Kitchen, and the Aesthetics of Waste: A Process of Elimination*, *The Bauhaus and Design Theory*, and *Swarm*.

He is a member of the Alliance Graphique Internationale, AIGA, and SEGD. Miller's work has received numerous awards and is represented in the design collections of the San Francisco Museum of Modern Art, the Art Institute of Chicago, and the Cooper-Hewitt. In 2009 he received the Augustus Saint Gaudens Award for Art from his alma mater, The Cooper Union.

95348

JAMES MONTALBANO

TDC 2013

JAMES MONTALBANO

terminaldesign.com
@TerminalDesign

James Montalbano began his professional career as a public school industrial arts teacher, trying to keep his young students from crushing their hands in the platen presses. Having to teach wood shop was the last straw, and he quit and went to graduate school. After receiving a master of education degree in technology education, he studied lettering with Ed Benguiat and started drawing type and working in the wild world of New York City type shops and magazine art departments. He served as a magazine art director before moving on to become a design director responsible for twenty trade magazines whose subject matter no one should be required to remember. He was talked into designing pharmaceutical packaging, but that only made him ill. He started Terminal Design, Inc. in 1990 and hasn't been sick since.

Since 1995, Montalbano has been working on the Clearview type system for text, display, roadway, and interior guide signage. His work has been featured in The New York Times, Print, Creative Review, ID, and Wired, and is in the permanent collection of the Smithsonian Cooper-Hewitt National Design Museum.

He is a past president of the Type Directors Club and has taught typography at Pratt Institute. He currently teaches type design at Parsons The New School for Design and the School of Visual Arts in New York City.

AUDERE

EST

FACERE

The Qualities Of the Squid, As Observed In the Capitol

TYPEFACE DESIGN
2013
JUDGES' CHOICES

The Brill Types are a family of large and complex fonts commissioned by the academic publisher Brill. In 2013, Brill will celebrate its 330th anniversary as a publisher of scholarly works in the humanities. During that long history, Brill has published works in or about many dozens of languages both living and dead. Their needs are both linguistically exacting and typographically sophisticated. The fonts support an extensive Latin character set, including all aspects of the International Phonetic Association notation system, diacritics for transliteration of many other writing systems, and specialist characters for medievalist and classical scholarship. The Greek set supports not only the standard polytonic and monotonic orthographies but also archaic letters, classical weights and measures, acrophonic numbers, and provision for nonstandard diacritic combinations as encountered in some manuscripts. The Cyrillic set is currently limited to Slavic languages, the publishing focus of Brill's Cyrillic use, but includes locale-specific variant forms for Balkan languages. An extensive set of symbol characters, various numeral sets, arbitrary fraction support, and a set of fraktur letters for use in apparatus critici round out the glyph complement. Each of the four fonts in the family contains around 5,000 glyphs, supporting not only an extensive character set but also sophisticated typographic options, with true smallcaps for all alphabetics including rare and historical characters, ligating contextual forms, and dynamic mark positioning. John Hudson was assisted in the design of the bold weights by Alice Savoie. The fraktur letters were designed by Karsten Luecke. As well as being used in Brill publications, the types are being made available under free non-commercial license for use by scholars and in education.

JUDGE'S STATEMENT

Looking at the many adventurous and eye-catching entries to this year's TDC competition, I kept putting my chips in for this quiet Roman in the corner. I'm a big fan of text for long reading, but this typeface took me the distance in time, space, and typography. I had to stare at it quietly for a while to figure out what was included because it's all so pleasantly integrated. From the fraktur to the Euro to 16/32, Roman and italic, old and new, simple and complex, whatever a Latin writer would need to publish a good book for reading, this font's got it, and well done—my favorite.

94759
DAVID BERLOW
TDC 2013

Au IVe siècle, Denys d'Alexandrie, dans ses Scholies à l'Ecclésiaste,[5] procède à une lecture anagogique des paroles de bonheur chez Qohélet. En recourant au genre littéraire des *scholies*, il situe les paroles sur le manger et le boire en relation avec le banquet eschatologique. *Ainsi, dans son explication du propos sur le bonheur de 2, 24–25, le disciple d'Origène relie le thème de la joie au banquet divin à venir:*

Ὅτι μὴ περὶ αἰσθητῶν βρωμάτων ὁ λόγος νῦν, αὐτὸς ἐποίσει· ἀγαθὸν πορευθῆναι εἰς οἶκον πένθους ἢ εἰς οἶκον πότου, καὶ ἃ τοῖσδε νῦν ἐπήγαγε· καὶ δείξει τῇ ψυχῇ αὐτοῦ ἀγαθὸν ἐν μόχθῳ αὐτοῦ. Καίτοι οὐκ ἀγαθὸν τῇ ψυχῇ αἰσθητὸν βρῶμα ἢ πόμα· ἡ γὰρ σὰρξ προστρεφομένη πολεμεῖ τῇ ψυχῇ καὶ στασιάζει κατὰ τοῦ πνεύματος. Πῶς δὲ καὶ οὐ πάρεξ θεοῦ ἀσωτία βρωμάτων καὶ μέθη; Οὐκοῦν περὶ μυστικῶν φησι· πνευματικῆς γὰρ τραπέζης οὐδεὶς μεταλήψεται, μὴ παρ' αὐτοῦ κεκλημένος καὶ τῆς σοφίας ἀκούσας· ἐλθὲ καὶ φάγε.

В одном из вагонов третьего класса, с рассвета, очутились друг против друга, у самого окна, два пассажира, —оба люди молодые, оба почти налегке, оба не щегольски одетые, оба с довольно замечательными физиономиями, и оба пожелавшие, наконец, войти друг с другом в разговор. *Если б они оба знали один про другого, чем они особенно в эту минуту замечательны, то, конечно, подивились бы, что случай так странно посадил их друг против друга в третьеклассном вагоне петербургско-варшавского поезда.*

s'əhajɪnna kəsəmen bəkkʷʊl jemminəfsəw nəfas ine nɛɲ t'ənkarra ine nɛɲ t'ən-karra bəmmil jɪkkərakkəru nəbbər. bəzzi gize and məŋgədəɲɲa jebɪrd mək-kəlakəja lɪbs ləbso jɪggʷaz nəbbər.

jeuꜚ jetꜚ tsʰi꜔ | pekꜚ fʊɲꜚ tʰʊɲꜚ tʰai꜔ jœɲꜚ hei꜔ tou꜔ au꜔ ken꜔ pin꜔ kɔ꜔ lekꜚ ti꜔ ‖ kʰθyꜚ tei꜔ am꜔ am꜔ tʰia꜔ tou꜔ jeu꜔ kɔ꜔ jen꜔ heɲꜚ kʷɔ꜔ liꜚ kɔ꜔ jen꜔ tsœk꜔ tsy꜔ kin꜔ tai꜔ leuꜚ ‖

At fravaxshyâ nû gûshôdûm nû sraotâ ýaêcâ asnât ýaêcâ dûrât ishathâ nû îm vîspâ cithrê zî mazdânghô-dûm nôit daibitîm dush-sastish ahûm merãshyât akâ varanâ dregvâ hizvâ âveretô.

Sarvē mānavāḥ svatantrāḥ samutpannāḥ vartantē api ca, gauravadṛśā adhi-kāradṛśā ca samānāḥ ēva vartantē. Ētē sarvē cētanā-tarka-śaktibhyaṁ susam-pannāḥ santi.

41 ⌐† ουκ εγεννηθημεν B D* .2 | ου γεγενημεθα 𝔓⁶⁶ N W 0250 f¹³ 565 *al* | *txt* 𝔓⁷³ ℵ² C D¹ Θ Ψ f¹ 33 𝔐 (ℵ* L 070: ουκ εγ–); Or · **42** ⌐ουν ℵ D Δ 070 f¹³ 700. 892. 1424 𝔐 aur f vg sa^mss | ⌐ 𝔓⁶⁶ B *pc* | ⌐εκ γ. του θ εξεληλυθα 𝔓⁶⁶ | ⌐ου 𝔓⁶⁶ D Θ (579) *pc* it | ᶠ–σταλκεν 𝔓⁶⁶

DESIGNER'S STATEMENT

Bernini Sans was designed to speak with a clear and definite voice but without commenting on the text. In situations when the content is heterogeneous or unknown—such as in news websites or papers—the parametric extremes such as compressed or extrabold can give headlines a strong visual presence without stylistically interfering with the articles or images. From a formal point of view, the family is inspired by the sturdy, unpretentious Franklin Gothic and its "sculpted," rather than pen-based or monolinear, approach. It features open apertures in letters such as a, c, e, g, and s but combines them with round counters and shoulders flowing in. This formal paradox is rare but not unseen, most notably in Frutiger. JAF Bernini Sans's finely balanced weight distribution and open shapes make it a great text face, while the wide variety of weights and widths provide the designer with a rich toolbox for headings and display typography. What's more, each style of Bernini Sans includes two fonts: JAF Bernino Sans and his sister, JAF Bernina Sans—a more playful version with alternate shapes such as round dots and a double-story g. The alternates are also available as OTF features, so you can mix and match them without having to switch fonts.

JUDGE'S STATEMENT

Type design is a skill that has spread wide and fast in the past few years, and this democratization of the craft showed in the quality of the entries. Nearly all of them were well drawn and competently produced. The trouble is that there was very little among these accomplished designs to get excited about. We found ourselves repeating, "Nice execution—where's the concept?"

So, if we were starved for excitement, why would I call your attention to this plain-looking, utilitarian design? The answer is as plain as the face: JAF Bernini Sans is the entry I was most excited to use. As with Lucida Grande (Sans), the operating system font that is as familiar to Mac users as the Apple menu, Bernini delivers content without any effort. It functions like an involuntary muscle. In many contexts, it is as close as we can get to an "invisible" typeface.

Of course, invisibility is not in itself a virtue. What makes

Tamagoyaki

Klöße

Gateau de ménage

ROAST BEEF

Äg

Äg

Skalický trdelník

Nougat

Crêpes & Cider

BRÖSELSCHMARRN

DESIGNER'S STATEMENT

Athena Ruby is a specialist typeface for scholars of Byzantine sigillography and numismatics, i.e. , the study of official seals and coins. It was commissioned by the Dumbarton Oaks Research Library & Collection in Washington, DC, one of the foremost publishers in the field, and will be used in their print, electronic, and web editions as well as being made available to scholars. The font supports uncial Greek and Latin text, and most characters have multiple variant and ligated forms representing the changing appearance of the two alphabets across more than a thousand years. These variant forms may be substituted using OpenType Layout features, enabling scholars, for the first time, to represent the visual appearance of particular seals and coins while preserving cleanly encoded, searchable Greek or Latin text. Athena Ruby is also a kind of palaeographic encapsulation: a font that reveals the often unexpected shapes that letters have taken, the use of the same form to represent different letters in different times and places, and the origin of some of the discrepancies between the related Greek, Latin, and Cyrillic scripts. The study of Byzantine seals and coins is a highly specialized field: The intended user base for the Athena Ruby font is about twenty people worldwide (which isn't to say that other people might not find it an interesting and unusual display typeface).

The Athena Ruby project was initiated and guided by Joel Kalvesmaki, Dumbarton Oaks. The fonts were hinted for enhanced screen readability by Ross Mills, Tiro Typeworks Ltd.

JUDGE'S STATEMENT

I was drawn to Athena Ruby as a provocative example of an "interfont," a bridge between historical writing systems and technical platforms. Although conceived for an incredibly specific and limited audience, it will have a strong impact on interpretation and scholarship. A critique of typography in many quarters is that "we don't need another X or Y font," but Athena Ruby is an example of a typographic project that is deeply needed, albeit by a very small number of

· SⲘOI · |ⲔONOMⲱ|TⲱNΔVCIK,|ЄⲠICKЄѰЄ|ⲱNTⲱXPV

+ ΘЄⲱ|PǪЄIΘ,|TⲱCⲱΔ|ǪVΛ,

+ NHKO|.AOP,CⲠA|.ĶЄKⲱMЄP|.IAPIO.|.CЄOϛ

ⲔЄPOHΘHTⲱCⲱΔꙒΛ|IⲰAN|CⲠAVΘA|ṢAPXONP|ĘΔЄCTO

ODDA·DVXIVSSIꙀ·ⱨⱮ/C·REGIAM·AVIAM·CONSꙀRVI·AꙀQVE
DEDICARI·IN·HONORĒ·Ṡ·ꙀRINIꙀAꙀIS·PRO·ANIMA·GER
MANISVI·ÆLFRICI·QUE·DE·HOꞒ·LOCA·SV̄PꙀA·EALDREDVS

ΦOЄ
OΔUPOC
+ΔЄCⲠOT+
HCOΔOЧ
ⲔΛC

ⲔⲰN|ʃⲠΔΘ,PⲰ|ⲔANΔΔ,
ΔCH|KPIT,R̄N,|TaPI,| - ∴ -

dNⱨЄPACLI ЧSPPAVC

VICTOPIAAVꙄЧ CONOb

BPOTⲰ̂N|ṖOⱨ̇Cⱨ̇CTÁCIC
TÀCPÁ̵ЄICKV́PꙄAIⲰCIⱧAKPOÎ
TⱧ̂CṖOⱨ̂CAÍ|XAKÓPⱨ

M̅P̅ Θ̅V̅ H ΛΦHOCⲰPHTHCΔ | ΘЄOΔⲰPOCΔЄCⲠO
IⲰΔЄCⲠO ⱭΔHMHT Ō̅ΔⱧ IⲰΔ ЄѰⲠ

SUM SPECULUM VITE IOHⱭNNES ꙀHⱭINIER EꙀ RIꙀE

TYPEFACE ATHENA RUBY Design John Hudson ● , Canada Foundry Tiro Typeworks Ltd., Canada
Client Dumbarton Oaks Research Library & Collection, Washington, DC

Karol is a text type family specially designed for the composition of books, but it allows a wider range of uses. With proportions inspired by the Renaissance, it has great personality in display sizes without losing delicacy in bodies of text, providing a very comfortable reading and excellent legibility. It is also inspired by wood engraving and by some masters whose work is very calligraphic, such as Bram de Does, Oldricht Menhart and Rudolph Koch. Karol has all the indispensable OpenType features for a text typeface like small capitals, different sets of figures, fractions, and many others. The old-style figures are standard.

JUDGE'S STATEMENT

Karol is a type family I wish was done in metal. That way users would be forced to set it in very specific sizes, none of which should be over 14 points. When I first suggested the design to my fellow judges, their comments were, "Look at those terrible ink traps; they don't add anything to the design" and "Can you see some junior art director falling in love with something so hideous?" I agreed, but then I pointed them to how the design functioned in text sizes. They all agreed that in small continuous text, the design sparkled. So that is how it should be used: small, 6-12 points, and as continuous text. If the designer of Karol submits a showing of the font in large sizes, you will know he didn't pay attention to the reasons I chose it.

6'0"
5'10"
5'8"
5'6"
5'4"
5'2"
5'0"
4'10"

95348

JAMES MONTALBANO

TDC 2013

victory

«Berlinstraße & Marienplatz, Munich»

¿€1569?

{LA LUTTE CONTRE L'IMPUNITÉ}

Tipo Latino

En 2010 España ganó su 1º título en el mundial de la FIFA

Hollande or Holland?

A nice effect

Subjects considered too shameful to discuss are not shrouded.

TYPEFACE DESIGN
2013
WINNERS

Italic	*Carpano & Bianchi*
Regular	FAUSTO COPPI
Medium Italic	*Il Campionissimo*
Medium	World Champion
Bold Italic	***Castelleto d'Orba***
Bold	**The Hour Record**
Extra Bold Italic	***Every grand tour***
Extra Bold	**GIRO D'ITALIA**

TYPEFACE BLANCO Design David Foster, Sydney **Client** Royal Academy of Art (KABK), Den Haag
Members of Typeface Family/System Regular, Italic, Medium, Medium Italic, Bold, Bold Italic, Extra Bold, and Extra Bold Italic
Blanco is a typeface intended for extending reading, optimal for small sizes in print. It has a sturdiness derived from the influence of
typefaces like Plantin, Fleischmann, and Caslon. It was made as the final graduation project at the Type and Media Masters Program
at The Royal Academy of Art (KABK) in Den Haag. Lecturers: Erik van Blokland, Paul van der Laan, Peter Verheul, Peter Bil'ak, and
Christoph Noordzij.

SNØKRYSTALL

Carnutum Carnotum

FROSTRØYK

1816 — The Year Without a Summer

Diagonalgang

The Pole Perspective

TYPEFACE VINTER **Design** Frode Bo Helland, Oslo, Norway **Foundry** Monokrom
Members of Typeface Family/System Regular and Light

The words "designed in Norway" usually evoke images of a cold, clean style. You don't have to stay here long to understand why—under snow-covered mountains, on islands surrounded by endless blue seascapes, or in tiny wooden cottages in the vast pine woods. Circumstances like these can easily strip crafts of ornamental bells and whistles, leaving nothing but bare necessities. Vinter is an unusual meeting between stark geometry and subtle contrast. More line than shape, basic geometric figures such as the circle, square, and triangle invite playful compositions, overlaps, and deconstruction. Vinter's cursive deviates from the norm in several ways. It is a so-called true italic, i.e., the shapes are not necessarily oblique variants of the Roman—in itself unusual enough for a geometric sans serif. This is very obvious in the letters a, e, f, j; they all have the typology of italic letters, contrasting the Roman in more ways than slant alone. More radically, the glyphs derived from circles retain their roundness instead of being distorted into slanted ellipses, shifting merely the contrast around. One would think that a concept like Vinter's would easily lend itself to a typeface ladled with ligatures, swashes, and conceptual alternates. But in keeping with the simplicity and no-nonsense approach to type design that is at the heart of Monokrom's philosophy, it has almost none. Vinter speaks its own language and needs neither embellishment nor fancy dress.

TYPEFACE ISKRA **Design** Tom Grace, Heidelberg, Germany **Foundry** TypeTogether, Prague, Czech Republic
Language Latin and Cyrillic
Members of Typeface Family/System Ultra Thin, Ultra Thin Italic, Thin, Thin Italic, Light, Light Italic, Regular, Italic, Medium, Medium Italic, Bold, Bold Italic, Ultra Bold, and Ultra Bold Italic
A practical sans serif needn't look dry, constructed, or derivative. It can excel in its role of making texts comfortable to read and still possess a distinct flair. Iskra (spark or flash) is a lively sans serif typeface that offers a fresh look at the relationship between the utilitarian and decorative. Its forms are a subtle tribute to the less-predictable style of brush lettering and contain elegant curves, economical proportions, and a slight top-heavy asymmetry. Its warm tones come from an attention to the unique details of individual letterforms, whereas its solidity is based on a balanced rhythm suitable for long spans of text. The type family is an excellent choice for presentations, articles, branding, and advertising. The full character repertoire comprises an extended Latin as well as a Eurasian Cyrillic set that supports the major languages in the CIS. Iskra is also available in Latin-only and Cyrillic-only subsets, providing a better value for a broader marketplace.

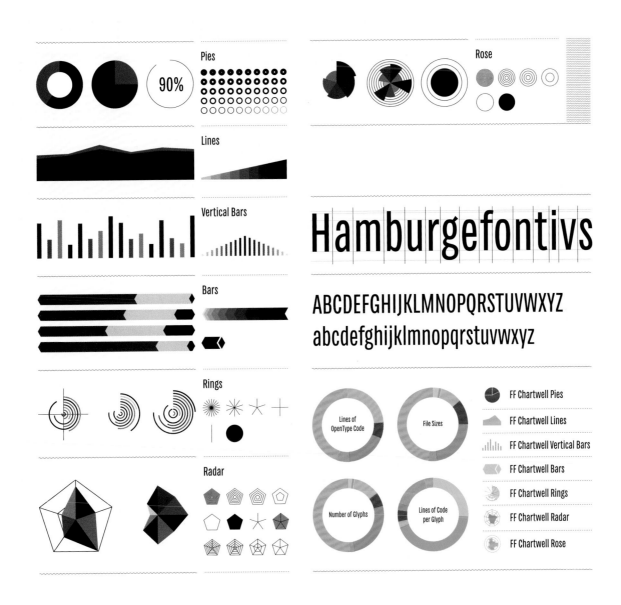

TYPEFACE FF CHARTWELL Design Travis Kochel, Portland, Oregon **Foundry** FontFont, Berlin
Members of Typeface Family/System Bars, Bars Vertical, Lines, Pies, Radar, Rings, and Rose
FF Chartwell is a typeface for creating simple graphs. Driven by the frustration of creating graphs within design
applications and inspired by typefaces such as FF Beowolf and FF PicLig, Travis saw an opportunity to take advantage
of OpenType technology to simplify the process. Primarily suitable for Adobe Creative Suite, FF Chartwell for print
uses OpenType ligatures to transform strings of numbers automatically into charts. The data remains in a text box,
allowing for easy updates and styling. You simply type a series of numbers such as: "10+13+37+40." Turn on ligatures
and a graph is created. Turn off ligatures to see the original data. In September 2012, we released FF Chartwell Web.
All the chart-drawing functions of FF Chartwell Web are provided as small JavaScript libraries. To create a chart,
you enter the values in a similar way to the desktop font and use HTML code to determine color and appearance.
FF Chartwell was originally released in 2011 under the TK Type Foundry. It was added to the FontFont library in May
2012 with the addition of four new chart styles.

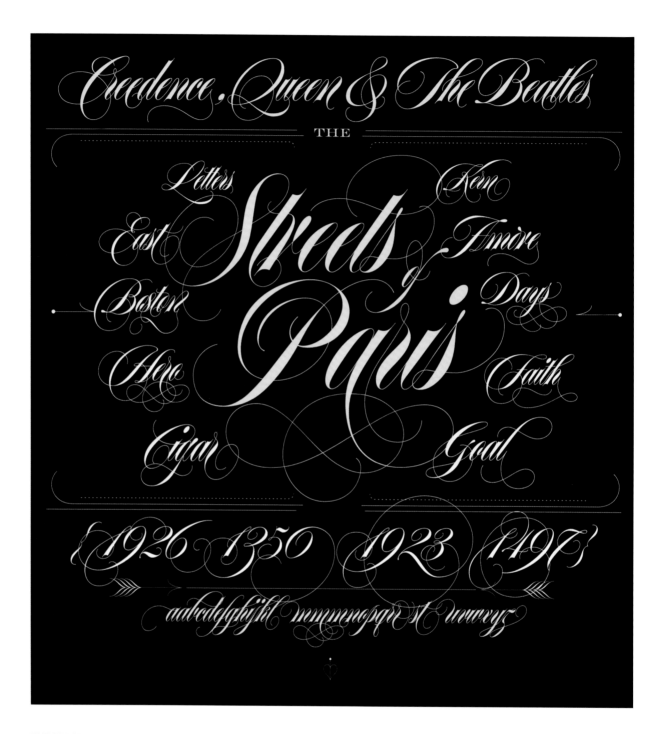

TYPEFACE EROTICA **Design** Maximiliano Sproviero, Buenos Aires, Argentina **Foundry** Lian Types

"Know the forms well before you attempt to make them" is what E.A. Lupfer, a master of this kind of script, used to say a century ago. Encouraged by these words, Erotica follows the essential rules of the Roundhand or Engrossers Script form of calligraphy and takes them to the extreme. Some calligraphers, graphic artists, and type designers experimented in this field in the mid- to late twentieth century and made a playful style out of it: Letters show a lot of personality, and sometimes they seem drawn rather than written. Erotica has that something that makes its glyphs look alive. The transition from its shades to its thins had to be smooth to achieve this, which I would also call sensuality. Many alternates, ligatures, and variations for each glyph were designed in order to satisfy the needs of the user.

It was not only my own hand that inspired my work. I want to use this space to express my sincere admiration to the fantastic Herb Lubalin and his friends Tony DiSpigna and Tom Carnase, and of course my fellow countryman, Ricardo Rousselot. All of them, amazing.

Selection
Logotypen
Reisezeitschrift
Turnbeutelvergesser
was glauben diese Leute denn

Hubert Jocham

TYPEFACE JOCHAM **Design** Hubert Jocham, Lautrach, Germany
People ask me about the typeface my new logotype is based on. But it did not exist, and I did not believe that it would actually work. I still love my logotype, and so I went on to try to make it work as a font. After many versions and some doubts, I am glad to present Jocham. It is the first typeface with my name, for an obvious reason.

ימים ולילות באַרבעה משקלים

ימים - המשקל הרגיל:

אבגדהוזחטיכלמנסעפצקרשת
רסוףץ?!;::,,""+=–{}([|)(א/שם*0123456789[|])}

לילות- המשקל הנטוי:

אבגדהוזחטיכלמנסעפצקרשת
רסוףץ?!;::,,""+=–{}([|)(א/שם*0123456789[|])}

ימים שחורים - המשקל השמן:

אבגדהוזחטיכלמנסעפצקרשת
רסוףץ?!;::,,""+=–{}([|)(א/שם*0123456789[|])}

לילות חשוכים - המשקל הנטוי השמן:

אבגדהוזחטיכלמנסעפצקרשת
רסוףץ?!;::,,""+=–{}([|)(א/שם*0123456789[|])}

TYPEFACE DAYS AND NIGHTS Design Ben Nathan, Jerusalem **Foundry** hafontia.com
Client Bezalel Academy of Arts and Design, Jerusalem **Language** Hebrew
Members of Typeface Family/System Regular, Italic, Bold, and Bold Italic
"Days and Nights," a thesis on the possibility of a Hebrew italic, was designed as my graduation project at the Bezalel Academy of Arts and Design, Jerusalem. The upright style (Days) was developed in the first semester of my final year as a calligraphy-based typeface for display purposes. That experience has led me to further explore styles within the Hebrew script. For my final project I decided to work on an italic counterpart to the upright font I designed, which is a challenge because Hebrew has no official italic style. Most render the italic style of contemporary Hebrew faces as an oblique version of the upright, with no alternative or unique features, albeit a slanted manipulation. The work on the italic face began with historical and contemporary audits of Hebrew faces and scripts, as well as a reworking of the original upright design to make the typeface suitable for use as a text face. During research on Hebrew italic-like styles, I found the Hebrew semi-cursive script, perfected in the twelfth century as a secular alternative to the formal square letter used exclusively for sacred texts. This script served as a major reference point in my work. In the design of the italic style (Nights), my goal was to create a harmonious type family that will have the same color and motives. This was achieved by reworking the skeleton of the upright style while maintaining the values of the letters' expressions, treating the new slanted forms with a cursive calligraphic feel and fewer decorations.

水のこころ

水は つかめません
水は すくうのです
指をぴったりつけて
そおっと 大切に

水は つかめません
水は つつむのです
二つの手の中に
そおっと 大切に

水のこころ も
人のこころ も

なに。とりなくこです ゆめ
さませ みよあけわたるひ
んかしを そら いろ はえ
て おきつへに ほふねむ
れぬ もやのうち。

れぬ

ありがとうございます

ではありませんでした

つけペンは先端にインクを付けながら筆記・描画に用いるペン。

あ妹ゆ遠ポ限

TYPEFACE TEGAKI Design Neil Summerour ●, Jefferson, Georgia **Foundry** Positype **Language** Japanese
Tegaki is a Japanese typeface modeled on the American Spencerian Script styles that evolved during the early nineteenth century. Replacing the dipped brush with the dipped-ink steel nib, early development of the typeface yielded a common system of movements, stresses, and modulations that proved that a "Japanese Spencerian" would be possible. The naturally beautiful Japanese letterforms took on a new life, allowing personal expression and improvisation, with OpenType providing the necessary platform for ligatures, extremes in movement, and baseline liberties to be realized.

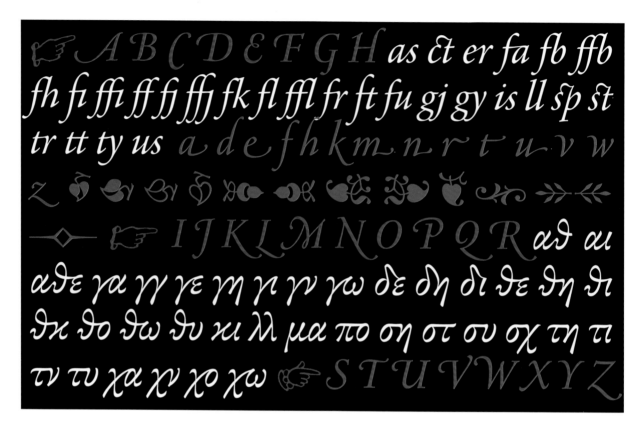

AGMENA™ ‖ Book *Italic* ◆ Regular *Italic* ◆ **SemiBold** *Italic* ◆ **Bold** *Italic*

In every period there have been better or worse types employed in better or worse ways. The better types employed in better ways have been used by the educated printer acquainted with standards and history, directed by taste and a sense of the fitness of things, and facing the industrial conditions and the needs of his time. Such men have made of printing an art. The poorer types and methods have been employed by printers ignorant of standards and caring alone for commercial success. To these, printing has been simply a trade. The typography of a nation has been good or bad, as one or other of these classes had the supremacy. And

Οι δεκαετίες του 50 και 60 είδαν την άνθηση του International Style –της λεγόμενης «ελβετικής» σχολής σχεδιασμού. Τα πιο γνωστά γεννήματά της στο χώρο των γραμματοσειρών είναι η Neue Haas Helvetica και η Univers, ξεκάθαροι αντιπρόσωποι της τάσης για ορθολογικοποίηση και κανονικοποίηση των γραμματομορφών. Εκείνον όμως τον καιρό η Ελλάδα βρισκόταν σχεδιαστικά τρεις δεκαετίες πίσω: η Monotype λανσάριζε την οικογένεια των Times, που είχαν πρωτοσχεδιαστεί το 1932, και έχει τις ρίζες της στα εντελώς διαφορετικά πρότυπα του Ολλανδικού 16ου αιώνα. Τα ελληνικά Times ενσωμάτωσαν αυτή την ασυνέπεια επιρροών στο σχεδιασμό τους, διαπράττοντας το πρώτο χν

Милијана се тргла и нагло окренула, затим се опет вратила у непомичан положај у коме је већ неко време била. Гледала је у један навиљак сена, који је личио на рушевину. У том навиљку она је препознала себе, и у свакој осушеној травци јасно видела своју судбину. А онда је изненада праснула у смех сетивши се свих лудости које је у младости, једра, луда и млада чинила у сену, опијена љубављу. Сетила се и речи: ›пицање‹, ›чора‹, ‹јалоцuja‹. Те речи су за тренутак потпуно промениле њено расположење. Младост јој се вратила у мислима, мириси сена и јагода, Зокијеви знојави мишићи, који су ломили и њу и сено и читаву обл-

TYPEFACE AGMENA™ Design Jovica Veljovic, Hamburg **Foundry** Linotype Germany
Members of Typeface Family/System Regular, Italic, Book, Book Italic, SemiBold, SemiBold Italic, Bold, and Bold Italic
Jovica Veljovic is well known for his typeface designs and his masterful calligraphy. It is less widely known that Veljovic is also passionate about handsomely printed antique books. His Agmena typeface pays homage to this passion. "Though many of my typefaces are used to set books and publications," he says, "none of them were designed specifically for this purpose." Veljovic originally drew what was to become Agmena as part of several book design commissions dating back to 2000. "I was able to see how the typeface performed when printed in various publications," Veljovic recalls. "After each project, I carefully studied the results and made subtle—and sometimes not so subtle—changes to the design." After twelve years of fine-tuning, Veljovic was ready to release Agmena as a suite of commercial fonts.

TYPEFACE BALDUFA **Design** Ferran Milan Oliveras, Barcelona **Language** Arabic and Latin
Members of Typeface Family/System Regular, Italic, Bold, and Arabic

Baldufa is a typeface for books, catalogs, and small publications with cultural content (art, design, etc.). It is designed to be used in bilingual publications—Latin and Arabic—however, both scripts can work well individually. The typeface's natural environment is editorial material where users are looking for added value rather than just a compilation of information—an interesting object to be kept. The font family provides a wide range of weights to cover all the needs for book design: Roman, italic, bold, small caps, ligatures, and an Arabic companion. The design of the typeface explores the structure of the letter, breaking with some conventional ways of distributing contrast, stems, or serifs. The anatomy of the letters abandons the coherent movement of the nib pen to introduce more expressive and personal shapes. The final design provides movement, repetition, and expressiveness in text, encouraging the reader to read.

Ads Try for Hip and Edgy
But Become Offensive

———————

ins with Mr. Sh

TDC10
AWARDS CATALOG

FROM THE TDC BOARD OF DIRECTORS

What the judges said about the following pages in 1964:
The state of the art of typography… American designers splitting from European influences… The beginning of a new era in typography… Overall raising of the level of quality of design criterion for selection: Visual effectiveness and excellence of design… Examples of good type/weak design were voted down… Fine design/weak type were similarly voted down (but have been seen in other art director club shows)… More sophistication is evident…"

What follows is an accurate reproduction of the TDC's tenth typographic competition, Galley 10. Galley, for those who may not be familiar with pre-digital page makeup, was typeset copy provided by a typesetting house and used for a paste-up or "mechanical." The paste-up was subsequently photographed and converted into a printing plate for reproduction.

The TDC typographic competition started in 1955 for members only and had no catalog of winners. The 1956 competition was the first to have a catalog. The TDC competition was opened to global entries in 1956.

The Board of Directors began reprinting the early catalogs of competition winners with its *Typography 26* in 2005 to preserve those early documents that were beginning to age and fall apart. There is much that can be learned from these older examples: The design relationships may be simpler, but they are precise and reveal outstanding visual thought. Finding inspiration—and fresh interpretations of these ideas in modern terms— is a subtle and effective way to hide your sources. And, as Albert Einstein is credited with having said, "The secret to creativity is knowing how to hide your sources."

GALLEY 10 / *The 10th annual awards exhibit of The New York Type Directors Club, 1964.*

Final proof: The award-winning pieces pictured here are the product of electronic judging by Freeman Craw, Vice President and Art Director, Tri-Arts Press. Martin Solomon, designer and typographic consultant, Royal Typographers, Inc., and Arnold Shaw, designer and typographic consultant, The Composing Room, Inc. The selecting procedure was non-verbal and the judges were aware only of their own vote. It was, therefore, an impartial vote.

Here are some comments by the judges:

"To judge the entries submitted to GALLEY 10 is to judge the state of the art of typography. The application of typography for the last several years has been influenced by our European colleagues. However, there has been an attitude, expressed by many American designers, to create a definite image within his own right . . . an image that rejects any pre-set formula and permits the individual to express himself in his own creative way.

"Very obvious in many pieces submitted to GALLEY 10 is the intelligent handling of the total type medium. The awareness of typographical refinements is revealed not only in headlines and text but in the extreme intermediate parts of the design page. This was not a year of typographical fads (although some indication of one was seen in several entries). I feel we are entering an important era in typography . . . one that will give the designer and type director a chance to regain his balance and go on to apply all his creativity to the art of typography." . . . MARTIN SOLOMON.

"Entries were high in number. There were many good pieces submitted. In many cases the difference between an "in" or "out" vote was slight. Most of the selections, however, were by the unanimous decision of the jury and no accepted items received more than one negative vote.

"Overall, this was not a year of great innovations; more apparent is a raising of the general level. One sees more well-set typographic-design jobs—more finesse—but the number of great designs seems lower than other years.

"There was considerable variety in this show. Most of the current styles were exploited intelligently; but there were fewer innovations than were seen 6 or 7 years ago. This, I believe, would hold true for other design-for-printing exhibitions of 1964.

"In such a show it is impossible to discover all of the subtle connotations of expressive type selections and of ingenious layout. The magnitude of the typographic problem cannot be fairly judged. The criterion had to be 'visual effectiveness — excellence of design.'

"It was not feasible to separate excellent type handling from inferior design. Such examples of good type/weak design were voted down. By the same token, some very fine designs were voted down because the type was considered weak. Some of the latter pieces have found their way into current art director club shows." . . . FREEMAN CRAW.

"It was a privilege as well as a unique experience for me to serve as a juror for GALLEY 10 and the TYPE DIRECTORS CLUB. I wish to thank my fellow members for the honor.

"From the pieces that were selected for showing this year, the typographic design community seems to be in a transitional state. We all know where we've been and it appears we're still there—with this big qualification: there is a great deal of polishing and refinement going on. More sophistication is being shown in regards to type selection and handling. This is more evident than any marked trend or typographic direction. I personally see it as an indication of the design communities' knowledge and maturity. In brief, design and typography have reached a new peak of graphic perfection." . . . ARNOLD SHAW.

GALLEY 10 is a more typographic show than in previous years. It is a different show than any other major graphics show in the country. As we stated in the call for entries, this exhibition constitutes the proofing of the nation's best typographics. MO LEBOWITZ, Chairman, for the GALLEY 10 Committee.

Committee for Galley 10:

MO LEBOWITZ, Chairman

HERSCHEL WARTIK, Jury Chairman

LARRY OTTINO/JOHN SCHAEDLER, Design

ARTHUR LEE, Exhibit Tour; Educational Chairman

AL ROBINSON, Exhibit Design

VERDUN COOK, Judging

Credits:

ROBERT SUTTER, Editorial Photographs

MICHAEL CHASSID, Photography

AD AGENCIES' SERVICE COMPANY, Typography

PUBLICATION PRESS, Printing

MEAD PAPERS, (Mead Printflex Offset Enamel, Dull, 80 lb., Text and Cover.)

FENGA & DONDERI, INC., Mechanical Production

Grateful acknowledgment is made to the following people for their contributions to the success of this exhibition: Edward Rondthaler and his staff at Photo-Lettering, Inc. Michael Schacht and the staff of the Mead Library of Ideas. Mead Corporation.

Officers of the Type Directors Club

FRANK E. POWERS, Chairman, Board of Governors

MILTON K. ZUDECK, President

GLENN FOSS, Vice President

TED BERGMAN, Treasurer

MARTIN SOLOMON, Corresponding Secretary

EDGAR J. MALECKI, Recording Secretary

FRANCIS L. MONACO, Member at Large

JERRY SINGLETON, Executive Secretary

Objectives of the Type Directors Club: To raise the standards of typography and related fields of the graphic arts. To provide the means for inspiration, stimulation, and research in typography and related graphic arts fields. To aid in the compilation and dissemination of knowledge concerning the use of type and related materials. To cooperate with other organizations having similar aims and purposes.

The 10th annual awards exhibition is sponsored by the Type Directors Club of New York and will be held at the Mead Library of Ideas, New York City, May 4 to 29, 1964.

GALLEY 10

Martin Solomon, Freeman Craw

Martin Solomon, Milton Zudeck

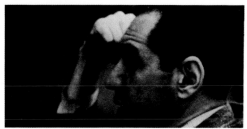

Arnold Shaw

Arnold Shaw, Martin Solomon, Verdun Cook

Herschel Wartik, Mo Lebowitz

Designer and type director was Tony Zamora. Graphic Arts set the type for the New York Herald Tribune.

Everett Aison was the designer and type director, Empire, the typographer, for Grossman Publishers.

Designed and type directed by Shel Seidler and John Cavalieri for Univac. Aaron Burns assisted with type direction and typography.

Dorothy Kienast did the design and type direction for Angie Inc. Adcomp, Inc. did the typesetting.

Ken Saco and Curt Lowey did the design. Ken Saco type directed for MGM Television. Rapid Typographers did the setting.

Designers were Robert Sutter, Herschel Wartik and Richard Krueger. Type directed by Sutter and Wartik, Inc. for Educational Facilities Laboratories, Inc. Composing Room set the type.

Freeman Craw was the designer and type director for Columbia University Printing Office. Tri-Arts Press set the type.

Design and type direction by Freeman Craw. Typography by and for Tri-Arts Press, Inc.

Mo Lebowitz and The Antique Press did everything.

Walter Lefmann and Sheldon Cotler did the designing. Sheldon Cotler did the type directing.
For Time, Inc. Haber, Composing Room and Typo Service did the setting.

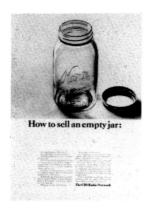

Bernie Zlotnick did the design and type direction for the CBS Radio Network. Type was set by The Composing Room.

Designed by Will Martin. Type direction by Jerome Gould for Sunset International Petroleum. Type setting by Monsen.

Design and type direction was done by Amil Gargano for Carl Ally, Quality Importers. Tri-Arts Press set the type.

Design and type direction by A. Richard de Natale for the Virginia Museum of Fine Arts. Type by J. W. Ford Co.

Designer and type director was Ben Rosen. Typography for Ben Rosen Associates was by Composing Room.

Paul Rand was designer and type director for IIT Research Institute. Tri-Arts Press was the typographer.

Ryszard Horowitz and Michael Hampton did the design. Ryszard Horowitz type directed for Pratt Institute. Graphic Arts set the type.

Anthony Mann did the design and type direction for Cooper & Beatty, Ltd. Cooper & Beatty set the type.

Both design and type direction were done by R. Mutch and K. Howard for Canada House Bottling Co. Typography was by Boro Typographers.

Designed and type directed by Mo Lebowitz. Typographed by The Antique Press. For Mead Paper Company.

Sam Cooperstein was the designer, Klaus F. Schmidt, the type director, for Arrow at Young & Rubicam. Typography by Ad Agencies' Service Co.

Designed by Sylvia Winter. Type direction by William R. Stone for Simpson Lee Paper Company. Type set by Sylvia Winter and Sequoia Press.

Designed by John Massey and Robert Lipman. Type direction by John Massey for the Container Corporation of America. Type set by Monsen.

Eisenman & Enock did the design and type direction for Total Color. Progressive set the type.

Design and type direction by Herb Lubalin for the CBS Radio Network. Composition by Composing Room.

Design and type direction for his own card and letterhead was done by Verdun P. Cook. Typo Craftsmen did the setting.

William J. Hermes was the designer and type director. Royal was the typographer for Ben Sackheim, Burlington Industries.

Ben Kuwata was the designer and type director for J. Walter Thompson, McCall's Magazine. Adlet Studios handled the typography.

Jerome Gould handled both design and type direction for the Ford Motor Co. Regensteiner Corp. set the type.

Frank Wagner was the designer. I. Barrett and Frank Wagner type directed for Sudler & Hennessey, Bristol Laboratories. Composing Room composed.

George J. Tassian was the designer and type director for Roger Karshner at Capitol Records. J. W. Ford set the type.

Designers were Ken Parkhurst and Jay Novak. Type was set by Vernon Simpson with Ken Parkhurst type directing for the Northrop Corp.

Robert M. Jones was the designer, type director and typographer for The Typophiles.

Design and type direction by Clifford Stead, Jr. and Lester Beall for Martin Marietta Corporation. Type set by Lexicraft Typographers.

William A. McCaffery designed and type directed for 50 East Associates. Royal set the type.

Fred Harsh designed and type directed for Harsh-Finegold, Business Week. Empire Typographers set the type.

Design and type direction was done by A. Richard de Natale for the Virginia Museum of Fine Arts. Setting was done by J. W. Ford Co.

Designer and type director was Charles Attebery, typographer was Empire, for L. W. Frohlich & Co., Inc.

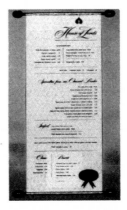

Design and type direction by Jerome Gould for Sahara-Nevada Corporation. Type set by Monsen.

Bob Salpeter did the design and type direction, Haber the typography, for IBM World Trade Corporation.

John Isely was the designer, Burton Brockett, the type director, Central Typesetting, the typographer, for General Dynamics-Astronautics.

Ron Barrett did the design and type direction, Ad Agencies' Service Co. set the type, for Young & Rubicam.

Bradbury Thompson did the design and type direction for the New York Group of the Advertising Typographers Association of America.

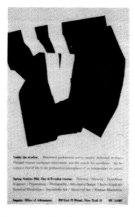

The School of Visual Arts had George Tscherny do the design and type direction. Haber Typographers did the type.

Designed by Dan Cromer with Will Sekuler as type director for Benton & Bowles—Allied Chemical. Typography by Compo Service. One of a series of ten.

Bill Tobias was the designer. Type Director was Robert M. Runyan for Litton Industries. Monsen set the type.

Al Robinson did the design and type direction for Richard Swann. Typographic composition by 89 Sense Press.

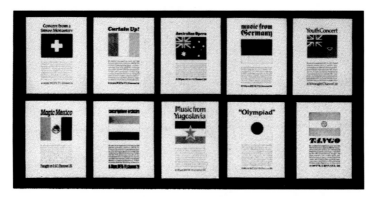

Ted Andresakes, Joel Azerrad, Herb Levitt and Barbara White handled the design, with type direction by Mort Rubenstein for WETA-TV. Rapid, Typography Place, Photolettering, Graphic Arts and Morgan Press shared the typography.

Design and type direction by Eisenman & Enock, typography by Progressive, for Pepsi-Cola.

Designed by Brad Boston and Advertising Designers, Inc. for Beckman Instruments, Inc.
Joe Weston did the type direction, Advertising Designers the typography.

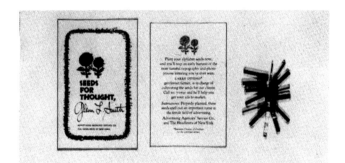

Larry Ottino was designer and type director for Advertising Agencies Service Co. and the Headliners of N.Y. Ad Agencies' set the type.

Herb Reade did the design and type direction, Empire Typographers set the type, for DuPont.

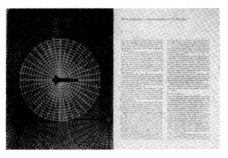

Design and type direction by Brad Boston and Advertising Designers, Inc. for Beckman Instruments. Advertising Designers also set the type.

Design and type direction by George Tscherny for Lampert Agency, Strathmore Paper. Type set by Royal Typographers.

Designer was Ronald Watts with Louis Lepis type directing for McCann-Erickson, Esso International.
Type setting by Arrow Typographic Service.

Robert M. Jones was the designer and type director for RCA Victor Records. Finn Typography set the type.

Design and type direction by Martin Friedman for Empire Typographers who also set the type.

Designer and type director was Peter Hirsch. Composing Room set the type for Douglas D. Simon, Supima Assoc. of America.

Arnold Shaw, designer and type director for the Composing Room, did this job for Gallery 303.

Freeman Craw was the designer and type director for Tri-Arts Press who also set the type.

Design and type direction by Robertson-Montgomery for Polytron Company. Typography by Spartan.

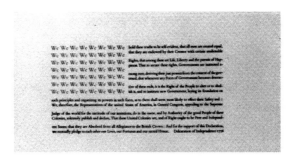

Borg Fabrics' design and type direction was done by Eileen Platt for Douglas D. Simon Adv. Typography by Composing Room.

Designed by Bradford and Archie Boston. Type directed by Bradford and Archie Boston. A self promotion by Archie and Bradford Boston.

Saadyah Maximon did the design and shared the type direction with Joel Oppenheimer. Type was set by and for Graphic Arts Typographers.

Design and type direction was done by Ben Rosen for ICOA Life Insurance Co. Composing Room set the type.

Donald Wood was the designer and type director for Visual Ad. Ben Franklin was the typographer.

Designed by Gustav Jäeger. Type direction by Konrad F. Bauer for Bauersche Giesserei.

John Massey designed and type directed, Monsen set the type, for the Art Directors Club of Chicago.

Designed by Barbara White, type directed by Mort Rubenstein for
e CBS Owned Television Stations. Typography by Rapid Typographers.

Design and type-direction by Jerome Gould for
Douglas Barr and Associates. Typography by Monsen.

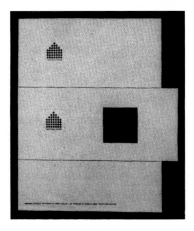

Tom Woodward did the design and type direction for Halftone House. Type was set by Ad Compositors.

Designed by Walter Landor & Associates. Type direction by Francis Mair for Stitzel-Weller Distilleries. Carton typography by F. M. Burt.

Michael A. Schact designed and type directed for his own greeting card. Typography by the Antique Press.

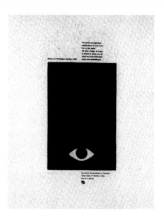

Design and type direction was done by John V. Massey for Container Corporation of America. Frederick Ryder handled the typography.

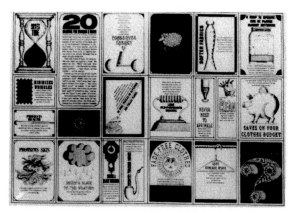

Joseph Taveroni did the design and type direction for American Home Magazine.
Typography by Frederick Nelson Phillips, Huxley House, Aaron Burns and Photolettering.

Design and type direction by Peter Claydon. Thomas Claydon Printing Co. set the type for themselves.

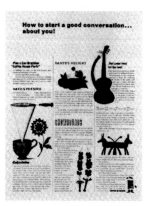

Frank Attardi was the designer and type director for Coffee of Brazil. Graphic Arts was the typographer.

Cristos Gianakos was the designer and type director for The Society of Gourmets. Rieggert & Kennedy set the type.

Designer and type director was Martin Solomon with Royal Typographers' typography. For Hy Abbott Inc.

Design and type direction by Herb Lubalin for Eros Magazine, Inc.

Bob Farber did the design and type direction for the Lampert Agency, Strathmore Paper. Royal did the typography.

Herb Lubalin designed and type directed for himself. Aaron Burns & Co. set the type. John Pistilli did the lettering.

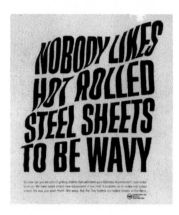

Design and type direction by Hal Riney for B.B.D.&O., Columbia-Geneva Steel. Lettering and typography was handled by Bill Coppock.

Designed by Paul Hauge. Type direction by Robert M. Runyan for Litton Industries. Type set by Keith Axelson, Vernon Simpson.

Designed by Harvey Gabor. Type direction by Verdun P. Cook for Redbook Magazine. Typographic Craftsmen set the type.

James Fitzgerald did the design with type direction by Robert M. Runya For Beckman Instruments, Inc. Magoffin Co. set the type.

Albert Squillace did the design and type direction for the Ridge Press, National Cultural Center. Typography by Composing Room.

Peter Rauch did the design with Mort Rubenstein type directing for WCBS-TV. Rapid set the type.

Design and type direction by Georg Olden for the U.S. Post Office. QQ was the typographer.

Ralph Coburn was designer and type director for the M.I.T. Department of Physics. Machine Composition set the type.

Design and type direction by Herb Lubalin, typography by TPI, for Eros Magazine.

Design and type direction by Wally Littman for J. Wiss & Sons at Hicks & Greist. Ad set by Adset.

Irwin Schwartz and Katherine Hahn shared the designing. Type was set by Clarke & Way, with type direction by George Salter for Cooper Union.

Design and type direction was done by Onofrio Paccione for the All-Rite Pen Co. Typo Craftsmen did the setting.

Design and type direction was by Peter Max and the Daly & Max studio for the Bettman Panoptican Show. Composing Room set the type.

Designed by Robert Kennedy Associates with type direction by Robert Kennedy for Champion Papers.
Typography by Photolettering and Empire typographers.

Frank Kacmarcik handled the design, type direction and typography for the Whitby School.

Design and type direction was done by Robertson-Montgomery for D. M. Christensen Construction Co., Spartan Typography handled the setting.

Designer and type director was Everett Aison, typographer was Empire, for Grossman Publishers, Inc.

Brad Boston and Advertising Designers did the design and type direction for Beckman Instruments. Advertising Designers set the type.

Design and type direction by Paul M. Dunbar for C-E-I-R, Inc. Progressive Composition did the composition.

Design and typography by Harry Eaby for James H. McWilliams, director of typography for the Philadelphia Museum College of Art.

Designed by Rey Abruzzi. Type direction by Robert Donald. Type set by and for Typographic Service, Inc.

Richard Danne did the design and type direction for Wilmans. Jaggers-Chiles-Stovall set the type.

Design and type direction by John Evans for Howarth & Smith Monotype Ltd. Type set by Howarth & Smith.

Roger Cook was the designer and type director for Graphic Directions, Merrill, Lynch, Pierce, Fenner & Smith.

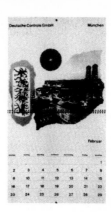

Designed by J. Massey, E. Hughes and William Sontag. Type directed by John Massey for Controls Company of America.

George Rosenfeld did the design and type direction for The Bell System. Empire Typographers set the type.

Designer was Leonard F. Bahr, type director was Freeman Craw, typographer was Frederick W. Schmidt for the Advertising Typographers Association of America, Inc.

Gollin, Bright and Zolotow handled the design and type direction for Continental Graphics, Inc. Type set by John F. Mawson Co.

Designer and type director was Bradbury Thompson. Wm. Rudge's Sons set the type for West Virginia Pulp and Paper Company.

Designer and type director was Mary Beresford with Tri-Arts setting the type for the IBM Corporation.

Elaine Lustig was designer and type director for The Jewish Museum.

Design and type direction by Arthur Boden for IBM. A. Colish set the type.

Harvey Gabor did the design and type direction for The Illustrator's Club. Typographic Craftsmen helped with the typography.

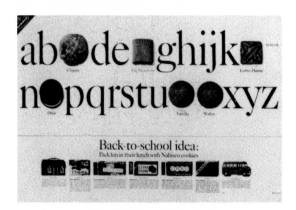

William Alderisio produced the design. Milton Zudeck type directed for the National Biscuit Co. at McCann-Erickson. Superior set the type.

James H. McWilliams did the design, type direction and typography for Janus Press.

Both design and type direction was done by Verdun P. Cook for Redbook Magazine. Typo Craftsmen set the type.

Designer and type director was Freeman Craw for The Bank of New York. Tri-Arts Press did the typography.

Herb Lubalin did the design and type direction for himself.

Design and type direction by Eisenman & Enock for Pepsi-Cola. Type set by Progressive.

Amil Gargano designed and type directed, Tri-Arts did the type, for Quality Importers at Carl Ally Inc.

Designed and type directed by Freeman Craw for Columbia University Printing Office. Lane Printers set the type.

Ronald Watts was the designer. Milton Zudeck was the type director for Esso International at McCann-Erickson. Superior was the typographer.

Otto Preminger at Columbia Pictures had Saul Bass do the design and type direction. Type was set by Monsen.

Design and type direction by Elton Robinson, lettering by John Pistilli, typography by H. Wolff. For Horizon Magazine.

Chris Yaneff produced the design. Manfred Gotthans type directed. Cooper & Beatty did the setting. For Fermac Printers.

Robert Weissberg produced the design with type direction by George Krikorian for Look Magazine. Rieggert & Kennedy set the type.

Freeman Craw handled design and type direction, Tri-Arts Press, the typography, for Columbia University Printing Office.

Design and type direction by Jack Sheridan, typography by Ad Compositors, for the Great Western Financial Corporation.

Brad Boston and Advertising Designers shared the design and type direction for Beckman Instruments. Advertising Designers also set the type.

Richard Lopez handled the design, type direction and typography for The Holy Name Society.

The designer was Anthony Olivetto. Otto Storch type directed and Composing Room set the type for McCall's Magazine.

Joel Azerrad was the designer. Mort Rubenstein type directed for WCBS-TV. Rapid was the typographer.

Robertson-Montgomery did the design and type direction for Polytron Company. Typography by Spartan.

Peter Gee did the design, type direction and typography for his own design studio.

Eisenman & Enock did the design and type direction for Pepsi-Cola. Empire Typographers set the job.

Design by Norm Herbert with type direction by Larry Aaron. Typography by Composition Service for Associated Press at Fladell Advertising.

Milton Ackoff did the design, Georgian Press did the type. For Olin Aluminum.

John Murello was the designer, type director and typographer for West, Weir, Bartell.

Arnold Shaw was the designer. Type direction by Steven Richter for New York University. Typography by Photo-Composing Room, Inc.

Gips & Klein did the design and type direction for Westinghouse Broadcasting Co. Empire Typographers did the setting.

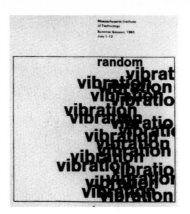

M.I.T. had Ralph Coburn do the design and type direction for the Office of the Summer Session. Machine Composition Co. did the setting.

Bruce Dambrot was the designer. Otto Storch type directed for McCall's Magazine. Type set by Composing Room.

Peter Hirsch did the design and type direction for Composing Room's Gallery 303.

Typo Craftsmen set the type, with design and type direction by Onofrio Paccione for Burberry at Leber Katz Paccione.
One of a series of three

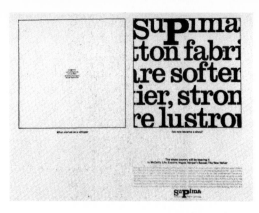

Eileen Platt was the designer and type director for the Supima account at Douglas D. Simon Adv. Composing Room did the setting.

Tony Mandarino did the design and type direction for Eleni Hope Inc. Aaron Burns & Co. set the type. Lettering by John Pistilli.

Everett Aison designed and type directed for Grossman Publishers. Empire did the typography.

Designed by Ewald Breuer with type direction by Robert M. Runyan for Litton Industries. Type set by Keith Axelson.

Design and type direction, with type set by Rieggert & Kennedy, was by Cristos Gianakos for The Society of Gourmets.

Design and type direction was done by Tony Zamora for the New York Herald Tribune. Graphic Arts set the type.

Joseph A. Pastore did the design and type direction on this job for William Young. Diamant Typographers did the typesetting.

Designed by Gary Geyer. Al Robinson did the type direction for Warner's at Doyle Dane Bernbach. Royal produced the type.

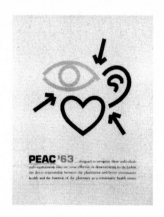

Designer and type director was Bernard B. Sanders for American Pharmaceutical Association. Progressive Composition Co. set the type.

Designed by James Fitzgerald with type direction by Robert M. Runyan for Vinnell Corporation. Typography by Monsen.

Claire van Vliet did the design, type direction and typography for Janus Press.

Herb Lubalin did the design and type direction for himself. John Pistilli did the hand lettering.

Designed and type directed by Gips & Klein for The School of Visual Arts. Composition by Composing Room.

Designed and type directed by Richard Danne for the Harvard Business School. Empire Typographers did the settings.

Design and type direction was done by Mel Platt for Jim Zaccaro. Type was set by Olsen.

Design and type direction by Herb Lubalin for The Lampert Agency, Strathmore Paper.
Hand lettering by John Pistilli. Typography by Aaron Burns.

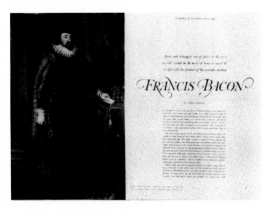

Elton Robinson designed and type directed for Horizon Magazine. John Pistilli did the lettering. H. Wolff did the typography.

Ben Rosen did the design and type direction for his own company. Composing Room and York Typesetting helped.

Design and type direction by Bob Salpeter for IBM World Trade Corp. Type set by Allied.

Design and type direction by Mo Lebowitz for the Lebowitz family. Typography by The Antique Press.

Design and type direction by Jay Novak, typography by Vernon Simpson and Monsen Typographers for Northrop Corporation.

Designer and type director was Bob Salpeter for IBM World Trade Corporation. Type was set by Allied.

A self promotion, designed and type directed by Bradford and Archie Boston.

Design and type direction by Art Glazer for Redbook Magazine. Rapid set the type.

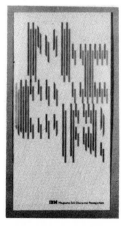

Bob Salpeter did the design and type direction for IBM World Trade Corp. Composition by Graphic Arts Typographers.

Design, type direction and typography by Mo Lebowitz for The Antique Press.

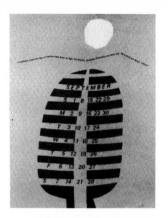

George Nakano designed and type directed for Visual Ad. Ben Franklin set the type.

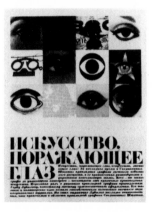

Design and type direction by Herb Lubalin for the United States Information Agency. Hand lettering by John Pistilli, typography by King Typographers.

Designed and type directed by Donald Wood for Robert F. Six. Typography by Vernon Simpson.

Peter Gee designed and type directed for The Chase Manhattan Ba Type was set by The Composing Room.

Designed by Bernard Most for himself. Type direction by Bernard Most and H. Altman with type set by Altman Typographers.

Design and type direction by Salvatore Lodico for Leber Katz Paccione, Coopchik-Forrest. Typo Craftsmen set the type.

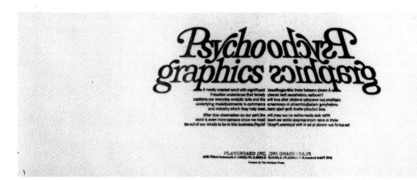

Mo Lebowitz did the design, type direction and also set the type for Plansboard Inc. Hand lettering was by Carl Lapidus.

George Tscherny did the design and type direction for The School of Visual Arts. Haber did the typography.

Designed and type directed by A. Richard de Natale for the Virginia Museum of Fine Arts. Type set by the J. W. Ford Co.

Dugald Stermer did the design, type direction and typography for Middaugh Associates.

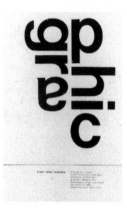

Design and type direction was done by Peter Gee for Basic Research Unit. Composition was by Composing Room.

*Herb Lubalin was the designer and
type director for Fact Magazine. Stilset set.*

*Design and type direction was done by Michael Tesch for
Chermayeff & Geismar, Howard Wise Gallery. Progressive set t*

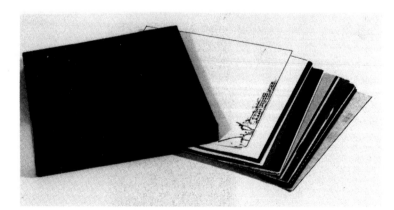

*Design and typography by the Junior Typographic Design Class at the Philadelphia Museum College of Art.
Type direction by James H. McWilliams.*

Design and type direction by Joe Weston for Robert L. Steinle, The Mitre Corporation. Typography by Advertising Designers.

Designed, type directed and set by Mo Lebowitz for his Antique Press. Chandler & Price helped with the typography.

Design and type direction was done by Bert Angelus for Visual Ad. Type setting was done by Ben Franklin.

A. Richard de Natale did the design and type direction for the Virginia Museum of Fine Arts. J. W. Ford Co. did the type.

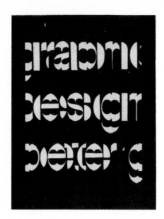

Peter Gee was the designer, type director and typographer for Peter Gee Graphic Design.

Jacqueline S. Casey did the design and type direction for M.I.T. Dept. of Mathematics. Machine Composition Co. set the type.

Design, type direction and lettering was done by Laurence C. Hammond for his own company.

Designed by John Isely. Type direction by Burton Brockett. Typography by Central Typesetting. For General Dynamics-Astronautics.

Design, typography and printing by the Stinehour Press for PAGA. (One of a series of nine).

Type Directors Club Membership, 1964

Robert David Adams / Kelvin J. Arden / Joseph Armellino
Leonard F. Bahr / Arnold Bank / Paul Bennett / Ted
Bergman / Amos G. Bethke / Pieter Brattinga / John H.
Bright / Bernard Brussel-Smith / Aaron Burns / Will Burtin / Travis Cliett / Mahlon A. Cline / Martin Connell
Verdun P. Cook / Nicholas A. Constantino / Freeman
Craw / James A. Cross / Thomas L. Dartnell / Eugene De
Lopatecki / O. Alfred Dickman / Louis Dorsfman / Cieman Drimer / Claude Enders / Eugene M. Ettenberg
Robert Farber / Sidney Feinberg / Charles J. Felten
Roger G. Ferriter / Bruce Fitzgerald / Glenn Foss / Vincent Giannone / Louis L. Glassheim / Arthur Glazer
William P. Gleason / Edward M. Gottschall / Austin
Grandjean / James Halpin / Kurt Hintermann / Hollis W.
Holland / Jack Hough / Robert M. Jones / R. Randolph
Karch / Lawrence Kessler / Wilbur King / Zoltan Kiss
Emil J. Klumpp / Edwin B. Kolsby / Ray Komai / Ray
Konrad / Bernard Kress / Richard A. Kroll / Morris
Lebowitz / Arthur B. Lee / Acy R. Lehman / Clifton Line
Wally Littman / Gillis L. Long / Melvin Loos / John H.
Lord / Herb Lubalin / Edgar J. Malecki / Sol Malkoff
James H. McWilliams / Egon Merker / Frank Merriman
Lawrence J. Meyer / Herbert M. Myers / R. Hunter Middleton / Francis Monaco / Lloyd Brooks Morgan / Tobias
Moss / Louis A. Musto / Alexander Nesbitt / Martin S.
O'Connor / Oscar Ogg / Robert J. O'Dell / Gerard J.
O'Neill / A. Larry Ottino / Dr. G. W. Ovink / Joseph A.
Pastore / Eugene P. Pattberg / Michael N. Pellegrino
John A. Pfriender / Jan van der Ploeg / George A. Podorson / Conrad Pologe / Frank E. Powers / Ernst Reichl
Andrew Roberts / Al Robinson / Robert Roche / Richard
Victor Rochette / Edward Rondthaler / Herbert M. Rosenthal / Frank Rossi / Gustave L. Saelens / Lou Sardella
John N. Schaedler / Klaus F. Schmidt / James M. Secrest
William L. Sekuler / Arnold Shaw / Edwin W. Shaar / Jan
Sjödahl / Martin Solomon / James Somerville / Walter
Stanton / Herbert Stoltz / Otto Storch / Herb Strasser
William A. Streever / Robert Sutter / David B. Tasler
William Taubin / Anthony J. Teano / Bradbury Thompson
M. Joseph Trautwein / Abraham A. Versh / Meyer Wagman / Beatrice Warde / Herschel Wartik / Stevens L. Watts
Joseph F. Weiler / Irving Werbin / Howard Wilcox / Hal
Zamboni / Hermann Zapf / Zeke Ziner / Milton Zudeck.

Sustaining Members

Advertising Agencies' Service Co., Inc. / American Type
Founders / Amsterdam-Continental Types & Graphic
Equipment, Inc. / Cooper & Beatty Ltd. / Craftsman Type
Inc. / A. T. Edwards Typography, Inc. / Electrographic
Corporation / Empire Typographers / Graphic Arts Typographers Inc. / Huxley House / King Typographic
Service Corporation / Intertype Company / Lanston
Monotype Company / Mergenthaler Linotype Company
Oscar Leventhal, Inc. / Linocraft Typographers / Ludlow
Typograph Company / Mead Corporation / William Patrick Company, Inc. / Philmac Typographers Inc. / Progressive Composition Company / Rapid Typographers,
Inc. / Frederick W. Schmidt, Inc. / Superior Typographers,
Inc. / The Composing Room, Inc. / The Highton Company / The Typographic House, Inc. / Typography Place,
Inc. / Typo-Philadelphia / Tudor Typographers / Kurt H.
Volk, Inc. / Westcott & Thomson Inc.

How to make a crisp crispy
and a crumble crumbly.

TDC OFFICERS, MEMBERS, TYPE INDEX, AND GENERAL INDEX

Robson Grieve 2010
Jeff Griffith 2012
Catherine Griffiths 2006
Jon Grizzle 2012
Katarzna Gruda 2009
Rosanne Guararra 1992
Artur Marek Gulbicki 2011
Nora Gummert-Hauser 2005
Raymond Guzman 2010
Peter Gyllan 1997

Faris Habayeb 2012
Andy Hadel 2010
Michael Hagemann 2012
Diane Haigh 2012
Brock Haldeman 2002
Calum Hale 2012s
Allan Haley 1978
Debra Hall 1996
Jonathan Halpern 2012s
Christopher Hamamoto 2012s
Carrie Hamilton 2013
Lorain Hamilton 2013s
Dawn Hancock 2003
Jeffrey Hanson 2012
Egil Haraldsen 2000
Kat hargrave 2013a
Lamis Harib 2011s
Jillian Harris 2012
Julie Harris 2012s
Knut Hartmann 1985
Lukas Hartmann 2003
Luke Hayman 2006
Oliver Haynold 2009
Amy Hayson 2012
Bonnie Hazelton 1975***
Amy Hecht 2001
Jonas Hecksher 2012
Eric Heiman 2002
Karl Heine 2010
Elizabeth Heinzen 2013
Anja Patricia Helm 2008
Eric Helmstetter 2012
Kyle Helmstetter 2012s
Cristobal Henestrosa 2010
Oliver Henn 2009
Nitzan Hermon 2013
Berto Herrera 2009
Victoria Herrera 2012s
Christine Herrin 2012s
Aymeric Herry 2013
Klaus Hesse 1995
Jason Heuer 2011
Fons M. Hickmann 1996
Jay Higgins 1988
Clemens Hilger 2008
Bill Hilson 2007
Kit Hinrichs 2002
Jessica Hische 2010
Genevieve Hitchings 2010
Sarah Ho 2012
Mark Ho-Kane 2012
Sissy Emmons Hobizal 2012
Henry Hobson 2012
Fritz Hofrichter 1980***
Alyce Hoggan 1987
Michael Hoinkes 2006
Richard Holberg 2012

Karen Horton 2007
Kevin Horvath 1987
Joshua Howard 2012s
Christian Hruschka 2005
Karen Huang 2012
John Hudson 2004
Aimee Hughes 2008
Keith C. Humphrey 2008
Grant Hutchison 2011
Hyun-Jung Hwang 2010

Albert Ignacio 2011s
Jana Igunma 2013
Yuko Ishizaki 2009
Alexander Isley 2012

Christopher Jackson 2011
Donald Jackson 1978 **
Torsten Jahnke 2002
Mark Jamra 1999
Christina Janus 2012s
Etienne Jardel 2006
Alin Camara Jardim 2011
Whittline Blanc Jean-Palillant 2013s
Jesus Jimenez 2013
Becky Johnson 2010lc
Elizabeth Johnson 2011s
Robert Johnson 2009
Marilyn Jones 2013
Giovanni Jubert 2004
Leo Jung 2012
Benjamin Jura 2012

Jeannette Kaczorowski 2012
Edward Kahler 2010
John Kallio 1996
George Kalofolias 2013s
Wenkang Kan 2013lc
Basia Karpiel 2013s
Milt Kass 2009a
Remy Kass 2012s
Diti Katona 2006
Quinn Keaveney 2012s
Richard Kegler 2012
Dr. John Kell 2013
Scott Kellum 2012
Paula Kelly 2010
Philip Kelly 2011
Saskia Ketz 2012
Helen Keyes 2011
Satohiro Kikutake 2002
Hayim Kim 2013s
Jee Kim 2013
Julie Kim 2013lc
Mina Kim 2012s
Minsun Kim 2012s
Rick King 1993
Sean King 2007
Katsuhiro Kinoshita 2002
Khuplunmang Kipgen 2013s
Dmitriy Kirsanov 2013
Nathalie Kirsheh 2004
Keith Kitz 2011s
Susanne Klaar 2011
Amanda Klein 2011
Arne Alexander Klett 2005
Erica Knauss 2012s
Ros Knopov 2012

Akira Kobayashi 1999
Claus Koch 1996
Florian Koch 2013
Boris Kochan 2002
Masayoshi Kodaira 2002
Markus Koll 2011
Thomas Kowallik 2010
Hannah Kramer 2011s
Dmitry Krasny 2009
Markus Kraus 1997
Willem Krauss 2012
Stephanie Kreber 2001
Ingo Krepinsky 2013
Bernhard J. Kress 1963***
Gregor Krisztian 2005
Stefan Krómer 2013
Jan Kruse 2006
Henrik Kubel 2010
John Kudos 2010
Ken Kunde 2011
Christian Kunnert 1997
Dominik Kyeck 2002

Gerry L'Orange 1991***
Ginger LaBella 2013
Raymond F. Laccetti 1987***
Annabelle Ladao 2011s
Nicole Lafave 2012
Karen LaMonica 2013
Greg Lamarche 2012
Christopher David Lane 2012s
John Langdon 1993
Brian LaRossa 2011
Amanda Lawrence 2006
Heesang Lee 2012lc
Jaedon Lee 2013s
Sophy Lee 2012
Elizabeth Leeper 2012s
Pum Lefebure 2006
David Lemon 1995
Gerry Leonidas 2007
Mat Letellier 2010
Olaf Leu 1966***
Joshua Levi 2010
Edward Levine 2011
Celeste Li 2012lc
Esther Li 2012s
Siwei Li 2012s
Xiaozhu Li 2012lc
Yue Li 2013s
Chen-Wen Liang 2012s
Jiaru Lin 2012s
Maxine Lin 201s
Armin Lindauer 2007
Domenic Lippa 2004
Caren Litherland 2009
Jason Little 2009
Wally Littman 1960***
Sascha Lobe 2007
Ralf Lobeck 2007
Uwe Loesch 1996
Oliver Lohrengel 2004
Amy Lombardi 2013
Kirsten Long 2012
Adriana Longoria 2012lc
Jamie Lopez 2013lc
Sabrina Lopez 2011s
John Howland Lord 1947**

Chercy Lott 2008
Arline Lowe 2009
Christopher Lozos 2005
Luke Lucas 2012
Jessica Lucivero 2013lc
Gregg Lukasiewicz 1990
Annica Lydenberg 2012
Peter Lytwyniuk 2011

Callum MacGregor 2009
Stephen MacKley 2011
Donatella Madrigal 2012
Rui Maekawa 2012lc
Danusch Mahmoudi 2001
Avril Makula 2010
Reesa Mallen 2013s
Yael Mann 2012
Anastasios Maragiannis 2012s
Courtney Marchese 2013
Alane Marco 2013s
Marilyn Marcus 1979***
Bernardo Margulis 2010
Nicolas Markwald 2006
Bobby Martin 2011
Shigeru Masaki 2006
Jakob Maser 2006
Sophie Masure 2013
Vijay Mathews 2012
Mary Mathieux 2012
Steve Matteson 2006
Scott Matz 2011
Ted Mauseth 2001
Andreas Maxbauer 1995
Cheryl McBride 2009
Nick McBurney 2011s
Mark McCormick 2010
Rod McDonald 1995
Shannon McLean 2012s
Alexa McNae 2011
Marc A. Meadows 1996
Samuel Medina 2012s
Arturo H. Medrano 2013s
Roland Mehler 1992
Niyati Mehta 2013s
Maurice Meilleur 2013s
Matt Meiners 2012s
Uwe Melichar 2000
Lulu Men 2012s
Frédéric Metz 1985***
Liz Meyer 2011
Jeremy Mickel 2009
Michael Mierzejwski 2012lc
Javier Miguelez 2013s
Abbott Miller 2010
Brian Miller 2006
Erma Miller 2012s
Noah Miller 2013
John Milligan 1978***
Debbie Millman 2012
Dexter Miranda 2012s
Michael Miranda 1984
Nick Misani 2012s
Susan L. Mitchell 1998
Jose Luis Coyotl Mixcoatl 2012
Amanda Molnar 2010s
Geoffrey Monaghan 2011
Sakol Mongkolkasetarin 1995
James Montalbano 1993

Elizabeth Hart Montgomery 2012s
Aaron Moodie 2012
Christine Moog 2011
Ahyoung Moon 2013s
Richard Earl Moore 1982
Tobias Moore 2011lc
Tyler Moore 2012
Minoru Morita 1975***
Lars Müller 1997
Joachim Müller-Lancé 1995
Gary Munch 1997
N. Silas Munro 2011
Kara Murphy 2006
Jerry King Musser 1988
Louis A. Musto 1965***
Steven Mykolyn 2003

Miki Nagao 2009s
Marc Nahas 2012
Andrea Nalerio 2008s
Miranda Nash 2012lc
Angela Navarra 2012
Cayetano Navarrete 2013s
Ralph Navarro 2013
Jamie Neely 2013
Eduardo Nemeth 2011
Titus Nemeth 2010s
Cristiana Neri-Downey 1997
Helmut Ness 1999
Nina Neusitzer 2003
Ulli Neutzling 2009
Christina Newhard 2012
Joe Newton 2009
Vincent Ng 2004
Vivian Nguyen 2012s
Yunis Ni 2012s
Charles Nix 2000
Michelle Nix 2008
Dirk Nolte 2012
Gertrud Nolte 2001s
Alexa Nosal 1987***
Thomas Notarangelo 2010
Yves Nottebrock 2011
Beth Novitsky 2013

Francesa O'Malley 2008
Tomo Ogino 2012
Debra May Ohayon 2012s
Gaku Ohsugi 2003
John Olson 2012s
Robert Overholtzer 1994

Michael Pacey 2001
Michael Padgett 2012
Aaron Padin 2012
Ross Palumbo 2013lc
Marisa Pane 2013lc
Lauren Panepinto 2010
Amy Papaelias 2008
Jaewon Park 2013s
Jeongho Park 2013s
Juhyun Park 2013s
Nari Park 2013lc
Jonathan Parker 2009
Jim Parkinson 1994
Karen Parry 2008
Donald Partyka 2009
John Passfiume 2010

Dennis Pasternak 2006
Mauro Pastore 2006
Neil Patel 2011
Gudrun Pawelke 1996
Alan Peckolick 2007
Andre Pennycooke 2008
Esteban Perez 2011s
Sonia Persad 2013s
Giorgio Pesce 2008
Caitlyn Phillips 2013
Max Phillips 2000
Amanda Phingbodhipakkiya 2012s
Stefano Picco 2010
Clive Piercy 1996
Ian Pilbeam 1999
Massimo Pitis 2012
Cory Pitzer 2011s
Deana Pnea 2013s
J.H.M. Pohlen 2006
Niberca Polo 2009s
Albert-Jan Pool 2000
Rachael Pope 2011s
Jean François Porchez 2013
James Propp 1997
Lars Pryds 2006
Marsha Pugachevsky 2012s
David Pybas 2013

Jessie Quan 2012lc
Chuck Queener 2010
Vitor Quelhas 2011s
Thomas Quinn 2012

Jochen Raedeker 2000
Jesse Ragan 2009
Erwin Raith 1967***
Sal Randazzo 2000
Steven Rank 2011
Patti Ratchford 2012
Kyle Reed 2013
Ben Reece 2012
Byron Regej 2013
Reed Reibstein 2012
James Reyman 2005
Douglas Riccardi 2010
Claudia Riedel 2004
Helge Dirk Rieder 2003
Sally Rinehart 2013
Laura Rings 2012
Oliver Rios 2012
Phillip Ritzenberg 1997
Chad Roberts 2001
Duncan Robertson 2011s
Julie Robins 2013s
Katherine Robinson 2011s
Sofija Rockomanovic 2013s
Allison Rodde 2012s
David Roehr 2012
Jeff Rogers 2012
Stuart Rogers 2010
J. Mark Rokfalusi 2012
Samantha Rooney 2013lc
Kurt Roscoe 1993
Nancy Harris Rouemy 2007
Theo Rosendorf 2013
Fiona Ross 2011
Lance Rusoff 2012
Jen Russo 2011s

Erkki Ruuhinen 1986
Carol-Anne Ryce-Paul 2001
Michael Rylander 1993

Mamoun Sakkal 2004
Karla Saldana 2012s
Ilja Sallacz 1999
Ina Saltz 1996
Rodrigo Sanchez 1996
Ronald Sansone 2012
Nikko-Ryan Santillan 2012s
Josefina Santos 2012s
Michihito Sasaki 2003
Johanna Savad 2012
Nathan Savage 2001
DC Scarpelli 2012
Sonia Scarr 2012
Nina Scerbo 2006
Hartmut Schaarschmidt 2001
Hanno Schabacker 2008
Anja-D Schacht-Kremler 2012
H.D. Schellnack 2009
Paula Scher 2010
Emily Scherer-Steinberg 2013
Robbin Schiff 2013
Peter Schlief 2000
Hermann J. Schlieper 1987***
Evan Schlomann 2011s
Holger Schmidhuber 1999
Hermann Schmidt 1983***
Klaus Schmidt 1959***
Bertram Schmidt-Friderichs 1989
Thomas Schmitz 2009
Elnar Schnaare 2011
Guido Schneider 2003
Werner Schneider 1987
Wanja Schnurpel 2011
Hannah Schreiner 2012s
Markus Schroeppel 2003
Holger Schubert 2006
Eileen Hedy Schultz 1985
Eckehart Schumacher-Gebler 1985***
Robert Schumann 2007
Paul Schwartzenberger 2012
Mary Scott 2012
Peter Scott 2002
Leslie Segal 2003
Chris Sergio 2011
Thomas Serres 2004
Ann Marie Sexton 2012lc
Michelle Shain 2012
Daphna Shalev 2012s
Susanna Shannon 2013
Paul Shaw 1987
Benjamin Shaykin 2012
Andrew Sheffield 2013
Chris Sheldon 2012
Nick Sherman 2009
David Shields 2007
Jeemin Shim 2010s
Kyuha Shim 2012s
Philip Shore, Jr. 1992***
William Shum 2013s
Dipti Siddamsettiwar 2013s
Etta Siegel 2011
Scott Simmons 1994
Anthony Simone 2011s

Mark Simonson 2012
Dominque Singer 2012
Fred Smeijers 2013
Elizabeth Carey Smith 2010
Kevin Smith 2008
Mark Addison Smith 2012
Richard Smith 2012
Steve Snider 2004
Jan Solpera 1985***
Patrick Sommer 2012s
Brian Sooy 1998
Allen Spector 2012lc
Erik Spiekermann 1988
Kirsli Spinks 2013
Maximilano Sproviero 2012
Sunny Stafford 2013
Frank Stahlberg 2000
Nancy Stamatapoulos 2012
Rolf Staudt 1984***
Olaf Stein 1996
Olivia Sterling 2013s
Charles Stewart 1992
Roland Stieger 2009
Michael Stinson 2005
Clifford Stoltze 2003
Sumner Stone 2011
DJ Stout 2010
Charlotte Strick 2010
Ilene Strizver 1988
Hansjorg Stulle 1987***
Sean Suchara 2012s
Martin Sulzbach 2012s
Neil Summerour 2008
Monica Susantio 2010s
Derek Sussner 2005
Zempaku Suzuki 1992
Don Swanson 2007
Paul Sych 2009
Lila Symons 2010

Shoko Tagaya 2012
Robin Tagliasacchi 2012s
Yukichi Takada 1995
Yoshimaru Takahashi 1996
Kei Takimoto 2011
Katsumi Tamura 2003
Jef Tan 2011
Siena Tan 2012s
Trisha Wen Yuan Tan 2011s
Matthew Tapia 2012
Judy Tashji 2011s
Jack Tauss 1975***
Lindsay Taylor 2011s
Pat Taylor 1985
Anthony J. Teano 1962***
Marcel Teine 2003
Eric Thoelke 2010
Corey Thomas 2012s
Drue Thomas 2012lc
Simone Tieber 2010
Eric Tilley 1995
Colin Tillyer 1997
Emily Tobias 2011s
James Tocco 2012
Alexander Tochilovsky 2010
James Todd 2012s
Laura Tolkow 1996
Danielle Tremblay 2012s

Jakob Trollbäck 2004
Klaus Trommer 2004
Niklaus Troxler 2000
Andrey Truhan 2011lc
Yi-Chen Tsai 2012lc
Chavelli Tsui 2011
Ling Tsui 2011
Minao Tsukada 2000
Korissa Tsuyuki 2009
Richard Tucker 2011
Manfred Tuerk 2000
Osman Tulu 2011
Natascha Tümpel 2002
François Turcotte 1999
Jamie Turpin 2012s
Anne Twomey 2005

Andreas Uebele 2002
Isabel Urbina 2011lc

Diego Vainesman 1991
Scott Valins 2009
Patrick Vallée 1999
Emma Van Deun 2013s
Jeffrey Vanlerberghe 2005
Leonardo Vasquez 2010
Massiel Vasquez 2013s
Rozina Vavetsi 2011
Meryl Vedros 2010s
Juan Villanueva 2013s
Nastassia Virata 2013
Frank Viva 2010
Oscar Von Hauske 2013
Mark Von Ulrich 2009
Danila Vorobiev 2013
Angela Voulangas 2009

Frank Wagner 1994
Oliver Wagner 2001
Paul Wagner 2011
Tad Wagner 2012
Allan R. Wahler 1998
Jurek Wajdowicz 1980***
Sergio Waksman 1996
Andrej Waldegg 2013
Garth Walker 1992
Michelle Wang 2013s
Craig Ward 2011
Tiffany Wardle 2013
Katsunori Watanabe 2001
Michele Waters 2011
Cardon Webb 2009
Harald Weber 1999
Jiangnan Wei 2012s
Claus F. Weidmueller 1997
Sylvia Weimer 2001
Terrance Weinzierl 2012
Craig Welsh 2010
Sharon Werner 2004
Shawn Weston 2012
Alex W. White 1993
Christopher Wiehl 2003
Michael Wiemeyer 2013
Richard Wilde 1993
Luke Wilhelmi 2011
James Williams 1988***
Pamela Williams 2013
Steve Williams 2005

Grant Windridge 2000
Conny J. Winter 1985
Delve Withrington 1997
Burkhard Wittemeier 2003
Lisa Wolfman 2012
Alison Wolin 2013s
David Wolske 2012
Desmond Wong 2011s
Fred Woodward 1995

Wendy Xu 2011

Henry Sene Yee 2006
Kylene Yen 2013s
Burnham Yu 2013s
Garson Yu 2005

Diego Zaks 2012s
Hermann Zapf 1952**
David Zauhar 2001
Xuan Zhang 2012s
Zipeng Zhu 2010s
Maxim Zhukov 1996***
Jenna Zilincar 2012
Ron Zisman 2011s
Roy Zucca 1969***
Federico Zuleta 2012s

Corporate Members
Diwan Software Limited 2003
École de Visuelle
 Communications 2011
Grand Central Publishing
 2005
New York Media 2012
School of Visual Arts,
 New York 2007
Sullivan 2012

* Charter member
** Honorary member
*** Life member
s Student member
 (uppercase)
lc Lowercase Student
 member
a Associate member

Membership as of
 June 12, 2013

353

TYPE INDEX

4Seven 102
Fontsmith

A&D Bespoke 33
custom

Acta Display 58
Dino dos Santos

Agency 105
David Berlow

Akkurat 39, 92, 147, 239
Laurenz Brunner

Akkurat Mono 170
Laurenz Brunner

Akkurat Mono Regular 156
Laurenz Brunner

Akkurat Pro Bold 156
Laurenz Brunner

**Berthold
Akzidenz-Grotesk 130, 251**
Günter Gerhard Lange

**Berthold Akzidenz- Grotesk
Medium 226**
Günter Gerhard Lange

Amasis MT 171
Ron Carpenter

Amerigo 168
Gerard Unger

Archive 170
Fontfabric

Archive Garfield 143
Fontfabric

Archive Gothic Ornate 143
Fontfabric

Archizoom 250
custom

Arno Pro 81
Robert Slimbach

Avenir 177, 249
Adrian Frutiger

Avenir Next 163
Adrian Frutiger

Baskerville 115
John Baskerville

Bauer Bodoni 76
Heinrich Jost
and Louis Holl
after Giambattista Bodoni

Bauer Bodoni BT 78
Heinrich Jost
and Louis Holl
after Giambattista Bodoni

Bauer Bodoni Bold 186
Heinrich Jost
and Louis Holl
after Giambattista Bodoni

Bauer Bodoni Bold Italic 186
Heinrich Jost
and Louis Holl
after Giambattista Bodoni

Bauer Bodoni Std 34
Heinrich Jost
and Louis Holl
after Giambattista Bodoni

Benton Sans Condensed 187
Tobias Frere-Jones
and Cyrus Highsmith

Bespoke 211
Angus MacPherson

Blanch 238
Atipus

Blender Pro 211
Nik Thoenen

Bodoni (modified) 212
Giambattista Bodoni

Bodoni 120, 173, 231
Giambattista Bodoni

Brandon Grotesque 201
Hannes von Döhren

Brauer Neue 234
Lineto

Brioni 236
Nikola Djurek

Brothers (modified) 41, 172
John Downer

LL Brown 72
A. Sack

LL Brown Bold Italic 47
A. Sack

LL Brown Bold Reclining 47
A. Sack

Bureau Grotesque 169
Gustavo Piqueira

Calibre 218
Kris Sowersby

Caslon 175, 282
William Caslon

Adobe Caslon 131
Carol Twombly
after William Caslon

Adobe Caslon Pro 89, 235
Carol Twombly
after William Caslon

Century Gothic 196
Sol Hess and
Morris Fuller Benton

Century Schoolbook 179
Morris Fuller Benton

Chalet 188
Ken Barber

Champion Gothic 65, 114
Jonathan Hoefler

Chromosome 248
Brian Willson
Chronicle Display 60, 224
Hoefler & Frere-Jones

Chronicle G1 249
Hoefler & Frere-Jones

Chronicle Text 224
Hoefler & Frere-Jones

Chronicle Text G2 79
Hoefler & Frere-Jones

Chronicle Text G3 Roman 35
Hoefler & Frere-Jones

Clarendon 171
Hermann Eidenbenz

Clavier 122
unknown

Compatil 166
Silja Bilz, Erik Faulhaber,
Reinhard Haus, and
Olaf Leu

Consolas 139
Luc(as) de Groot

Consolas Bold 97
Luc(as) de Groot

Copperplate Gothic 204
Frederic W. Goudy

Courier 139
Howard Kettler

Cubano 105
Chandler van Der Water

CUBI 246
Jihye Yang

Cyclone 96
Hoefler & Frere-Jones

Cyclone Inline 249
Hoefler & Frere-Jones

FF DIN 33, 108, 252
Albert-Jan Pool

DIN 1451 Engschrift 89
German Institute for
Industrial Standards

BW Druk 87
Berton Hasebe

Eloquent 176, 177, 197
Jason Walcott

Engravers MT 137
Monotype Staff

Escorial EF 78
Lars Bergquist

Esta Pro 250
Dino dos Santos

Fairplex Wide 207
Zuzana Licko

Falfurrias 96
Nick Curtis

Fedra Momo Std 59
Peter Bil'ak

FindReplace 90
Eric Olson

Firenze 173, 231
Tom Carnase

Flama 171, 173, 231
Mario Feliciano

Franklin Gothic 274
Victor Caruso after
Morris Fuller Benton

ITC Franklin Gothic 179
Victor Caruso after
Morris Fuller Benton

ITC Franklin Gothic Std 213
Victor Caruso after
Morris Fuller Benton

Freight 65
Joshua Darden
and Thomas Jockin

Friz Quadrata 222
Ernst Friz

Frutiger 57 Condensed 97
Adrian Frutiger

Futura 45, 181
After Paul Renner

Futura Bold 129
After Paul Renner

Futura Script Regular 249
After Paul Renner

Futura Std Bold 202
After Paul Renner

ITC Futura 134
After Paul Renner

Garage Gothic 165, 176
Tobias Frere-Jones

Adobe Garamond 240
Robert Slimbach
after Claude Garamond

Garamond Premier 137
Robert Slimbach
after Claude Garamond

Georgia 139
Matthew Carter

Gill Sans 101
Eric Gill

Gill Sans MT 242
Eric Gill

Gill Sans Regular 151
Eric Gill

Gotham 66, 75, 128, 157
Tobias Frere-Jones
with Jesse Ragan

Gotham Black 237
Tobias Frere-Jones
with Jesse Ragan

Gotham Light 70
Tobias Frere-Jones
with Jesse Ragan

Gotham Rounded 227
Tobias Frere-Jones
with Jesse Ragan

Gotham Thin 70
Tobias Frere-Jones
with Jesse Ragan

Gridnik 200
David Quay

F Grotesk Book 206
Laagte Kadijk

Guadalupe Essential Gota 83
Daniel Hernández

BW Haas Head 88, 144, 146
Commercial Type

BW Haas Mono 146
Commercial Type

BW Haas Text 146
Commercial Type

Harriet 133
Jackson Cavanaugh

**Helvetica
164, 175, 189, 253**
Max Miedinger

Helvetica Inserat 236
Max Miedinger

**Neue Helvetica
LT Std 45 Light 191**
D. Stempel AG
after Max Miedinger

Neue Helvetica
LT Std 127
D. Stempel AG
after Max Miedinger

Neue Helvetica
Light Pro 135, 224
Stempel AG
after Max Miedinger

Neue Helvetica
65 Medium 210
D. Stempel AG
after Max Miedinger

Neue Helvetica 35 Thin 70
Stempel AG
after Max Miedinger

Hermes 248
Matthew Butterick
after Heinz Hoffmann

Hermes Sans 248
Matthew Butterick
after Heinz Hoffmann

Hessian 96
MadType

Hiragino Sans GB 59
JIYUKOBO Ltd. and Beijing
Hanyi Keyin Information
Technology Co., Ltd.

Hoefler Text 143, 176
Jonathan Hoefler

Horley Old Style 244
Monotype Staff

Hudson 60
Jonathon Yule,
Curriculum Studio

Adobe Jenson 204
Robert Slimbach
after Nicolas Jenson

FF Kievit 41, 172
Mike Abbink

Klavika 90
Eric Olson

Knockout
92, 93, 197, 204
Jonathan Hoefler

Knockout HTF50
Welterweight 73
Jonathan Hoefler

Knockout HTF 78
Jonathan Hoefler

Korolev Condensed 127
Rian Hughes

Lace Script 61
coton design

Larish Neue 203
RP Digital Foundry

Letter Gothic 213
Roger Roberson

Loveland Ale 77
custom

Loveland Rail 77
custom

Magnel 177
Eimantas Paskonis

Manu Sans 223
Jeffery Keedy

FF Meta Serif 142, 150
Christian Schwartz,
Kris Sowersby,
and Erik Spiekermann

Metro Black 235
W.A. Dwiggins

Miller 187
Matthew Carter

Mini type v2 Bold 127
unknown

Minion 147
Robert Slimbach

AF Module 98
Acmefonts

MoMA Gothic 126, 214
Carter & Cone

Monrod 119
V.H. Fleishe

Mrs. Strange 238
Slub Design

National 65
Kris Sowersby

Neutra 183
Richard Neutra

Neutraface 228
Christian Schwartz
after Richard Neutra

Neuzeit Grotesk 131
Wilhelm Pischner

Nonpareille 230
Matthieu Cortat

Nutcase 190
Jeremy Mickel

Optimo 232
Optimo Type Foundry

Pennsylvania 220
Christian Schwartz

Perla 173, 231
Gareth Hague

Pershing 82' 199
Gruppo Ferretti

Pitch 133
Kris Sowersby

Pitch Regular 160
Kris Sowersby

Plantin 282
Robert Granjon and
Frank Hinman Pierpont

Plantin Std 138
Robert Granjon and
Frank Hinman Pierpont

Poem Script 83
Alejandro Paul

Pradel 39
Andreu Balius

Priori 91
Jonathan Barnbrook

Proforma 93, 223
Petr van Blokland

Proxima Nova 150
Mark Simonson

ITC Quay 220
David Quay

Ravenna 162
Joffre LeFevre

Sabon Next 145
Jean François Porchez
after Jan Tschichold

Scala Fraktur Medium 140
Verena Gerlach

FF Scala Sans 140
Martin Majoor

Sentinel 72, 188, 228
Hoefler & Frere-Jones

Siseriff 163
Bo Berndal

Square Slabserif
711 (City) 122
Georg Trump

Standard Pennsylvania
License Plate Font 184
Pennsylvania Department
of Transportation

Stempel Schneider 205
F.H. Ernst Schneidler

Stuart 230
Nonpareille

Suisse 80
Ian Party

Swift 75
Gerard Unger

Tahoma 139
Matthew Carter

Távora Display 229
Daniel Santos

Theinhardt 35, 232
François Rappo

Theinhardt Family 241
François Rappo

Tilda Script 51
custom

FB Titling Gothic 219
David Berlow

Times New Roman 136
(Regular, Italic, and Bold)
Stanley Morison
and Victor Lardent

Timmons 137
custom

Town Original Font 151
custom

Trade Gothic 167, 216
Jackson Burke

Trade Gothic Bold
Condensed 20 135
Jackson Burke

Trade Gothic
Condensed 20 214
Jackson Burke

Trade Gothic Light 214
Jackson Burke

T-Star Mono Round 79
Michael Mischler

Tungsten 251
Hoefler & Frere-Jones

Typ1451 76
Lineto

Univers 154
Adrian Frutiger

Univers LT 154
Adrian Frutiger

Univers LT Std 82
Adrian Frutiger

Univers 67 Bold
Condensed 154
Adrian Frutiger

Utopia 229
Robert Slimbach

Verlag 105, 207
Hoefler & Frere-Jones

Vitesse 41, 172
Hoefler & Frere-Jones

Walbaum 74
Justus Erich Walbaum

GT Walsheim (modified) 103
Noël Leu

Zentenar Fraktur Mager 205
Ralph M. Unger

ZWEI 55
Jacopo Severitano

ZWInterstate 74
Jürgen Weltin

160over90 249
3007 221
601bisang 154
A2/SW/HK 192
Abadie-Mendia, Trudy 156
Abifarès, Huda Smitshuijzen 258
Abnee, Nina 72
AD&D 43, 198
Adamik-Novak, Jiri 62
Addison 236
Adolph, Juergen 244
Ahrens, Tim 274, 275
AIGA 18, 22, 266
Aimar-Molero 122
Alberty, Thomas 217
Alexander, Dean 176
Alexander, Rob 44, 45, 181, 182, 233
Allen, Rob 73, 104
Alliance Graphique Internationale, The 18, 266
Alt Group 79, 80, 111
Amsalem, Myriam 54
Anatomy of Type, The 264
Andersen, Mike 44, 45
Anderson, LaRue 162
Anderson, Wes 50, 51
Andrecia, Chris 258
Angebrandt, Tanja 201
Animade 192
Anton, Emily 146
Applegate, Evan 146
Architecture and Design Museum 33
Ariane Spanier Design 48
Arnett, Dana 35
Arnold Worldwide 56
Art Center College of Design 33, 90, 91, 218
Art Institute of Chicago 266
Ashton, Andrew 35
Askour, Abdul Rahman 130
Assembly 242
Atelier Poisson 39, 228, 248, 250
Atrissi, Tarek 14, 38
Atwel, Alis 146
Auchu, Claude 41, 170, 172
Auckland University of Technology 35
Bae, In Hee 89
Balius, Andrew 35
Balzer, Yanik 194
Bantjes, Marian 35
Banton, Brian 241
Barcelona, Katie 188, 190
Barney, Matthew 266
Barone, Valentina 199
Barry, Ben 45, 251
Bartlett, Brad 33, 91, 218
Bathroom, The 266
Bauhaus and Design Theory, The 266
Baur, Nadine 131
Becker, Carsten 162
Becker, Rietje 16, 40
Becker, Tobias 148
Becky, Sucha 177, 178
Beer, Blandine 131

Behavior Design 200
Beletsky, Misha 258
Bellut, Sarah 244
Belonax, Tim 223, 251
Benguiat, Ed 268
Benns, Nic 134
Beresik, Christina 131
Bergmann Studios 101
Bergmann, Kai 101, 235
Berlow, David 258, 262, 272
Bernardin, Riley 72
Bezalel Academy of Arts and Design 288
Bichler, Gail 86
Bicker, João 229
Bierut, Michael 187, 188, 189, 190
Biles, Brian 156
Bitstream, Inc. 262
Bittner, Patrick 130
Björn Wolf 166, 168, 169
Blackletra 277
Bloomberg Businessweek 87, 88, 144, 146
Bolls, Emily 181, 182
Bologna, Matteo 94
Bong, Kim Hee 69
Boothroyd, Anne 242
Bordes, Sophie 41, 172
Boston, Michael 59
Bouillon, Chris 130
Bourjo, Pierre 206
Bradley, Thomas C. 216
Breithardt, Vivian 131
Brien, Donovan 202
Brighten the Corners 136
Brink, Michael 244
Brock, Emily 44, 45
Brown, Henry 131
Buckley, Lee 162
Buckley, Lynn 245
Budig, Ivonne 34
Bufler, Stefan 131
Bungard, Brigitta 222
Bunsas, Bianca 131
Burbidge, James 131
Burchiel, Kim 224
Burton, Carl 135
Bussmann, Pascal 244
Byrnes, Sam 59
Byrom, Andrew 18, 42, 155
Caggiano, Jeanie 72
California State University, Long Beach 155
Calixto, Charles 179
Callaway, Patricia 77
Calvert, Margaret 258
Cambronero, Jinki 79, 111
Caneso, Mark 68
Cantrell, Kevin 78
Cardinal, Chelsea 83, 84
Carleton College 26
Carlson, Britta 106
Carnase, Tom 286
Carrier, Ninon, 46, 47
Carthas, David 146
CDP 258
Central Saint Martins College of Arts and Design 98
CF Napa Brand Design 197
Chabrol, Claude 50
Chase, Matt 177
Chen, Ka Li 130

Chen, Stanley Xing 33, 218
Chen, Yue 157
Cheong, Kit 33
Chiat/Day 258
Chou, Ingrid 214, 220
Church of London, The 211, 215
Ciecka, Ashley 44, 45
Cilli, Darryl 249
Clearview 268
Clément, René 232
Clermont, Anne-Marie 170
Clifford, Graham 257
Cobonpue, Bryan 135
Cohen, Donna 146
Cohen, Emanuel 234
Colbourne, Richard 236
Coles, Stephen 258, 264, 274
Collard, Brittany 207
Collins, Brian 58
Collins: 58
Concrete Design Communications 219
Congdon, Lisa 45
Connell, Brad 70
Cooper Union, The 14, 266
Cooper, James 209
Cooper, Molly 51
Cooper-Hewitt 266
Cooper-Hewitt National Design Museum 26
Corey, Claire 126, 220, 222
Côté, Sabrina 170
Côté, Serge 40, 41, 171, 172, 173, 231
coton design 61
Cottrell, Hannah 131
Couchman, Brent 45, 109
Crabtree, Tom 77
Creation Ruediger Goetz 244
Creative Review 268
Creature 66, 113, 128
Credle, Susan 72, 73, 104
Crosby, Tom 92
Crouchman, Ryan 219
Cullen, Steve 66, 113, 128
Cullinane, Kate 35
Curtis, Matt 149
Daniel, Jennifer 146
Davison, Mike 242
Dawson, Jeremy 51
de Almeida, Claudia 174, 175, 237
de Does, Bram 276
de la Nuez, Ena Cardenal 129
De Leo, Anthony 92
de Vicq de Cumptich, Roberto 96
Dean, Jed 131
Deininge, Dana 197
DeLago, Ken 118
Delcán, Pablo 174, 175
Dennis, Jonothan 35
Design Army 176, 177, 178, 179
Design Writing Research 266
designdept 99
Dever, Wade 56
Disney Animation 112
DiSpigna, Tony 286
Dorau, Marcus 244
Doret, Michael 112

Dorsey, Kelly 72
Dranaz, Eva 221
Draplin Design Co. 20
Draplin, Aaron James 20, 44
"Dream Machine Lullaby" 120
Dubé, Julie 170
Duchaine, Chris 60, 206, 224
Duhamal, Simon 170
Duplessis, Arem 86, 119
Dye, Alan 45
Ebelhar, Wes 135
Echolab 135
Ecke, Will 44, 45
Eckersley, Sam 64
Edwards, Aaron, 80
Eggers, Dave 45
eggnerd 139
Egner, Alex 139
Ellis, William 137
End of Work 152
Escola, Ramon 161
Evans, Josie 131
Evans, Poppy 22
Facebook 251
Facebook Communications Design 251
Fahey, Chris 200
Farrar, Straus and Giroux 95
Fashion Institute of Technology 16, 196
Favat, Pete 56
Fay, Aron 188, 190
FBA 229
Feerer, Ryan 193
Fenge, Martin 195
Fensterheim, Eric 127
Ferguson, Adam 72
Fernandez, Terry 228, 248
Ferriera, Nuno 73, 104
Fill, Jochen 221
Fink, Jessica 131
Finke, Tim 75. 93
First Person American 22
Fletcher, Bradley 131
Flynn, Brian 45
Fons, Hickmann 23 166, 167, 168, 169
Font Bureau, Inc., The 262
FontFont 285
Fonts In Use 264
FontShop 264
Forbes, Dan 160
formdusche 75
Foster, Angela 135
Foster, David 282
Fournier, Pénélope 41, 172
Freeman, Sean 85, 86
Friedl, Jasmine 44, 45
Frommer, Benedikt 131
Fuchs, Sven 130
Fuenfwerken Design AG 76, 81
Fütterer, Dirk 145
Fuze Reps 206
Fz, Stefanie 98
Gafsou, Matthieu 250
Gagnon, Louis 234
Gais, Michael 194
Gallardo, Hugo 199
Gamache, Monique 70
Garcia, Daniel 135
Geedrick, Michael 225
Geiger, Frank 227

Gencer, Geray **132**
Gerritsen, Roy **161**
gggrafik **103**
GGI **258**
Giguere, Paulette **214**
Gilbert, Marie-Pier **173**, **231**
Girard, Martin **172**
Giustiniani, Maria **99**
Giustiniani, Stefano **99**
Glaser, Milton **35**
Go Welsh **183**, **184**
Goldberg, Carin **108**, **174**, **175**, **237**
Goldenberg, Jamie **146**
Golf Digest **118**
good morning inc. **151**
Goodman, Timothy **208**
Goulet, Cindy **173**, **231**
Goweiler, Alexandra **130**
GQ **83**, **84**
Grace, Tom **284**
Gramlich, Götz **103**
Grand Deluxe Inc. **210**
Graphic Design Reference & Specification Book: Everything Designers Need to Know Every Day, The **22**
Greenberg, Lisa **60**, **206**, **224**
Gretel **135**
GREY **244**
Griffith, Wade **193**
Guaran, Eugene **162**
Guerrera, Francesco **199**
Gunderson, Dane **72**
Gurney, Skye **85**
Gustafson, Laurie **72**
Guzy, Stefan **230**
Haacke, Hans **266**
Haakman, Sander **161**
Haas **262**
Hafen, Dominik **203**
hafontia.com **288**
Hahn, Greg **135**
Haller, Katharina **130**
Halsman, Philippe **165**
Han, Song-Yi **243**
Harding-Jackson, Kate **72**
HarperCollins Publishers **114**, **115**
Hartley, Anna **249**
Hastro, Shawn **146**
Haven, Jim **66**
Heckmann, Julia **244**
Heckner, Marc **97**
Hector, Myriam **130**
Hedin, Cecilia **44**, **45**
Heik, Gloria **153**
Heimbuche, Florentine **235**
Helland, Frode Bo **283**
Heller, Steven **35**, **89**
Helms Workshop **56**
Hendy, Mark **244**
Henschel, Antonia **185**
Herburg Weiland **195**
Herguijuela, Ricarda **130**
Hervy, Etienne **99**
Hesse, Irmgard **74**, **97**
Hickey, Emma **80**
Hinrichs, Kit **153**
Hirai, Hidekazu **141**
Hische, Jessica **45**, **50**, **51**
Hisquin, Romain **165**
Hobson, Henry **162**

Hochschule Augsburg **131**, **235**
Falmouth University **131**
Hochschule der Bildenden Künste Saarbrücken **130**
Hoffman, Cynthia **146**
Hoffman, Erin **59**
Hoffmann, Alexander **130**
Hoffmann, Julia **126**, **214**, **220**, **222**
Hong, Minji Aye **120**, **121**, **122**
Horn, Maria **130**
Hospodarec, Joe **70**
House Rulez **122**
Hsu, Mariela **176**, **177**
Huang, Wen Ping **127**
Hudson, John **258**, **272**, **273**, **277**, **278**
Huml, Michaela **74**
Hummel, Timo **75**, **93**
Huschka, Jane **64**
Hwang, Jin-young **154**
Hyperkat **127**
Hyun, Cho **69**
I am Robot and Proud **120**
Ibler, Sebastian **205**
ID **268**
Ide, Hisa **143**
Ide, Kumiko **143**
Ide, Toshiaki **143**
IF Studio **143**
Igunma, Jana **258**
Illick, Chandra **146**
Imhof, Nadja **110**
Infiltrate: The Front Lines of the New York Design Scene **26**
Iniguez, Dante **77**
Ising, Tom **195**
Jaeger, Olaf **213**
Jaeger, Regina **213**
Jenkins, Gaelyn **44**, **45**
Jocham, Hubert **287**
John, Judy **60**, **224**
Johnson, Joseph **138**
Johnston, Simon **90**
Joyce, Mike **226**
Jung, Jong-in **154**
Jung, Leo **160**
Jung, Su-jin **154**
Jungmann, Phil **72**
Just Another Foundry **275**
Kalle, Martin **130**
Kaltenthaler, Annika **74**, **97**
Kalvesmaki, Joel **272**
Kander, Nadav **84**
Kao, Goretti **133**
Katogi, Mari **204**
Katona, Diti **219**
Kavulla, Brandon **160**
Keaveney, Quinn **238**
Keegin, Emily **146**
Keith, Gideon **207**
Kentridge, William **266**
Kidd, Chip **10**
Kilroe, Brett **54**
Kim, Alison Kim **44**, **45**
Kim, Jamie **159**
Kim, Minjeong **67**
Kim, Sang Wook **252**
Kim, Seonghye **124**
Kim, You Jin **125**
King, Ben **158**

King, Sean **9**
King, Shannon **70**
Kiosoglou, Billy **136**
Kirsanov, Dmitriy **258**
Kitchen, The **266**
Kleiner, Ori **105**, **122**, **123**
Knight, Eve Lloyd **215**
Koch, Rudolph **276**
Kochel, Travis **285**
Kofoed, Johnny **242**
Kokott, Raul **167**
Köln International School of Design **194**
Kookmin University **82**, **243**
Kookmin University College of Design **67**
Kozlowski, Caleb **45**
Kravtchenko, Youri **250**
Kronbichler, Thomas **168**
Ku, Bryan **155**
Kubel, Henrik **192**
"Ku-Chi-Ta-chi" **122**
Kumalasari, Yorie **162**
Kupferschmid, Indra **130**
Kurchak, Morgan **224**
Kuwertz, Max **194**
KW43 BRANDDESIGN **244**
Kwon, Wooksang **82**
L2M3 Kommunikationsdesign GmbH **227**
La femme infidèle **50**
Laag, Ed **162**
Lador, Clement **248**
LaFontaine, Justin **249**
Lampugnani, Nicola **199**
Lanctôt, Catherine **23**, **41**, **172**
Landor Associates **26**
Lane, Kris **80**
Larcombe, Randy **92**
Lay, Jackie **177**
Le Pierrès, Margaux **196**
Leder, Scott **60**, **206**, **224**
Lee, Eileen **77**
Lee, Irina **22**, **46**
Lee, Tony **214**, **220**
Lefebure, Jake **176**, **178**, **179**
Lefebure, Pum **176**, **177**, **178**, **179**
Lefebvre, Audrey **171**
Lefebvre, Joanne **232**
Leiber, Patrick **161**
Leo Burnett Chicago **72**, **73**, **104**
Leo Burnett, Toronto **60**, **206**, **224**
Leonidas, Gerry **258**
lg2boutique **41**, **170**, **171**, **172**, **173**, **231**
lg2fabrique **41**, **170**, **171**, **172**, **231**
Li, Gilbert **241**
Lian Types **286**
Lindmeier, William **181**
Linotype **262**
Linotype Germany **290**
Little, Jason **59**
Lobe, Sascha **227**
Locascio, Matt **91**
Longworth, Rob **211**
Lubalin, Herb **286**
Lucci, Ralph **200**

Luckhurst, Matt **58**
Luecke, Karsten **278**
Lueken, Jon **73**
Lunde, Ken **258**
Lupfer, E. A. **286**
Lussier, Pierre **231**
Lyons, Chris **204**
Ma, Tracy **60**, **87**, **88**, **144**, **146**
Mach, Seth **107**, **116**
MacPherson, Angus **215**
Magpie Studio **102**
Mahon, Emily **204**
Mak, Jonathan **35**
Mandate Press, The **78**
Mann, Chris **44**, **45**, **182**
Mannix, Jason **180**
Mannix, Lindsay **180**
Manual **77**
Mao, Dominique **44**, **45**
Maret, Léonard **228**
Marianek, Joe **188**
Marino, Alexandra **64**
Marinovich, Erik **45**
Marks **47**
Marmer, Renée **236**
Martin, Cade **178**
Martin, Casey **72**
Marz, Scott **183**, **184**
Matos, Alexandre **229**
Matsumoto, Koji **210**
Matthews, Daniel **207**
McCormick, Lara **120**
McFerrin, Grady **204**
McGuiness, Sam **59**
Mediadesign Hochschule München **205**
Mediadesign University of Applied Sciences, Munich **34**
Menchin, Scott **157**
Menhart, Didricht **276**
Menke, Marcel **205**
Mergenthaler **262**
Messias, Pedro **108**
Messinger, Max **244**
Mid-Century Modernist, The **264**
Mill, The **162**
Miller, Abbott **258**, **266**, **276**
Miller, Matt **72**
Mills, Ross **272**
Mollica, Greg **212**
MOMOCO **134**
Monokrom **283**
Montalbano, James **258**, **268**, **278**
Moonrise Kingdom **50**
Moore, Ryan **124**, **135**
Mora, André **133**
Moreillon, Adrien **110**
Morin-Laurin, Florence **41**, **172**, **173**, **231**
Mrsic, Katarina **79**, **111**
Mucca Design **94**
Muetze, Rolf **244**
Mugikura, Shoko **275**
Mulligan, Clara **66**, **113**, **128**
Mulvaney, Dylan **135**
Munch, Gary **258**
Munday, Oliver **115**, **240**
Myers, Anna **80**
Myers, Jack **135**
Nathan, Ben **288**
Navas, Antonio **242**
Nemo Design **216**

New York **217**
New York Times, The **268**
New York Welcoming
 Stories **22**
Newman, Bob **107, 116**
NG, Esther **130**
Nguyen, David **232**
Nguyen, Trong **224**
Niemann, Christoph **190**
Nix, Charles **117**
Nogueira, Maria **48, 49**
Nosenzo, Christopher **146**
Number Seventeen **26**
Office of Gilbert Li, The **241**
Office: Jason Schulte
 Design **45, 181, 182, 233**
Ogilvy **258**
Okell, John **258**
Oliveras, Ferran Milan **291**
OMG **115, 240**
Ono, Yoko **266**
Osiander, Elias **34**
Oslislo, Zofia **140**
Oyama, Megumi **43**
Pagan and Sharp **158**
Pagan, Juan Carlos **158**
Paik, Nam June **266**
Palmer, Ged **209**
Pan, Jenny **44, 45**
Paprika **232, 234**
Pardue, Deva **187**
Park, Elaine **123**
Park, Irene **135**
Park, Kum-jun **154**
Parsons The New School for
 Design **26, 117, 268**
Peace Graphics **141**
Pearl, Maayan **146**
Pedrazzini, Francesco **199**
Pemrick, Lisa **182**
Pentagram Design Austin
 71, 239
Pentagram Design New York
 187, 188, 189, 190
Pepe, Paolo **245**
Peraza, Deroy **127**
Perez, Richard **44, 45**
Perreault, Jen-François **170**
Perret, Guillaume **65**
Perron-Thomas, Frédérique
 170
Perry, Mike **217**
Pesce, Giorgio **38, 39, 65,
 228, 248, 250**
Pfeffer, Annette **244**
Philippin, Frank **136**
Phillips, Andrew **131**
Piazza, Jeff **200**
Picard, David **60**
Pieczynski, Rich **104**
Pine, DW **85**
Pinheiro, Hugo **229**
Poff, Kyle **72**
Polygraph **180**
Poole, Dean **35, 79, 80, 111**
Popplestone, Andrew **134**
Popular Lies About Graphic
 Design **24**
Positype **289**
pprwrk studio/pstype **68**
Pratt Institute **157, 268**
Priddy, Rose **131**
Print **264, 268**
Proctor, Andrew **162**

Pylypczak, John **219**
Rabbit! **181**
Raidt, Rob **104**
Random House Publishing
 Group **96, 204, 212, 245**
Raper, Josh **72**
Ratliffe, Kate **66**
Reese, Greg **162**
Reeves, Kevin **197**
Reinmuth, Steve **44, 45**
Rhie, Daniel **208**
Rivera, Jerod **90**
Ro, Chris **67, 243**
Robertson, Jill **45, 181, 182,
 233**
Robertson, Stuart **162**
Robertson, Travis **56**
Robitaille, Luc **173, 231**
Rockport Publishing **22**
Rodriguez, Marie-Hélène **232**
Rogers Eckersley Design **64**
Rogers, Jeff **193**
Rogers, Stuart **64**
Rose, Maria Sofie **117**
Ross, Fiona **258**
Rothermich, J. Kenneth **236**
Rouette, Andrée **40, 41, 172**
Roussel, Ingrid **170**
Rousselot, Ricardo **286**
Rudolph, Ashley **131**
S/O Project **69**
Sabino, Daniel **276, 277**
Saelinger, Dan **118**
Sagmeister, Stefan **35, 159**
Sahre, Paul **26**
Sakai, Hiroko **61**
Salczynski, Eric **184**
Sample Copy **35**
San Francisco Museum
 of Modern Art **266**
Santos, Daniel **229**
Satalecka, Ewa **140**
Sato, Maki **198**
Sauter, Yvonne **131**
Sauvé, François **171**
Savannah College of Art
 and Design **107, 116, 156**
Savasky, Julie **239**
Savoie, Alice **278, 279**
Schauer, Theresa **34**
Scheuss, Rick **244**
Schiffer, Kevin **244**
Schmitz, Sybille **34, 205**
Schneider, Corinna **130**
Schoenhaar, Sabine **244**
Schönfeld, Helene **131**
School of Art Institute of
 Chicago **238**
School of Visual Arts,
 New York **14, 22, 54, 89,
 105, 106, 108, 120, 121,
 122, 123, 124, 125, 159,
 174, 175, 237, 252, 253,
 268**
Schroeder, Astrid **244**
Schuemann, David **197**
Schulte, Jason **44, 45, 181,
 182, 233**
Schwarz, Isabel **130**
Schweig, Sebastian **130**
Schwenk, Frauke **131**
Scofidio, Diller **266**
SEGD **266**
Senn, Bernhard **203**

Sensus Design Factory **147**
Serf, Muriel **130**
Sérigraphie Uldry **39**
Severitano, Jacopo **55**
Shannon, Susanna **99**
Shaughnessy, Adrian **35**
Sherin, Aaris **22**
Sherman, Sam **126**
Simone, Bill **184**
Slusher, Rick **236**
Smith, J. **251**
Smith, S.W. **177, 179**
Smithsonian Cooper-Hewitt
 National Design Museum **268**
Smyth, Hamish **187, 189**
Sobota, Alexandra **244**
Somosi, Dora **83, 84**
Song, Andy **208**
Song, So-hee **154**
Sonnabend, Catrin **101**
Sons & CO. **80**
Soo, Kim Ryun **69**
Soto, Gerald Mark **121, 125,
 252**
Spanier, Ariane **48**
Spitzer, Aymie **127**
Spoljar, Kristina **147**
Spoljar, Nedjeljko **147**
Sproviero, Maximilian **286**
St. Victor, Yego Moravia **106**
Stammers, Mark **238**
Stefanizen, Susann **166, 169**
Steffen, Markus **244**
Stempel **262**
Stereotype **226**
Stern, Laura **73**
Steurer, Chris **76**
Stevanovic, Mia **34**
Stieger, Roland **203**
Stölzle, Daniela **131**
Stout, DJ **71, 239**
Strategy Design and
 Advertising **207**
Strick, Charlotte **95**
Strohl **63, 100**
Strohl, Christine Celic **45,
 63, 100**
Strohl, Eric **45, 63, 100**
Studio Atelier Poisson **65**
Studio Hinrichs **153**
Studio Tobias Becker **148**
Studio/lab **191**
Stupidshit **161**
Stvan, Tom **96**
Sucara, Justin **162**
Sugawara, Takahiro **151**
Summerour, Neil **289**
Summers, Pavlina **62**
Sung, Jaehyouk **82**
Suryakusuma, Diana **146**
Sutton, James **131**
Swarm **266**
Takaya, Ren **42, 43, 198**
Takizawa, Asuka **43**
Tam, Gary **135**
Tamura, Katsumi **151**
Tanamachi, Dana **193**
Tarek Atrissi Design **14**
Tavendale, Kirsty **131**
Taylor, Guybrush **73, 104**
Taylor, Jarrod **114**
Taylor, Nic **54**
Taylor, Stu **71**
Tbwa/Italia spa **199**

Terashima Design Co. **57**
Terashima, Masayuki **57**
Terdich, Matthew **191**
Terminal Design, Inc. **268**
TGG Hafen Senn Steiger **203**
The Aesthetics of Waste: A
 Process of Elimination **266**
The Museum of Modern Art
 (MOMA), Department of
 Advertising and Graphic
 Design **126, 214, 220, 222**
The New York Times
 Magazine **119**
The Times **149**
THERE IS Studio **85**
Thompson, Michael **83**
Thurner, Sara **131**
Tiro Typeworks, Ltd. **272,
 273, 279**
TK Type Foundry **285**
Toda, Maiko **198**
Tonge, Alice **102**
Trakakis, Katerina **145**
transistor.ch **110**
Trump, James **44, 45**
Türkmen, Mehmet Ali **164**
Turley, Richard **87, 88, 144,
 146**
Turner Publishers **129**
Tutssel, Mark **72**
Ty, Peter **72**
Tynan, Sarah **73**
Type@Cooper **10, 14**
TypeTogether **284**
Typographica.org **264**
Tzaj, Virgilio **105**
Uchida, Yoshiki **247**
UnderConsideration **16, 31,
 55, 142, 150, 163**
University of Applied
 Sciences, Bielefeld **145**
University of Applied
 Sciences–Faculty of
 Design **201**
Utrecht School of the Arts,
 Holland **14**
Valentine, Sophie **171**
Vance, Arlo **78**
Vargas, Robert **146**
Veillon, Cyril **250**
Veljovic, Jovica **290**
Vella, Vincenzo **196**
Venning, Stephen **162**
Verreault, Maryse **173**
Vierrether, Annkatrin **131**
Vignelli, Massimo **35**
Vit, Armin **30, 31, 55, 142,
 150, 163**
Voettiner, Christian **244**
Voice **92**
von Doehlen, Svenja **75, 93**
von Hausen, Marcus **74, 97**
Wade, Gavin **180**
Wagman, Ryan **73, 104**
Wagner, Annabelle **130**
Wahler, Adam **2**
Wahler, Carol **2, 7, 9, 10,
 257**
Wahlstrom, Kelly **44, 45**
Waller, Alexis **59**
Walls, Jim **249**
Walter, Tammo **249**
Ward, Craig **24, 48**
WAX **70**

Waxman, Alyce **26**
Webb, Jessica **131**
Webster, Ben **78**
Welsh, Craig **183, 184**
Wesely, Manuel **130**
Western Michigan
 University **26**
Wheeler, Doug **118**
White, Eric **212**
Wiatowski, Stefani **131**
Wiedemann, Nicole **131**
Wierer, Steffen **75, 93**
Wilburn, Danielle **104**
Willey, Matt **137**
Williams, Bennett **237**
Willoughby, Bob **137**
Willoughby, Paul **215**
Willson, Alisdair **134**
Wilson, Lee **146**
Winkler, Magdalena **131**
Wired **160, 268**
Wittmann, Svenja **145**
Wolfgramm, Alan **80**
Wolfson, Alicia **72**
Wong, Jon **44, 45**
Wood, Chris **102**
Woodward, Fred **83, 84**
Wörle, Oliver **227**
Woyte, Günter **235**
Wright, Tom **177**
Wu, Cindy **45**
Yang, Jihye **246**
Yeo, Aran **253**
Yeomans, Jane **146**
Yuet, Tin **130**
Yuh, James **249**
Zaagsma, David **161**
Zack, Alison **200**
Zahno, David **46, 47**
Zankel, Harun **186**
Zeichen & Wunder **74, 97**
Zhukov, Maxim **257**
Ziegler-Haynes, Meagan **146**
Zinker, Christine **104**
Zwoelf **230**

Unfulfilled at an Art Deco Bathhouse

A pet that
had to be fed
raw chickens
every day.

'My motto i
no to anyt
designe